The Cos Cob Art Colony

Impressionists on the Connecticut Shore

Susan G. Larkin

National Academy of Design
New York

Yale University Press
New Haven and London

Designed by Daphne Geismar
Set in Minion type by Amy Storm
Printed in Singapore by C S Graphics

Library of Congress Cataloging-in-Publication Data
Larkin, Susan G., 1943–
 The Cos Cob art colony: impressionists on the
 Connecticut shore
 p. cm.
 Includes bibliographical references and index.
 ISBN 0-300-08852-3 (hc: alk. paper)—
 ISBN 1-887149-06-6 (pbk.: alk. paper)
 1. Impressionism (Art)— Connecticut— Cos Cob. 2.
 Artist colonies— Connecticut— Cos Cob. 3. Cos Cob
 (Conn.)— In art. 4. Painting, American. 5. Painting,
 Modern— 19th century— United States. 6. Painting,
 Modern— 20th century— United States. I. Title.

ND210.5.I4L37 2001
759.146'9— dc21 00-043679

A catalogue record for this book is available from the British Library.

The paper in this book meets the guidelines for permanence and durability of the Committee on Production Guidelines for Book Longevity of the Council on Library Resources.

10 9 8 7 6 5 4 3 2 1

The Cos Cob Art Colony: Impressionists on the Connecticut Shore was published on the occasion of the exhibition of the same title organized by the National Academy of Design. Major support for the exhibition was provided by the Robert Lehman Foundation and the Peter Jay Sharp Foundation. Additional support was provided by the F. Donald Kenney Foundation and Mr. and Mrs. Richard J. Schwartz.

Exhibition Itinerary

National Academy of Design Museum
February 13 to May 13, 2001

Museum of Fine Arts, Houston
June 17 to September 16, 2001

Denver Art Museum
October 27, 2001, to January 20, 2002

Contents

Foreword

In Europe, the concept of the art colony is well known. In fact, many
American artists studying abroad in the nineteenth century experienced
the camaraderie and exchange of influences that took place in these
summer hideaways. In the United States they formed similar groups. A
few American art colonies were deliberately organized—the Byrdcliffe
colony in Woodstock, New York, for example, was a planned Arts
and Crafts community inspired by the Utopian principles of the British
artists and reformers John Ruskin and William Morris. Others, like
Byrdcliffe's successor, the Woodstock art colony, originated as summer
schools and expanded to include artists of all ages. A handful of art
colonies, including those in Cornish, New Hampshire, and the Lawrence
Park section of Bronxville, New York, were initiated by businessmen
who anticipated a more interesting social life—and increased property
values—if their communities boasted resident artists. Most, how-
ever, evolved casually as several artists visited the same picturesque
locale and encouraged their friends to join them and buy or rent
places in the vicinity. Among this group are Monhegan Island, Maine;
Gloucester, Massachusetts; and Old Lyme and Cos Cob, Connecticut.
The story of Cos Cob is unfolded herein in the flowing prose of
Susan Larkin, with whom it has been my great pleasure to work during
the past two years.

 Small art institutions like the National Academy of Design
expand their curatorial expertise by hiring guest curators. The National

Academy of Design has not only benefited from Susan Larkin's knowledge about American art colonies, in particular the one in Cos Cob, but we have also gained from her sound organizational skills, her gentle persistence, and her diplomacy. Her work has augmented and complemented other projects at the National Academy of Design Museum, and our professional staff have enjoyed working with her.

On behalf of the National Academy of Design and Susan Larkin, I should like to thank those who have contributed to this book and its companion exhibition. Without the initial encouragement and support of the Robert Lehman Foundation and the subsequent support of the Peter Jay Sharp Foundation, the exhibition and publication could not have taken place. We are also grateful for the support of Mr. and Mrs. Richard J. Schwartz.

The staff of the National Academy of Design, who worked harmoniously with Susan Larkin to organize the exhibition, include Anne Rehkopf Townsend, director of development; Cecilia Bonn, director of communications; Anne Cafferty, director of finance; David Dearinger, chief curator; Kathy Fieramosca, rights and reproductions; Simone Manwarring, former registrar; Wendy Rogers, registrar; and Joanna Sternberg, curator of education. We appreciate their hard work.

Dan Kershaw is responsible for the handsome exhibition design at the National Academy of Design Museum, and we are indebted to him for his expertise. Working in concert with Dan were conservator Lucie Kinsolving and associate conservator Nadia Ghannam, as well as our contract installers and preparators.

At the Museum of Fine Arts, Houston, Emily Neff, curator of American art, energized us with her enthusiasm from an early stage. We are also grateful to Peter C. Marzio, director, and Barry Walker, curator of prints and drawings. Among the staff of the Denver Art Museum, we extend special thanks to Lewis I. Sharp, director; Carolyn L. Campbell, exhibitions director; Ann Daley, curator of American paintings and sculpture; and Bridget O'Toole, curatorial assistant.

Our collaborative partners, the Historical Society of the Town of Greenwich and the Bruce Museum in Greenwich, Connecticut, enriched the exhibition's content and expanded its audience by planning complementary programs at two sites that were crucial to the Cos Cob art colony: the boardinghouse where the artists gathered and the

museum they helped to shape. At the Historical Society of the Town of Greenwich, we express special appreciation to Debra Mecky, Jane Hoder, Susan Richardson, Victoria Hackman, Melinda Sherman, and Karen Blanchfield White. At the Bruce Museum, Cynthia Drayton efficiently coordinated the complementary exhibition, *Art for the Great Estates: The Bruce Museum's First Decade*. In addition, we are especially grateful to former director Hollister Sturges, to interim director Homer McK. Rees, and to Deborah Brinckerhoff, Robin Garr, Nancy Hall-Duncan, Michael Horyczun, and Anne von Stuelpnagel.

We are deeply indebted to the lenders, both individuals and institutions, who have generously agreed to share their works of art with audiences in New York, Houston, and Denver. We thank Mr. and Mrs. Robert P. Gunn, Marie and Hugh Halff, Richard A. Manoogian, Charles M. Royce, Mrs. Hugh B. Vanderbilt, and the private collectors who wish to remain anonymous.

Staff members at the lending institutions deserve special recognition: Susan Faxon, Denise Johnson, and Julie McDonough, Addison Gallery of American Art; Stephanie Cassidy and Pamela N. Koob, Art Students League; Alain Joyaux, Ball State University Museum of Art; Nicolette B. Meister, Beloit College Museums; Dawn Pheysey and Sue Thompson, Museum of Art, Brigham Young University; Lisa Cain, Linda Ferber, and Marilyn S. Kushner, Brooklyn Museum of Art; James Crawford, Canajoharie Library and Art Gallery; Julie Aronson, Anita Ellis, Gretchen Shie, and former curator of paintings and sculpture John Wilson, Cincinnati Art Museum; Henry Adams, Diane De Grazia, Kate M. Sellers, and Mary E. Suzor, Cleveland Museum of Art; Gail F. Serfaty and Thomas Sudbrink, Diplomatic Reception Rooms, United States Department of State; William U. Eiland and Lynne Perdue, Georgia Museum of Art; Judith Lefebvre, Hartford Steam Boiler Inspection and Insurance Company; Margaret Dong, Brian G. Kavanagh, and Phyllis Rosenzweig, Hirshhorn Museum and Sculpture Garden; Amy Meyers, Huntington Library; Margaret Brown, Library of Congress; George R. Goldner, John K. Howat, Peter M. Kenny, Nestor Montilla, Suzanne L. Shenton, Thayer Tolles, and H. Barbara Weinberg, Metropolitan Museum of Art; Diane Fischer, Gail Stavitsky, and Mara Sultan, Montclair Art Museum; Franklin Kelly and Earl A. Powell III, National Gallery of Art; former director Daniel Rosenfeld,

Lorena Seghal, and Sylvia Yount, Pennsylvania Academy of the Fine Arts; Jay Gates, Joseph Holbach, and former director Charles S. Moffett, The Phillips Collection; Ann Eichelberg and Prudence F. Roberts, Portland Art Museum; Elizabeth Broun and Abigail Terrones, Smithsonian American Art Museum; Kirk Delman and Mary MacNaughton, Williamson Gallery, Scripps College; Karen Merritt and George W. Neubert, Sheldon Memorial Art Gallery; Mary Ellen Goeke, John Hallmark Neff, and Shelly Roman, Terra Museum of American Art; David Park Curry, Katharine C. Lee, John B. Ravenal, and Mary L. Sullivan, Virginia Museum of Fine Arts; and Constance Evans, Weir Farm Trust.

Others who were helpful in the course of organizing the exhibition are Warren Adelson, Elizabeth Oustinoff, and Caroline Owens, Adelson Galleries; Charles Burlingham; William B. Carlin; Thomas Colville; Janice Connors and Joel Rosenkranz; William M. Curtin, professor emeritus, University of Connecticut; David Findlay, Jr., of David Findlay, Jr., Inc.; Everett Fisher; Cameron Shay, James Graham and Sons; Joseph Goddu, Kathleen Burnside Kilbride, M. P. Naud, and Arlene Nichols, Hirschl & Adler; Kenneth T. Jackson, Columbia University; Martha Fleischman and Lillian Brenwasser, Kennedy Galleries; Joan Barnes and Cheryl Robledo, Manoogian Collection; Gay Myers and Lance Mayer, conservators; Elizabeth Milroy, Wesleyan University; Stuart Lee Parnes, Mystic Seaport Museum; Roberta Waddell, New York Public Library; Michael Owen and Jim Yost, Owen Gallery; Lara Shirvinski, Sotheby's; Ira Spanierman, Betty Krulik, Lisa Peters, and Judy Salerno, Spanierman Gallery; Dolores Tirri, Weir Farm National Historic Site; and Eli Wilner and Suzanne Smeaton, Eli Wilner and Company.

As always at the National Academy, we appreciate the confidence and encouragement of the Exhibition Committee.

Annette Blaugrund
Director of the National Academy of Design

Acknowledgments

Over the years of work on this project, I have benefited from the intellectual stimulus, moral support, and practical help of many people. Elizabeth Boone, Hildegard Cummings, Elizabeth Milroy, Arlene Nichols, and Susan Richardson read drafts of the manuscript and offered perceptive criticisms that resulted in numerous improvements to the text. In addition to specialized knowledge of art and history, each also brought to the reading an ear for language.

Annette Blaugrund, director of the National Academy of Design, has been a generous supporter of this project from the beginning. Annette's reputation as a scholar enabled us to secure several loans that might otherwise have been unavailable, and her oversight of all aspects of the exhibition and publication allowed a complex project to come to fruition. It was a pleasure to work with her and the dedicated staff of the National Academy of Design, whom I wish heartily to thank.

My work on the Cos Cob art colony originated with my 1996 doctoral dissertation at the City University of New York. My adviser, William H. Gerdts, and the other members of my committee, Annette Blaugrund, Diane Kelder, and Sally Webster, offered astute criticism and welcome encouragement. While I was writing my dissertation, my two years as a Chester Dale Fellow at the Metropolitan Museum of Art enabled me to work within an unparalleled collection and community of scholars. I am especially grateful to H. Barbara

Weinberg, Alice Pratt Brown Curator of American Paintings and Sculpture, and would also like to thank Kevin Avery, Marian Burleigh-Motley, Claire Conway, Alice Cooney Freylinghuysen, Morrison Heckscher, John K. Howat, Peter Kenny, Amelia Peck, Pia Quintano, Carrie Rebora, Thayer Tolles, Frances Safford, and Catherine Hoover Voorsanger.

Many colleagues have generously shared information over the years. Lisa Peters, Sona Johnston, and Kathleen Burnside Kilbride, authors of the forthcoming catalogues raisonnés on Twachtman, Robinson, and Hassam, respectively, graciously answered questions, helped me contact collectors, and performed many other kindnesses for which I am most grateful. In addition to their scholarly monographs, another invaluable reference has been Doreen Bolger's book *J. Alden Weir: An American Impressionist*.

The Historical Society of the Town of Greenwich contributed many of the archival photographs used in the book. In her role as the society's archivist, Susan Richardson patiently answered my questions and guided me to significant documents at every stage of research and writing. I profited from the long memory of the late William E. Finch, Jr., Historian of the Town of Greenwich, and relied on Nils Kerschus's deed research for the history of Cos Cob's built environment. Debra Mecky, Jane Hoder, Karen Blanchfield White, former director Susan Tritschler, and former program director Barbara Freeman offered valuable assistance and support. I also wish to express my appreciation to Claire Vanderbilt and her late husband, Hugh, for their dedication to the preservation and dissemination of the town's history.

Librarians, archivists, and curators shared insights and expedited the retrieval of information. I would especially like to thank Arlene Pancza-Graham and Nancy Malloy, Archives of American Art; Stephanie Cassidy and Pam Koob, Art Students League; Marisa Keller and Paul Manoguerra, Corcoran Gallery of Art; Jeffrey W. Andersen and Jack Becker, Florence Griswold Museum; Richard Hart, Alice Sherwood, and the late Marion Nicholson, Greenwich Library; Kate Johnson, Historic Hudson Valley; Ardie Myers, Library of Congress Humanities and Social Sciences Division; Edward Baker, Mystic Seaport Museum; Jack Larkin, Old Sturbridge Village; and Elizabeth Kornhauser, Wadsworth Atheneum.

Others who have helped in various ways include Helen Brody, Bob Capazzo, Diana B. Carroll, Mabel Burke Delage, David Donald, the late Frances Donald, Cynthia Drayton, Sue Dunlap, Martha Gardiner, Bernadette Passi Giardina, Katherine C. Grier, Bev Harrington, Paula Henderson, Andrea Husby, Alexander Katlan, Irene Murphy Keeley, Eric De Lony, Elizabeth M. Loder, Thom and Gail Hogan Lucia, Laura Macaluso, Sally Mills, Emily Nelson, John Nelson, Frank Nicholson, Christine Oaklander, the late Haru Matsukata Reischauer, Eleanor DelMar Revill, John Seel, Deborah Solon, Harold G. Spencer, Nancy Standard, Davidde Strackbein, the late Max Taylor, Sid Uhry, David Wierdsma, Martha Zoubek, and Julie, Craig, and Chet Zieba.

Earlier versions of chapters 2 and 5 appeared in *American Art Journal*, where I enjoyed the editorial advice of Jayne Kuchna. A previous version of chapter 3 appeared in *Greenwich History*, then edited by Susan Goldberg, who made helpful suggestions.

At Yale University Press, I am indebted to Jenya Weinreb for her superb editing, Daphne Geismar for the elegant design, and Mary Mayer for overseeing the production of the book. I would also like to thank the anonymous outside reader, whose perceptive critique helped me refine my thinking and writing, and Judy Metro, who offered advice and encouragement in the initial stages of the book project.

Finally, I thank my wonderful family for their patience during what seemed an interminable project. I owe warmest appreciation to my husband, Jim, and our children, Kate and Jim, for their consideration during the long years of work on this book and the accompanying exhibition.

Introduction

From 1890 to 1920, the Cos Cob section of Greenwich, Connecticut, was the site of a lively art colony. There, John H. Twachtman, Childe Hassam, Theodore Robinson, and J. Alden Weir participated in shaping American Impressionism. Cos Cob in the 1890s was as important to them as Argenteuil in the 1870s had been to Monet, Renoir, and Manet. It was their testing ground for new styles and new themes. As they encouraged one another to challenge artistic conventions, they benefited from the stimulus of the writers, editors, and journalists who were also members of the art colony. Through summer schools and friendships with younger artists, they passed Cos Cob's experimental spirit on to a new generation.

The Cos Cob art colony was well known in its heyday. Many artists included local place names in the titles of their artworks; Hassam even designated part of one of his exhibitions "The Cos Cob Set." Today, although devotees of American art know the colony's name, few realize its importance. Confusion over geography is largely responsible. Whereas many art historians acknowledge that Twachtman produced his most important body of work in Greenwich, some are not aware that Cos Cob is a section of that town. (A natural reluctance to pronounce the odd name may contribute to the confusion; *Cos* is pronounced *cahss*.)[1] Yet the Cos Cob area of Greenwich, a place steeped in tradition, proved a crucible of artistic innovation.

At the end of the nineteenth century, the time was right for the evolution of art colonies in New England. The artists who gathered in Cos Cob and in other enclaves were accustomed to working in groups. During their student years in Europe, they had banded together to paint in the countryside. After spending the summer of 1873 painting with his former art-school classmates in France, the twenty-six-year-old Weir wrote to his parents of the value he placed on stimulating companionship. "I begin to think that an artist can be bred a good workman anywhere," he mused, "if he has some healthy men to work with who are not influenced by the old pictures except in sentiment."[2]

Back in the United States, the European-trained artists continued to seek out one another for support as they challenged the orthodoxies of the conservative art establishment. Twachtman, who had returned to his native Cincinnati, roamed the East Coast in the summer of 1880 searching not only for inspiring scenery but also for invigorating fellowship. Although he had intended to go to Maine's Mount Desert Island, he ended up in Nonquit Beach, Massachusetts, because, as he explained in a letter to Weir, he had learned that other artists were there and "I might as well have stayed West as to have gone to M. D. alone."[3]

This desire for companionship led to the evolution of many art colonies. I define an art colony as a group of artists working near one another outside a city and sharing a communal identity. The size of the group may vary, but a critical mass is necessary for a true art colony. Although many colleagues visited Weir's farm in Branchville, Connecticut, for example, it was not an art colony because only one or two artists worked there at any given time. Similarly, William Merritt Chase's famous summer school at Shinnecock, Long Island, does not qualify as an art colony because it included only one professional artist.[4] In addition, an exurban location is essential to the sense of escape that characterizes art colonies. Because artists tend to congregate in cities to pursue teaching careers and exhibition opportunities, an urban neighborhood, regardless of how many artists live there, does not involve the deliberate withdrawal implicit in the concept of an art colony.

Not every cluster of artists summering in the countryside constitutes an art colony, however. The crucial element is self-identification as a distinct group, within but apart from the surrounding

community. In Cos Cob, the Holley House provided an inspiring and affordable gathering place, allowing innovative, cosmopolitan artists to work within a traditional waterfront village. In turn, the village was surrounded by a prosperous farm town undergoing rapid suburbanization. In this book I shall examine those concentric circles of community, exposing the often uneasy relations between the Cos Cob Impressionists and the diverse groups beyond the Holley House. On the surface at least, the art colonists enjoyed a casual rapport with the working-class villagers. Some painters set their easels in the shipyard, where they bantered with the sailmakers and carpenters while painting the nautical landscape. Children hung over artists' shoulders as they sat in the shade of ancient elms to depict pre-Revolutionary houses. From the porch of the Holleys' boardinghouse, other artists greeted passersby while sketching the quiet village. By comparison, the art colonists' relations with the other newcomers from the city, who were ostensibly from the same class and background, were initially conflicted. The artists adopted a bohemian stance that differentiated them from the prosperous suburbanites. Eventually, however, they shed their aloofness when they recognized the new residents as potential patrons. Their efforts to cultivate that market resulted in the establishment of an exhibition society and the development of a museum, both of which thrive to this day.

The Cos Cob group's self-consciousness was heightened by its relations with other artistic centers, such as Shinnecock and Old Lyme. The Holley House regulars generally shunned publicity, fearing that the hamlet would lose its charm if it became too crowded. They recognized, however, that their art colony represented a major source of income to the owners of the Holley House, to other local businesses, and to Twachtman during the years he taught in Cos Cob. The artist faced competition from Chase's summer school at Shinnecock, which overshadowed Twachtman's much smaller classes. Both teachers solicited students from the ranks of the Art Students League in New York City, where Chase taught until 1896 and Twachtman until his death in 1902. The dates of Chase's summer school—1891 to 1902—bracket the period from the beginning of Twachtman's sessions at the Holley House until his death, promoting the suspicion of friendly rivalry between the two Impressionists. Disdaining Chase's teaching methods,

3

Robinson recorded an acquaintance's description of Chase's critiques at Shinnecock: "sixty odd pupils all crowded into a room—ampitheatre [sic]—and two hundred sketches criticised in 3 hours." The rivalry between the schools extended to their pupils. When Twachtman's summer students mounted a "Cos Cob Exhibition" at the Art Students League in December 1897, their pride was enhanced by the belief that they had outshone their Shinnecock counterparts.[5]

The art colony in Old Lyme, about seventy-five miles northeast of Greenwich, seems justifiably to have viewed Cos Cob, together with the groups at Barbizon and Giverny in France, as a progenitor. The artist who "discovered" Old Lyme, Clark Voorhees, belonged to a prominent Greenwich family. He bicycled up the coast to Old Lyme in 1896 after spending a rainy month painting in Cos Cob. Apparently on Voorhees's recommendation, Henry Ward Ranger paid a visit three years later and returned in 1900 with five friends—the nucleus of the Old Lyme art colony.[6] Hassam, who had painted in Cos Cob as early as 1896 and would return there until 1916, visited Old Lyme between 1903 and about 1907.[7] Matilda Browne, Charles and Mary Roberts Ebert, Will Howe Foote, Henry Bill Selden, and Allen Butler Talcott all painted in both Cos Cob and Old Lyme.[8]

An artist who worked best in a communal atmosphere would often seek out more than one enclave. Hassam, the most peripatetic of artists, visited the Isles of Shoals (off the New Hampshire coast), Cos Cob and Old Lyme (in Connecticut), Gloucester and Provincetown (in Massachusetts), and numerous other colonies before buying his own home in East Hampton, New York, in 1919. Twachtman also painted in Gloucester; Ebert worked in Gloucester, Old Lyme, and Monhegan (in Maine); D. Putnam Brinley was affiliated with both Woodstock (in New York) and Silvermine (in Connecticut). The landscape painter Leonard Ochtman, who settled in the Cos Cob area in 1891, sometimes taught at Byrdcliffe in Woodstock, New York, where he became director of the summer school in 1905. Birge Harrison, who occasionally painted at the Holley House, is more closely identified with Byrdcliffe and Woodstock. Robert Reid and Walter Clark, who painted in Greenwich in the 1890s, later settled in the artsy Lawrence Park section of Bronxville, New York. Kerr Eby, Rose O'Neill, and Oscar and Lila Wheelock Howard—all of whom had previously lived and worked in

Cos Cob—settled after World War I in Westport, Connecticut, the home of many artists and illustrators.[9]

Although rivals emerged and proliferated, Cos Cob supported a vital art colony for two decades. During that time, the town was undergoing a dramatic transition from an agricultural and maritime community to an upper-middle-class suburb of New York. The sense of change that permeated life in turn-of-the-century Greenwich over-flowed to the process of art-making there, promoting an experimental spirit that made this colony significant in the history of American art.

That spirit was shared by a cohesive group of artists who painted in the same vicinity during the day and discussed their work in the evenings. In large part, the Cos Cob art colony was shaped by compelling personalities. The individual who, more than any other, set the group's experimental tone was Twachtman. Lincoln Steffens, an investigative journalist affiliated with the art colony, remarked of him, "I'm not so interested in his pictures, I'm interested in his tempera-ment."[10] Twachtman's temperament—by turns gregarious and introspec-tive, restless and serene—was a major factor in preventing the Cos Cob art colony from becoming a backwater of nostalgic complacency. Ironically, his lack of commercial success contributed to his artistic inde-pendence, freeing him from the temptation of producing salable pictures according to a proven formula. His art, conversation, and teach-ing fueled the creative fires of his friends and students in Cos Cob.

Other artists also contributed valuable personal qualities to the art-colony milieu. Robinson's friendship with Monet, coupled with his perceptive criticisms of his own and others' work, made him a key figure in the translation of French Impressionism into an American idiom. Weir's kindly supportiveness and his astute observations about artistic predecessors from Rembrandt to Hokusai encouraged and stimulated the Holley House regulars. Hassam, on visits extending over more than two decades, never stopped trying new things. One of his last sojourns in Cos Cob, in 1915, bore results as significant as any of his earlier ones, marking his first extended foray into printmaking at the age of fifty-six.

The membership of the art colony reached beyond the core group of artists to encompass a wide range of professions, ages, nationalities, and social backgrounds, thereby encouraging a critical

5

approach to conventional wisdom. Such novelists as Willa Cather and Irving Bacheller, like such painters as Robinson and Hassam, tapped a growing national self-confidence and respect for homegrown tradition, coupled with a poignant awareness of change. Nonfiction writers, most notably Steffens, raised the intellectual temperature of the art colony with their relentless challenging of received ideas. Women professionals, among them illustrator Rose O'Neill, playwright Kate Jordan, and editor Viola Roseboro', were indisputable evidence of a major social shift. Japanese artist Genjiro Yeto enriched the group with an outsider's view of American life. In their diversity and dynamism, the quiet rebels of the Holley House formed a bohemian enclave within the larger community.

The art colony's independent spirit prompted those who had come to Cos Cob as students to continue the experiments of their elders, rather than simply perpetuate the strategies they had learned from them. In that spirit of innovation, Cos Cob's second generation made the shift to a new Post-Impressionist idiom. Accustomed to collaborative endeavors during their formative years, they organized independent exhibition groups on both the local and the national level. Several members of the art colony, notably Elmer MacRae and Henry Fitch Taylor (one of the colony's founders), were among the principal organizers of the Armory Show, the landmark exhibition that in 1913 introduced modernist European art to a vast American audience.

The Cos Cob art colony flourished during a period of sweeping social, cultural, and artistic change. Why did it thrive for so long? Stimulating companionship and affordable accommodations were essential to the colony's origins, but they are insufficient to explain its enduring appeal. The key factor, I argue in this book, was that in Cos Cob the artists found subject matter rich enough to engage them for years, even, in Hassam's case, for decades. Whereas many of their preferred subjects—colonial architecture, quiet landscapes, contemplative women—were also treated by others, the Cos Cob artists interpreted those subjects with unusual acuity and depth. Close analysis of their art reveals the integration of design and content to express their intense engagement with the landscapes, the buildings, and the people around them.

1 | The Genteel Bohemians
of Cos Cob

"I have been at work on a six foot canvas at Holly Farm, working like a beaver," the twenty-eight-year-old Julian Alden Weir wrote to his half-brother on October 1, 1880.[1] Three years earlier, Weir had returned to the United States after four years' study in Paris. He established his studio in New York, but continuing the practice he had adopted in Europe, he spent the summers painting with friends in rural retreats. Unlike such remote painting grounds as the Adirondacks, Holly Farm was easily accessible from the city. When Weir wanted to spend a few weeks in the country, he took the train to Greenwich, Connecticut, stopping at the station in the Cos Cob section of town. If he caught the express train, the thirty-mile trip took about forty minutes; adding a ten-minute buggy ride from Cos Cob to Holly Farm, he could travel from Grand Central Station to his country retreat in less than an hour (see the map on page 8).

Weir was one of many New Yorkers who exploited the convenient rail link to spend holidays in Greenwich. The New York and New Haven lines had served the town since 1848, but it was only after the Civil War that New Yorkers began taking the train out to Greenwich for summer holidays. During the 1870s, the coming and going of vacationing city folk became season markers as reliable as the return of the robins in the spring and the departure of the wild geese in the autumn. In 1874, the town had five hundred summer visitors. The following year, that many arrived on just one day, the third of July.

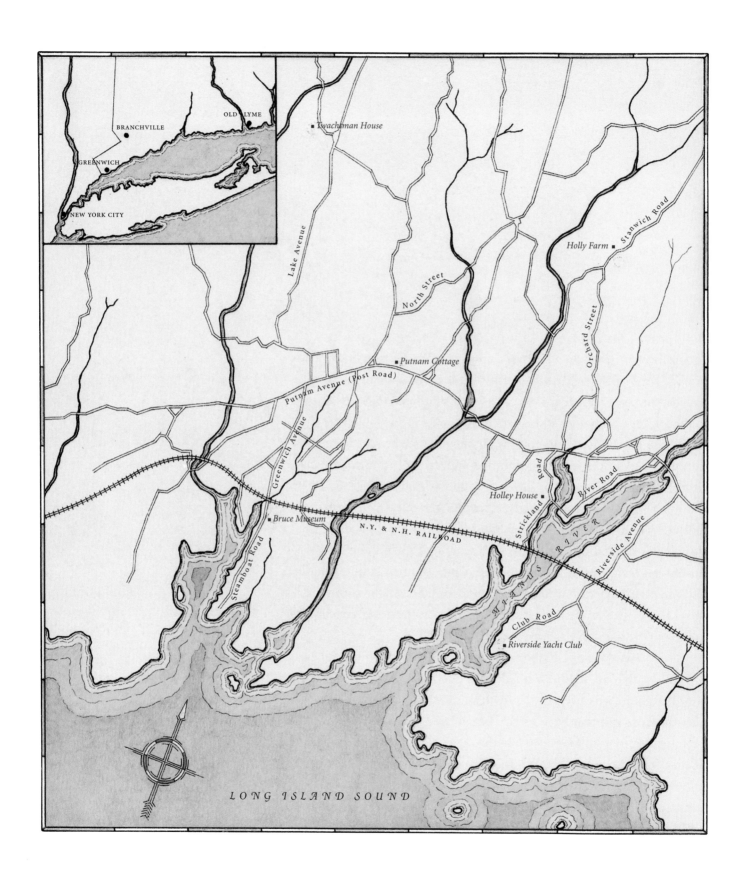

BRANCHVILLE

OLD LYME

GREENWICH

NEW YORK CITY

■ *Twachtman House*

Lake Avenue

North Street

Holly Farm ■

Stanwich Road

Orchard Street

■ *Putnam Cottage*

Putnam Avenue (Post Road)

Greenwich Avenue

Holley House ■

Strickland Road

River Road

M A N U S R I V E R

Riverside Avenue

Steamboat Road

■ *Bruce Museum*

N.Y. & N.H. RAILROAD

Club Road

■ *Riverside Yacht Club*

L O N G I S L A N D S O U N D

Many became seasonal, and eventually permanent, residents. As a result, between 1890 and 1920, the peak years of the Cos Cob art colony, the town's population soared by 118 percent.[2] The sleepy farming and fishing community had been transformed into a residential suburb of New York.

For New Yorkers like Weir, proximity was one of the town's attractions, but it was not the primary one. New York's Westchester County is closer to the city than Greenwich, but its manicured suburban character lessened its appeal for many potential visitors. As early as 1853, one writer complained that Westchester's "lawns and park-gates, . . . trim edges and well-placed shrubberies, fine houses and large stables, neat gravel walks and nobody on them" combined "to make a dull tune of Westchester."[3] Greenwich, in contrast, was slow to lose its agricultural and maritime identity. A fox raiding a hen house and a good catch of fish rated mention in the local papers, where the market prices for apples ran beside lists of arrivals at the resort hotels. As late as 1911, the town's "principal industry" was still farming.[4]

Even more important, Greenwich was in New England, the region identified as the wellspring of American history and the source of enduring national values.[5] This powerful appeal was invoked in an 1892 column in a New York newspaper, which defined Greenwich as "the western doorway of the State of Connecticut, being the first town across the line which divides the Land of Steady Habits from the Empire State." During the Colonial Revival, which lasted from 1876 to about 1920, New England was idealized as the essentially American region.[6] Contemporary local-color literature by Irving Bacheller, Sarah Orne Jewett, Celia Thaxter, Harriet Beecher Stowe, and others celebrated life in long-settled villages where wise, taciturn people lived in harmony with nature. Although their stories are usually set in Maine or New Hampshire, the communities those authors describe resemble Greenwich in the late nineteenth century. Like Jewett's fictional Dunnet Landing, for example, Greenwich appeared to be a "salt-aired, white-clapboarded little town."[7] In fact, Greenwich was (and is) a very large town, covering forty-eight square miles. Composed of numerous distinct communities, however, it retained a small-town atmosphere.

The town also offered varied scenery, which proved a major attraction to visitors, including artists. Tidal marshes, bustling

(opposite) Greenwich, Connecticut, showing sites significant to the art colonists. *Inset:* The relative locations of New York City, Greenwich, Branchville, and Old Lyme.

9

harbors, winding rivers, rocky pastures, backcountry farms, woodland streams: all these and more could be found within its boundaries. Landscape painter Leonard Ochtman told an interviewer that "all about the old town of Greenwich, Conn., there are splendid materials for sketching. . . . You can get fine marine views, and wooded bits back in the country. . . . pretty roads, woods and delightful shore and sea views." As early as the 1870s, residents grew accustomed to seeing painters at work along the shore or on the edges of the grainfields. In 1874, a local paper reported that "Mr. W. B. Cox, an artist from Columbia Hights [*sic*], Brooklyn, is at Rock Cliff Camp on Field Point. His sketch book is filled with familiar scenes." Three years later, another paper reported that painter and illustrator Charles Stanley Reinhart "has been making numerous sketches about town . . . so we may expect soon to see some of the natural beauties of Greenwich during the coming winter." [8] Painters became so numerous in the area that by 1884, the hardware store's advertisements featured artists' materials almost as prominently as farm implements.

The painters, even more than the other city folk, were invested in preserving the town's appearance of unspoiled rural tradition. The second-generation Hudson River School painter David Johnson produced at least six paintings in Greenwich between 1878 and 1889.[9] Although Johnson was part of the influx of vacationers who were, by then, trans-forming the area, he disguised that change in his *View near Greenwich, Connecticut* (fig. 1), dated 1878. Four years earlier, Johnson had painted a similar work, *Lake George Looking North from Tongue Mountain Shore* (fig. 2), also depicting figures in rowboats on placid, rock-rimmed water. The canvases differ, however, in two significant details. First, the boaters in *View near Greenwich* are working fishermen—two shirt-sleeved men in a workaday dinghy dip nets into the water— whereas the presence of three fashionably dressed women and a child, the idleness of all the figures, and the elegance of the boats prove the view of Lake George to be an image of modern leisure and tourism. Second, whereas the Adirondacks vista recedes into hazy wilderness bounded only by a distant mountain, the Greenwich scene is abruptly arrested by a railroad embankment and a passing train. In this telling juxtaposition, Johnson's *View near Greenwich* encapsulates the tensions that would pervade the work of the Cos Cob art colony:

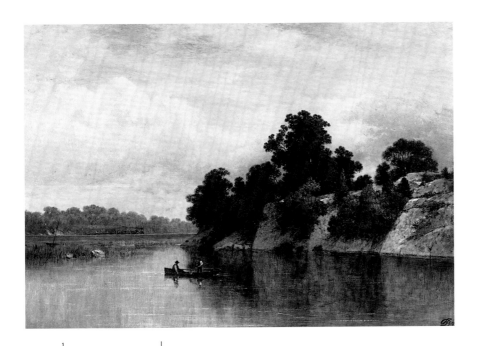

1

David Johnson, *View near Greenwich, Connecticut*,
1878, oil on board, 13 ⁷/₈ x 19 ³/₄ in. Hartford Steam Boiler
Inspection and Insurance Company, Hartford, Conn.

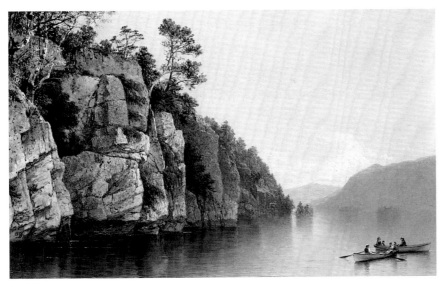

2

David Johnson, *Lake George Looking North from
Tongue Mountain Shore*, 1874, oil on canvas, 14 ¹/₈ x 22 ¹/₈ in.
The Adirondack Museum, Blue Mountain Lake, N.Y.

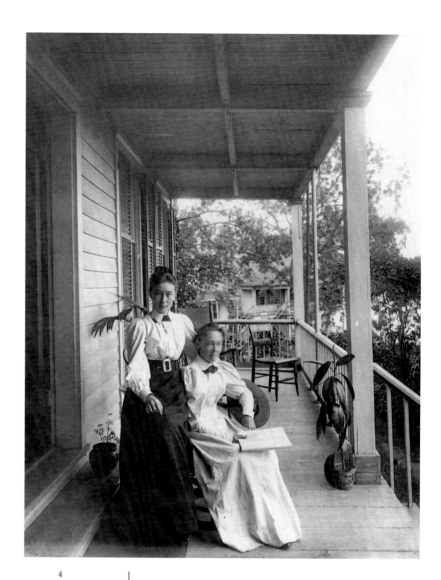

4

Josephine Lyon Holley (1848–1916), seated, with her daughter Constant Holley (1871–1965) on the front porch of the Holley House, ca. 1895, photograph. Constant Holley married artist Elmer MacRae in 1900. Historical Society of the Town of Greenwich.

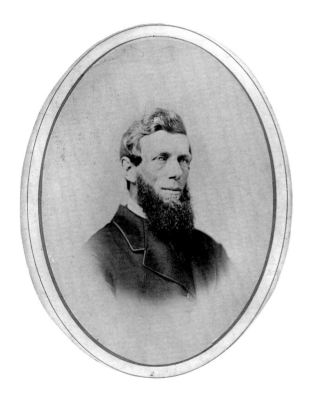

3

Edward Payson Holley (1837–1913), ca. 1885, photograph. Historical Society of the Town of Greenwich.

those between tradition and modernity, nature and technology, boat and train.

It is not known where Johnson stayed during his visits to Greenwich in the 1870s and 1880s, but it is possible that he, like the younger artist J. Alden Weir, boarded at Holly Farm on Stanwich Road in central Greenwich. The farm was owned by Edward Payson Holley (fig. 3), who added the flourish of an *e* to his surname after he inherited the land from his father.[10] Holley recognized the influx of summer visitors as a business opportunity. After his marriage in 1866 to Josephine Lyon (fig. 4), he rapidly expanded his property from 31 to 114 acres, probably with the intention of reselling it to newcomers for residential lots. In 1873 he went deeply into debt to build a three-story boardinghouse on the family farm (fig. 5). The Second Empire–style mansion had twenty bedrooms and two dining rooms, where fifty-four persons could be seated at meals. The Holleys advertised its attractions in a New York newspaper:

5

The boardinghouse at Holly Farm on Stanwich Road, ca. 1880, photograph. The house was demolished by the 1950s. Historical Society of the Town of Greenwich.

Greenwich, Conn.—First-class board for select parties at a private residence; large airy rooms, wide piazzas, extensive grounds, splendid shade, no mosquitoes, no chills and fever; one hour from New-York to Coscob, all trains stop; ten minutes from depot, carriages waiting for all trains; references required. Parties can be seen to-day, at parlor No. 45 Grand Union Hotel, from 1 to 6 P.M., or address Holly Farm, Greenwich, Conn.[11]

While Edward Holley continued to grow potatoes, apples, and onions for the city market, Josephine catered to their paying guests. For a woman, running a boardinghouse was a socially acceptable occupation, largely because it was an extension of her traditional domestic role.[12] Within her own home, the landlady cooked, cleaned, and laundered for her boarders as she did for her family. The surrogate family of boarders was carefully selected, however. A guest could obtain a room in a proper boardinghouse only if recommended by someone known to the proprietor; as the Holleys' advertisement stipulated, references were required. Conversely, a genteel person would not stay at a boardinghouse unless a friend had recommended it.[13] In addition, the Holleys and their potential guests could inspect one another on neutral territory, the parlor of a city hotel. As a result of this intensely personal transaction, most boardinghouses specialized, catering to clients linked by profession or other affinities. The guests' shared interests and the family structure of management made a good boardinghouse a home away from home. As one contented boarder told an interviewer from the *Ladies Home Journal,* "If you want real home life, you've got to board. Then you have real people sitting around you at dinner—your own kind who are there for much your sort of reason. You feel that bond."[14]

The Holleys' Yankee ancestry enhanced the nostalgic appeal of a sojourn at their farm. Although they were not wealthy, their families were long established and well respected in the community. Edward Holley was descended from one of the original English settlers of Stamford, the large town just northeast of Greenwich. Josephine Lyon Holley's ancestors on both sides had settled in New England in 1632; on her father's side, she was descended from the first governor of the Massachusetts Bay colony.[15] Josephine's brother, Hartford physician Irving W. Lyon, was an avid antiquarian who pioneered the documentation of American furniture. He is credited with proving

that most old oak chests and cupboards found in New England were not imported, as had been assumed, but were made in the region.[16] The extended Holley family possessed the ability—rare at the time— to view their heirlooms not simply as household furnishings but as indigenous American art.

One of the Holleys' paying guests in the late 1870s was the respected artist Robert W. Weir, who retired from a long career as drawing instructor at West Point in July 1876 and moved to Hoboken, New Jersey, just across the Hudson River from New York City. Thereafter, he and his wife boarded occasionally at Holly Farm, sometimes joined by their youngest son, J. Alden Weir.[17] The younger Weir's friend John Henry Twachtman boarded at the farm with him in 1878 and 1879, according to the later reminiscences of the Holleys' daughter, Constant.[18] Born in Cincinnati to German immigrant parents, Twachtman had studied at the Royal Academy in Munich in the mid-1870s and had painted with colleagues in Bavaria and Venice. He and Weir may have met at the first exhibition of the Society of American Artists, held in New York in March 1878. Their friendship deepened when both had studios in the University Building in New York, probably beginning that autumn.[19] Twachtman's visits to Holly Farm in the late 1870s were, as far as is known, the first that he made to Greenwich—the place with which his life and his art would become entwined. They were also the genesis of the Cos Cob art colony.

Cos Cob itself became known to artists after the Holleys went bankrupt and lost their farm and stylish new boardinghouse. After the holders of four mortgages on the property foreclosed in 1877, the Holleys paid rent to continue to live on their homestead and operate their boardinghouse.[20] Rent on the farm was steep, however, and the scenery and recreational possibilities were limited. Early in 1882, they rented an old house on about three-quarters of an acre overlooking Cos Cob's small harbor (fig. 6). Much smaller than the place on Stanwich Road, it consisted of fourteen rooms, of which about nine were used as bedrooms. Apparently the Holleys had decided that only by scaling back could they recoup their disastrous losses. In May 1882, they were ready to welcome summer visitors.[21] They operated the Cos Cob boardinghouse for two years as renters before purchasing it in 1884.

The rambling old saltbox had served intermittently as a boardinghouse before the Holleys moved in. Like many homes in the neighborhood, it had occasionally included among its residents two or three boarders, bachelors who worked in the nearby shipyard or on the railroad.[22] At their farm, however, the Holleys had developed a clientele of artistic New Yorkers who could be expected to follow them to their new waterfront establishment.

The Holley House, as it became known, was conveniently located to attract visitors from the city. (Now called the Bush-Holley House, it is the museum of the Historical Society of the Town of Greenwich.) The New York–New Haven trains stopped about a quarter-mile from the house—just "three minutes' walk," as one advertisement stated.[23] Large porches on the first and second stories overlooked the millpond, the Mianus River, and the Long Island Sound, about four

The Holley House in Cos Cob, ca. 1890, photograph. Historical Society of the Town of Greenwich.

6

hundred yards away as the gull flies. The advertisement boasted
that the house was "one minute from boating, bathing and fishing"—
activities that the art colonists would enjoy (figs. 7 and 8).

The house itself was far more appealing to prospective
artist-visitors than the fashionable mansion on Stanwich Road. The ear-
liest portion had been built about 1732. The prosperous Bush family
bought the house in 1738; they and subsequent owners added rooms over
the ensuing century and a half (fig. 9). The Holleys, their neighbors,
and their paying guests appreciated the building's antiquity; indeed, it
was often called simply the Old House, the name used on the inn's
stationery. According to a contemporary newspaper column, "The shining
brass knocker upon the broad front door, . . . the steep pitch of the
rear roof and the massive chimney, all tell their story of the long ago."[24]

Inside, Josephine Holley and her daughter, Constant,
combined family heirlooms with simple newer pieces in a manner that
perfectly expressed the Colonial Revival aesthetic. One visitor described
the Holleys as "charming, cultivated people [whose] good taste is
apparent everywhere. The walls are hung with photographs of the old
masters; the living room is furnished in mahogany and the dining
table is set with old silver and quaint blue china."[25] The Old Master repro-
ductions indicated the Holleys' knowledge of European art, whereas
the antique silver, blue china, and mahogany furniture conveyed their
appreciation of the American past.

Accommodations at the Holley House were simple, with guests
doubling up in small rooms, but meals were bountiful and healthy.
To supply the table, the Holleys cultivated a vegetable garden, grape arbor,
and orchard; raised chickens, ducks, and turkeys; purchased dairy
products, meat, and seafood from farmers and fishermen; and preserved
the summers' bounty by pressing apples for cider and pickling,
canning, and preserving. An expert gardener and flower arranger, Con-
stant Holley kept the house filled with fragrant and unusual bou-
quets. She elevated that domestic skill to an art form, coordinating col-
ors, shapes, and textures in arrangements that—like the paintings
of the Cos Cob Impressionists—combined homegrown materials with
cosmopolitan, often Japanese influences.[26]

The Holleys' enterprise produced an economic boomlet
in sleepy Cos Cob. Neighbors happily lodged the overflow when all the

17

Swimming party at the Palmer & Duff Shipyard, ca. 1900, photograph. The prow of a sailboat is visible at the left; the Mianus River railroad bridge extends across the background. Historical Society of the Town of Greenwich.

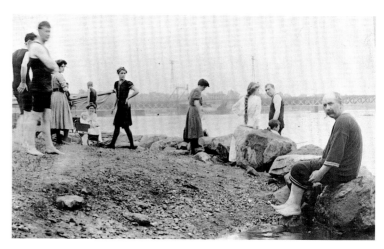

7

Fishing off the Lower Landing, after January 1899, photograph. According to an item about Cos Cob in the local paper on August 25, 1888, "Young ladies with brown cheeks and bright eyes, in groups of three and four, can be observed fishing for snappers any day. They propose to catch something, any way." Historical Society of the Town of Greenwich.

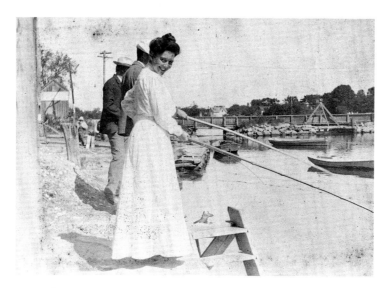

8

boardinghouse beds were filled. Guests could "room" with local families and "board" at the Holleys'. One undated advertisement for the Old House offered "rooms in adjoining cottage at reduced rates." The influx of visitors prompted a flurry of construction as villagers added rooms for boarders. In 1888 the local paper reported that two home-owners were building additions and that the unidentified artist boarding with one of them was "putting up a studio on the premises."[27]

For artists, Cos Cob offered congenial company, affordable accommodations, varied recreational opportunities, and—most important—inspiring subject matter. The harbor village retained an appealing rusticity long after other sections of Greenwich had become gentrified. As one writer observed in 1899, "Coscob is as unspoiled by the summer visitor as if it were miles back in the country instead of being forty minutes by train from New York." An article on the art colony published in a New York newspaper reported that the painters found the "artistic possibilities" of the Holley House and its sur-

The north end of the Holley House, showing the original saltbox, ca. 1890–1900, photograph. The rear wing and the front porches were later additions. Historical Society of the Town of Greenwich.

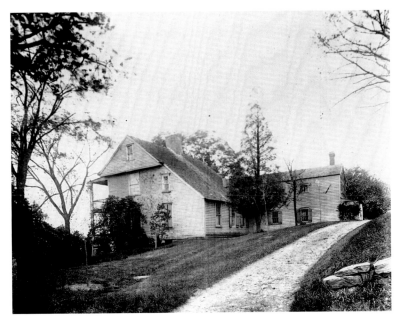

9

roundings "infinite." They "liked the gravelly path shaded with lilac bushes that lay before the house. Better still they liked the back part of the house," with its tall red hollyhocks and "the low grape arbor leading to the garden."[28]

On Cos Cob's two short streets, which hugged the diminutive waterfront, the artists found even more subjects (see the map on page 22). Within sight of the Holley House were two other residences believed to date from before the Revolutionary War. In addition, just across Strickland Road was the tide-powered mill, built around 1763 (fig. 10), and the row of warehouses along the waterfront, which was called the Lower Landing (fig. 11).[29] The small harbor and the shipyard offered a variety of sailing vessels (fig. 12). A short stroll along the riverbank opened wide vistas to Long Island Sound. All these subjects were compressed within a small, densely built village whose compactness liberated painters from long treks with heavy equipment. In fact, they did not even have to leave the Holley House. From its upper porch, they "could see the whole village; the irregular dusty 'green,' with its bordering stores and the three or four old white dwelling houses. They could look across the creek to the old mossy dock, and the dull red factory, which is always as quiet as a church. They could see the shipyard beyond it; the rusty ways and the weather-beaten oyster sloops. They could look across the mill race . . . and see the mill pond and the red lilies that grow along its edges."[30]

In spite of all its advantages, the Holley House seems to have made a slow start as the base for an art colony. No paintings have been identified with the site for the years between 1882, when the Holleys arrived, and 1889, when Twachtman settled in central Greenwich. However, given the evidence of earlier artistic activity in the area, it seems likely that the art colony had begun to emerge before Twachtman's arrival. Because the place names are confusing and the early years of the art colony have never before been documented, art historians may have overlooked possible connections. With further research, paintings from the art colony's lost decade may surface.

During those years, Twachtman shuttled back and forth between the United States and Europe; his movements are difficult to trace, especially toward the end of the 1880s. Like Twachtman, Weir married and began a family in the 1880s. He acquired a farm in Branch-

The tide-powered mill on the Lower Landing, Cos Cob, ca. 1890, photograph. The sign reads "COSCOB MILLS / E. P. HOLLEY & CO." Edward P. Holley, who was the miller, stands in the doorway. The mill, built about 1763, was destroyed by fire in January 1899. Historical Society of the Town of Greenwich.

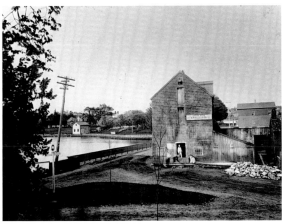

10

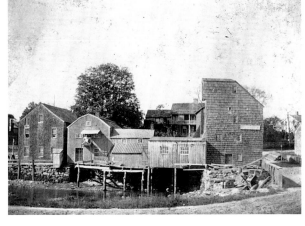

11

Rear view of the Lower Landing, before 1899, photograph. The mill is the tall building to the right; the other buildings were stores, warehouses, and, at one period, the post office. The Holley House is visible to the left of the mill. Historical Society of the Town of Greenwich.

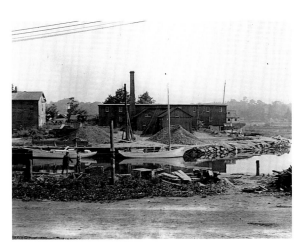

12

Frank Seymour, the Palmer & Duff Shipyard as seen from the Holley House, 1906, photograph. This view was opened up by the fire in January 1899 that destroyed the mill and several adjacent buildings. Two sloops (one without a mast) are moored by the shipyard; a steamboat is visible to the right of the long building. Historical Society of the Town of Greenwich.

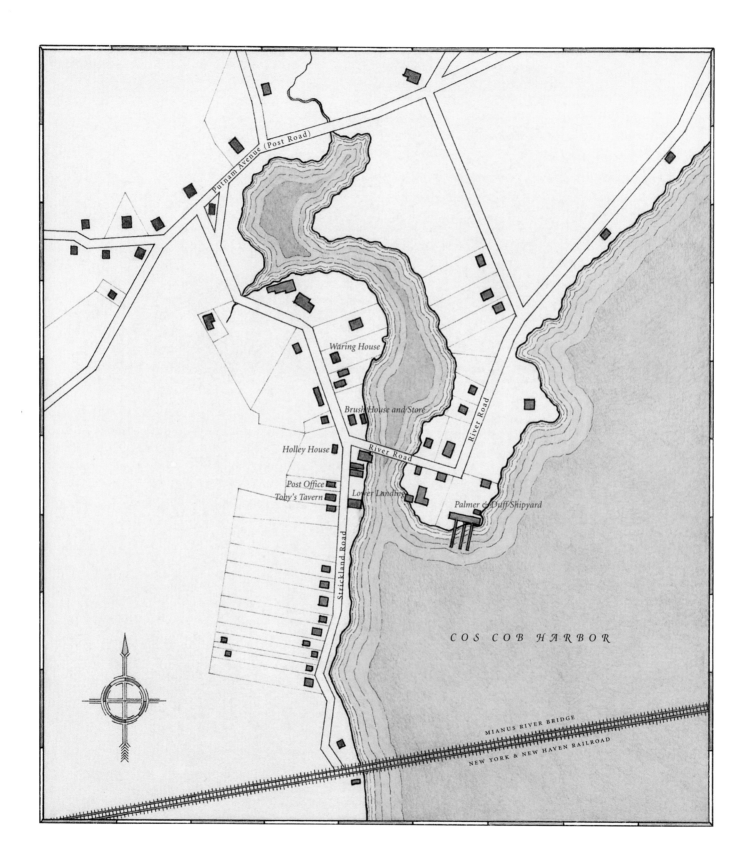

Putnam Avenue (Post Road)

Waring House

Brush House and Store

Holley House

River Road

Post Office

Toby's Tavern

Lower Landing

River Road

Strickland Road

Palmer & Duff Shipyard

COS COB HARBOR

MIANUS RIVER BRIDGE

NEW YORK & NEW HAVEN RAILROAD

ville, Connecticut, in 1882, which, together with his in-laws' home
in Windham, supplanted the defunct Holly Farm as his rural retreat. Still,
Weir hoped that he and Twachtman would someday live near one
another. When he bought property in the Adirondacks in 1882, he urged
Twachtman to buy the adjoining land. Weir's then-fiancée, Anna
Dwight Baker, supported the plan because, she wrote, "you say he always
inspires you with so much enthusiasm for art."[31] But Twachtman's
finances and his preference for an intimate landscape made the Adiron-
dacks unenticing. During the summer, autumn, and early winter
of 1888, Twachtman boarded near Weir's farm in Branchville. There, the
friends experimented together on pastels and printmaking, showing
the exchange of influences that would mark their work during the crucial
transitional phase in their careers.[32] At Cos Cob, the two would con-
tinue their collaborative researches in the company of other colleagues.

 The Cos Cob art colony emerged when Twachtman
settled with his wife and children on Round Hill Road in central Green-
wich, about three miles from the Holley House and twenty-five
miles southwest of Branchville. The Twachtmans had lived in their clap-
board farmhouse near Horseneck Brook for at least eight months
before Twachtman was able to buy it.[33] He made that purchase on Feb-
ruary 18, 1890, acquiring the house and three acres for fifteen hun-
dred dollars. The following year, he added another thirteen and a half
acres.[34] With Twachtman happily settled on his brookside farm and
the Holley House well established in Cos Cob, conditions were right for
the blossoming of the art colony.

The Founders of the Art Colony

Twachtman was a magnet attracting other artists to the area and
the nucleus around which the nascent Cos Cob art colony formed. He
was a painters' painter, never successful in the marketplace but
respected by his colleagues for his highly original work. For one pivotal
decade, from 1889 to 1899, Twachtman found the subjects for most
of his canvases on his home ground in Greenwich. Painting his house,
barn, and gardens and the brook that rippled past them, he ex-
pressed his intense emotional response to the place. Stylistically, he
borrowed from various sources, freely adapting the light palette of Im-

(opposite) Cos Cob during the art-colony period.

pressionism, the contemplative mood of Tonalism, and the economy of means, austere poetry, and thin paint application of Chinese screen paintings. The results sometimes bewildered collectors—Twachtman may have been the first American painter to have a canvas hung upside down—but they won the admiration of his peers.[35]

Twachtman's personality also attracted friends and students. Although he was moody, perhaps as a result of his heavy drinking, his letters and the testimony of his associates reveal that he was capable of both playful camaraderie and profound friendship.[36] So many friends came out to paint with him that when Robert Reid exhibited a canvas titled *Twachtman's Valley at Sunset* in 1895, one critic wrote, "Mr. Twachtman's country place seems to be a regular rendezvous for Impressionists. It has already been painted by several, and now Mr. Robert Reed [*sic*] adds his testimony to its attractions."[37] Although that reviewer mentioned only Twachtman's home, the Holley House was an even more important rendezvous because larger and more diverse groups could gather there than in a private residence. A surrogate home that answered the artists' demand for ordinary domestic subject matter, the Old House was a semi-public place where they could meet freely, on equal ground. It was also Twachtman's principal residence for the last two years of his life, and it ensured that the art colony would survive his death in 1902.[38]

Together, the Holley House and Twachtman's place were the art colony's focal points, where artists gathered to paint and to talk about painting. The Impressionists of Cos Cob, encouraging one another to try new approaches, generated a spirit of innovation that distinguished this art colony from many others. The energizing effect of their exchanges is captured in a letter that Twachtman wrote to Weir in 1891: "That was a splendid talk we had this evening and I become more convinced each time I see you. I want to tell you how confident I feel. To-morrow will be a fine day and I wish for lots of canvas and paint to go to work with."[39]

The art colony's impact on Weir, who was one of its founding members, can be measured not by specific paintings he may have produced there, for few have been identified, but rather by its general effect on his work. Weir's style became more modern, daring, and "Impressionist" during the years that he worked close to Twachtman,

Robinson, and Hassam—partly at his home in Branchville but mostly in Greenwich and Cos Cob.[40] The four friends socialized together in New York during the winter, but it was in the warmer months, when they shared the insights newborn at the easel, that the crisscross of stimulation, influence, and mutual experimentation was most fruitful. When, after spending two consecutive summers working together, Weir and Twachtman had a joint exhibition at Boston's Saint Botolph Club in December 1893, the critics were astonished by the similarity in their work. "Some ten years ago, these men painted in such styles that it would have been difficult for anyone at all familiar with their productions to mistake a canvas by Twachtman for a picture by Weir, or vice versa," one wrote; "today they paint so much alike that one is obliged to look at the signatures on the pictures in order to distinguish them."[41] The look-alike phase in Twachtman and Weir's art was transitional, analogous to the same phenomenon in Monet's and Renoir's careers in the late 1860s and early 1870s. The French artists, painting together at La Grenouillère in 1869, increased their understanding of the principles of color, light, and shadow that underpinned Impressionism.[42] Their works of that period are very similar, as they would be again in 1874 when they painted together at Argenteuil. After a time of collaboration, however, Monet and Renoir developed their own distinct styles, as would Twachtman and Weir some two decades later. In both cases, the combined effort at a crucial juncture enabled each artist to develop his individuality.

Theodore Robinson painted in the Connecticut countryside in the course of only about three years before his death in 1896 at the age of forty-four, but those campaigns resulted in some of his finest works. His first visits were short. From 1888 until early December 1892, he usually spent about half of each year in Giverny, France, where he lived next door to Claude Monet, and the other half in New York. During his months in America, Robinson socialized with colleagues in the city and visited them in the country. He was especially pleased with the result of one sojourn in Connecticut, his painting *Twachtman's House*, which he inscribed with the date "17 January 1892" (fig. 13). Two years later, after examining the oil with Twachtman and fellow painter Henry Fitch Taylor, Robinson noted in his diary that both friends considered it "one of my best things."[43]

Robinson spent a long weekend with the Twachtmans in early April 1892. His disappointed diary notation—"rather cold and raw. No work"—suggests that he valued those visits as an opportunity to paint in Twachtman's company. Following his usual practice, Robinson sailed for France in May 1892, returning to New York in December for what would prove to be the last time. He spent Christmas with the Twachtmans, enjoying the family atmosphere and "much talk with T. who has done some good things."[44]

The following summer, Robinson first stayed for an extended period in Greenwich. This time, accompanied by Taylor, he took a room at a farmhouse near the Twachtmans'. Taylor, who had boarded there before, may have been an old friend of Twachtman's; they were born in Cincinnati just six weeks apart and attended the Académie Julian in Paris at the same time. Taylor and Robinson had been among the first American artists to visit Giverny (in 1887) and among the few in that art colony to develop a friendship with Monet and his family.[45] Robinson and Taylor stayed in Greenwich from May 17 to July 10, 1893; during that time, they saw Twachtman nearly every

Theodore Robinson, *Twachtman's House*, 1892, oil on canvas, 18 x 22 in. Private collection, reproduced in John I. H. Baur, *Three Nineteenth Century American Painters: John Quidor, Eastman Johnson, Theodore Robinson* (New York: Arno Press, 1969), plate 25.

day. Robinson noted the visits of other artists to that "rendezvous of Impressionists": Weir, Lyle Carr, Susan Hinckley Bradley, and two unidentified women.[46] (Had he visited Cos Cob, where Twachtman and Weir were conducting classes, he would have seen many more.) The artists' gatherings were casual: card games most evenings, midday Sunday dinners followed by long afternoon walks, fireworks on the Fourth of July. Relaxing together in the evenings, the artists discussed their work while they were immersed in its creation. Robinson undoubtedly contributed firsthand accounts of Monet's experiments, kept up to date by letters from Giverny.[47]

The summer of 1893 was the first in five years that Robinson had spent in the United States, and he agonized over the competing claims of American versus European subject matter. That quandary, which roiled the American art world of the day, unfolds with compelling immediacy in the pages of the artist's diary. "Am trying to get interested in things here, but am not enough," he wrote on May 25. He conceded that a sunny morning was probably "as fine here as anywhere" but found "not much charm . . . except in color" and emphatically "less grace of line." In his dilemma, Robinson at first chose American equivalents for the subjects he had favored in France. He was swayed by Monet's praise for his painting *Watching the Cows* (1892, Butler Institute of American Art). Monet "liked the 'cows and baby,'" Robinson had noted in Giverny; "I will try cows—perhaps next summer, seriously."[48] In Greenwich, he fulfilled his resolution to "try cows" with several paintings of cattle, including *Oxen* (fig. 14). The major result of Robinson's stay in Greenwich in the summer of 1893 was *Stepping Stones*, which depicts two of Twachtman's daughters crossing the hickory-shaded brook near their home (fig. 15).

Robinson and Taylor returned to the farmhouse near Twachtman's on May 16, 1894, intending to stay most of the summer, but after their landlord died, they moved in early June to the Holley House. Robinson's seven-week stay in Cos Cob would result in at least thirteen paintings, all depicting sailboats (see chapter 2).

In contrast with Robinson's productive but brief involvement in the Cos Cob art colony, Childe Hassam was one of its central figures for more than two decades—longer than any other of its major painters. Hassam provided a sense of continuity to the group; one

of its earliest members, he continued to return for years after Robinson and Twachtman had died and Weir had divided his summers between his own homes in Branchville and Windham, Connecticut. Hassam's first recorded visit to Greenwich was on May 30, 1894, when Robinson noted in his diary that Hassam was at Twachtman's house, helping to lay the foundations for an addition. It was probably not Hassam's first stay, or his host would not have put him to work, and it was far from his last. In 1897 Hassam painted two of Twachtman's children at a table in front of a curtained window in their living room (fig. 16).[49] Usually, however, Hassam stayed at the Holley House, where he was a frequent guest between 1896 and 1916. During those visits, he produced at least twenty-eight oils.

As significant as the paintings, however, are the pastels, etchings, and watercolors that Hassam produced in concentrated bursts of technical virtuosity. He used three of his sojourns in Cos Cob to experiment with one "minor" medium at a time. Pastel claimed his attention in 1902. During a series of visits that spanned the seasons from spring through late autumn, he produced at least

Theodore Robinson, *Oxen*, 1893, oil on canvas, 18 1/2 x 22 1/8 in. Private collection.

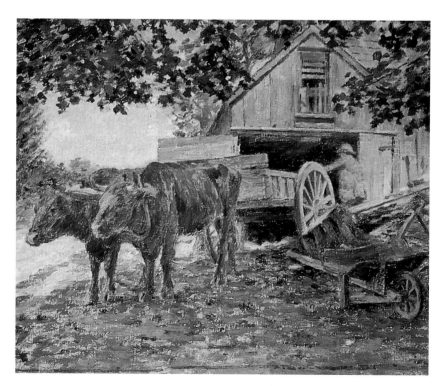

14

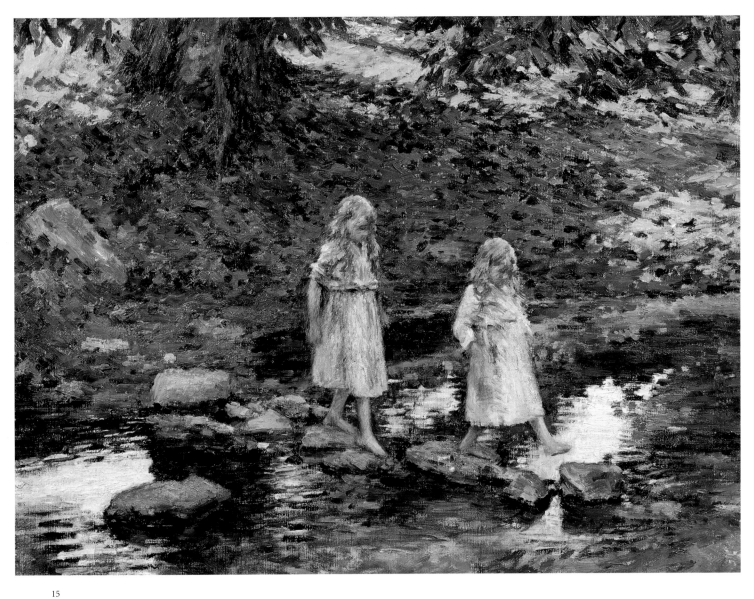

15

Theodore Robinson, *Stepping Stones*, 1893,
oil on canvas, 21 1/2 x 28 1/2 in. Courtesy of Senator and
Mrs. John D. Rockefeller IV.

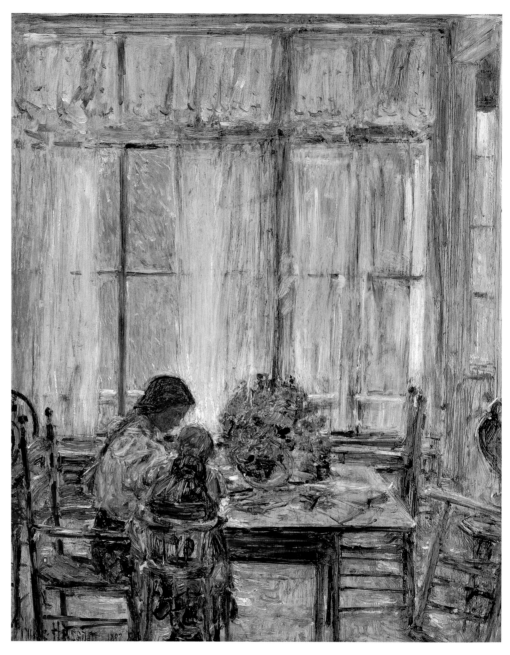

16

Childe Hassam, *The Children*, 1897, oil on board, 18 1/4 x 14 1/2 in. Cincinnati Art Museum, Cincinnati, Ohio. Bequest of Ruth Harrison.

twenty-one pastels. One of them, *Summer at Cos Cob* (fig. 17), exemplifies his mastery of the colored chalks. The exuberance of the finished drawing obscures the surprising economy of means. Employing a limited palette composed primarily of blues, whites, and yellow-greens, Hassam captured the vibrant sunlight of early spring. Architecture is linked to nature in a tangle of wisteria and the rhyme Hassam makes between the porch posts and the pale trunks of two trees. The untouched paper represents the earth, dappled with dark-green shadows, while the scarlet accent of geraniums in a window box invites the eye to sweep up the sunlit façade.

Etching sparked Hassam's enthusiasm in 1915. Printmaker Kerr Eby, who kept an etching press in his Cos Cob studio, guided Hassam's first serious work in that medium.[50] The twenty-five-year-old Eby had already demonstrated his skill in such technically demanding works as *Morning Mists* (fig. 18), in which a lacy network of foliage, possibly the drooping branches of the elm tree in front of the Holley House, frames a hazy view of a river and the opposite shore. Eby placed the expertise manifested in this delicate work so completely at Hassam's disposal that the younger man produced no prints in the summer of 1915. Hassam, meanwhile, printed about thirty etchings of Cos Cob subjects on Eby's press and brought back an equal number of copper plates from travels elsewhere in New England to print there as well. In works like *Old Lace* (fig. 19), Hassam brilliantly translated the Impressionist concern with light into the linear, black-and-white medium of etching. As he himself later acknowledged of his Cos Cob etchings, "from that series whatever distinction that I may have given the graphic arts comes."[51]

The watercolor medium captivated Hassam during his 1916 stay at the Old House. He produced a suite of luminous watercolors there, nine of which he grouped as "the Cos Cob Set" in his solo exhibition at the Montross Gallery in New York the following year.[52] Playing on James McNeill Whistler's "Thames set" and "Venice set," Hassam implicitly claimed the rustic Connecticut village as a significant site for the production of art. As a sophisticated marketer of his own art, he must have judged, too, that by 1916 the label "Cos Cob" meant something to his patrons and critics. That assumption proved correct. Reviewing the Montross exhibition, Royal Cortissoz called the Cos

31

17

Childe Hassam, *Summer at Cos Cob*, 1902, pastel on paper, 22$^{1}/_{8}$ x 18$^{1}/_{8}$ in. Montclair Art Museum, Montclair, N.J., gift of William T. Evans, 1915.24.

Kerr Eby, *Morning Mist*, 1913, etching, 7 ⁵/₈ x 6 ¹/₂ in.
The Metropolitan Museum of Art (62.554.65).

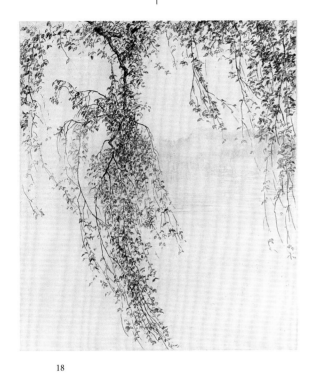

18

19

Childe Hassam, *Old Lace*, 1915, etching and
drypoint, 6 ⁷/₈ x 6 ⁷/₈ in. The Metropolitan Museum of Art,
Gift of Mrs. Childe Hassam, 1940 (40.30.16).

Cob watercolors "little marvels," declaring that "if ever the character of a New England town was set on paper with a brush this is the perfect instance." For Cortissoz—and presumably for other viewers—the Cos Cob images transcended the particulars of place to acquire larger significance; their "nominally prosaic titles" had, for that critic, "something of the eloquence of old family names."[53]

The Metropolitan Museum of Art purchased *The Brush House* (fig. 20) from the Montross exhibition. *The Brush House* demonstrates Hassam's distinctive manner of building up his image through a network of brushstrokes. In some areas, he painted wet-into-wet to produce veils of color; in others, he left the paper bare to suggest patches of sunlight. The quick execution demanded by the watercolor medium conveys an immediacy especially suited to Impressionism.

Hassam, Twachtman, Robinson, and Weir were the major artists in the Cos Cob art colony and the ones who, together with their little-known friend Taylor, established its experimental climate.

Childe Hassam, *The Brush House*, 1916, watercolor and charcoal underdrawing on off-white wove paper, 15 5/16 x 22 5/16 in. The Metropolitan Museum of Art, Rogers Fund, 1917 (17.31.1).

20

Other artists of their generation—those who came to maturity in the 1870s—also worked there. Among them were Robert Reid, Leonard and Mina Fonda Ochtman, Birge Harrison, Emil Carlsen, Walter Clark, Alfred Q. Collins, Charles Warren Eaton, Caroline Haynes, Albert Insley, Bolton Jones, David Walkley, sculptor Edward Clark Potter, and illustrators E. Boyd Smith and Ernest Thompson Seton. Some were occasional visitors, whereas others (including the Ochtmans, Potter, Smith, and Seton) settled in the area.

Summer Classes

The art colony's youthful spirit would have aged along with its leaders had it not been for the steady infusion of new members, young artists who came for summer school at the Holley House. Twacht-man may have established summer classes in Cos Cob as early as 1890, after he completed his first year of teaching at the Art Students League, where J. Alden Weir was also on the faculty. By 1891 Twachtman was certainly conducting summer school at Cos Cob, and in 1892 and 1893 Weir taught with him. In 1894 and probably thereafter, Twachtman handled the classes alone. His 1895 summer classes were affili-ated with the Brooklyn Art Association.[54] Twachtman's last formal teaching session at the Holley House was held in 1899. Among the Cos Cob summer students over the years were Ernest Lawson, Allen Tucker, Elmer MacRae, Charles Ebert, Mary Roberts Ebert, D. Putnam Brinley, Alice Judson, and the Japanese artist and illustrator Genjiro Yeto.[55] Like most of the other summer students, all of them were enrolled at the Art Students League.

The summer sessions ran for about three months, but students could come for part of that time. (Shorter courses were occasion-ally offered during the winter.) Criticisms, usually given twice a week, were held under an old apple tree dubbed the Criticismus Tree.[56] Photographs show Twachtman talking with students in the Palmer & Duff Shipyard (fig. 21) and examining one pupil's sketch of the Lower Landing painted from a nearby vantage point (fig. 22). Students paid about ten dollars a week for room and board at the Holley House (some lodged elsewhere in the village). Tuition for the summer school was fifteen dollars a month in 1896—expensive in comparison with the eight

dollars a month charged by the Art Students League.[57] In Cos Cob, however, classes were smaller and instruction more individualized than in New York. Students, liberated from such academic tasks as drawing from plaster casts of ancient sculpture, painted in the open air.

One of the summer students contrasted Twachtman's New York and Cos Cob classes in an article published in the *Art Interchange* in September 1899. "In the winter Mr. Twachtman has charge of the largest class in the League working from the antique," that anonymous writer reported, "but in his summer criticism he is the farthest removed from the academic." The anonymous writer recorded Twachtman's comments to his students. He encouraged them to alternate oils with watercolors and pastels, which he believed would encourage "a suggestiveness and charm even if you fail in literal truth, and after all it is nature interpreted, not copied, that we want." He urged his

21

John H. Twachtman (center) with summer students in the Palmer & Duff Shipyard, probably 1897, photograph. Elmer MacRae is at the right. Historical Society of the Town of Greenwich.

pupils to simplify their compositions by eliminating details, using a limited palette, and working on a large scale, but he was less concerned with technique than with the development of a personal vision. "See with your own eyes," he challenged the young artists. "Be your own self and save your self-respect."[58]

Allen Tucker, who was a summer student in 1892 or 1893, later recalled the impact of that demand for originality: Twachtman "opened the door for me, and made me understand that it was what *I* did that mattered, . . . that I didn't have to be like or unlike anyone else, . . . that the world was mine and that there was nothing between me and the wonder of it all but that rectangle of white canvas."[59]

Ernest Lawson, described by Tucker as "the leading member of the class" in Cos Cob, would become the most famous of Twachtman's and Weir's students. The two instructors insisted on simplicity,

John H. Twachtman with a student in the Palmer & Duff Shipyard, probably 1897, photograph. The Lower Landing is visible across the inlet. Historical Society of the Town of Greenwich.

direct observation, and genuine emotional response, as the young Lawson discovered when he presented his first painting of the summer for criticism. "By Jove, I have never seen so bad a picture," Weir exclaimed of Lawson's panorama, crammed with rivers and brooks, hills and valleys, flowers and weeping willows. After discussing the picture with Weir, Lawson told a writer years later, the neophyte realized that it contained "nothing he had seen, nothing he had felt." Taking his instructor's criticism to heart, Lawson next painted a simple sketch of an old red barn that won Weir's approval for its "color and dash and a relentless energy of light."[60] Another canvas that Lawson may have painted during his student years in Cos Cob shows him developing an individual vision. Accented with fireworks bursting against the dark sky, *Yacht Club—Night, Greenwich* (fig. 23) reveals the young artist's knowledge of the works of James McNeill Whistler, but its freedom of brushwork, simplification of forms, and intense, jewel-like palette anticipate the signature style of Lawson's *Spring Night, Harlem River* (1913, The Phillips Collection).

Lawson and the other students profited from the advice of Twachtman and Weir's friends. When Lawson returned to Cos Cob from France in the summer of 1894 with his friend Allen Butler Talcott, Robinson criticized their French paintings as "a little too much like a lot of other men—not much delicacy of vision."[61] The easy give-and-take between established painters and those just embarking on a career benefited both generations: the younger artists learned from their seniors, who in turn enjoyed the constant rejuvenation of outlook.

Elmer MacRae was a member of Twachtman's summer class in 1896, 1897, and 1899. (In 1898, when Twachtman moved the summer session for one year to Norwich, Connecticut, MacRae and other loyalists stayed in Cos Cob.) MacRae fell in love with the Holleys' daughter, Constant, married her in 1900, and spent the rest of his life at the Old House. After Twachtman's death in 1902, MacRae helped to ensure the continuity of the art colony. In addition to developing his own oeuvre, which moved from Impressionism to Post-Impressionism to Arts and Crafts furniture and decorations, MacRae proved to be a highly effective behind-the-scenes organizer of the Pastellists (a cooperative artists' organization dedicated to the exhibition of pastels) and the 1913 Armory Show.[62]

One of MacRae's close friends and summer-school classmates was the Japanese artist Genjiro Yeto.[63] Yeto, whose father owned a porcelain factory in Arita, Japan, had planned a business career until he came to the United States around 1890. He studied at the Art Students League from 1895 until 1899, joined the summer class in 1896, and lived at the Holley House for extended periods until 1901. Yeto revered Twachtman. In an ironic circle of influence, he emulated his teacher's style, which itself owed much to Japanese art. The Cos Cob art colony, which enthusiastically shared the ardent Japanism that swept Europe and America in the last quarter of the nineteenth century, embraced Yeto as an incarnation of the culture they had long admired.

Years before Yeto arrived in Cos Cob, Twachtman, Robinson, and Weir had shared their excitement about the Japanese prints that

Ernest Lawson, *Yacht Club—Night, Greenwich*, ca. 1892, oil on canvas, 20 x 24 in. Location unknown, photograph courtesy of C. G. Sloan and Co.

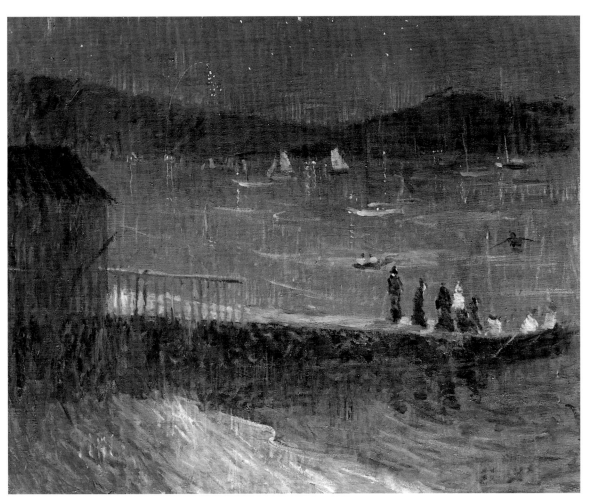

23

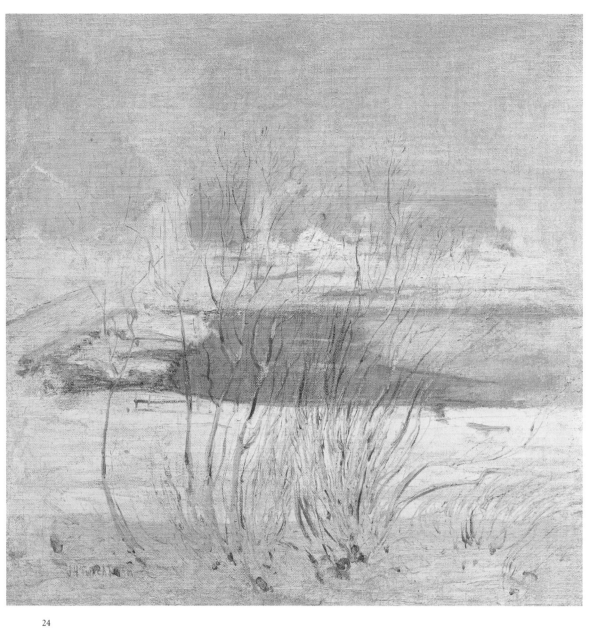

24

John H. Twachtman, *Bridge in Winter*, ca. 1901, oil on canvas, 30 1/8 x 30 1/8 in. Courtesy of Marie and Hugh Halff.

all three collected. After spending an evening with Twachtman, Weir, and Taylor discussing Japanese art, Robinson noted that "Tw. & W. are rabid just now on the J."[64] The *ukiyo-e* prints that the Cos Cob Impressionists studied together encouraged their experimentation with composition, viewpoint, and color, but they were not the only Asian sources that informed the Americans' art. In its understated color and refined facture, Twachtman's *Bridge in Winter* (fig. 24) evokes Chinese scroll paintings, while the shrubbery with calligraphic stems through which one views the distant landscape recalls similar screening devices in Japanese prints. Weir alluded to Japanese sources with the pattern of flattened leaves that frame *In the Shade of a Tree* (fig. 25). Two prints in Weir's collection may have directly inspired this unconventional composition, but the use of a foreground element as a framing device is found in many ukiyo-e prints.[65] Robinson's *Boats at a Landing* (fig. 26) represents his boldest adaptation of Japanese prints (see chapter 2). Hassam was also infected with Japanism, although this aspect of his art has received far less attention than that of his three colleagues. At times he merely used imported artifacts as props—like the kimono that appears in many of his paintings—but he also integrated principles of

J. Alden Weir, *In the Shade of a Tree*, 1894, oil on canvas, 27 x 34 in. Sheldon Memorial Art Gallery, University of Nebraska-Lincoln, Nebraska Art Association collection, Nelle Cochrane Woods Memorial.

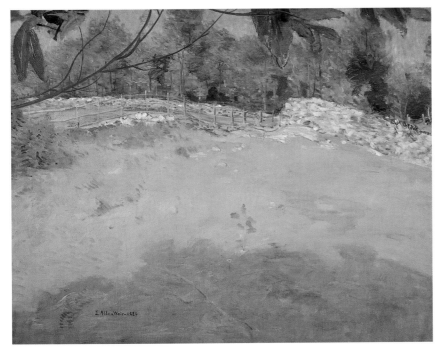

25

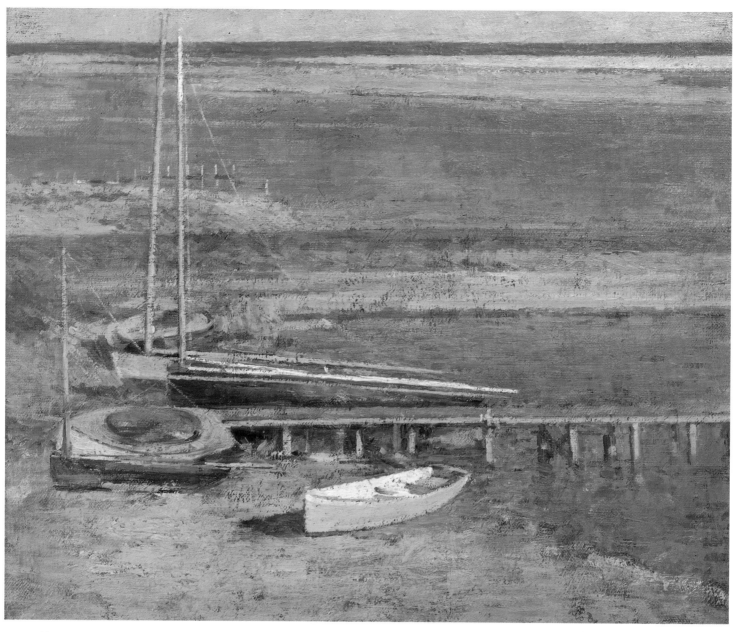

Theodore Robinson, *Boats at a Landing*, 1894,
oil on canvas, 18 x 22 in. Courtesy of Mr. and Mrs. Meyer
P. Potamkin, photograph courtesy of Owen Gallery.

Japanese design into compositions including *The Mill Pond, Cos Cob* (fig. 27). The vertical format (common in Japanese landscapes but unusual in Western ones), asymmetrical composition, and focus on an unexpected foreground element reveal Hassam's debt to such prints as Hiroshige's view of Edo (fig. 28), in which a scaffold tower performs the same function as the ladder in Hassam's oil.

Among the art colony's younger generation, the influence of Japanese art was both filtered through the work of their elders and directly transmitted by Yeto's example. MacRae deliberately imitated the delicate flower studies that won critical praise for Yeto in New York and Philadelphia. The art colonists enjoyed dressing up in kimonos and acting out their fantasies about Japan. A photograph shows Yeto with other kimono-clad art students posing on a porch festooned with fans, paper lanterns, and hanging scrolls (fig. 29).

Similar accessories were used to create an aesthetic environment for the exhibitions that the students mounted in the hayloft of the Holleys' barn, probably at the end of the summer sessions. One year, at least, the students also exhibited their work in New York City. In early December 1897, MacRae, Yeto, Mary Roberts, and Otto Heinemann hung one room at the Art Students League with the summer students' oils, pastels, and watercolors. They arranged the show, MacRae explained in a letter to Constant Holley, to ensure that the works, including their frames, would harmonize.[66] Their installation was undoubtedly influenced by Twachtman, whose solo exhibition in 1891 had attracted attention for its novel presentation, featuring white frames on his pastels and snowscapes.[67] The "Cos Cob Exhibition" won Twachtman's praise, impressed the other League students, and convinced the participants that they had outshone their rivals, the students of William Merritt Chase at Shinnecock, Long Island, who mounted annual New York exhibitions. MacRae reported the conversation between two of his summer-school classmates: "Louis Vaillant told Miss [Helen F.] Andrews that he was proud of it. 'Better than the Chase Exhibition' etc. etc."[68]

As mature artists, Twachtman's students revealed their greatest debt to him not in slavish mimicry of his style but in their openness to new concepts and techniques—attributes the Cos Cob alumni demonstrated in their involvement with the groundbreaking

43

Ando Hiroshige, *The Ekoin-ji at Ryogoku and the Moto-Yaniga Bridge*, 1857, number five of *One Hundred Famous Views of Edo*, brocade print, oban size. British Museum, London.

28

29

Genjiro Yeto (standing, left) with other kimono-clad art students, ca. 1897, photograph. Historical Society of the Town of Greenwich.

45

Childe Hassam, *The Mill Pond, Cos Cob*, 1902, oil on canvas, 26 1/4 x 18 1/4 in. Bruce Museum, Greenwich, Conn., anonymous gift, 94.25.

Armory Show of 1913, which introduced modern European art to a large American audience. The idea for the show originated at a meeting between MacRae, Taylor, and fellow artists Walt Kuhn and Jerome Myers at Taylor's Madison Gallery.[69] They formed an organization, the Association of American Painters and Sculptors, in which about half the thirteen charter members had ties to the Cos Cob art colony: MacRae, Taylor, Weir, Lawson, Tucker, and Brinley. MacRae served the organization in various capacities, including that of treasurer. His behind-the-scenes work helped ensure the exhibition's success. The Cos Cob contingent cannot be credited with the daring selection of European artists that made the Armory Show a turning point in American art—that distinction goes to Kuhn, Arthur B. Davies, and Walter Pach. But whereas many American artists recoiled from the European art they saw at the Armory Show, Twachtman's former students demonstrated an unusual receptivity to early modernism. MacRae changed direction in the wake of the show, adopting aspects of Post-Impressionism before abandoning easel painting entirely in favor of carved and painted Arts and Crafts decorations. Ebert experimented with Fauve colors in a painting of Cos Cob's shipyard (*Water's Edge*, Florence Griswold Museum, Old Lyme, Connecticut). Even before the Armory Show, Tucker had experimented with a painterly, heavily textured impasto. He found validation for that approach in the paintings by Van Gogh he saw at the Armory Show, adopting a method of paint handling so expressive that one critic called him "Vincent in America."[70]

Although Twachtman's summer classes were the best known in Cos Cob, they had some competition. Leonard Ochtman offered instruction in landscape painting at his home, about a mile and a half from the Holley House, for students who boarded in nearby farmhouses. Ochtman had settled permanently in Greenwich in 1891, shortly after his marriage to his former student, Mina Fonda. His classes, which seem to have been fairly regular for at least two decades, represented a Tonalist alternative to Twachtman's Impressionism. Clark Voorhees studied with Ochtman in the summer of 1896, along with Elisabeth Spalding of Denver and at least two other students. In his diary, Voorhees records sketching outdoors in an orchard, a rye field, and an Italian family's vegetable garden.[71] Ochtman considered such open-

air sessions preliminaries to work in the studio, as he explained in his two-part essay "A Few Suggestions to Beginners in Landscape Painting." In pencil, charcoal, and oil sketches made outdoors, Ochtman advised, the artist should simply record "the plain facts before him" to stimulate his memory when composing paintings indoors. Although Ochtman's methods were different from Twachtman's, his goal was similar. "We want the effect of the day, hour or moment, the mood and not a transcript of the place," Ochtman wrote.[72] His philosophy seems close to Twachtman's "it is nature interpreted, not copied, that we want."

A Bohemian Enclave

The art colony's experimental climate was heightened by its mixture of professions. In Cos Cob, painters exchanged ideas not only with other painters but also with poets, novelists, playwrights, editors, publishers, journalists, and musicians, many of whom were nationally prominent during the art-colony period (see appendix B). Lincoln Steffens, who was a key member of the art colony from about 1901 to 1911, was the most famous of the journalists whose exposés of business and government corruption prompted Theodore Roosevelt to label them "muckrakers."[73] Questioning the status quo was Steffens's vocation, and he brought a highly developed spirit of inquiry to the Holley House table. In the chapter of his autobiography devoted to the art colony, Steffens described the debates that he and Twachtman started over dinner. They sometimes tricked their companions by gradually reversing sides, leading their unwitting partisans to argue vehemently for a position they had begun by opposing. The topics they discussed, however, reveal the group's engagement with broad social and aesthetic issues: what kind of society best nurtures art; how to define beauty; whether art making is predominantly intellectual or emotional; what subjects are appropriate for the painter.[74] Years later, when one of MacRae's daughters wanted to attend college, one of the art colonists exclaimed, "Oh, little does she know, college would seem like nothing after conversation like this at the table."[75]

The art colony included many staffers from the crusading magazine *McClure's*, where Steffens worked from 1901 to 1906. The art editor at *McClure's*, August Jaccaci, was a close friend of Robin-

son and Twachtman and bought a house in Cos Cob in 1902. The magazine's highly respected fiction editor, Viola Roseboro', was a regular at the Holley House for two decades, during which time she published Willa Cather's first nationally circulated stories. Cather, who joined the staff of *McClure's* in 1906, visited Cos Cob frequently enough that village children recognized her.[76] Like the painters, Cather claimed American themes as worthy subjects for art, as did another of the art colony's writers, Irving Bacheller, a best-selling author of nostalgic local-color fiction. Cather's lyrical descriptions of the prairies and Bacheller's verbal sketches of the St. Lawrence Valley honored places as unmistakably American as the harbor village and ramshackle shipyard depicted by the Cos Cob Impressionists. Art colonist Clyde Fitch, a playwright who was famous for his ability to pinpoint social nuances through contemporary drawing-room chatter, also honored the American past in plays about the Revolutionary patriot Nathan Hale and the Civil War heroine Barbara Frietchie.[77]

Many of Cos Cob's literary workers were well known in their day. Poet and playwright Ridgely Torrence wrote the first serious plays about, and performed by, African Americans: *Plays for a Negro Theatre*, produced in New York in 1917. Jean Webster's novel *Daddy-Long-Legs* (published in 1912) was produced twice as a play and three times as a movie. Ernest Thompson Seton was a prolific writer and illustrator of animal stories for children, which despite their anthropomorphism are still respected by naturalists for their keen observations of animal behavior. The writer and illustrator Rose O'Neill originated the Kewpie doll. The humorist Wallace Irwin traced a fictional Japanese immigrant's bewildered confrontation with American culture in *Letters of a Japanese Schoolboy*, which appeared in *Collier's* and other magazines from 1905 to 1925. Other members of the art colony included poet Richard Le Gallienne, playwright William Vaughn Moody, humorist Bert Leston Taylor, singer Greta Torpadie, critic Katherine Metcalf Roof, and print specialist Carl Zigrosser.

Although many of the artists, writers, and editors eventually acquired their own homes in Greenwich, most were introduced to the town as boarders at the Holley House. The shared interests and self-containment of the boardinghouse made it an ideal setting for an art colony. Such separation from the larger community constitutes

bohemianism, defined by Milton Brown as "essentially an intellectual revolt against the confines of established society, resulting in the creation of an intellectual community within the framework of that society but with a different set of mores and an antagonism toward those outside the community." [78]

The Holley House, redolent of tradition, became a bohemian enclave of avant-garde art, progressive politics, and a degree of sexual freedom. The letters exchanged by Constant Holley and Elmer MacRae before their marriage in 1900 reveal that the boardinghouse residents enjoyed access to one another's bedrooms that would not have been possible in a proper one-family home. A poem written on the Holleys' forty-second wedding anniversary in 1908 is amusingly frank about their marriage, calling Edward "a dreadful rake" and Josephine "a holy fake" who "now and then . . . cocks her eye at other men." Some of the letters that Twachtman wrote to Josephine during the years his wife was living apart from him in France suggest a deep emotional attachment between the painter and his hostess. [79] Twachtman's friend Henry Fitch Taylor, who lived at the Holley House for many years, also contributed to its bohemian atmosphere. Despite his heavy drinking, Taylor amused friends with his playful, irreverent wit. Acknowledging the quirkiness of their gathering place, the art colonists sometimes called it "the Freak House." And Hassam dubbed Florence Griswold's boardinghouse in Old Lyme, Connecticut, "the Holy House" in joking contrast to the unholy Holley House. [80]

"Antagonism toward those outside the community," which Milton Brown defines as one aspect of bohemianism, permeates Steffens's account of the Cos Cob art colony. "We talked art," he wrote, "and we had a contempt for people who talked business and politics. The townspeople and fishermen were all right; they fitted into the land- and seascapes, but toward the . . . successful New Yorkers who were buying up Greenwich and modernizing that lovely old town, we were such snobs that after cutting us and then discovering that we were cutting them, they used to try to get in with us. And they couldn't." [81] Steffens mentally segregated the larger community into two sharply contrasted groups: the urbane newcomers and the provincial old-timers. He described the newcomers in terms that betray the illogic of his animosity. They were outsiders—"New Yorkers"—but so were the art

colonists. Steffens was from Sacramento, Twachtman and Taylor were from Cincinnati, Hassam was born in Boston, Ochtman in Holland, Lawson in Canada, Jaccaci in France. Furthermore, the art colonists, like the other newcomers, were linked to New York by their professions, if not by their primary homes. Despite his "contempt for people who talked business and politics," Steffens made a career of writing about those fields. The art colony's numerous editors, publishers, journalists, and even humorists were also professionally concerned with business and politics.

Steffens accused the "New Yorkers" of "buying up Greenwich and modernizing that lovely old town." The art colony flourished during Greenwich's transition from a farm town to a suburb, and Steffens was describing the changes to the built environment as new houses sprang up on subdivided farms, destroying the landscape the artists had come to paint. Once, Steffens recounts, the art colonists had the satisfaction of snubbing an offending newcomer. When a "rich woman whose husband had taken, cleared, gardened, and illuminated with electric light the side of a hill our painters used to paint, drove up to the Holly House . . . to ask for rooms," Steffens wrote, Constant Holley MacRae "told her that 'we did not take in rich people.'"[82]

The wealthiest newcomers built palatial mansions along the shore or on backcountry estates, while the merely prosperous constructed spacious houses in the fashionable Queen Anne and Shingle styles.[83] Those modern structures threatened the artists' cherished sense of history. To them, an old house, however dilapidated, was preferable to an elaborate new one. When artist Henry C. White noticed some shanties near Twachtman's place, Twachtman remarked, "Those shacks are occupied by a Negro family. I am so happy to have them here instead of the Queen Anne people."[84] The art colonists were also acquiring property in the area, but unlike "the Queen Anne people," they usually bought old houses and undertook renovations that enhanced the sense of tradition and harmony with nature. Twachtman enlarged his modest farmhouse by extending it into the natural contour of the hillside and adding a portico whose classicism recalled Greek temples and Jefferson's Monticello.[85] The Colonial Revival home of Twachtman's former students Charles and Mary Roberts Ebert was featured in an article on remodeled farmhouses that appeared in *House and*

Garden in 1910. Under a photograph of the Eberts' handsome white shingled house, the caption explained that although "practically the whole of the main building is new, . . . its character and detail were governed by the old farmhouse" that survived as a small wing of the spacious home.[86]

It was not just taste in housing that divided the artists from the other newcomers. In a larger sense, the art colony's questioning, experimental outlook put it at odds with the smug optimism of the Gilded Age. One of Twachtman's students remembered his comment "The business man is always certain, the artist is never sure."[87] Furthermore, the artists and writers were divided from the other newcomers by the level and unpredictability of their income and their attitude toward material success.[88] Steffens, whose family inheritance shielded him from financial worry, affected a defiantly bohemian air. Hassam could have afforded to stay at a fashionable resort hotel, but he chose instead the shabbily genteel Holley House.

Robinson assessed his financial situation in his diary entries at the end of each year. His annual income peaked at $3,307 in 1893; in 1894, he earned only $1,080.25, and in 1895, a total of $1,817.08. Although the bachelor artist spent little on housing or clothing, he frequented concerts and plays, collected Japanese prints, and enjoyed a busy social life. Twachtman, in contrast, was hard-pressed to support his large family. Robinson noted that his friend had earned $3,500 in 1895, of which $2,500 came from teaching (including summer school) and $1,000 from sales of his paintings.[89] Although Twachtman and Robinson struggled financially, both artists' 1895 income was well above the national average of $415. Farm laborers earned only $216 that year; federal government employees earned $1,104.[90] The artists were not measuring their income against occupations like those, however, but against the bankers, lawyers, and businessmen in Greenwich and New York, whose earnings were far higher.

The Cos Cob artist colony's hostility toward the wealthy newcomers seems to have arisen from interwoven issues of money and lifestyle. An additional source of resentment was that the new gentry decorated their homes with European art. Twachtman bitterly told a group of students in Chicago, "You are studying art here now, and some day some of you will become painters, and a few of you will do dis-

tinguished work, and then the American public will turn you down for second and third rate foreign painters."[91]

The art colony's attitude toward the Yankee old-timers was equally complex. On one hand, the heritage the locals represented was among the town's major attractions. Artists and writers in search of the American past must have been gratified that tiny Cos Cob boasted an unusual concentration of residents whose New England roots extended to the seventeenth century.[92] Some of them were well-educated professionals, but it was the farmers and boatmen among them whom the art colony celebrated in word and image. The long-established, working-class local people appear as figurative accents in such works as Robinson's *Oxen* (see fig. 14) and Eby's *Cos Cob Harbour* (fig. 30), where they are as essential as the barns and sailboats in signifying New England.

Condescension toward the old-timers tinges writing by members of the art colony. In 1899 the New York *Commercial Advertiser* ran a front-page story on the art colony that was probably written by Steffens, then its city editor, or fellow art colonist Harry Thurston

Kerr Eby, *Cos Cob Harbour*, 1916, etching, 4 15/16 x 8 13/16 in. Private collection, photograph courtesy of the Historical Society of the Town of Greenwich.

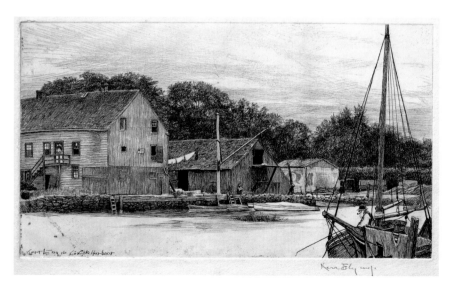

30

Peck, its literary editor. The writer described the group's relations with the local people: "To the old inhabitants of the village the artists are a constant source of wonder. Whenever one of the art students takes easel and brushes and settles down quietly on the dock or by the roadside he is presently surrounded by a gaping group. The spectators are usually silent, but sometimes they whisper comments. The villagers, young and old, have an exalted idea of the market value of pictures painted by hand. They don't understand painting simply for the effort—that is, studying."[93] That coy description of "gaping" villagers who are most concerned with the "market value" of a painting—as if it were a bucket of clams or a peck of apples—assumes the superiority of artist, writer, and reader.

The self-flattering juxtaposition of sophisticated artist and naive rustic is also reflected in an anecdote that Leonard Ochtman related to critic Thomas Whipple Dunbar. "A neighboring farmer would come and glance over Ochtman's shoulder while he painted," Dunbar wrote. One morning, the farmer "was particularly impressed with the sketch the artist was making and offered a dozen eggs for it which, of course, Ochtman tactfully declined. The completed picture became one of Ochtman's important canvases and won for him a gold medal."[94] Whether they undervalue or overvalue the artwork, the joke is that the country folk just don't understand. Dependent on the natural world for their livelihood, the farmers and fishermen had not learned to see the landscape in aesthetic terms.

Perhaps the old-timers sensed—and if so, understandably resented—the artists' condescension. Steffens boasted in his autobiography about his easy relations with the locals but confessed in a letter that it was years before "the fisher people hereabouts" would speak to him. When Twachtman was building a wall on his property, a neighboring farmer asked wryly, "Building a wall to keep us out, Mr. Twachtman?"[95]

The old-timers had what the artists coveted: a long American heritage and the antiques to prove it. By their own accounts, the art colonists sometimes exploited the locals' presumed ignorance to purchase their family heirlooms. Steffens related that the artists made a game of what they called "real estating," going around with a realtor to inspect property for sale. "It gave you an excuse to go into houses,

good old New England houses, and see antique fireplaces and furniture," he wrote; "some of the more unscrupulous people degraded the game to a free hunt for furniture and, I was sorry to observe, they found real bargains in chairs, tables, beds, etc." When Ochtman failed to get a bargain price on a pair of andirons from a Greenwich farmer, his then-fiancée Mina Fonda (a New Hampshire native) commiserated that "these Conn. Yankees are shrewd." But when, pretending to be lost, he stopped at a farmhouse to ask an elderly woman for directions and left with an antique chair, she praised his persuasiveness and persistence.[96]

The artists' education and cosmopolitanism meant that they had little in common with the old-timers, some of whom were barely literate. At the same time, however, their socioeconomic anxiety, questioning outlook, and desire for unspoiled landscape set them apart from the other urbane newcomers. As a result, during the early years of the art colony, they were doubly outsiders, alienated from both old-timers and newcomers. By the turn of the century, however, lines between the two factions had blurred, as the Yankee families—especially their younger members—began to emulate the more worldly summer people. This change, and the art colony's attitude toward both groups, is given literary form in Bacheller's "Keeping Up with Lizzie," first published in *Harper's* magazine in 1910 and expanded to novel length a year later. The story's narrator, attorney Socrates Potter, tells what happens when the middle-class families of fictional Fairview, Connecticut, abandon plain living for stylish city ways. The grocer's daughter, Lizzie, sets the pace. To enable their daughters to keep up with Lizzie, the other merchants go into debt to pay for "automobiles, piano-players, foreign tours, vocal music, modern languages, an' the aspirations of other people."[97] New York, exemplified by the Gottriches of Fifth Avenue, represents materialism and decadence. Even worse is Europe, personified by Lizzie's fortune-hunting suitor, the bogus Russian nobleman Alexander Rolanoff. Potter turns the tide by persuading Harvard graduate Dan Pettigrew to abandon his plans for a law career and become a farmer. When Potter tells Lizzie that her father cannot afford her extravagance, she drops her affected British accent, goes to work in the grocery store, and leads a return to wholesome simple living. Rolanoff is exposed as a scoundrel, and Dan and Lizzie are married. In his popular story, Bacheller reversed the social change that

swept many American communities before World War I. In Bacheller's version, a farm town glimpsed the temptations of a more urbane lifestyle and, after a brief dalliance, rejected them to return to the old agrarian ways.

Even in fictional Fairview, however, the population was not neatly divided between picturesque old-timers and cosmopolitan newcomers. Bacheller allowed a glimpse of ethnic diversity only in a disturbing reference to Dan's farm hands as "eight gangs o' human oxen from Italy."[98] In real-life Greenwich, the population was multicultural, nowhere more so than in compact Cos Cob. There, the art colonists lived in closer proximity to a mixed population than they did in New York, where neighborhoods were defined by class and income. In addition to descendants of colonial settlers, Cos Cob's residents included a Chinese laundryman, an Alsatian shoemaker, an Irish tavern keeper, two Irish coal merchants, and at least two African American couples. The Holley House itself was home for a time to a Japanese artist, Genjiro Yeto, and to live-in help, sometimes Irish, sometimes African American.[99] A Russian Jewish family arrived in 1910 to run the village newsstand. Across the Mianus River from the Holley House were the homes of Japanese silk importers Rioichiro Arai and Yasukata Murai.[100] Italians lent a European flavor to Cos Cob's harbor; the *Art Interchange* essayist related that when the students went rowing on warm summer evenings, "the Italian workingmen, skimming past us in other boats, singing their songs, make us think of Venice." Visiting the Ochtmans one Sunday, Robinson saw "a lot of Italians playing at bowls in the road as in Italy."[101]

The immigrants and the African Americans are all but invisible in the work of the Cos Cob Impressionists, however. In a period when native-born Americans felt threatened by heavy immigration, the artists suppressed evidence of their historical retreat's diversity.[102] The only image that includes an immigrant who is identifiable as such is Hassam's etching *Toby's, Cos Cob* (fig. 31), depicting an Italian organ grinder outside the village tavern. (The Toby of the title was the Irish tavern keeper, Tobias Burke.) The African American population is also represented in a solitary image, an etching by Eby with the distressing title *Coon Quarters* (fig. 32).[103] The print depicts an old warehouse that had been converted into three apartments, two of which were

rented by black couples, the other by Eby.[104] The young printmaker's decision to live under the same roof as the African Americans surprised the white villagers. Eby depicted the home of his neighbor, the black woman who stands on the top step, as somewhat disheveled. Laundry dangles from a clothesline, window shades are haphazardly drawn, and discarded lumber and clothing clutter the area below the stairs. However, an equally shabby appearance is evident in Eby's portrayal of the Brush House, home of one of the oldest families in Cos Cob (fig. 33). In both images, decay signifies age. The buildings and their inhabitants—black or white—are presented as picturesque survivors of an enduring past.

Although the artists and writers were friendly toward the villagers, they socialized mainly within their own group. They maintained contact with one another throughout the year, returning to the Holley House for nutting parties in the fall, skating and sleigh-riding

Childe Hassam, *Toby's, Cos Cob*, 1915, etching, 6 7/8 x 8 7/8 in. The Metropolitan Museum of Art, Gift of Mrs. Childe Hassam, 1940 (40.30.8).

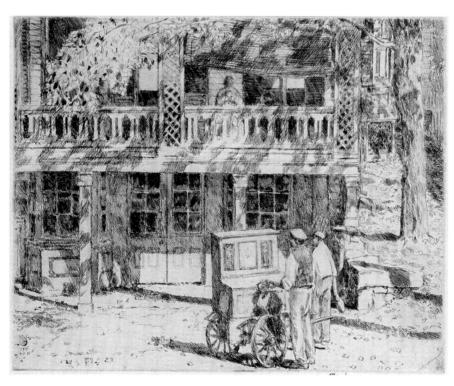

31

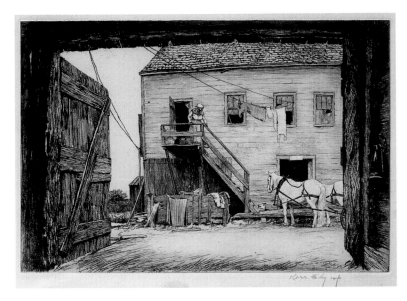

32

Kerr Eby, *Coon Quarters*, 1913, etching, 6 x 8 ⁷/₈ in.
Private collection, photograph courtesy of the Historical
Society of the Town of Greenwich.

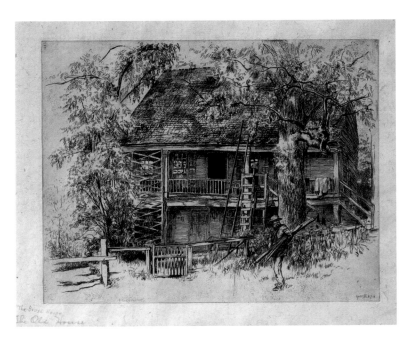

33

Kerr Eby, *Brush House*, 1916, etching, 5 ¹⁵/₁₆ x 7 ¹⁵/₁₆ in.
Private collection, photograph courtesy of the Historical
Society of the Town of Greenwich

in the winter, viewing the apple blossoms in the spring, and Sunday dinners year round. Many of their leisure activities were typical of the period. Besides swimming, boating, fishing, and cycling (fig. 34), they played charades on the porch, sang songs around the piano, popped corn in the fireplaces, pulled taffy, and made fudge. Other entertainments—such as Japanese tea ceremonies and tableaux—seem to have been calculated to express their identity as an aesthetic group.

The Halloween party held at the Holley House in 1903 demonstrates how the art colony used entertainment to define itself as a community. The party, which was reported in the local newspaper, doubled as a reunion of summer guests; twenty-five assembled in addition to the Holleys, the MacRaes, and the unidentified reporter.[105] The evening's entertainment was an aestheticized version of American holiday traditions. On arrival, each guest was given a pumpkin with instructions to carve it into a likeness of another guest; the familiar jack-o'-lantern thus became a document of group membership. At dusk, according to the newspaper article, "the great fireplaces were kindled with blazing pine knots and the rooms from garret to cellar were illuminated with the grotesque lanterns fashioned from the ingeniously carved pumpkins." The sound of a gong was the signal to change into cos-

58

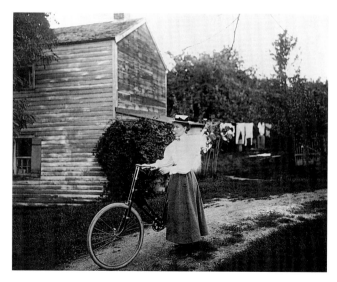

34

Constant Holley with bicycle in the driveway behind the Holley House, ca. 1895, photograph. Historical Society of the Town of Greenwich.

tume, but some were so eccentric that it was impossible to guess what they represented. Among the identifiable characters were the Wild Woman of Borneo, the Beautiful Circassian Lady, a Bulgarian Princess, a Serpent Dancer, a Japanese Giantess, and a Chinese Warrior. Edward Holley, carrying a gramophone blaring Beethoven's Turkish March, led the festive parade to the dining room. After dinner, the group played parlor games until midnight, when they descended to the oak-beamed cellar to bob for apples, tell one another's fortunes, and listen to ghost stories by the eerie light of a pan of burning salt and alcohol.

Changing Relations with the Community

As artists and writers bought homes in the area, it became more difficult to maintain their studied aloofness, especially after they realized that the wealthy newcomers were potential patrons. In the early years of the art colony, the local farmers and summer residents did not represent a significant source of patronage. By the first decade of the twentieth century, however, a sizable population of prosperous year-round residents needed pictures for the walls of their new homes. The art colony's belated recognition of this untapped market was spurred, no doubt, by their colleagues in Old Lyme, about ninety miles up the coast. Beginning in 1902—just two years after an art colony emerged in Old Lyme—the artists there mounted annual exhibitions in the local library that attracted both summer visitors and New York critics. Those exhibitions, the first organized by an American art colony, were part of a broader movement to expand marketing opportunities for artists that dated back to the formation of the Society of American Artists (SAA) in 1877. Founded as a vehicle to present the work of progressive, European-trained artists when the National Academy of Design proved hostile to the new cosmopolitan styles, the SAA in turn had grown conservative by the 1890s. In order to create a sympathetic venue for their work, Twachtman, Hassam, and Weir resigned their membership in the SAA, enlisted seven of their friends, and established Ten American Painters in 1898. (Chase became a member upon Twachtman's death in 1902.) At first, the Ten exhibited only in New York and Boston, but in 1906 they began sending their shows farther afield.[106]

59

Meanwhile, in cities across the United States, artists were joining forces to present their work to audiences who might never visit a Manhattan gallery. The artists who had settled in Greenwich, accustomed to sending their work to exhibitions in Washington, Chicago, St. Louis, San Francisco, Buffalo, and other cities, finally became frustrated that they had no place to exhibit in their hometown.

During the same period, the status of artists was changing. *Vogue* magazine chronicled the "Passing of the Long-Haired Artist" in 1912, declaring that the successful artists and writers "have pretty houses, motors and country places, belong to the best clubs and are immaculately turned out." Reflecting this new status were articles in fashionable magazines on the Greenwich homes of Twachtman, Bacheller, Ebert, and Seton.[107] Such a situation was a far cry from the quiet bohemianism the artists and writers had cultivated at the Holley House.

Yet it was at the Holley House that the first public indication of a major shift in relations between the Cos Cob art colony and the surrounding community occurred. MacRae organized and hung his own first solo show there in October 1908. The reticent artist's friendships with journalists paid off: the exhibition was reported in the *New York World*, and more than two hundred visitors came. When MacRae mounted a second exhibition the following October, the *New York Herald* devoted a half-page to what it called "the event of the week, both in the artist colony and among the society folk who have prolonged their summer's stay here on account of the fine weather." In his lengthy review of MacRae's third Holley House exhibition in 1910, *Evening World* critic Henry Tyrell implicitly compared Cos Cob to art colonies in France, calling the event "a most unique, Barbizone [*sic*] like affair!" Recalling that Twachtman, too, had lived for a time in the Old House, Tyrell wrote that "the old-fashioned, lavender-scented loveliness of the ancient Holley manse" was an "ideal environment" for the display of paintings.[108]

MacRae's exhibitions were commercial as well as critical successes. Before the first of them, the artist had never earned more than $300 a year from his profession, generally through sales to, and portrait commissions from, other artists. His 1908 exhibition, by contrast, realized a respectable $601 in sales. More significantly, MacRae had extended his patronage from the art colony to the wider community:

of the seventeen visitors who purchased works from the exhibition, only four were members of the art colony.

MacRae's ventures alerted his colleagues to the advantages of reaching out to the community. However, it was a wealthy summer resident, Florence Wolf Gotthold of New York, who prodded the art colony into organizing. Gotthold, who had exhibited at the National Academy of Design, the Pennsylvania Academy of the Fine Arts, and the New York Water Color Club, invited other artists to her home in April 1911 to discuss her dream of an organization. The resulting Greenwich Society of Artists (GSA) ratified its constitution on January 21, 1912.[109] Charter members included Gotthold, MacRae, Taylor, Leonard and Mina Fonda Ochtman, Edward Clark Potter, writer and artist George Wharton Edwards, and painter Matilda Browne. Twachtman had died ten years earlier, but his former students Charles and Mary Roberts Ebert and Carolyn Mase, and his oldest son, Alden, were also charter members.

The society allied the art colony with the new gentry they had previously scorned. Architect members, including Richard Howland Hunt, Joseph Howland Hunt, Thomas Hastings, and Isaac Newton Phelps Stokes, were designing elaborate homes for the new year-round residents.[110] The GSA shrewdly enlisted social leaders, among them art collector Louisine Havemeyer, as associate members. The associates, who included both old and new gentry, would fund the society's exhibitions, lend cachet to their previews, and, it was hoped, purchase paintings and sculptures.

In reporting the formation of the artists' association, the local paper linked the Cos Cob art colony to European predecessors. Predicting that the artists would "attract to the town ever-increasing numbers" of cultured persons, one writer anticipated that "something like the atmosphere of Barbizon, Giverney [*sic*], and of similar places abroad" would soon extend to Greenwich.[111] That article also reported that the society was considering erecting its own building; had it done so, the building would have been the country's first art-colony gallery. Instead, however, the society decided to base its exhibitions at the nascent Bruce Museum.

In 1909 textile merchant Robert M. Bruce had bequeathed his home and fifty thousand dollars to the town for a museum of art,

history, and natural history.[112] The house had stood empty since his death while civic leaders and townsfolk debated what to do with the somewhat unwelcome gift. The initial steps in converting it to a museum were taken by the GSA in preparation for their first exhibition, which was also the first ever held at the museum. Although the society had originally planned a summer show (like those in Old Lyme), all its exhibitions in the first two years were held in the autumn or winter. This schedule reflected the town's transition from a summer resort to a year-round commuter suburb.

The opening of the Greenwich Society of Artists' first annual exhibition of paintings and sculpture, on September 28, 1912, marked a new phase in the art colony's relations with the community. An editorial writer commented on the change: "Greenwich has long been the home of many artists of more or less note but it [is] only recently that . . . they have become definitely a recognized force in the life of the community. . . . The trouble has been in the past that these people have for one reason or another held more or less aloof from the life of the place. We are glad to see that they are entering into it."[113]

The artists adopted their new social status with a flair, making the preview a "notable society event" that received front-page coverage in the local newspaper.[114] While an orchestra played in the background, 150 guests nibbled refreshments and ended the evening with a dance in the long gallery. The social trappings were designed to help the artists sell their works. Almost all of the sixty-six paintings and about fifteen sculptures were for sale, at prices ranging from fifteen to two thousand dollars. No record of sales survives, but the society's optimism is indicated in its quick follow-up that December with an exhibition of works on paper, timed to attract Christmas shoppers.

The second annual exhibition, in 1913, attracted national coverage in the form of a three-column article in the *Christian Science Monitor*, whose headline announced the GSA's ambitions: "Permanent Gallery Collection Greenwich Artists Hope." In the local paper, a celebratory account of the exhibition ended with a discreet sales pitch: "Many of the paintings are on sale, and where could they find a fitter resting place than on the walls of our splendid Greenwich

homes?" [115] The owners of those "splendid" homes were targeted more directly a few months later with an exhibition of designs and models for architecture, murals, cabinetry, and gardens. Nationally prominent architects, including Charles Platt, exhibited along with GSA members. [116]

Although Hassam and Weir, as nonresidents of Greenwich, were not eligible to join the Greenwich Society of Artists, those senior members of the art colony participated in the group's third annual exhibition, held at the Bruce Museum in the summer of 1914. Weir sent a painting titled *June* (location unknown). Hassam was ensconced at the Holley House during the exhibition, as he had been at times during the two previous summers, but he did not exhibit a canvas he had painted there. Instead, he showed *The Jonquils* (ca. 1907, private collection), depicting a model arranging flowers in his city studio. In addition to their old friends Hassam and Weir, the GSA artists invited painter Horatio Walker and sculptor Isadore Konti, neither of whom is known to have had any previous connection to the art colony, to exhibit with them. Although no record of sales survives, the participation of the four guest exhibitors suggests that the society had succeeded in attracting new patrons. A 1914 newspaper article supports this assumption, reporting that previous exhibitions had "been very well patronized and very successful." The society even hired a New York dealer to manage the gallery and stimulate sales. [117]

The GSA suspended exhibitions during World War I but rebounded strongly with its exhibition held at the Bruce Museum from May 18 to October 18, 1919. As a result of the astutely selected list of guest exhibitors, visitors enjoyed an outstanding, if conservative, survey of Impressionist paintings and Beaux-Arts sculpture. No early modernists were included. Instead, the guest exhibitors were well-established artists working in styles that were by then generally accepted. Hassam participated again, as did Robert Reid, who had painted years earlier at Twachtman's place, but most of the guest exhibitors were linked to the art colony only by friendship. Frederick Frieseke, Richard Miller, Ivan Olinsky, and Charles Courtney Curran sent paintings depicting beautiful women, while Irving Couse exhibited one of the genre paintings of Native Americans for which he was known. Landscapes and marine paintings by Charles H. Davis, Edward Potthast, Frederick Judd

Waugh, and Paul Dougherty were also included, along with still lifes by Emil Carlsen, Florence Gotthold, and Dorothy Ochtman (the daughter of Leonard and Mina).

The sculpture section was especially strong. America's most famous living sculptors—Daniel Chester French, Frederick Mac-Monnies, and Herbert Adams—participated, along with the highly respected *animaliers* Phimister Proctor and Anna Vaughan Hyatt. Several pieces were suited to the gardens of a great estate: a sundial by Harriet Frishmuth, fountains by Janet Scudder and Louis Urich, MacMonnies's famous *Diana*, and Edward McCartan's *Faun*. Other sculptors courted portrait commissions by showing examples of their work. Gutzon Borglum, James Earle Fraser, Herbert Adams, and Evelyn Beatrice Longman all exhibited portrait busts. Bessie Potter Vonnoh sent a small bronze of a mother and child, the subject for which she was best known.[118]

The stellar 1919 annual resulted in the GSA's only documented sales: the Bruce Museum's purchase of eight paintings for a total of four thousand dollars. Leonard Ochtman, doubling as the society's president and the museum's art adviser, probably guided the acquisitions. The museum's trustees and the "committee of women" who assisted them in making the selections favored local artists. Only two of the eight whose works were selected—Emil Carlsen and Charles Davis—were from out of town, and they both lived in Connecticut. The others whose canvases would form the core collection of the fledgling museum were GSA members Leonard Ochtman, Elmer MacRae, George Wharton Edwards, Matilda Browne, James Gale Tyler, and Florence Wolf Gotthold.[119]

Although the museum's choices seem provincial, they also indicate the society's success in cultivating patronage. Years earlier, Twachtman had complained that American collectors patronized only European artists. Now, just seven years after the GSA's founding, civic leaders in the town where Twachtman had been an outsider were spending public funds to acquire paintings by artists they had come to know well. Furthermore, the eight works represented good value to prudent trustees. Carlsen, Davis, and Ochtman enjoyed national reputations at the time, while MacRae, Edwards, and Browne were re-spected artists whose work commanded lower prices than that of

such guest exhibitors as Frieseke. The Bruce Museum's modest flurry of patronage was not soon repeated, however, as the museum the art colonists had helped to establish turned its attention almost entirely to natural history.[120]

The Decline of the Art Colony

The most distinguished artists in the GSA's 1919 exhibition were not the art colonists but the guest exhibitors. Ochtman was past his prime. MacRae had virtually stopped painting, devoting himself instead to wood-carving. The other GSA members included many accomplished artists, but they could not claim the same high level of achievement as the earlier art colonists.

The art colony's decline resulted from changes both local and national. The original leaders of the art colony had died or moved away. Robinson died in 1896, Twachtman in 1902. Weir lived until 1919, but after Twachtman's death, he seems to have visited Greenwich only to see his friend's family. Hassam bought his own home in East Hampton, Long Island, in 1919. The irrepressible Henry Fitch Taylor ("Uncle Harry" to younger members of the art colony) married Clara Davidge and joined the stylish art colony in Cornish, New Hampshire.

The area's landscape had changed, too. As early as 1906, one reporter had observed that "there are really very few . . . genuine farmers living in the town now. . . . And it will only be a few years at the furthest, at the rate the farms are being sold and changed into private parks and gentlemen's estates, when there will be none."[121] By the end of World War I, Greenwich had nearly lost the agrarian character that had attracted artists. As a result, some sought painting locales farther from the city. Charles and Mary Roberts Ebert, who had lived in Greenwich for more than two decades, moved up the coast to Old Lyme in 1919. D. Putnam Brinley gravitated to the Woodstock art colony before joining the one in the Silvermine section of Norwalk, Connecticut.

The automobile made painting sites farther from the city more easily accessible. As a writer in *Harper's Weekly* observed in 1911, "The automobile gives one the country, not merely the suburbs . . . there is no longer the necessity of attaching oneself to a railroad station, nor even to a village."[122] The shift from trains to automobiles also

reflected the increased value placed on privacy. Instead of sharing rail-road cars with strangers, motorists traveled in their own private capsules. At their destination, they sought accommodations that sustained this privacy, not the communal, family-style boardinghouses that had been so well suited to the heyday of trains.

Scenery was in any case losing its importance as a reason for an art colony. As early modernists turned toward abstraction, they no longer needed to leave their studios to seek compelling subject matter. Georgia O'Keeffe is a case in point. She visited Cos Cob in the early 1920s as the house guest of the wealthy Alma Wertheim, who had purchased Ernest Thompson Seton's wooded estate, Wyndygoul.[123] Commemorating that visit, O'Keeffe painted a close-up view of a skunk cabbage (fig. 35). Her composition originated in close observation of the plant, but it evolved through numerous increasingly stylized trans-mutations before reaching its ultimate form. Although skunk cab-bage is a harbinger of spring on the East Coast, O'Keeffe's oil lacks the sense of place that imbued the works of the Cos Cob Impressionists. In fact, she may have painted it back in New York, using sketches she had made at Wyndygoul.[124]

By 1920, the heady years of artistic innovation by artists and writers at the Holley House were largely the stuff of memory. "There is quite a nice orderly crowd with us, most too orderly," MacRae wrote wistfully to poet Ridgely Torrence. "Oh, for some of the bright sayings and mischief of the Uncle Harry period!"[125] The MacRaes continued to operate the boardinghouse for several more years, but the loss of its bohemian vitality saddened those who remembered the old days in the Freak House.

We turn now to those vibrant earlier days to examine the art colony through the shifting lenses of the artists' four favorite themes: the nautical landscape, or images of boats in their maritime setting; architecture, defined as views of Cos Cob's built environ-ment; "familiar faces," portrayals of women and children; and "familiar places," depictions of the modest landscape the artists knew, loved, and, in some cases, altered before they set brush to canvas.

Georgia O'Keeffe, *Skunk Cabbage (Cos Cob)*, 1922, oil on canvas, 23$\frac{1}{8}$ x 16 in. Williams College Museum of Art, Williamstown, Mass., bequest of Kathryn Hurd.

35

66

The shore is somewhat deeply indented with bays and small
harbors. . . . The traveler has frequent glimpses of the sound, and catches
the occasional gleam of sails through a vista of forest trees.

—*Hand Book and Business Directory of the N. Y. and*
N. H. Railroad, 1871

As the train from New York approached Cos Cob, artists and writers
on their way to the Holley House enjoyed a preview of the scenery that
had attracted them there. Oyster sloops dredged the beds around
the islands near the shore. Fishermen hauled lobster traps into catboats
or dories, pausing, perhaps, to wave to a schooner carrying farm
produce to the city. Farther out on Long Island Sound, a cluster of white
sails might mark the progress of a regatta. Once they arrived in Cos
Cob, the art colonists lived in a village where boats outnumbered buggies
and carts. Little wonder, then, that sailing craft became one of the
major themes of their artwork.

The artists did not, for the most part, depict isolated boats.
Instead, they positioned sailing craft within the nautical landscape:
the natural and built environment—the marsh grass, river shore, yacht
club, shipyard, and harbor—that constituted a complex maritime
culture during a time of transition. In their portrayals of this nautical
landscape, the Cos Cob Impressionists suggested the dynamics of
change and their own ambivalent attitudes toward it. The subject's layered

meanings are revealed in careful study of the social, economic, and cultural context of the water traffic that so fascinated the art colonists.

The Railroad Bridge

The railroad that transported the artists to the Connecticut shore figures in the background of many of their nautical landscapes. The first train crossed the newly completed bridge over the Mianus River in 1848. Within a half-century, the railroad transformed Greenwich from a farming and fishing community to a suburb of New York. The railroad promoted the development of organized leisure boating because, as a reporter for a New York newspaper observed in 1894, "Greenwich is a famous yachting resort, and there is nothing pleasanter than being able to come to town in the morning, knowing that at night it will be possible to board one's yacht within one hour from the office."[1] But at the same time, the railroad undermined commercial water traffic, as its owners had intended from the outset. The founders of the New York– New Haven line had chosen a shoreline route in order to compete with the sail-powered packet boats that had been shipping freight from coastal towns for nearly two hundred years. In the pre-railroad era, long lines of oxcarts laden with potatoes, apples, poultry, dairy products, hay, and grain waited to unload into vessels docked at Cos Cob's waterfront. Trains captured most of that trade by the end of the nineteenth century. A farmer who wanted to ship a perishable product like milk to city markets found the daily train service preferable to the packet boats, which sailed only two or three times a week and not at all in stormy weather. Before long, that same farmer would realize that the convenient rail link to New York made his land more valuable as residential building lots than as fields and pastures. The transformation was gradual, however, and it is subtly conveyed in paintings, drawings, and etchings produced in Cos Cob between the last decades of the nineteenth century and the second decade of the twentieth.

David Johnson set the railroad in the background of his *View near Greenwich, Connecticut* in 1878 (see fig. 1). Johnson contrasted the straight lines and mechanical forms of the train and its embankment with the rounded, irregular shapes and textures of the trees, clouds, and rocks. He mitigated the railroad's intrusion into the landscape by

setting the embankment low in the composition, blending the train with the colors of the trees behind it, and repeating its general size and shape in that of the dinghy. His painting exemplifies what historian Leo Marx calls "the machine in the garden," the endeavor by mid-century American painters to reconcile the new technology with the old agrarian ways.[2]

Almost two decades after Johnson, Childe Hassam juxtaposed fishermen with the railroad to a different effect. In *Fishing* (fig. 36), Hassam depicted two boys and several men fishing from the Lower Landing while a train streaks across the bridge in the distance. Unlike Johnson, Hassam did not integrate the railroad with its setting; instead, he distinguished the mechanical rigidity of the iron bridge from the softer lines of the curving stone seawall and the ramshackle warehouses. The iron of the bridge suggests permanence, whereas the wooden boats and buildings, subject to rot, evoke decay and loss. Hassam's composition contrasts the train's speed with the stasis of the community through which it races. A diagonal row of empty boats leads the eye gently back into space until recession is abruptly halted by

Childe Hassam, *Fishing*, 1896, oil on canvas, 14 x 17 in. Private collection; photograph © Christie's Images 2000, New York.

69

36

the bridge snapped high across the canvas. The horizontal slash of the bridge conveys the railroad's urgent speed, which astonished Hassam's contemporaries. "In the 1890s, the railroads virtually invented the notion of speed," writes historian George H. Douglas. "In May 1893, when Engine 999 pulled the Empire State Express at a speed of 112.5 miles an hour near Batavia, New York, it could honestly be advertised that no propelled vehicle had ever traveled so fast in the history of the world." That unprecedented velocity inspired the title of a play that premiered in New York in 1892—*A Mile a Minute*—and accelerated the pace of life in the cities, which drained young people from the countryside. In Hassam's *Fishing*, the adults are relegated to the margin, while the two boys in the center foreground enjoy front-row seats for the spectacle playing on the stage of the railroad bridge. For such rural youth, a locomotive's whistle stirred dreams of urban adventure. Hassam's young fishermen are the counterparts of the youngsters in Willa Cather's story "The Best Years," who lay awake in their farmhouse attic, waiting to hear the train approach across the plains. The locomotives, Cather wrote, "seemed to mean power, conquest, triumph. . . . They set children's hearts beating. . . . They were the awakeners of many a dream."[3]

The Cos Cob Impressionists could find precedents for their pairing of sailboats and railroad bridges in the paintings of the French Impressionists. In Monet's *Railroad Bridge, Argenteuil* (fig. 37), for example, a sailboat glides under a bridge over which a locomotive wafts cumulus clouds of smoke. The connection is clear: the train enabled Parisians like Monet to enjoy the leisure represented by the sailboat. "Together," Robert Herbert writes, "the boat and the railroad stand for the modern suburb which has relinquished its agricultural role to the pressures of industry and of urban leisure."[4]

Unlike their French predecessors, Cos Cob's artists linked the railroad not with the leisure activities it fostered but with the traditional economy it destroyed. The railroad bridge figures prominently in numerous paintings of the traditional work boats, the shipyard where they were repaired, and the Lower Landing where fish and freight were unloaded from their holds. Theodore Robinson's *The E. M. J. Betty* (fig. 38) is one such painting. To create it, Robinson set his easel in the Palmer & Duff Shipyard, near two sailboats undergoing repair.

The white paint of the smaller vessel identifies it as a pleasure craft, whereas the black tar coating of the larger one marks it as a work boat. Robinson not only titled his painting after the commercial vessel, he also made the lettering of its name unrealistically crisp in his otherwise soft-focus picture. Why was this particular sailboat so significant to him?

The *E. M. J. Betty* was the only packet boat still sailing from Cos Cob in 1894, when the painting was made, and its continued survival was recognized as tenuous. It had already been retired once, in 1890, but had returned to the cargo trade the following year. Competition from the railroads was fierce, however, and in 1896 the *Betty* made its final voyage as a packet boat.[5] Robinson was familiar with this type of vessel from his landlord in backcountry Greenwich, Captain Lewis Augustus Merritt. "The old captain," as Robinson called him, was a member of the family that for two generations had dominated commercial shipping from the harbor in central Greenwich. The eighty-two-year-old Merritt had died earlier in the summer of 1894, leaving no descendants in the business.[6] Robinson had recorded amusing anecdotes about the elderly sailor, depicted him with his oxen in one painting (see fig. 14), and empathized with his asthma. Always conscious of his own physical frailty, Robinson may have

Claude Monet, *Railroad Bridge, Argenteuil*, 1874, oil on canvas, 21 ¼ x 28 ⅝ in. The John G. Johnson Collection, Philadelphia Museum of Art.

37

71

identified with Merritt and the fast-fading remnants of Cos Cob's nautical past. Although the *E. M. J. Betty* appears to dominate Robinson's canvas by virtue of its size and name, the composition expresses its compromised state. Two laborers devote their full attention to the yacht, while work on the *Betty* seems to have stopped in mid-course. The bridge squashes the battered schooner into a confined space in a striking visual analogy of the economic pressure that the railroad exerted on packet boats.

"Worked this A.M. three hours—a schooner unloading coal—made a rather coarse study," Robinson jotted in his diary on June 12, 1894.[7] The painting that resulted, *Coal Schooner Unloading* (fig. 39), is similar to *The E. M. J. Betty*. Approximately the same size, it also juxtaposes a working sailboat with the railroad bridge. For both pictures, Robinson selected a vantage point so close to the boats that he was forced to crop the masts. That cropping undoubtedly owed something to Japanese prints and photography—both important influences on Robinson's work—but it also expressed the crippled condition of commercial shipping. The coarse quality that the artist acknowl-

Theodore Robinson, *The E. M. J. Betty*, 1894, oil on canvas, 12 1/4 x 20 in. Private collection.

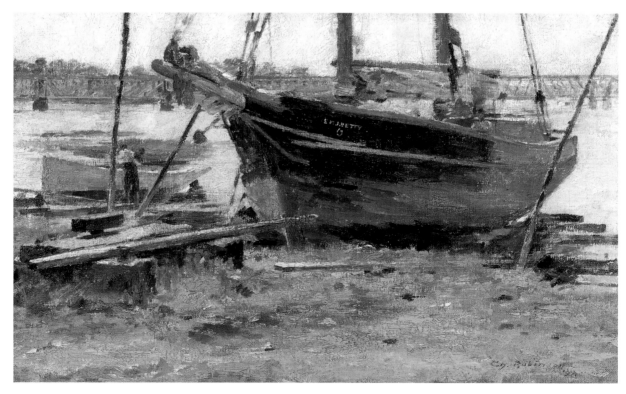

38

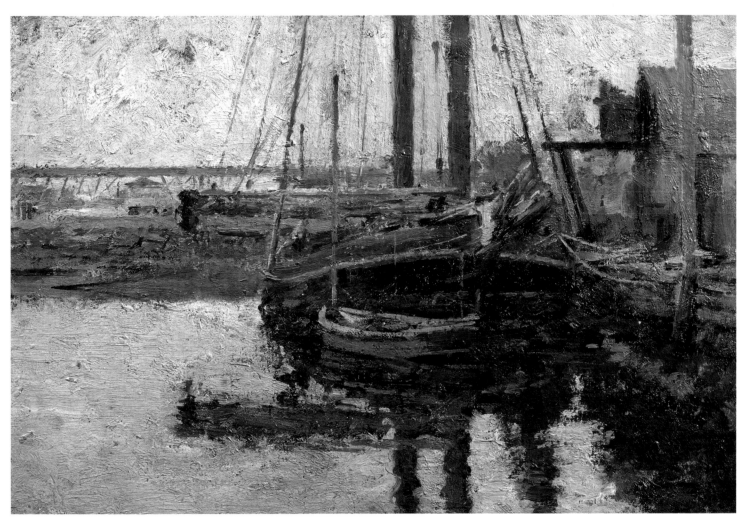

Theodore Robinson, *Coal Schooner Unloading*, 1894,
oil on canvas, 12 ³/₄ x 19 ¹/₈ in. Private collection, photograph
courtesy of Spanierman Gallery, LLC, New York.

edged in his oil sketch of the coal schooner is the visual equivalent of the gritty subject matter. Using a somber palette of gray, brown, black, and rust, he constructed an asymmetrical grid from the verticals of the masts and the horizontals of the bridge and the schooner's boom, countered by the diagonals of the rigging. In Robinson's careful design, the heavy sailboat is pinned in place by the deceptively delicate-looking railroad bridge.

The railroad's inevitable triumph over the old cargo fleet lends piquancy to Elmer MacRae's *Schooner in the Ice* (fig. 40). A handsome cargo vessel tied up at the Lower Landing is frozen in place by floating ice while, in the distance, two locomotives, one pulling a colorful train of freight cars, approach one another on the bridge. The contrast between enfeebled boat and efficient trains exemplifies a new relationship between humans and nature: instead of enduring the vicissitudes of weather, as sailors, fishermen, and farmers had done, people of the twentieth century would, to a large extent, conquer it. The altered relationship with the natural world bolstered Americans' faith in progress even as many regretted the passing of the old ways. That

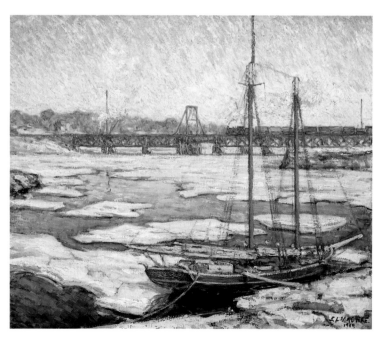

40

Elmer MacRae, *Schooner in the Ice*, 1900, oil on canvas, 25 x 30 in. Courtesy of Mr. and Mrs. Hugh B. Vanderbilt.

ambivalence is captured in the paintings and writings of the art colonists after the beginning of the twentieth century. In his autobiography, Lincoln Steffens offered an example of their changing attitude, occasioned by the renovation of the Mianus River railroad bridge beginning about 1901. As the construction project dragged on, Steffens wrote, the Holley House regulars were disgusted by the noise and smoke. Ever the gadfly, Steffens, by his account, "defended the railroad on the theory that activity also was a theme for painters; not a dead village only, but a busy harbor was worth painting, and I prophesied that in a month or two all the painters would be painting that bridge-building, with the girders a-swinging and the smoke a-blowing in the wind. I had to go west that summer, and when I got back one forenoon in the fall I passed all the Cos Cob school with their easels set and painting the noisy, dirty bridge improvement. . . . Twachtman alone spoke to me, and all he said was, 'Ah, go to hell.'" [8]

No painting of the bridge renovation by Twachtman survives, but the work is recorded in Hassam's *The Mill Pond, Cos Cob*, dated 1902 (see fig. 27). Hassam, who had never before depicted industrial labor, candidly described the messiness of the construction. Rough scaffolding sheathes the bridge, floating logs litter the water, and coal-black smoke blows from the two locomotives. Working with an urgency suited to the modern theme, Hassam brushed a tapestry of thin strokes on the canvas, leaving the buff primer to suggest the glint of sunlight on the river. The sparkling colors and lively brushwork lend a sunny optimism to this remarkable image of change in progress. *The Mill Pond, Cos Cob* marks a significant shift in the work of the Cos Cob Impressionists: here, for the first time, the bridge is not merely the backdrop to a nautical landscape but is itself the major subject. The tall ladder braced on a scow resembles a sailboat, but the only real boats in the painting are a couple of dories, as insignificant as the scrap lumber drifting in the current.

This shift in the balance between boats and trains became more pronounced in the work of the colony's artists during the second decade of the twentieth century. Kerr Eby made the railroad bridge the subject of a delicate Tonalist etching dated 1916 (fig. 41). As Hassam had done in *The Mill Pond, Cos Cob*, Eby found in the industrial bridge the elegance of line that both men admired in sailing craft. In

41

Kerr Eby, *Railroad Bridge*, 1916, etching, 4⁷/₈ x 8⁷/₈ in.
The Metropolitan Museum of Art, Gift of Phyllis Brevoort
Eby, 1962 (62.554.87).

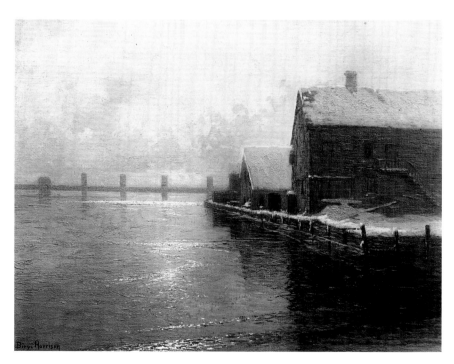

42

Birge Harrison, *Bridge at Cos Cob*, ca. 1912, oil on
canvas, 29¹/₂ x 39¹/₂ in. Butler Institute of American Art,
Youngstown, Ohio.

Eby's print, the bridge's latticed verticals and swooping power lines recall the masts and riggings of sailboats. A small catboat and a rowboat merely provide a sense of scale in Eby's poetic homage to the railroad.

Boats are entirely absent from Birge Harrison's painting *Bridge at Cos Cob* (fig. 42). A thin dusting of snow covers the Lower Landing. No footprints mar this white shroud, no boats edge the harbor, no smoke curls from the chimney. Cos Cob appears to be a ghost town. The straight lines and right angles of the iron railroad bridge stitch up the horizon line with mechanical efficiency, dividing luminous sky from sparkling water and contrasting with the crooked, snow-capped wooden posts of the old seawall.

The Shipyard

The railroad bridge did not appear in every image of Cos Cob's fishing and packet fleet. Robinson stood under the bridge and looked back upriver to depict the barn-red buildings in *The Ship Yard, Cos Cob* (fig. 43). According to his diary, Robinson began that sunlit view of Palmer & Duff's on the morning of July 5, 1894. That afternoon, he stood on the bridge to paint the shipyard from an elevated viewpoint (that painting is unlocated), and the following morning, until he was caught in the rain, he again stood under the bridge painting "a grey day ship-yard," probably *Creek at Low Tide* (fig. 44).[9] On those three canvases, Robinson studied the old shipyard under different atmospheric conditions, at different times of day, and from different viewpoints. He completed the paintings later that summer, sent two of them to exhibitions in the two years remaining to his life, and gave the third to the influential critic Hamlin Garland.[10] Clearly, Robinson found the subject compelling. What did it mean to him and his contemporaries?

The changes at the Palmer & Duff Shipyard reflected the area's social and economic metamorphosis at the turn of the century. A shipyard had occupied the spit of land opposite the Holley House since colonial days. Its cluster of buildings included a sawmill, a blacksmith shop, a sail loft, a paint store, and a long shed where carpenters built new sailboats. John Duff bought the shipyard in December 1848, taking possession, he remembered later, the same day the first train crossed the nearby Mianus River railroad bridge. Under the propri-

Theodore Robinson, *The Ship Yard, Cos Cob*, 1894, oil
on canvas, 16 x 22 in. Private collection, photograph courtesy
of Thomas Colville.

etorship of Duff and his partner, Denom Palmer, the shipyard became renowned on both shores of Long Island Sound for the fine packet boats built there. By the 1880s, Palmer & Duff no longer built boats but kept forty or fifty workers busy repairing them. According to one account, "There might have been seen as many as twelve Sound packets lying just off the shore waiting their turn to be pulled on the ways for repair."[11] The type of vessels that came into the yard changed rapidly in the decade before Robinson arrived in Cos Cob. An article in 1882 reported that the work crew was unusually busy outfitting "coasters," or packet boats. Just six years later, a column headlined "How the Business Has Changed" quoted Palmer: "We used to fit out many coasting vessels years ago, while comparatively few come here now. . . . That shows that the carrying trade has gone into other channels; probably railroads and steamboats. . . . It is chiefly pleasure yachts and small steamboats that come into the yard now."[12]

That was in 1888, six years before Robinson painted the site. The shipyard's decline was evident by 1894. The owners were in their seventies, their advanced age an intimation of the impending demise

Theodore Robinson, *Creek at Low Tide*, 1894, oil on canvas, 15 1/$_2$ x 18 1/$_2$ in. Wright Museum of Art, Beloit College, Beloit, Wisconsin, Gift of Reverend Louis Van Ess (WMA 10.625).

44

of Cos Cob's traditional nautical life.[13] Local people considered the place picturesque, which is usually a symptom of economic stagnation. In a description of Cos Cob published in 1894, a Greenwich journalist equated "the click of the carpenters' hammers in the ship-yard" with "the song of the robins" as cheerful wake-up calls for the Holleys' boarders. "It's a great place to loiter in—Palmer & Duff's ship yard," the writer continued. Creating a pun on the *ways*, or tracks used to haul boats out of the water, he employed a scriptural verse to evoke the tranquility of the shipyard: "the 'ways' are ways of pleasantness, and all the paths are peace."[14]

Robinson seems to have been keenly aware of this transformation as he stood painting at the railroad bridge. In his diary notation for July 6, he recorded the name of a vessel he saw: "A.M. under the bridge . . . it is fine as the tide begins to rise, showing patches of water and reflections of the James K. Polk." The *Polk*, which may be the large two-masted boat in his shipyard paintings (see figs. 43 and 44), was then the only packet boat still sailing between Rocky Neck, the harbor in central Greenwich, and New York.[15] When the *Polk* made its final run in 1897, the year after the *E. M. J. Betty* had ended service between Cos Cob and the city, a local newspaper eulogized it as "the last of the boats engaged in carrying produce to New York. Forty years ago there was business enough for four or five boats, but today there is not enough for one."[16]

In the years after Robinson's departure in 1894, the shipyard's continued decline was witnessed by other members of the art colony. They sometimes exploited the unobstructed view of the shipyard that was opened up in January 1899 when the eighteenth-century gristmill across the road from the Holley House burned to the ground. A photograph taken in 1906 documents the unglamorous reality of the view from the boardinghouse porch (see fig. 12). In Ernest Lawson's *River Scene in Winter* (fig. 45), snow conceals the jumbled mess and accentuates the silence of the unpopulated landscape. Lawson employed a palette of sepia, rust, brown, and gray that recalls the natural aging of a weathered barn or an abandoned plow. He filled his canvas with visual information, faithfully describing the ramshackle buildings. Framing the scene in a filigree of bare branches, he rendered the outmoded industry picturesque.

Twachtman, Lawson's teacher, also depicted the shipyard, in two winter landscapes (figs. 24 and 46). Unlike Lawson, Twachtman minimized detail and generalized form, reducing the buildings to two-dimensional shapes on a flat canvas. For *Bridge in Winter* (see fig. 24), he used a nearly monochromatic palette and screened the view of the shipyard with a clump of shrubbery. Those devices, coupled with the near abstraction of both paintings, create a sense of distance between viewer and subject—not the illusory physical distance produced by strict adherence to rules of perspective, but a temporal remoteness. Veiled by snow, the ghostly shipyard seems to inhabit a time removed from that of painter and viewer.

Winter—the end of the natural cycle—apparently seemed to Twachtman so appropriate to the portrayal of the moribund shipyard that when he painted a springtime landscape from approximately the same viewpoint as *Bridge in Winter*, he moved slightly to the left to eliminate the long boat shed that was the most distinctive of Palmer & Duff's buildings. *From the Holley House* (fig. 47) is suffused with the warmth of new growth; its energetic diagonals and verticals and varied colors contrast with the quiet horizontals and subdued monochrome of *Bridge in Winter*. Twachtman's shift of vantage point may reflect a reluctance to include a relic of the past—the shipyard—in a celebration of nature's rebirth.

By contrast, Hassam employed a summery palette when, in 1902, he set his easel on the upper porch of the Holley House to paint the shipyard in *Oyster Sloop, Cos Cob* (fig. 48). The fisherman in the foreground suggests the endurance of the traditional maritime way of life, but by then modernity had encroached even on the shipyard. In 1901, a factory producing gasoline engines and launches had relocated to the adjacent property from a smaller plant upriver; in that year, 150 motorboats on Long Island Sound were powered by the company's engines.[17] Hassam ignored any evidence of that thriving industry, however. Although the broken brushstrokes, cropping, and high-keyed palette he employed in *Oyster Sloop* recall Monet's paintings of boating on the Seine, Hassam's canvas betrays a nostalgia generally absent from the paintings of his French predecessor.

The vessels in Hassam's painting were as outdated as his romantic notion of the shipyard. A fisherman in a yellow oilskin stands

81

45

Ernest Lawson, *River Scene in Winter*, ca. 1899, oil on canvas, 30 x 30 in. Private collection.

in his rowboat to scull out of the small harbor. That method of navigating through narrow channels with a single oar set in the stern was unnecessary on boats equipped with up-to-date motors like those manufactured next door to Palmer & Duff.[18] The sail-powered oyster sloop moored at the shipyard was even more old-fashioned. The oyster industry in Greenwich had peaked in the 1880s, when about one hundred fishermen worked the privately owned beds, and had begun to decline about 1890.[19] Starfish, piracy, and water pollution were blamed for the decline, but a study of the charts of the oyster grounds suggests that the determining factor was the feudal nature of the local industry. In contrast with the large, quadrilateral plots off other shoreline towns, the Greenwich charts disclose a crazy quilt of small, oddly shaped beds. One owner's plots might be scattered over a wide area, separated by other owners' jealously—and sometimes violently—

John H. Twachtman, *View from the Holley House, Winter*, ca. 1901, oil on canvas, 25 $1/8$ x 25 $1/8$ in. The Hevrdejs Collection.

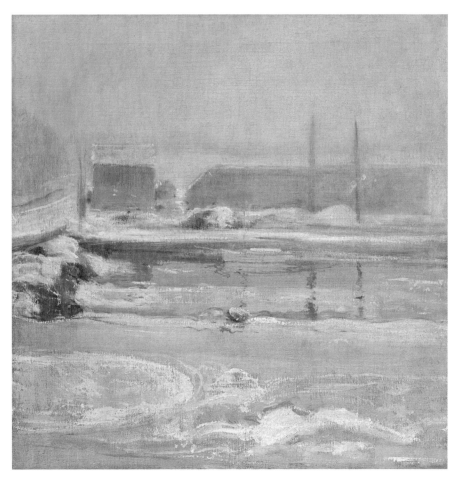

46

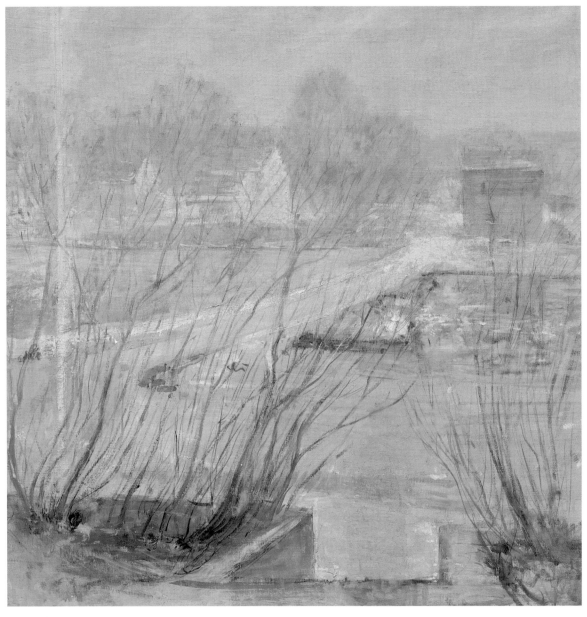

47

John H. Twachtman, *From the Holley House*,
ca. 1901, oil on canvas, 30 x 30 in. Courtesy of Marie
and Hugh Halff.

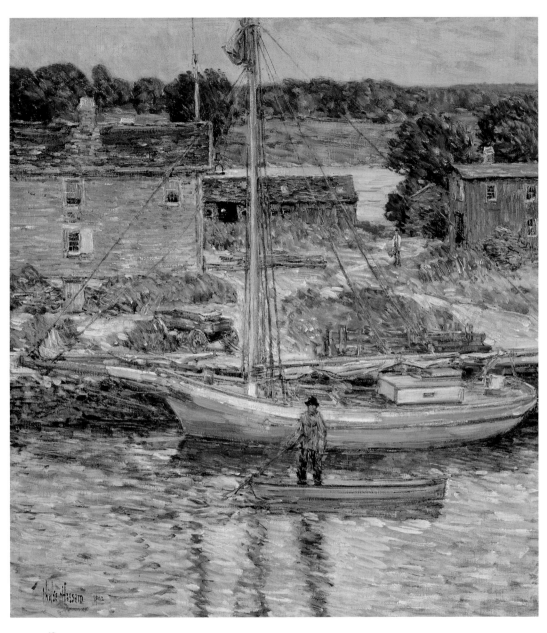

48

Childe Hassam, *Oyster Sloop, Cos Cob*, 1902, oil on
canvas, 24 ³/₈ x 22 ³/₈ in. National Gallery of Art, Washington,
D.C., Ailsa Mellon Bruce Collection.

guarded beds. That layout made harvesting by steamboats impossible. While oystermen in other coastal towns acquired up-to-date steamboats in order to harvest their beds more efficiently, Greenwich oystermen continued to work from sailboats or even dories. In 1900 the town claimed only five of the ninety-four oyster steamers registered in Connecticut.[20] The sail-powered oyster boats that made the Greenwich shoreline so appealing to artists like Hassam were a symptom of economic malaise.

An American Subject

In depicting the decaying commercial boating of Cos Cob, the artists consciously chose an American subject. Robinson's awareness of the significance of the theme was demonstrated by his gift of "a Coscob shipyard, 18 x 22" to critic Hamlin Garland on New Year's Day 1896. Garland had personally urged Robinson to remain in the United States and explore American subject matter—a course of action the influential critic advanced publicly in his lectures and articles. In a frequently quoted passage from his essay on Impressionism, Garland wrote: "I have just come in from a bee-hunt over Wisconsin hills, amid splendors which would make Monet seem low-keyed. One school cannot copy or be based upon the other without loss. Each painter should paint his own surroundings, with nature for his teacher. . . . [It is] my settled conviction that art, to be vital, must be local in its subject."[21] Robinson would naturally have given Garland a canvas that met the critic's nationalist criterion, so he must have recognized that his picture of the rustic boatyard was infused with the spirit of place.

In their devotion to Cos Cob's traditional maritime landscape, Robinson, Hassam, Twachtman, and other art colonists shared a cultural attitude that was also expressed in the local-color literature of the second half of the nineteenth century. Harriet Beecher Stowe's *Pearl of Orr's Island* (1862), Celia Thaxter's *Among the Isles of Shoals* (1873), and Sarah Orne Jewett's stories of New England coastal life have an elegiac tone, as if preserving folkways threatened with extinction. All of them portray the Yankee waterman as a hero. In Jewett's story "A Bit of Shore Life" (1879), "the good-natured fishermen . . . waited for the wind to change, and waited for the tide to turn, and waited for

the fish to bite, and were always ready to gossip about the weather, and the fish, and the wonderful events that had befallen them and their friends."[22] According to this description, which is typical of the genre, the fishermen are independent and work according to natural rhythms. In their freedom and lack of pretension, they embody qualities accepted as essentially American.

The literary waterman is usually an old salt, his age a sign of tradition and imminent death. One of the central characters in *The Pearl of Orr's Island* is "an old man, with the peculiarly hard but expressive physiognomy which characterizes the seafaring population of the New England shores. [He has] a clear blue eye, evidently practised in habits of keen observation, white hair, bronzed, weather-beaten cheeks, and a face deeply lined with the furrows of shrewd thought and anxious care."[23]

The heroicizing of the Yankee sailor extended to the Greenwich press, which in 1903 published a front-page account of a day on an oyster dredger.[24] The captain is identified with the natural world: "His eyes have caught the color of the water on a bright day, and his nature has partaken of the expansiveness of the limitless deep on which he spends his life." His arcane, highly specialized knowledge can mean life or death: "If there is a storm coming (and he always knows whether there is or not) he knows where there is a safe harbor. . . . A sailboat miles off across the water, which to an inexperienced eye is merely a gray spot against the sky, tells him many things. He knows in some mysterious way 'by the cut of her jib' whether she is coming or going, whether empty or freighted with shells."

That attitude toward the Yankee boatman is embedded in writing by members of the art colony. One article mentions an elderly Cos Cob oysterman "who is called 'the sage' because he knows so much."[25] Another describes "the old sea-dogs" who hang around the ship-yard watching the artists and offering "the sort of criticism that makes one blink a bit—just as a shower of sea spray might."[26] Steffens, who was an enthusiastic but inept sailor, once ran aground with a friend and sat perplexed until the rising tide set them free. When they came ashore, Steffens wrote, "an oysterman who had seen our distress said quietly to us, 'When you get stuck in the mud that-a way all you got to do is raise your centerboard a minute or so.'"[27] The

oysterman in Steffens's anecdote conforms to the literary stereotype: he knows a lot but says little, and when he does speak, his English is quaintly substandard.

These qualities are amplified in a children's book written and illustrated by art colonist E. Boyd Smith. In *The Seashore Book* (1912), the retired sailor Captain Ben Hawes introduces the vacationing young New Yorkers Betty and Bob to the lore of the New England coast. "Bluff and hearty, and with no end of sea yarns. . . , he was more interesting to the children than the most fascinating book." In the illustrations, class distinctions are vividly apparent. Captain Hawes's age, sagacity, and Yankee lineage mute the social discrepancy between him and his young charges, but a gaping chasm divides the well-bred city siblings and the local boy, Patsey Quinn, whose Irish name and rough clothing signify that he is the social inferior of the unmistakably upper-class Betty and Bob. Even Patsey's shaggy mutt appears scruffy beside Betty and Bob's sleek terrier (fig. 49). But Patsey, whom Captain Hawes calls "a little water-rat," far excels the urban youngsters in

49

E. Boyd Smith, "Digging Clams." Illustration in E. Boyd Smith, *The Seashore Book* (1912; reprint, Boston: Houghton Mifflin, 1985), p. 17.

knowledge of coastal life. He "knew just where the best clams and mussels were to be found, and where the crabs lived, and how to catch them." He taught Betty and Bob to fish, "though they never got to be as good fishermen as he was," and tried to teach them to swim, but they managed only "to keep their heads above water."[28]

The social distinctions that underlie *The Seashore Book*—the differences between country folk and city folk, New Englanders and New Yorkers, immigrants and natives—are the same that pervaded the art colonists' relations with the Cos Cob villagers. In Smith's book, even the shoreline locals' expertise is subtly undermined, when Captain Hawes and the children join a crowd of townsfolk to watch a newly launched three-masted ship set sail for China: "With all sails set she was a beautiful sight; a gentle land breeze filled her sails, and slowly and gracefully she drew away, headed for the open sea. . . . Captain Hawes, with a sigh, told the children that probably that was the last square-rigged ship they were likely to see leaving this port, as the old-style ship was now almost a thing of the past."[29] The festive event revealed the specialized knowledge of shipbuilders and sailors to be as antiquated as the two white-bearded old skippers who, in the illustration, watch the great ship sail away. Whether in Smith's fictional Quohaug or in his real home, Cos Cob, working sailboats—and those who built, sailed, and repaired them—were at once picturesque and passé.

Leisure Boating

While occupational boating represented the fast-fading past of coastal communities like Cos Cob, organized leisure boating represented the future. Recreational boating was not new to the Greenwich area; it had long been a diversion for the town's established residents. The first yacht race on Long Island Sound was a contest between two packet boats, the *Stella* out of Cos Cob and the *Abeel* out of Huntington, Long Island.[30] Oystermen, too, sometimes raced on weekends, and farmers borrowed boats for Sunday picnics. Summer visitors enthusiastically participated in the sport, using boats provided by their hotels or renting them at one of the docks around town.[31] As summer visitors became year-round residents, leisure vessels proliferated. Leonard Ochtman, who

settled in Cos Cob partly to indulge his passion for boating, captured the pleasure of having a sailboat anchored just a few steps from home in his painting *On the Mianus River* (fig. 50).

It was the establishment of yacht clubs, however, and the resulting organization of a sport that had long been enjoyed casually, that produced the most dramatic changes in the landscape. For the artists and writers who gathered at the Holley House, modern leisure was represented by the Riverside Yacht Club, situated on the opposite bank of the Mianus near its confluence with Long Island Sound (see the map on page 8). The stylish clubhouse became a popular destination for an evening row or a Sunday drive. "A wonderful morning—misty and bright sunlight," Robinson noted in his diary on July 1, 1894. "We drove to the Riverside Yacht Club. Yachts with sails up, brilliant, beautiful."

The club, established in 1888, opened its first clubhouse the following year. In the autumn of 1893, the clubhouse was expanded with the addition of a circular tower that became a landmark for sailors (fig. 51).[32] The yacht club's rapid growth attests to the changing local pop-

Leonard Ochtman, *On the Mianus River*, 1896, oil on canvas, 16 x 22 in. Bruce Museum, Greenwich, Conn., 83.08.02.

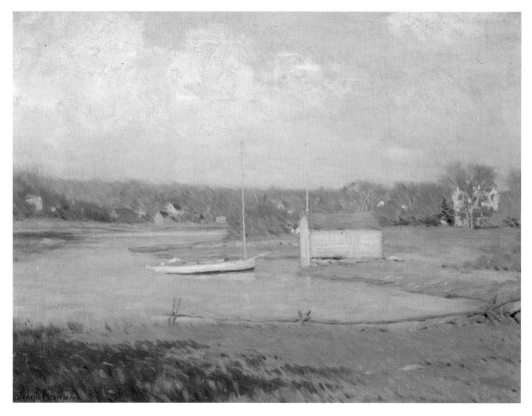

50

ulation. From 40 members with 10 boats in 1889, the club swelled
to 196 members with 67 boats in 1894.[33] Most of the members, including
art collector H. O. Havemeyer, were New Yorkers who lived in Green-
wich only during the summer. Membership in the Riverside Yacht Club
was beyond the means of most artists. In 1894, when Robinson's
total income was $1,080, the club's initiation fee was $25 and annual dues
were $15.[34] The club's expense and predominantly out-of-town
membership might have made it an object of disdain by the art colony
but for two factors: the accessibility of inexpensive leisure boating
and the artists' ties to some club members. Edward and Josephine Hol-
ley's son, Edward L. Holley, was a member, and his sister, Constant,
participated in club activities.[35] The father of D. Putnam Brinley, who
studied under Twachtman at the Art Students League, was also a
member. Steffens, who protested so vehemently the invasion of the "suc-
cessful New Yorkers" into the art colony's territory, not only joined
the yacht club but also bought the house next door. Evidence of the club's
cosmopolitanism that must have appealed to the artists was the

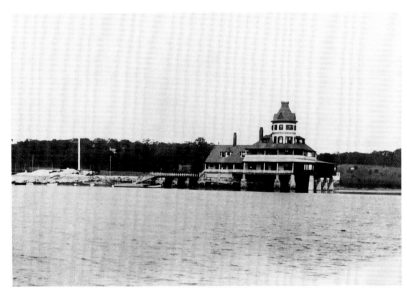

51

Riverside Yacht Club, 1913, photograph. This building was
demolished in 1928 and replaced by the present clubhouse.
Archives, Riverside Yacht Club, Riverside, Conn.

admission of two new members in 1894: Rioichiro Arai and Yasukata Murai, prosperous Japanese silk merchants who had built impressive Shingle-style houses near the club the previous year. The Japanese families, who lived just across the railroad bridge from Cos Cob, became friends of Constant Holley's.[36]

In the summer of 1894, Robinson produced a series of oils depicting the yacht club: *Low Tide* (fig. 52); *The Anchorage, Cos Cob* (fig. 53); *Low Tide, Riverside Yacht Club* (fig. 54); and *Yacht Club Basin* (fig. 55). All of them show the turreted clubhouse in the left background, another large building at the right, and numerous sloops and cat-boats in the middle ground and distance.[37] The artist was, for the most part, faithful to the material facts, including even the boulder to the left of the clubhouse where children basked after a swim. The wood shingles of the new tower—completed barely six months earlier— have not yet weathered to a silvery gray; they glow, fresh and golden, in the sunlight. Robinson portrayed the red-brick building to the right more sketchily than the clubhouse, balancing it without distracting from it. In his hands, the structure appears to be a fine residence or another yacht club, when in fact it was a factory that had stood empty for twenty-four years. It had housed the Continental Mower and Reaper Company from 1865 to 1867 and a cottonseed-oil plant from 1867 to 1870, when the business failed and the building was abandoned.[38] To Robinson's contemporaries, the derelict factory symbolized the community's gentrification. An article published in 1891 recalled that New Yorker George I. Tyson had bought the thirty-odd acres surrounding the industrial site, built his own handsome summer residence, laid a road, sold off lots for homes, and established the Riverside Yacht Club. As a result, the reporter exulted, "today that portion of Riverside that twenty years ago was designed for factory purposes is one of the most attractive residence portions of this town."[39] In each of his oils, Robinson endowed the abandoned factory with a spurious vitality by depicting smoke emerging from its chimney. He went furthest in *Low Tide, Riverside Yacht Club*, giving the smoke the same form as the burgee flying from the club's new tower.

Although Robinson's four paintings share a subject, they differ in tidal condition, light effects, palette, format, and design. Change is built into his investigation of the theme. Only one of the series, the

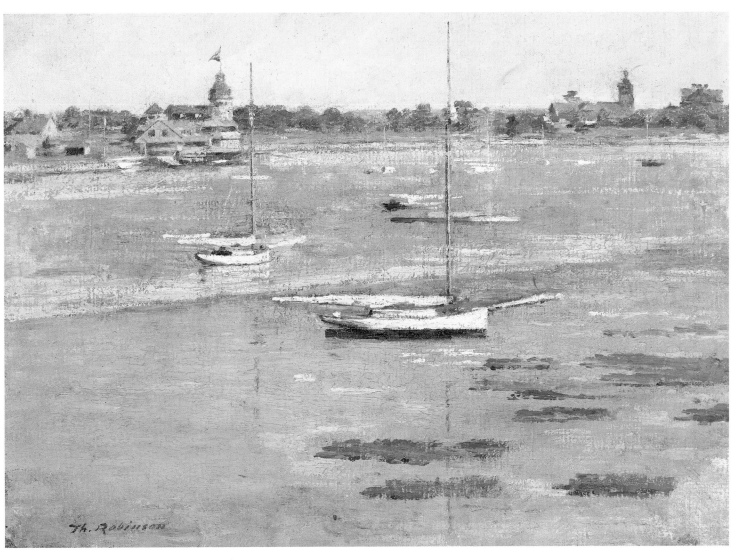

Theodore Robinson, *Low Tide*, 1894, oil on canvas, 16 x 22 ¼ in. Manoogian Collection.

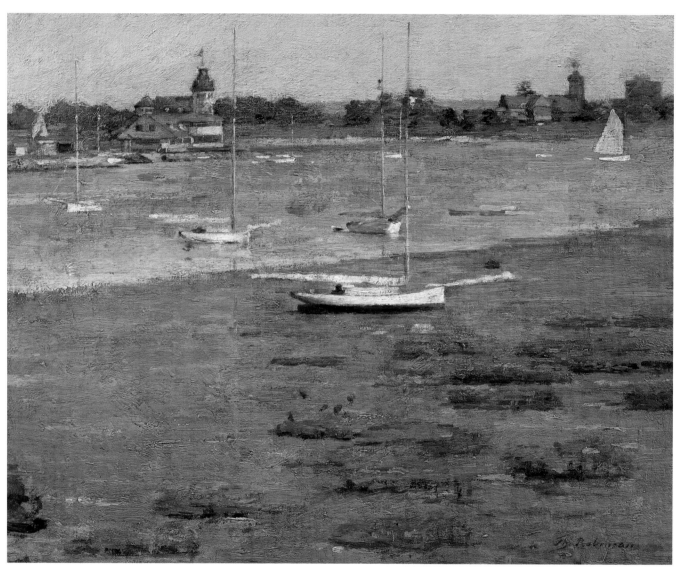

Theodore Robinson, *The Anchorage, Cos Cob*,
1894, oil on canvas, 18 x 22 in. Courtesy of Marie and
Hugh Halff.

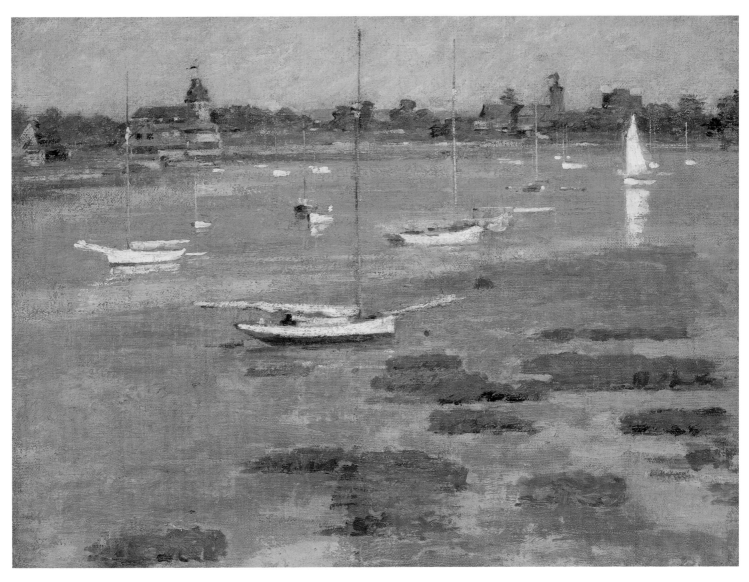

Theodore Robinson, *Low Tide, Riverside Yacht Club*,
1894, oil on canvas, 18 x 24 in. Collection of Margaret and
Raymond Horowitz.

small panel *Yacht Club Basin*, depicts the river at high tide—a phase that conveys fullness and completion. In the other paintings, Robinson focused his attention on the subtle, fleeting transitions of low tide. The river is at its ebb in *Low Tide, Riverside Yacht Club*, leaving the exposed land almost too dry to reflect the mast of the sailboat in the foreground. The tide seems to have turned in *The Anchorage, Cos Cob*, saturating the river bottom with puddles that reflect the blue sky. *Low Tide* captures a slightly later stage—the yacht in the foreground will soon be lifted on the rising water. Robinson, attentive to nuances of environmental conditions, created a sequence tracing a natural cycle of change.

Like the changing tide, the varied light effects in the three canvases also convey the passage of time. Robinson's diary notations reveal that, from his vantage point on the pedestrian walkway of the railroad bridge, he worked on the yacht club paintings in the afternoon, when the western sun spotlighted the river's eastern shore. "P.M. from R.R.

Theodore Robinson, *Yacht Club Basin*, 1894, oil on board, 10¹/₂ x 13¹/₄ in. Private collection, photograph courtesy of R. H. Love Galleries, Chicago, Ill.

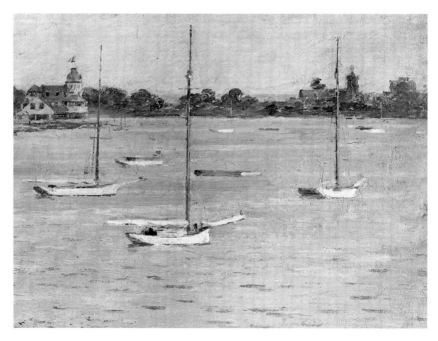

55

Bridge," the artist wrote on June 12, 1894; "the little yachts at anchor—a lovely hazy day—sun peeping through at 3 or 4." One week later, he noted his pleasure in the subject later in the day, finding it "particularly brilliant at about 5 P.M." By June 23, he was working later still, finding the view "charming in effect—especially at 6:30—richer and fuller in color than before." Although he probably worked on the three paintings simultaneously, shifting from one to the other as the light changed, Robinson's canvases correspond roughly to the light effects he recorded in his diary. The blonde palette of *Low Tide* suggests the strong sunlight of early afternoon, which bleaches color from the landscape. *Low Tide, Riverside Yacht Club* captures the hour when afternoon turns toward evening, intensifying colors and producing stronger contrasts of light and shade. *The Anchorage, Cos Cob* probably resulted from Robinson's work about 6:30, when the sinking sun tinted the wet mud with violet, mauve, salmon, pink, and warm gray.

 Robinson's exploration of the changing effects of light reflects the influence of Monet, who had begun his great series paintings during the years that Robinson lived in Giverny. While Monet was engaged with his grainstacks series of 1890–91, Robinson painted two explorations of the same theme.[40] Just as Monet had done for his paintings of grainstacks, Robinson selected canvases of slightly different sizes and proportions for his yacht club paintings. The differences among Robinson's canvases seem, at first, inconsequential. All three are horizontal rectangles, and they differ by only about two inches in either dimension. Those variations produce subtly different effects, however. *Low Tide*, at 16 x 22¼ inches, is the most insistently oblong of the group—the elongated proportions generally reserved for marine paintings.[41] That emphasis on length, coupled with the pale tonality and the sparse scattering of sailboats, conveys spaciousness and expansiveness. For *The Anchorage, Cos Cob*, Robinson selected a canvas just two inches taller than the one he used for *Low Tide*, but the added height makes the proportions nearly square. The squarish format draws attention to the surface of the canvas in a proto-modernist manner, an effect that Robinson reinforced by devoting the additional space to the pattern of seaweed-covered rocks in the foreground.[42] He mitigated any potential blockiness by adding a sailboat moving out of the picture on the right, thus directing attention along a horizontal axis.

In addition to experimenting with canvas sizes and proportions, Robinson made significant adjustments to his compositions. On close analysis, all of them reveal a strong geometric underpinning, with each canvas divided horizontally and vertically into three sections. The horizontal divisions correspond to a foreground strip of land, a central expanse of water, and an upper portion composed of the opposite shore, a band of trees offering glimpses of Long Island Sound, and the sky. The vertical segments, most obvious in *Low Tide*, are formed by the masts of two sailboats and their reflections. The grid-like design, which is offset by the diagonals of the river's edge and the pattern of mossy rocks, may have aided Robinson as he shifted from one canvas to another, perhaps making additions based on drawings in his pocket-sized sketchbook (fig. 56). In *Low Tide, Riverside Yacht Club*, masts play across the canvas like musical notes, increasing the sense of depth as the height and thickness of each mast indicates its distance from the viewer. On the three nearest boats, a break in the brushstroke or a dab of white paint suggests that Robinson first depicted the masts accurately and later heightened them. Had he left them at their original height, they would have stopped just short of the horizon. Extending them, he linked water, earth, and sky. The central mast and its faint reflection in the moist river bottom nearly bisects the canvas —a bold strategy undoubtedly inspired by Japanese prints. In a landscape print once in Weir's collection (fig. 57), Hiroshige employed a tree just as Robinson used the central mast in *Low Tide, Riverside Yacht Club*.

Robinson never recorded using a camera in Cos Cob, probably because he reserved it for figural works. However, he employed a photographic effect in *Low Tide, Riverside Yacht Club*, indicating motion by blurring forms. The reworked area surrounding the sail on the right suggests that he originally intended to show it in profile. Instead, he depicted it obliquely. The reduced area of white prevents the sail from upsetting the sensitively balanced design, while the ghostly halo creates a blur that suggests movement.

The differences among the yacht club paintings are subtle, but their contrast with Robinson's depictions of work boats is dramatic. *The E. M. J. Betty* and *Coal Schooner Unloading* (see figs. 38 and 39) are characterized by compressed space, muted colors, and stunted masts,

56

Theodore Robinson, *Low Tide under R. R. Bridge,*
P.M., 1894, sketchbook page, 4 x 6 ¹/₂ in. Terra Museum of
American Art, Chicago, Ill.

57

Ando Hiroshige, *Musa*, ca. 1838, color woodblock
print, 8 ⁵/₈ x 13 ⁷/₈ in., from *Sixty-Nine Stations of the Kisokaido.*
Courtesy of Charles Burlingham, Jr.

whereas the yacht club oils are notable for expansive vistas, high-keyed palettes, and unrealistically tall masts. In his compositional strategies, Robinson differentiated between the melancholy provoked by the passing of old ways and the exhilaration inspired by scenes of modern leisure.

Robinson's new daring is evident in another painting of Cos Cob's pleasure craft (see fig. 26). In *Boats at a Landing*, Robinson adapted the flattened shapes, layered space, and concern with pattern evident in Japanese prints to create a nearly abstract composition.[43] He divided the canvas into horizontal bands, alternating land (or its extension, a landing) and water, and accented those divisions by strong contrasts of blue and yellow. The horizontals are underlined by the booms and painted stripes on three of the boats, and countered by the vertical masts. The rectilinear grid is softened by a curving diagonal that begins with the shoreline in the lower right corner and swings to the upper left in the delicate arc of the rigging. The oval forms of two boats and the crescent of another repeat the curves. The high horizon line flattens the canvas, compelling attention to the strong asymmetrical design. The dramatic stacking of space could have resulted from either Robinson's study of Japanese art or his viewing the subject through binoculars, a telescope, or the lens of a camera. In *Boats at a Landing*, Robinson adapted strategies from photography and ukiyo-e prints to depict a subject that is modern in both subject and execution.

Twachtman's *Sailing in the Mist* (fig. 58) is modernist in its formal qualities: square canvas, expressive brushwork, and near abstraction. The apparent modernity of its subject matter—a female figure sailing a small boat—is misleading, however. Instead of celebrating contemporary leisure as Robinson and, before him, Monet had done, Twachtman used the boating theme to express ideas and emotions, as did the Romantics and Symbolists. The ancient metaphor of life as a voyage from birth to death had been employed by the American painter Thomas Cole in *The Voyage of Life* (fig. 59). Unlike Cole, Twachtman stripped the theme of religious connotations and narrative elements. Distilling the subject to its essentials, he retained only a solitary sailor moving into a mysterious void. For Twachtman, *Sailing in the Mist* held profoundly personal meaning; he called the work *Elsie Sailing* because he had painted it after his eight-year-old daughter, Elsie, died of scarlet fever in January 1895.[44] Whereas *Sailing in the*

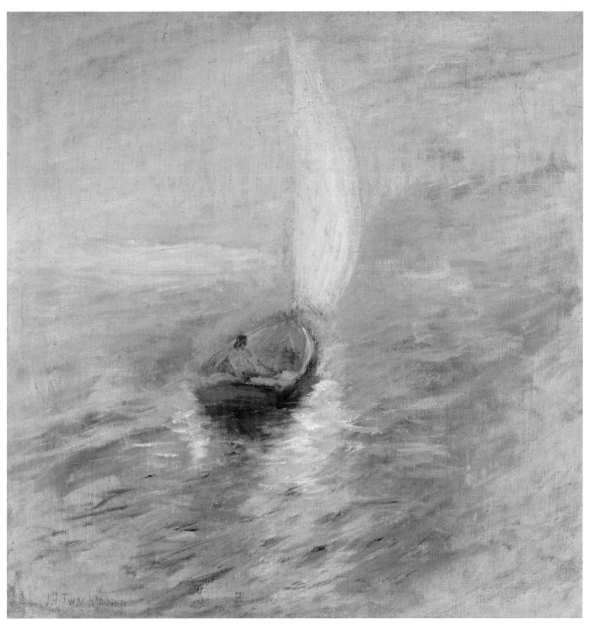

58

John H. Twachtman, *Sailing in the Mist*, ca. 1895,
oil on canvas, 30$^1/_2$ x 30$^1/_2$ in. Courtesy of the Pennsylvania
Academy of the Fine Arts, Philadelphia. Joseph E.
Temple Fund.

Mist was the artist's expression of grief, its emotional power transcends the circumstances of its creation.

For the Impressionists of Cos Cob, the nautical landscape was a rich mine of raw material, which they quarried, shaped, and polished to produce varied effects. Recreational boating, which was new to communities along Long Island Sound, inspired Robinson and Twachtman to produce pictures as modern as any they ever painted. Occupational boating, the traditional fishing and cargo boats that had long been essential components of the shore landscape, engaged Robinson, Twachtman, Hassam, and others in the effort to preserve on their canvases a way of life whose passing they witnessed with regret.

Thomas Cole, *The Voyage of Life: Old Age*, 1840, oil on canvas, 51³/₄ x 78¹/₄ in. Munson-Williams-Proctor Institute, Museum of Art, Utica, New York.

59

3 | Images of Cos Cob's Architecture

Architecture was such an important theme for the artists who gathered at the Holley House that Childe Hassam dubbed them the "Cos Cob Clapboard School."[1] That nickname implicitly acknowledged the art colony as a coherent group while distinguishing it from such earlier movements as the mid-nineteenth-century Barbizon School, whose adherents had fled Paris to paint in and around the forest of Fontainebleau. During their student years in Europe, most of the artists who would later paint in Cos Cob had also left the cities in search of scenic landscape. Why, then, did such urbane artists as Hassam, Twachtman, and their friends establish themselves in a densely built, rundown Connecticut village instead of seeking the American equivalent of Fontainebleau? What did they find so compelling about the clustered frame buildings of Cos Cob?

No single answer suffices. Instead, a combination of factors explains the strong attraction of the built environment of that waterfront village. First among those reasons is the age of the buildings. Many of them dated from before the American Revolution. Antiquity alone did not account for their appeal; rather, it was the continuity of the past into the present that engaged the artists' attention. In venerating not just the age but, more important, the endurance of those buildings—and, by extension, of the heritage they represented—the Cos Cob Clapboard School avoided the sentimentality of nostalgia, with its regret for an already extinct past.

Closely connected to age and endurance is the distinctly American quality that the artists perceived in the ramshackle warehouses, modest cottages, and old-fashioned country stores of Cos Cob. Those unassuming buildings lacked the cosmopolitan grandeur of the great estates then being constructed in other parts of Greenwich. But while stylish architects were designing new mansions redolent of the European past, the art colonists were discovering a genuine, indigenous tradition in the vernacular structures still in use along the Lower Landing.

Finally, the art colonists used the theme of architecture to depict not merely individual buildings but also a form of settlement—the rural village—that they recognized as endangered. With the suburbanization of communities surrounding New York City, the hamlets that had once served local farmers and tradesmen were being replaced by larger, more fashionable shopping districts. Cos Cob survived longer than most such enclaves, largely because the art colony provided a fresh source of income as the numbers of farmers and fishermen declined. In fact, newly arrived immigrants established three small enterprises—the tavern, the Chinese laundry, and the newsstand—to capitalize on the artist clientele. Housed within existing buildings, however, those new businesses sustained the traditional village atmosphere. The harmony between the built and the natural environment was crucial to that atmosphere. The village—softened by trees, shrubs, and flowers and enlivened by the glint of sunlight on the tidal inlet—offered urban artists access to nature.

Hassam's etching *Old Lace* (see fig. 19) summarizes the elements he found so attractive about Cos Cob. Nature provides the context for the image, but it is nature brought under human control: the brook rushes over a small dam, trees and shrubs shade the clustered buildings. Community is implied in the closely set houses and barns, the scarcely discernible figures chatting from opposite sides of the bridge, the rowboats ready for an afternoon's recreation. Continuity, rather than mere antiquity, is conveyed by the obvious fact that these old buildings are still in active use. The barn doors stand open, allowing light to penetrate the shadowy interiors; the houses are attractive and well maintained. Hassam's title conveys his appreciation of the past, yet he could accept and admire modern elements within the long-established

village. The iron-lattice bridge that is such a prominent feature of *Old Lace*, for example, was new; the earlier bridge (documented in photographs and depicted by Hassam and others) had been constructed of solid wooden panels. The neighborhood where artists gathered for decades offered connections to the past, to nature, and to a diverse human community.

For the artists, the village was workplace as well as subject. As they sketched, children played nearby and passersby paused to evaluate their progress. Although few of their architectural images include figures, the artists suggested that human presence through their viewpoints and compositions. In their paintings, drawings, and etchings, the Cos Cob Clapboard School created a composite portrait of a rural, maritime New England village.

Perhaps the most distinctive New England architectural form is the wood-framed, white-painted, tall-steepled church that, in numerous variations, towers over communities from Connecticut to Maine. Hassam's paintings of the elm-shaded meetinghouses of Provincetown, Gloucester, Newport, Old Lyme, and Portsmouth are iconic images. Surprisingly, however, churches are virtually absent in the paintings he and his colleagues produced in Greenwich.[2] The reason stemmed from the town's prosperity and rapid growth, which meant that as congregations outgrew their original meetinghouses, they could afford to build new ones. The four places of worship closest to the Holley House were all erected in the second half of the nineteenth century —too recently to kindle the imagination of the Cos Cob Impressionists. Furthermore, to ensure against fire, which had destroyed several older churches in the vicinity, all the new ones were built of stone instead of wood, the material associated with New England. Older white frame churches stood in backcountry Greenwich, but members of the Cos Cob Clapboard School seldom strayed far from the Holley House.

A Historic Building

Hassam ventured one mile from the boardinghouse—his farthest, except for visits to the Twachtman family—to produce *Sunlight on an Old House, Putnam Cottage*, dated 1897 (fig. 60).[3] A tall tree bisects the composition, partly obscuring the old house over which it throws a leafy

105

canopy. Hassam's unexpected viewpoint, his bold cropping of the façade, and his obvious fascination with the patterns of dappled sunlight might suggest that the subject matter was incidental to him. But the artist's keen interest in colonial architecture—dating back to his boyhood in Dorchester, Massachusetts—coupled with his uncharacteristic choice of a subject beyond the immediate neighborhood compels attention to the particulars of his thematic choice.

Putnam Cottage, known during the colonial period as Knapp's Tavern, was linked with a famous episode of the Revolutionary War. According to local tradition, General Israel Putnam had been staying at the tavern when, warned of the advance of British troops, the sixty-year-old soldier leaped on his horse and galloped down a nearby hill so steep the redcoats were afraid to follow him. At the foot of

Childe Hassam, *Sunlight on an Old House, Putnam Cottage*, 1897, oil on canvas, 24 x 20 in. Private collection, photograph courtesy of Hirschl & Adler Galleries, Inc.

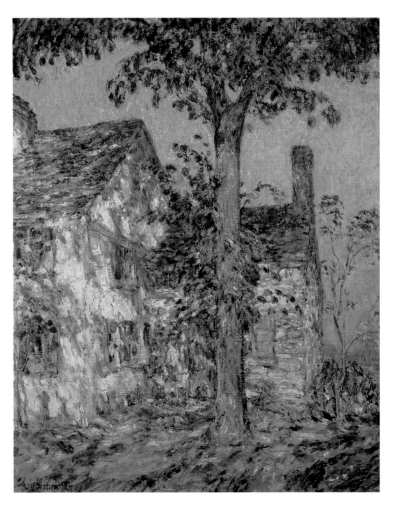

the precipice, the crusty Yankee turned in his saddle and shouted "damn ye" at the enemy firing at him from above.[4] Putnam's exploit was celebrated in New England folklore, especially in Greenwich, where Main Street was renamed Putnam Avenue in 1879 to celebrate the centennial of the storied ride. By that time, the landmark site had long been called Put's Hill.

For Hassam and the other art colonists, Putnam Cottage had the added appeal of a romantic, if farfetched, association with the Holley House. Legend held that the night before his escape from the British, the twice-widowed general had escorted to a ball the fifteen-year-old daughter of David Bush, then the owner of what is known today as the Bush-Holley House. It was said that they stayed so late at the party that Putnam did not return to his headquarters until nearly dawn. Although the story was probably untrue, the artists surely believed it. A review of one of MacRae's exhibitions described the Holley House as "the ancient . . . manse, where Gen. Israel Putnam went a-courting a century and a half ago."[5]

Hassam's interest in Putnam Cottage was not mere nostalgia, however, but an indication of his attentiveness to contemporary political issues. In 1897, when Hassam painted *Sunlight on an Old House*, the Putnam legend was at the heart of an emotional controversy. Beginning that June, the local papers carried editorials and letters opposing a proposed driveway whose construction would eliminate public access to Put's Hill, about a quarter mile from Putnam Cottage. Townsfolk crowded meetings on the issue, defending their right to continued access to the site. The Greenwich chapter of the Daughters of the American Revolution (DAR)—appropriately named the Putnam Hill Chapter —was established to fight the threatened privatization of the landmark, to preserve public access to it, and to mark it with a suitable monument. With this deceptively placid painting, then, Hassam entered a heated debate about private property rights versus public heritage.

The controversy was still boiling in 1899, when Hassam painted his second view of Putnam Cottage, entitled *Indian Summer in Colonial Days* (fig. 61). For this painting, as for his first on the theme, Hassam avoided the building's main facade. In the 1897 oil, he had focused on a stone annex; in 1899 he depicted the back of the house. Both viewpoints enabled him to ignore the wide porch and shuttered double

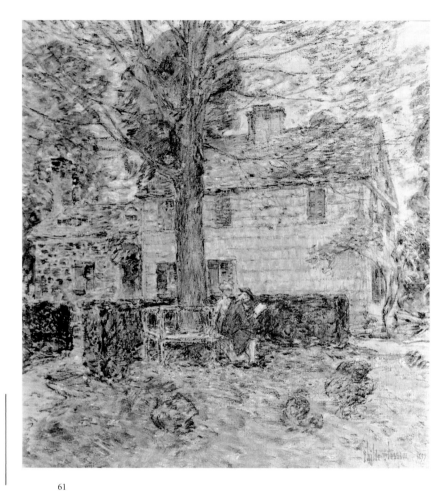

61

Childe Hassam, *Indian Summer in Colonial Days*, 1899, oil on canvas mounted on board, 22 x 20 in. Private collection, photograph courtesy of David Findlay, Jr. Inc., New York.

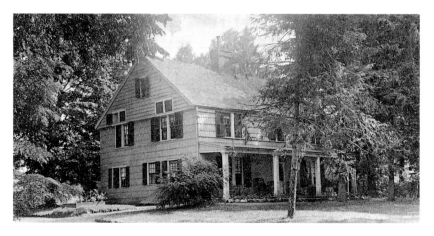

62

Postcard of Putnam Cottage, postmarked 1905. Historical Society of the Town of Greenwich.

windows that made the front of the house look Victorian (fig. 62). By carefully choosing his viewpoints—even focusing on a later addition—Hassam emphasized the building's age. The eighteenth-century costumes in *Indian Summer* seem to undermine the sense of continuity that permeates Hassam's architectural images. His decision to include them was probably motivated by his plan to exhibit the painting at the *Second Exhibition and Competition of Colonial Pictures under the Auspices of the Colonial Dames of Massachusetts* at the Boston Art Club in December 1899. Hassam won second prize of $150 in the exhibition and mention in the *Boston Evening Transcript*.[6] Although the costumed figures may have been a marketing device, they also support a political reading. Putnam Cottage was still privately owned in 1899 (the DAR would not acquire it until 1902), but Hassam claimed it for the common heritage by portraying the figures in costumes of the Revolutionary period. Instead of including soldiers, or even General Putnam, he depicted suave colonials relaxing under a tree—counterparts of the genteel New Englanders who were contesting access to Put's Hill in Hassam's day.

The house's actual residents at the time may have been Hassam's close friends John and Martha Twachtman. The *Greenwich Graphic* reported on December 9, 1899, that "Mr. and Mrs. John Twachtman are now occupying the Putnam Cottage, on Putnam avenue, having removed from their home on the Round Hill road for the winter." The Twachtmans' move, apparently prompted by financial hardship, was the first of many they would make over the next three years. If they were living at Putnam Cottage by the time Hassam painted *Indian Summer*, their presence would have intensified the subject's appeal to the artist.

Old Houses

Putnam Cottage was the only Greenwich building depicted by any of the art colonists that claimed a connection to a significant historic event. It was also the only building (other than those on or near Twachtman's place) that was more than a stone's throw from the Holley House. Not surprisingly, the boardinghouse itself was a popular motif. Hassam depicted it no fewer than seventeen times, and Twachtman, Ebert, and MacRae also favored it as a subject. Apart from their affection for

their home away from home, the artists were attracted by its antiquity; many of their titles include its alternate name, the Old House. That designation, which was used on the boardinghouse letterhead, extended the building's significance from the particular to the paradigmatic: the Holley House became the quintessential American old house.

In fact, the house was not as old as the artists believed it to be. Recent research puts construction of its oldest part at no earlier than 1732—several decades later than was once thought.[7] "Holly house built in 1664 they say," Theodore Robinson noted appreciatively in his diary in June 1894. A summer student described the house as "over two hundred years old," while the *Greenwich Graphic*, calling it "probably the oldest building in town," dated it to about 1650. Although the artists and their contemporaries were unsure of the exact age of the Old House, they revered it as a survivor from the past. That quality was emphasized by the *Graphic* reporter, who described the action of time and nature on "the big cedar shingles and siding." They are "grooved by the rains and snow," he wrote; "they are . . . faded by the sun; they are moss grown and worm eaten, but they stay; they are staunch and true, and the big, iron hand wrought nails, rusty and old, still hold them in place."[8]

An impression of steadfast endurance permeates Twachtman's *Old Holley House, Cos Cob* (fig. 63). Twachtman honored the past in a boldly modern composition. He chose a viewpoint that emphasized the structure's age by revealing its saltbox construction, then reduced the traditional architecture to a set of cubes, rectangles, and triangles. Cropping the two-story front porches that were nineteenth-century additions, he extended the building's solid geometry from edge to edge of the canvas. The square format reinforces the sense of equilibrium conveyed by the calm blue-violet palette, which unites the house with earth and sky. The slender sapling in the right foreground is a metaphor of youth in contrast with the aged building, whose arboreal emblem might be the evergreen that cushions its strong horizontals. Snow suggests the winter of life, the end of a cycle. For Twachtman, the old house inspired introspection on time and change.

Hassam, by contrast, stressed the social aspect of the house in a sunny watercolor (fig. 64). Although no figures are included, the human presence is unmistakable in this image, which supports the statement by the artist's contemporary, antiquarian Wallace Nutting, that

"an old back door has more of humanity in it than any other part of the homestead." Nutting maintained that "the back doors of old houses are more interesting than the front doors," because the churns, baskets, herbs, vines, and trees usually found there lend a simple, utilitarian charm to the family entrance.[9] Hassam affectionately documented the copper porch roof, trellised grapevine, and domestic clutter around the kitchen door of the Holley House. In his hands, the back view conveys a sense of familiarity and hominess.

The front view, however, was the building's public face. In *The Holly Farm* (fig. 65), Hassam used pastel to capture the sunlight and shadow flickering over the façade.[10] Allowing the exposed paper to suggest the warm tones of the dirt path, stone walls, and interstices of shrubbery, he employed a predominantly blue palette to convey the inviting shade of the old house and garden. Hassam portrayed the house among trees and shrubs even then considered old-fashioned. Lilacs, traditional companions to old farmhouses, billow atop the low stone wall, while a graceful elm shades the north side. The combination of old house and elm tree was a potent metaphor of the American past. A contemporary of Hassam praised the elm as a tree "of the people," distinctly American, long-lived, sturdy, refined, and "classic"—qualities highly valued during the Colonial Revival. New England was especially famous for its elms, "which, loved and cared for, arch over the long village streets that give character to the homes of the descendants of the Puritan fathers." The general affection for the American elm was intensified at the time of Hassam's painting because of the devastation wrought by the elm-leaf beetle, almost invariably described as an "imported" pest—language that projected the anxiety over immigration onto the plant world. The *Scientific American* reported in 1896 that in Connecticut, "the ravages of these insects have caused widespread regret . . . over the destruction of hundreds of noble elm trees."[11]

The Holleys' prized elm is prominent in an oil by Elmer MacRae depicting two women (probably his wife and mother-in-law) sewing on the upper porch of the boardinghouse (fig. 66). The lilacs, here in full bloom, brush the railing; a vine climbing along the roofline literally ties the house to its natural setting. Besides documenting the harmony between the house and nature, MacRae also revealed its social context by including two neighboring buildings: the roof and chim-

111

63

John H. Twachtman, *Old Holley House, Cos Cob*,
ca. 1890–1900, oil on canvas, 25 $\frac{1}{16}$ x 25 $\frac{1}{8}$ in.
Cincinnati Art Museum, Cincinnati, Ohio, John
J. Emery Fund.

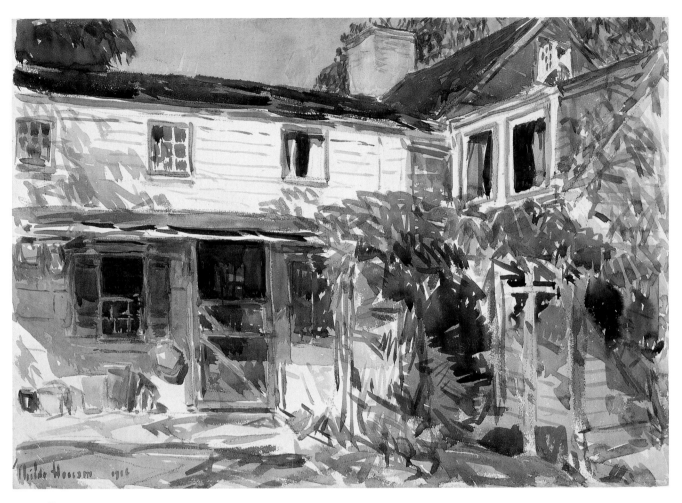

64

Childe Hassam, *Back of the Old House*, 1916,
watercolor over sketch in brown chalk, 15 $^1/_8$ x 21 $^3/_4$ in.
Yale University Art Gallery, New Haven, Conn.
Gift of George Hopper Fitch, B.A. 1932, and Mrs. Fitch.

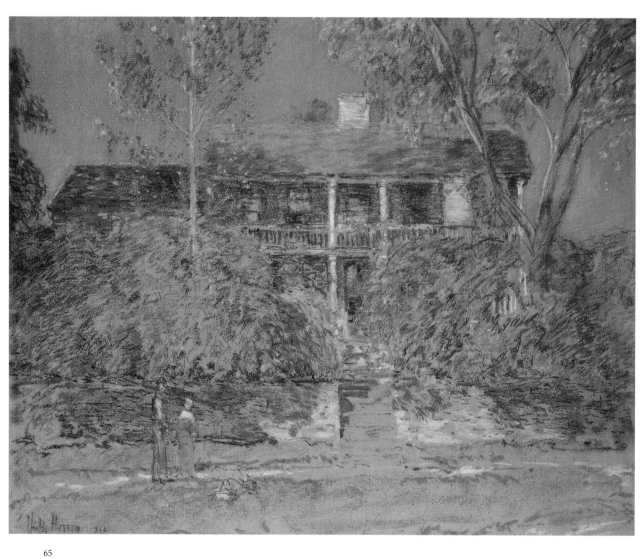

65

Childe Hassam, *The Holly Farm*, 1902, pastel on paper, 18 x 22 in. Diplomatic Reception Rooms, United States Department of State, Washington, D.C.

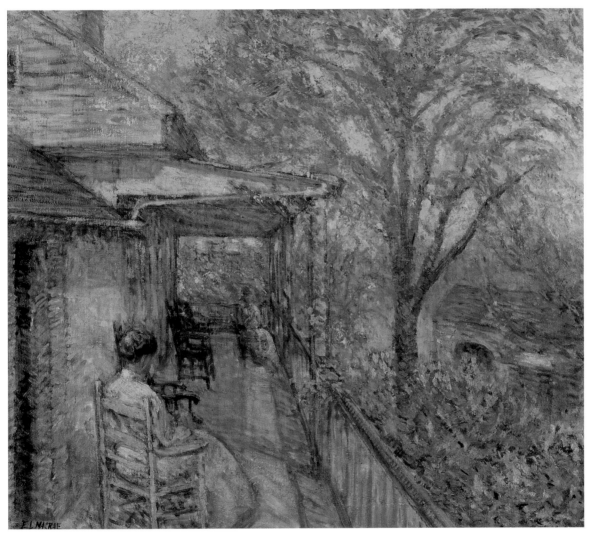

Elmer MacRae, *The Upper Porch at the Holley House*, 1900, oil on canvas, 24 x 28 in. Private collection, photograph courtesy of the Historical Society of the Town of Greenwich.

neys of the Brush House, framed by the end of the porch, and, beyond the lilacs, the rustic shed that served as the hamlet's newsstand. The porch itself is a transitional zone, extending the home into the life of the community and the world of nature. As they sew in the May sunshine, the women can smell the lilacs, hear the birds, and greet their neighbors passing on the street below.

The double verandas of the Holley House were relatively recent additions, dating only to the 1850s or 1860s. Porches were added to many houses during that period, and they soon became such valued amenities that they were accorded the same nostalgic veneration as the original structures. "These old porches are like the prefaces to old books in which the author spreads a broad invitation and calls you 'gentle reader,'" one writer declared, adding that on a country house, "the porch is a gracious neutral ground between the exclusiveness of the home and the impertinence of the world." [12] The double verandas of the Old House are the focus of Hassam's *Summer at Cos Cob* (see fig. 17). In that masterly pastel, Hassam summarized the porches' role as connectors to both nature and community. Vine-clad and tree-shaded, the porches offer comfortable access to nature. A windowbox attached to the railing of the upper porch brings domesticated nature to the second story. The community is implied by the chimney of the Brush House (a faded pink accent in the background) and the sun-dappled path leading from the steps to the road.

The enthusiasm for porches waned about the turn of the century, as periodicals like *Country Life in America* promoted a new suburban ideal glorifying privacy. An essayist who criticized the flaws of old farmhouses might have been describing the Holley House: "Most of them stand behind old elm trees, close to the roadside, with a straight path to the road in front," he wrote, adding, "It is strange how the past generation seems to have found its amusement in watching passing neighbors from the 'piazza' it generally strung along the house front." [13] The boardinghouse porches never lost their appeal to the art colonists, however. With a careless disregard for privacy, they used them for both work and recreation, relishing the opportunity for casual interaction with passing villagers. Twachtman even staged an impromptu dance on the lower porch when he hired an itinerant organ grinder to celebrate the sale of a painting. [14] In *Couch on the Porch, Cos Cob* (fig. 67), Has-

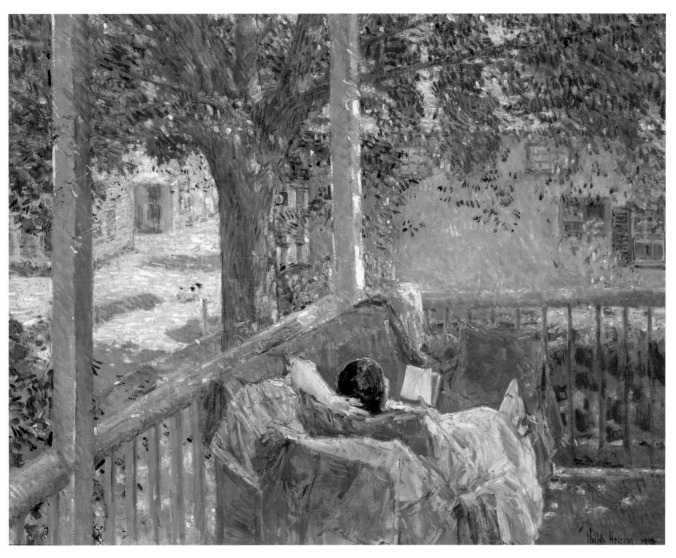

67

Childe Hassam, *Couch on the Porch, Cos Cob*, 1914,
oil on canvas, 26 $1/2$ x 32 in. Courtesy of Oprah Winfrey,
photograph courtesy of Sotheby's, Inc.

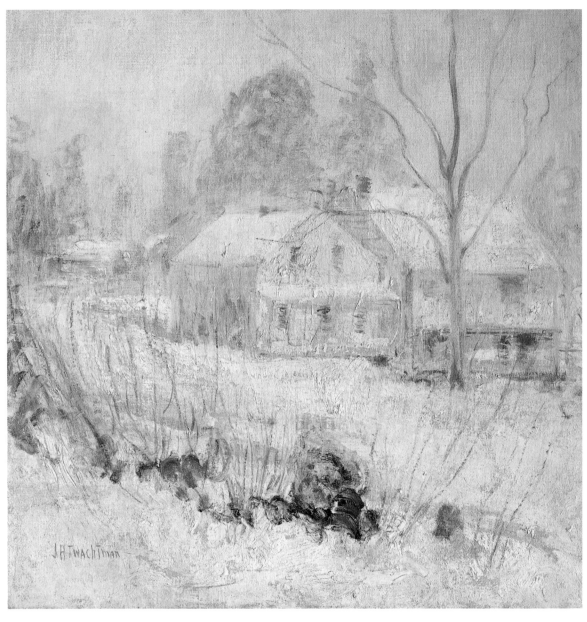

68

John H. Twachtman, *Country House in Winter, Cos Cob*,
ca. 1901, oil on canvas, 25 x 25 in. © Addison Gallery
of American Art, Phillips Academy, Andover, Mass. All
rights reserved.

sam depicted a woman reclining, serenely unconcerned that neighbors might see her.

The artists exploited the porches' extension into the community by using them as places from which to paint. Both Lawson and Hassam positioned themselves on the porch to produce views of the shipyard (see figs. 45 and 48). Twachtman probably set his easel on the porch to paint *Country House in Winter, Cos Cob* (fig. 68), a winter view of the Brush House (fig. 69). A contemporary photograph of two women on the Holley House porch, with the Brush House visible in the background, approximates Twachtman's viewpoint (see fig. 4). Located on opposite sides of Strickland Road, the Brush House and the Holley House were called "ancient sisters" in an article published in 1894. A 1907 newspaper article on the Brush House was vague about its age—a subhead speculated inaccurately that it "Must be Two Hundred Years Old at Least."[15] The assumption that the house dated to the Revolutionary period was correct, however; it was built sometime between 1751 and 1784. Its resident during the art-colony era, Joseph E. B. Brush, was a living link to the past. The eccentric, perhaps mildly retarded bachelor had retired from work on the packet boats owned by his family. Old Joe Brush, as he was called, was both a veteran of the area's traditional shipping industry and a descendant of one of the

Frank Seymour, the Joseph E. B. Brush House, Cos Cob, 1906, photograph. Historical Society of the Town of Greenwich.

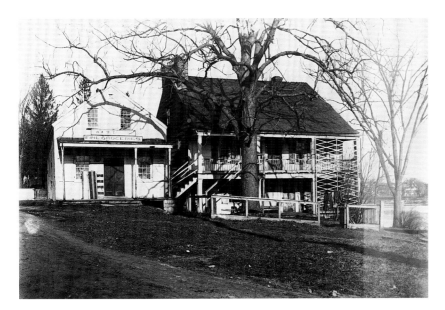

69

oldest families in town. Living in the house in which he had been born and would die, he embodied the rootedness the artists so admired.[16]

In *Country House in Winter*, Twachtman subtly situated the Brush House within a rural village. The tumbledown stone wall and leafless bushes in the foreground were actually on the Holley property; beyond them lay the rutted road that ran between the "ancient sisters." Another house is visible behind Brush's. Twachtman's concern with the relation between architecture and setting is also apparent in *October* (fig. 70).[17] The graceful elm at the left of the composition and the diagonal row of shrubs stood on the Holleys' side of Strickland Road, just beyond the porch where Twachtman set his easel. In *October*, he showed the relation of the Brush House to the millpond, sheltered the old house behind a neat white fence, and shaded it with a pair of trees perfectly matched in size and form. The reality was not so pristine as Twachtman's canvas suggests. Haphazardly maintained by Joe Brush, the house was shabby at best. The trees were not the same size or species; an elm stood near the millpond, an oak or maple near the porch steps. The fence was chicken wire stretched over a rudimentary wooden frame. Yet *October* celebrates an ideal of life in a country village.

Hassam, like Twachtman, found the Brush House an engaging subject, one he depicted at least five times.[18] For two pastels dated 1902, he sketched it close up, from slightly different viewpoints, like a portraitist studying different angles of an interesting face. In the version now in the Canajoharie Library (fig. 71), the whitewashed store adjacent to the house serves as a blank canvas for the shadows cast by the tree limbs. For the Royce pastel (fig. 72), Hassam shifted his position to eliminate the store and present the old house by the millpond as an idyllic country cottage. The liberal use of white highlights links the house to a family of ducks in the middle distance and another old house in the background.

Like Twachtman, Hassam disguised the rundown condition of the Brush House: it appears no worse in his 1916 watercolor (see fig. 20) than in the two pastels he produced fourteen years earlier. By 1909, however, it had deteriorated so badly that every time it rained, an artist-boarder dashed for pots and pans to catch the leaks. It was abandoned as a dwelling by 1913 and demolished in the 1920s.[19] Falling inexorably into ruin, the Brush House must have reminded Twachtman

and Hassam of the erosion of a way of life they cherished. To hold
back loss, they muted the signs of decay.

A younger colleague, Kerr Eby, seems to have viewed the build-
ing's decline in a different light (see fig. 33). Eby candidly depicted
its decrepit condition, portraying it as an American ruin. For the print-
maker, who was a generation younger than Twachtman and Hassam,
the Brush House must have seemed a picturesque relic of a way of life he
had experienced only briefly. In his etchings (as in the work of other
artists before World War I), decay became a signifier of antiquity—a posi-
tive rather than a negative value. Whereas Twachtman and Hassam
coupled age with endurance in their portrayals of the Brush House—even

John H. Twachtman, *October*, ca. 1901, oil on canvas,
30 x 30 in. Chrysler Museum of Art, Norfolk, Virginia. Gift
of Walter P. Chrysler, Jr., 71.713.

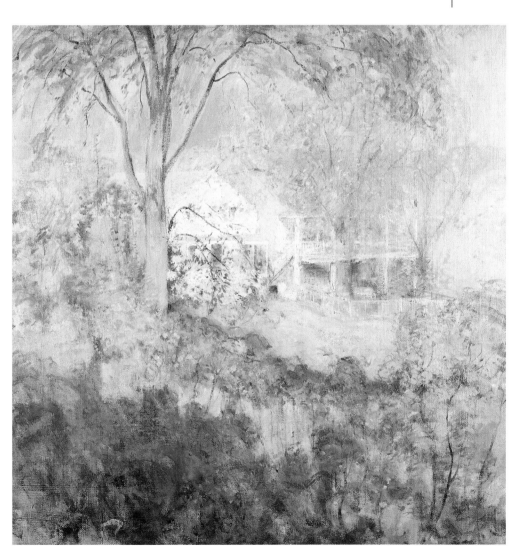

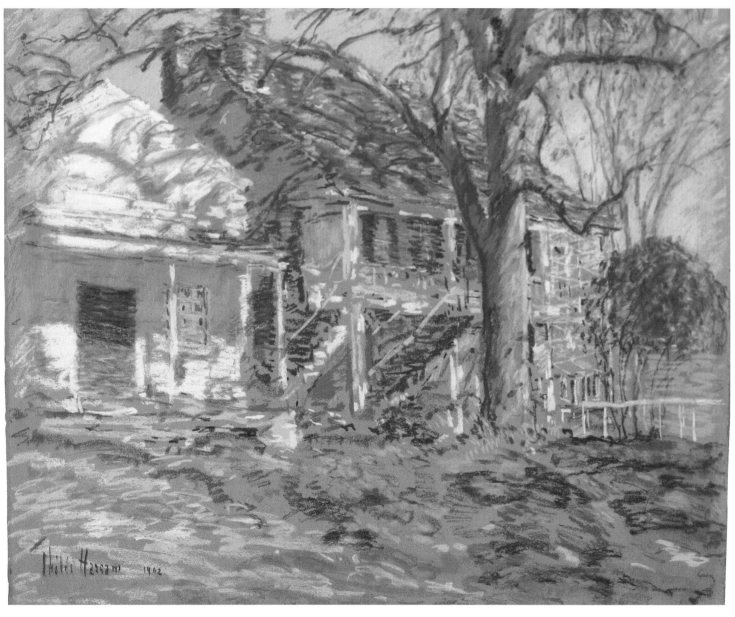

71

Childe Hassam, *The Brush House*, 1902, pastel on
paper, 18 x 22 ¹/₂ in. Canajoharie Library and Art Gallery,
Canajoharie, N.Y.

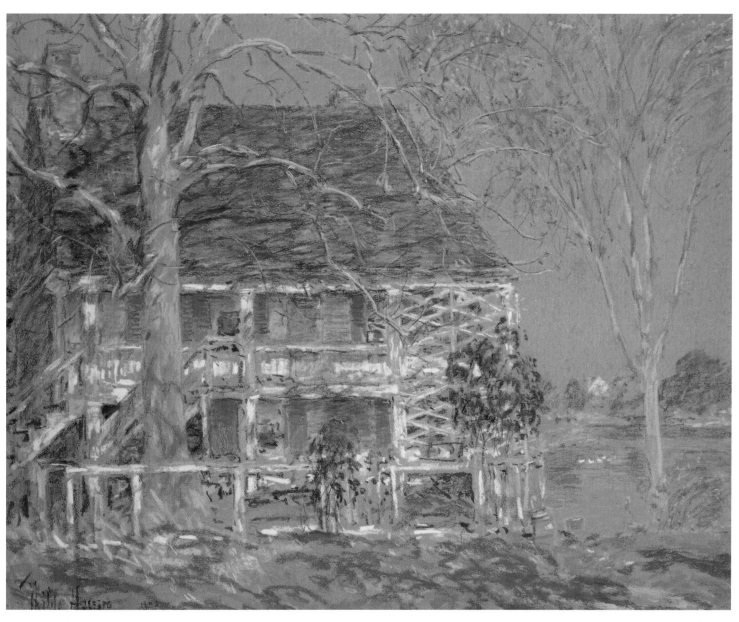

72

Childe Hassam, *The Old Brush House*, 1902, pastel on paper, 17⁷/₈ x 22 in. Courtesy of Charles M. Royce, photograph courtesy of the Historical Society of the Town of Greenwich.

when that endurance was tenuous—their younger colleague depicted a ruin on the verge of oblivion.

Unlike the Brush House, the Captain James Waring House was impeccably maintained. It wasn't really a *Colonial Cottage*, as Hassam titled his oil (fig. 73). Although its owners believed that the house had been built in 1749, it was actually built in the Federal style about 1820. Hassam would probably have painted it anyway; personal associations, as well as antiquity, influenced his thematic choices. The owners of the house, Frank and Kate Seymour, were popular with the art colony, with whom they shared a keen interest in the American past. Frank Seymour, an amateur photographer, was documenting the built environment of Cos Cob at the same time as the artists; the photographs of the shipyard and the Brush House reproduced in this book (see figs. 12 and 69) were printed from his glass-plate negatives. The Seymours

Childe Hassam, *Colonial Cottage*, 1902, oil on canvas, 25 x 30 in. White House Collection, courtesy White House Historical Association.

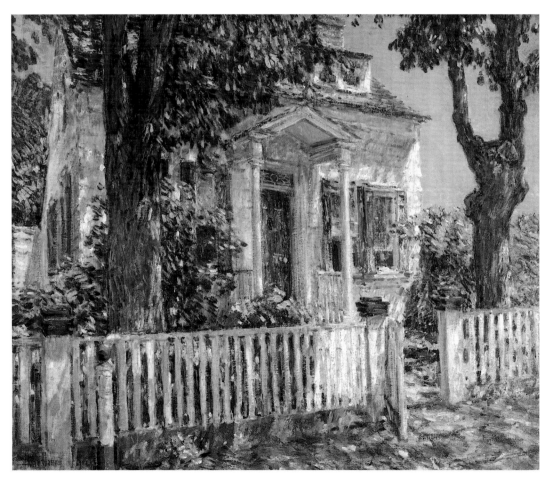

73

took great pride in their home, furnishing it with antiques and showing off to visitors its oaken beams and hand-wrought nails. On summer evenings, strolling artists and writers paused at the gate to greet the couple seated on their small front porch. Additional chairs would be brought out, the Seymours' daughter recalled years later, "and pretty soon we had a congregation, and the next thing we knew everybody was singing." [20] Hassam conveyed this warm hospitality by focusing on the blue-ceilinged portico and the open gate.

An Architectural Medley

Houses, however hospitable, were not the only type of building the artists chose to depict. As a working village, Cos Cob encompassed several architectural types—not just houses, as in a suburb, but also a mill, barns, stables, stores, warehouses, a tavern, and various other commercial and utilitarian buildings. In a traditional pattern that would have been anathema to those who embraced the new suburban ideal, some buildings combined residential and commercial functions. The street level of the Italianate building in Hassam's etching *Toby's, Cos Cob* (see fig. 31) contained a country tavern; the upper stories were shared by the tavernkeeper's family and their boarders. The mustard-colored building in the background of Hassam's pastel *Woodchopper* (fig. 74) housed the village post office and a small store as well as the postmaster's extended family. [21]

 Various building types were represented on the Lower Landing (see fig. 11). Like the houses the artists depicted, the buildings on the landing were old. The oldest, the tide-powered gristmill, was built in 1763. The adjacent warehouse also dated to the eighteenth century, and the next two were built in the early nineteenth century. Additional sheds of indeterminate age extended along the embankment. The functional commercial row, one of the artists' favorite architectural subjects, was a microcosm of a New England fishing village. Its handful of harborside structures exuded the same whiff of salt air and Yankee lore as larger ports like Gloucester. In addition, the Lower Landing may have had subliminal European associations. Nineteenth-century photographs of riverside villages in France resemble the landing in the way rickety buildings cling to the riverbank and to one another. Although

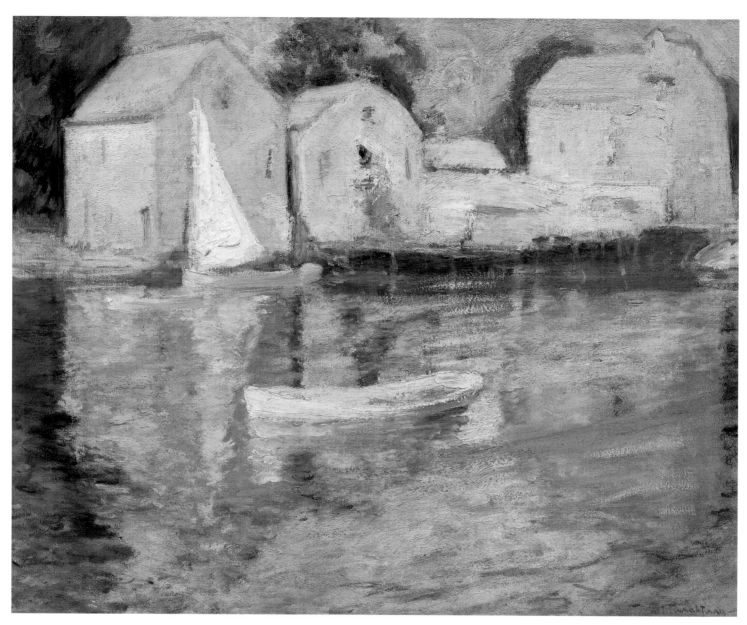

John H. Twachtman, *Cos Cob*, ca. 1890–99, oil on
canvas, 21 x 26 in. Private collection, photograph courtesy
of Spanierman Gallery, LLC, New York.

the mill, which stood to the right of the picture's border, but encompasses a building not visible in Twachtman's *Cos Cob*—the warehouse at the left, which had been partially converted to residential use. *The Smelt Fishers* is a carefully edited view of working-class labor. Accented by a woman with a red shawl over her head—an accessory associated with immigrants—the figures are peasant staffage who evoke a preindustrial age when people worked close to home. To enhance the rustic appeal of the simple buildings and humble folk, the artist embellished the right edge of his canvas with the leafy branch of a nonexistent tree. The agitated brushwork in the roof of the most distant warehouse betrays his decision to disguise a feature he had originally included: a skylight.

The skylight is clearly visible in a later view Hassam painted of Lower Landing, *The Fishermen, Cos Cob* (fig. 79). When the large warehouse was no longer needed to store farm produce awaiting shipment to the city, the upstairs was divided into two apartments and a skylight was cut in the north side of the roof to benefit artist tenants. Once again, Hassam added cosmetic touches to make the landing conform more closely to his ideal of a country village. Standing on the site of the burned mill, he transformed the scruffy vacant lot into a cottage garden. A clump of hollyhocks blooms in the right foreground; to their left, a solitary stalk of blossoms partially conceals a dis-

John H. Twachtman, *Waterfront Scene—Gloucester*, ca. 1901, oil on canvas, 16 x 22 in. Collection of Margaret and Raymond Horowitz.

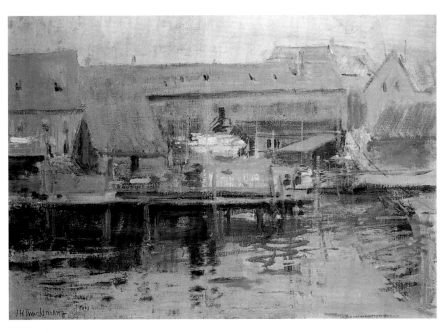

76

129

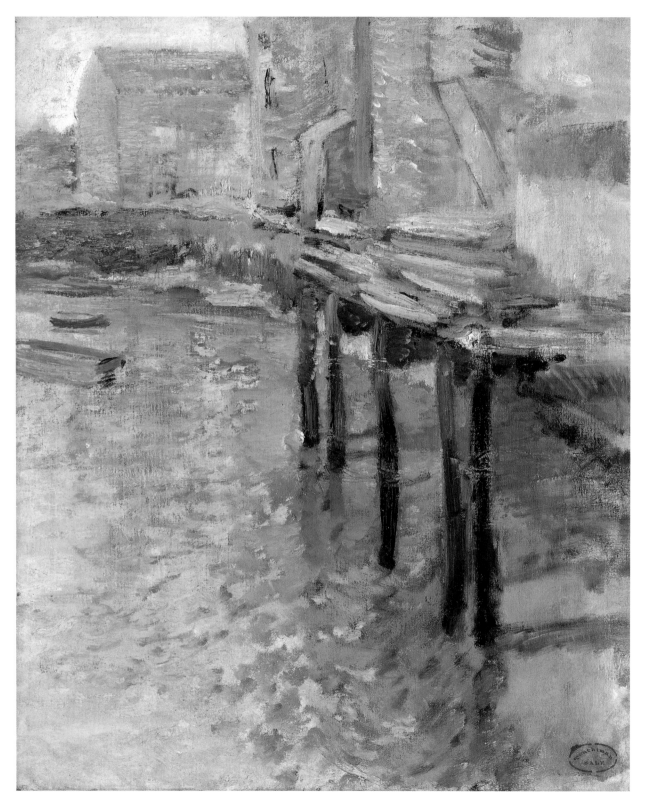

Childe Hassam, *The Smelt Fishers, Cos Cob*, 1896, oil on
canvas, 22 x 18 in. The Fine Arts Museums of San Francisco,
Gift of Rawson Kelham, 1989.37.

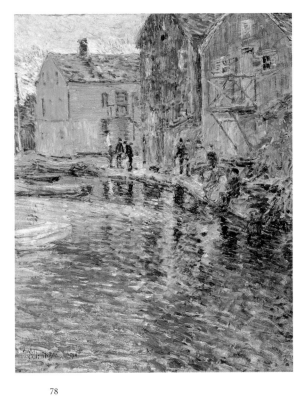

78

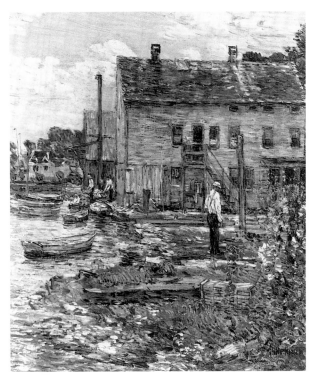

79

Childe Hassam, *The Fishermen, Cos Cob*, 1907,
oil on canvas, 22 ¹/₂ x 20 ¹/₄ in. Private collection, photograph
courtesy of Sotheby's, Inc.

John H. Twachtman, *The Old Mill at Cos Cob*, ca. 1900–
1902, oil on canvas, 24 x 20 in. © The Cleveland Museum of
Art, 1999, Bequest of Julia Morgan Marlatt, 1942.122.

carded crate. Hollyhocks, then as now, suggested old-fashioned farm-house gardens; it is unlikely that they were planted on this rubble-strewn site.[23] The tall biennials are rampant self-sowers, however, and the plants Hassam depicted may have been wind-sown from the Holley House gardens. More likely, the artist may simply have inserted them as an expression of his nostalgia. In Hassam's painting, hollyhocks, Yankee fisher-men, and weathered vernacular buildings convey a quintessentially American quality.

Hassam moved across the narrow inlet to the Palmer & Duff Shipyard to paint the watercolor *Casa Eby, Cos Cob* (fig. 80). The whimsical title saluted Kerr Eby as a resident of the warehouse that dom-inates the image. Eby himself depicted the building in two etchings (see figs. 30 and 32), domesticating the apparently commercial landing by including a line of laundry. The printmaker delineated a modest but not impoverished community where people lived close to one another and to nature. Hassam celebrated the same ideal in *Casa Eby*. Rather than isolating the title building, he revealed its proximity to five others. A smaller warehouse hugs the waterfront at the left edge; behind it is the new brick building that stood across Strickland Road. Built by the tavern keeper Tobias Burke, it housed a store on the ground floor and apartments upstairs. Beside it is an old house, backed by a red barn. To the right of Casa Eby is a glimpse of the building where villagers gathered twice a day to collect their mail, greet their neighbors, and per-haps buy tobacco or candy.

Hassam's image encompasses a mixture of housing types, a jumble of commercial and residential buildings, and an example of what preservationists would later call adaptive reuse (the warehouse con-verted to apartments). This mixture ran counter to the suburban ideal, which advocated the segregation of separate single-family residences on their own spacious lots as far as possible from any sign of commerce. Such residential areas tended to be homogeneous. By contrast, the cluster of buildings represented in Hassam's watercolor sheltered a varie-gated human tapestry: Burke was Irish; the postmaster, Charles Mun-singer, was the son of German immigrants; and at least one African Amer-ican couple lived in Casa Eby, where a Chinese laundry occupied the ground floor. Tiny Cos Cob resembled New York City in its ethnic diversity, population density, varied housing types, and residential-com-

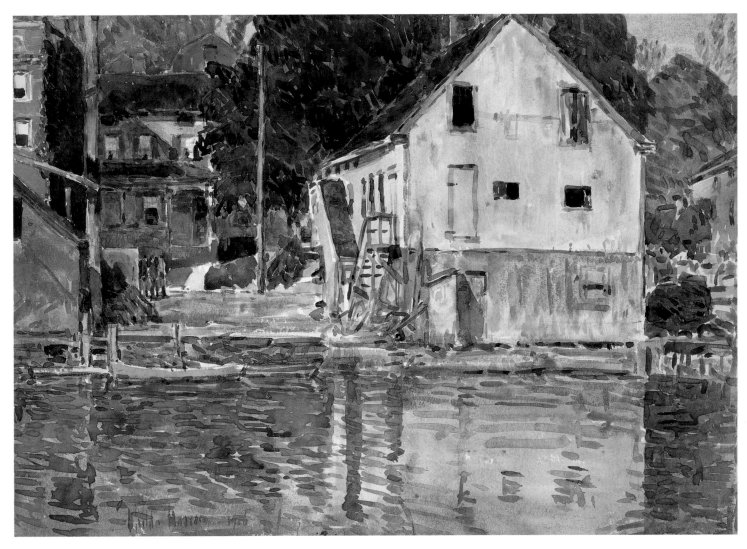

Childe Hassam, *Casa Eby, Cos Cob*, 1916, watercolor,
15^{7}/$_{16}$ x 22^{1}/$_{16}$ in. Courtesy of Everett Fisher.

mercial mix, although people of varied social and income levels lived in closer proximity in the Connecticut hamlet than in the neighborhoods of Manhattan.

Village and Metropolis

During the same decades that he was documenting Cos Cob's built environment, Hassam became known as the foremost chronicler of modern life in the city.[24] A comparison of a Cos Cob and a New York image, both executed in 1902, will reveal how he adapted similar strategies to sharply different locales. The title of *Broadway and 42nd Street* (fig. 81) summarizes, in an address, the city's vitality and glamour. Hassam evoked the élan of the entertainment district on a winter evening. Falling snow veils the tall buildings and carpets the sidewalk where elegantly dressed pedestrians stroll. Their clothing and the horse-drawn cabs create a velvety black cushion for the jewel-like glitter of the shop windows and the passing trolleys. In the early evening, Hassam later told an interviewer, "when just a few flickering lights are seen here and there . . . the city is a magical evocation of blended strength and mystery."[25]

Childe Hassam, *Broadway and 42nd Street*, 1902, oil on canvas, 26 x 22 in. The Metropolitan Museum of Art, bequest of Miss Adelaide Milton de Groot, 1967 (67.187.128).

81

To capture this fashionable scene, Hassam probably propped his canvas on the seat of a cab. "I paint from a cab window," he told an interviewer, "when I want to be on a level with the people in the street and wish to get comparatively near views of them, as you would see them as if walking in the street." His method thrusts us into the action, recreating the forced proximity with strangers that is characteristic of city life. The crowded canvas suggests the "madding whirl and roar of tangled vehicles and men" that a contemporary complained were typical of this area, particularly when "darkness falls, and the theatres open to receive or pour forth their multitudes."[26]

For *November, Cos Cob* (fig. 82), Hassam also chose a slightly elevated viewpoint, positioning himself at the south end of the Holley House, which is set on rising ground above the street. While the city observer confronts a throng of advancing pedestrians, the country viewer is invited to step out onto the ground just under her feet, descend the steps in the lower left corner, and join one of the three small clusters of figures in the background. The zigzag trajectory of this implied motion slows the gaze and suggests the leisurely pace of rural life.

Architectural elements project into both compositions. *Broadway and 42nd Street* is bracketed by tall buildings that extend beyond

Childe Hassam, *November, Cos Cob*, 1902, pastel on paper, 18 $\frac{1}{2}$ x 22 $\frac{1}{2}$ in. Courtesy of Mr. and Mrs. Hugh B. Vanderbilt.

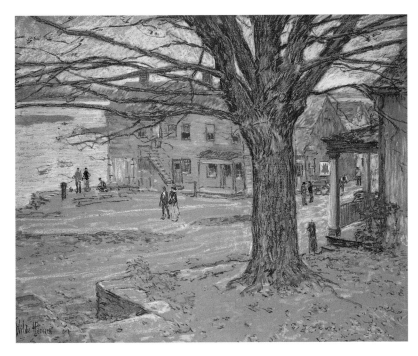

82

the upper edge of the canvas, looming over the pedestrians and vehicles. No tree or vine softens the hard masonry. Unlike those handsome new skyscrapers, the Connecticut buildings are old, wooden, and built to a human scale. The porch of the post office next door to the Holley House edges the right side of the pastel. The low structure does not constrict the viewer, however, but offers an additional resting place for the eye and a frame-within-the-frame for a vignette of country life. The built environment blends comfortably with its natural setting. A large tree in the foreground anchors the composition and extends to each edge, embracing a harmonious balance of humans, architecture, and nature.

In their affection for village life, Hassam and other members of the Cos Cob Clapboard School were in tune with the thinking of the contemporary reformer Liberty Hyde Bailey. Citing the havoc wreaked by incompetent city dwellers intent on taking up farming as an occupation, Bailey wrote in 1911, "It seems to me that what is really needed is a back-to-the-village movement." He urged the establishment of small commercial and manufacturing enterprises in villages, so that people could live close to their work. Their desire for a "nature-connection" would be met by cultivating their own small gardens. Through the widespread adoption of the village model, Bailey declared, "the social condition of both cities and country ought to be improved."[27]

In Cos Cob, the art colonists lived the ideal that Bailey preached. Like the fishermen they so often included in their architectural images, the artists worked close to their home base, the Holley House. Like the fishermen, they found a "nature-connection" not just in after-work pastimes, but in the work itself. The village seems the perfect theme for artists who chose to work in an art colony: both village and colony are tightly knit social networks offering mutual support and easy interplay between public and private. The buildings that the Cos Cob Clapboard School depicted offered a "human-connection": to the past, through their age and history, and to the present, through the casual daily interactions of a compact, mixed community. They appealed to the art colonists not only because they were "moss grown and worm eaten" but because they endured, "staunch and true," vital survivors of a time-tested way of life.

Little girls playing in the woods, caring for their pets, or reading in a
sunny room; women relaxing in the garden, on the porch, or in an
old house: these subjects engaged the Cos Cob Impressionists. When
the art colonists shifted their focus away from the landscape and
architectural images for which they were best known and turned to fig-
urative work, it was usually to portray women and children who
were dear to them. Twachtman produced few figure paintings, nearly
all of which depict his wife and children. Weir, Ebert, MacRae,
and Mina Ochtman also depicted their children (and the men, their
wives). Robinson and Hassam, who had no children of their own,
portrayed Twachtman's. In the first two decades of the twentieth cen-
tury, the versatile and prolific Hassam also produced a body of
oils and etchings depicting women at the Holley House. There, his
models included his wife, the Holley women, other artists, and a
local teenager whom he paid to pose for him. Whoever the model, the
Cos Cob Impressionists' paintings of women and girls promote
contemporary ideals of childhood and family life and illuminate their
attitudes about tradition, modernity, and the role of women.

Country Children

In the summer of 1893, Robinson painted *Stepping Stones* (see fig. 15),
depicting Marjorie and Elsie Twachtman (then nine and six years

old) crossing Horseneck Brook. As he had often done in preparation for figure paintings, Robinson took a photograph before he began work at the easel. For some of the canvases he had painted in France, he had even squared off the snapshot and transferred the image, with few revisions, to the canvas.[1] Because the photographic study for *Stepping Stones* is lost, it is impossible to determine how faithfully Robinson followed it. He probably used the photograph to establish the composition and evaluate light effects, but his diary entries reveal that he did not simply copy it. Instead, he devoted at least five sessions to painting *en plein air*, making a point of resuming at five in the afternoon, the hour at which he had taken the photograph.[2] The girls sometimes posed for him, but they were squirmy and the weather was hot, so the photograph was a practical aid. Some of Robinson's earlier photo-assisted works are static, but for *Stepping Stones*, he used the camera in a proto-cinematic manner: not to freeze a pose but to register motion. The resulting canvas captures the vitality of his young subjects. Marjorie and Elsie Twachtman were the children of one of his best friends, and the reticent bachelor's affection suffuses the canvas.

The sight of two little girls running barefoot on a summer day, familiar from Robinson's own rural childhood, must have seemed more precious as America's population shifted to the cities. Sarah Burns has shown how images of country children, so popular in the third quarter of the nineteenth century, channeled a nostalgic, idealized vision of nature and youth. This idealization, she writes, derived from "a romantic craving for innocent closeness to nature in an age when civilization and its ills were suffocating the earth under a crust of artifice."[3] In *Stepping Stones*, Robinson avoided the sentimental, moralizing overtones that frequently marred contemporary images of children. He also departed from convention in his portrayal of girls. As Burns has established, the barefoot boy was the focus of attention in art and literature. Winslow Homer, for example, underscored the freedom of boys playing outdoors by depicting them with bare feet in works like his famous *Snap the Whip* (1872, Butler Institute of American Art). By contrast, he depicted securely shod girls pausing at their chores, as in the watercolor *Weary* (fig. 83).[4] Robinson shunned both the association with labor and the subtle eroticism that permeates many of Homer's images of country girls. By depicting Marjorie's and Elsie's loose

clothing, bare feet, and absorption in play, Robinson extended to them the carefree independence his contemporaries usually reserved for their brothers.

In *After the Ride* (formerly *Visiting Neighbors*; fig. 84), Weir portrayed his youngest daughter, Cora, at the family farm in Branchville with one of the donkeys that had been handed down from the Twachtman children. Although family anecdotes recall the animals as cantankerous and unmanageable, Weir depicted a docile beast, neatly tacked up in sidesaddle and bridle. In the long tradition of equestrian paintings and sculpture, the mastery of a horse signifies the human subject's power. Weir, who admired Diego Velázquez, had probably seen the Spanish painter's *Baltasar Carlos on Horseback* (ca. 1635, Museo del Prado) on a trip to Madrid. In that portrait, the small prince's confident pose astride a rearing horse predicts his future success as king. Weir feminized the tradition, casting his dismounted daughter in a nurturing role as she strokes the head of her drowsy pet.

Twachtman also associated children with domestic animals in *Barnyard* (fig. 85), a view of his little daughter feeding chick-

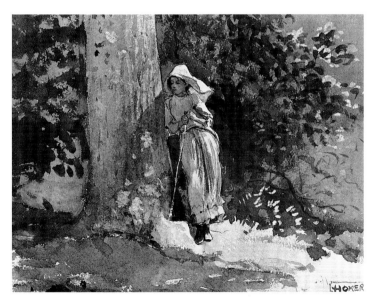

83

Winslow Homer, *Weary*, ca. 1878, watercolor and graphite on paper, 8 5/8 x 11 1/4 in. Terra Foundation for the Arts, Daniel J. Terra Collection (1992.41), photograph courtesy of the Terra Museum of American Art, Chicago.

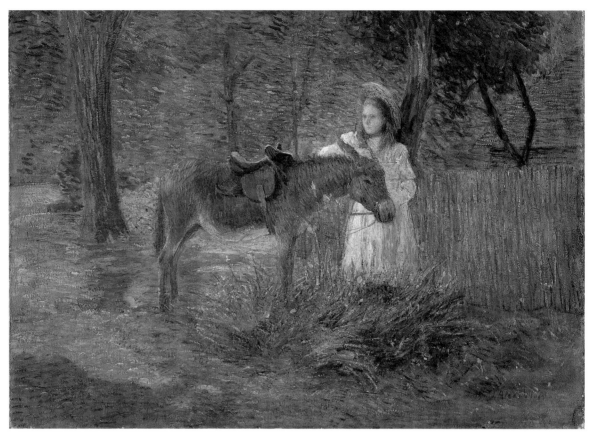

84

J. Alden Weir, *After the Ride* (formerly *Visiting Neighbors*), ca. 1903, oil on canvas, 24³/₈ x 34¹/₄ in. The Phillips Collection, Washington, D.C.

John H. Twachtman, *Barnyard*, oil on canvas, 30¹/₄ x 25¹/₈ in. The Fine Arts Collection of The Hartford Steam Boiler Inspection and Insurance Company.

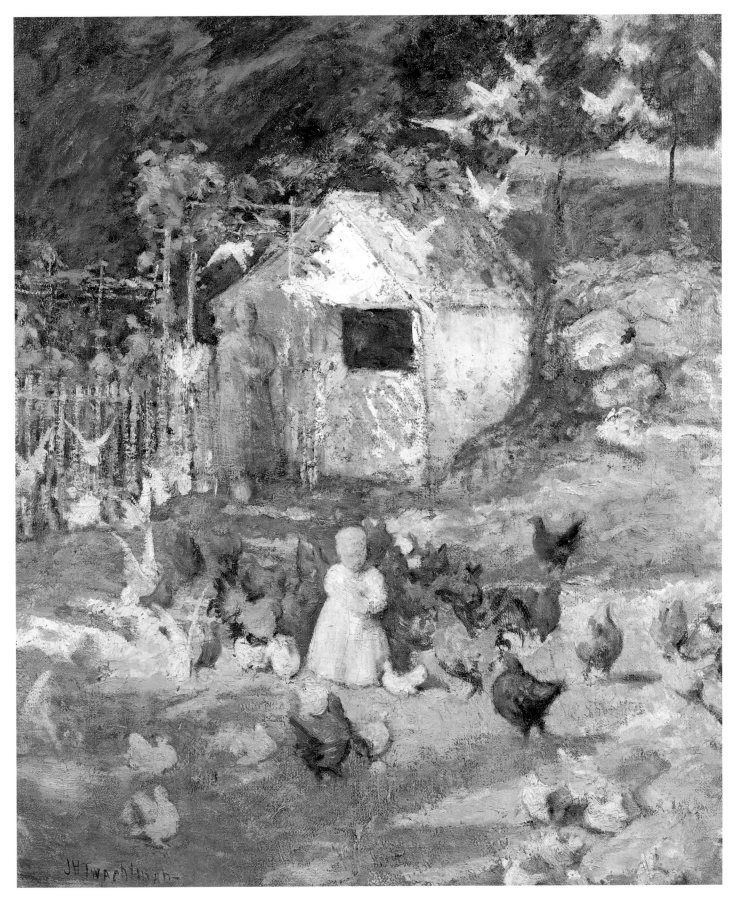

ens and doves while his wife looks on.[5] Such scenes were familiar to Twachtman's contemporaries, as many newcomers to the country took up poultry keeping. The Greenwich newspaper reported in 1888, "Almost everybody likes hens. They like to eat them and their eggs, but they also like to have them around, not only as a source of convenience and profit, but to fuss over, to look at, and make pets of. Almost everyone who has a place and grounds large enough for them, keeps a few hens. City people who come out into the country want them; hens, a cow and a horse they consider necessities of country life." That attitude was widespread among new suburbanites across the United States. One woman wrote in 1902, "The commuter's wife should have a hen rampant as her coat of arms, and adopt it as her patron saint." Asked in a 1911 survey why they had moved from Chicago to its outskirts, several homeowners replied that "they couldn't be happy without chickens, and had to move to the country to keep them."[6]

The theme of a poultry yard held strong family associations in the late nineteenth and early twentieth centuries. Women and children handled many of the chores associated with poultry keeping, which was considered a character-building activity. Andrew Jackson Downing called it "an almost necessary part of the means of developing the moral and industrial energies of a country household"—so much so that "he who will educate a boy in the country without a 'chicken' is already a semi-barbarian." Keeping doves or pigeons promised similar educational and recreational benefits. One writer maintained that a child caring for a flock of the birds would be "elevated" by the experience.[7] Doves are especially appropriate in a family image: they mate for life, sharing the incubation and feeding of their young, and the fabled "billing and cooing" of their courtship has made paired doves a symbol of romantic love.

In Twachtman's *Barnyard*, the mother stays in the background, allowing the child to exercise her emerging autonomy. Scarcely taller than the roosters, the little girl learns to assume responsibility for others, nurturing the poultry as her mother nurtures her. The woman, whose brown dress links her to the earth, is framed in the trellised gate like a saint in a cathedral niche. The dove hovering above her head inevitably suggests the Holy Spirit to anyone familiar with European art, as was Twachtman. Light, the symbol of grace in religious paintings,

touches the woman, the hen house, and the wings of the doves, with the strongest beam spotlighting the child, like the Infant Jesus in Nativity scenes. Twachtman's use of religious imagery is not overt. Instead, he drew on a body of artistic conventions to give a rustic image of family life an aura of benediction.

The almost religious atmosphere of *Barnyard* also permeates *On the Terrace* (fig. 86), in which Twachtman depicted his wife with three of their children in the garden behind their house. By concealing the horizon, the artist immersed the viewer in his private world. Although the figures are pushed to the rightmost third of the composition, their central importance is underscored by the wedge-shaped pedestal of white terrace. Garbed in metaphorically "pure" white, the fam-

John H. Twachtman, *On the Terrace*, ca. 1897, oil on canvas, 25 1/4 x 30 1/8 in. National Museum of American Art, Smithsonian Institution, Gift of John Gellatly.

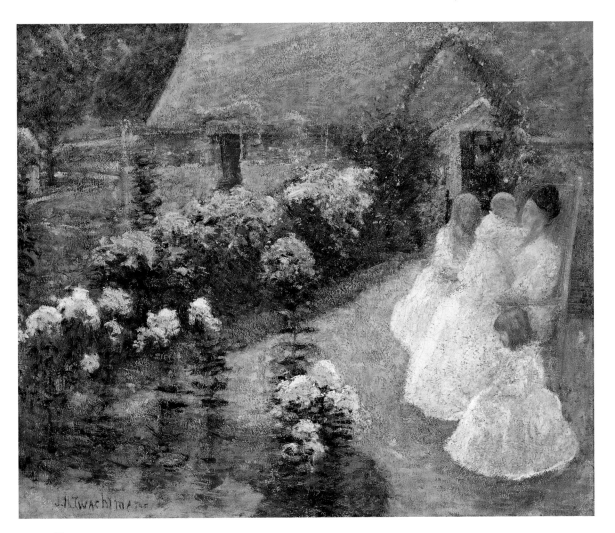

86

143

ily is obliquely enshrined by the sheltering gable and the Gothic-arched trellis crowned with yellow blossoms. A golden light glows within the house, as from a sanctuary. Twachtman exaggerated the scale of the white phlox in the center foreground and the pink one just behind it, making them secular counterparts of the Madonna's lily. Radiant golden highlights—on his daughters' hair, the roof of his house, the plants in his garden—glorify this tender image of home as shelter and shrine.

Twachtman's student Charles Ebert depicted his wife, Mary Roberts Ebert, sewing in their garden with their daughter, Betty, at her side (fig. 87). Twachtman's influence is evident in the painterly brushwork and sketchy rendering of features, while the bright colors and concern with light reveal Ebert's debt to Hassam. The Eberts probably met at the Holley House, where Mary, who was enrolled at the Art

Charles Ebert, *Mary Roberts Ebert with Betty*, ca. 1906, oil on canvas, 30 x 27 in. Courtesy of Mr. and Mrs. Robert P. Gunn.

144

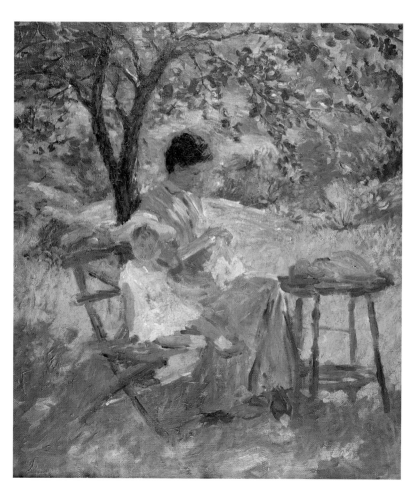

87

Students League, was a summer student in 1897. She was an accomplished watercolorist but did not exhibit her work until her only child was in her twenties.

Like Mary Roberts Ebert and Martha Scudder Twachtman, Mina Fonda Ochtman had pursued artistic training and begun to establish a career before marrying another artist.[8] Those women followed a familiar pattern; the early membership roster of the National Association of Women Artists (to which Ebert and Ochtman belonged) is studded with the names of women whose husbands were artists. Although her career remained secondary to her family, Mina Ochtman exhibited more frequently than Martha Twachtman or Mary Ebert. In *The Evening Lamp*, Ochtman portrayed her daughter, Dorothy (who also became a painter), reading in their living room (fig. 88). The books lining the walls and covering the table define the setting as a cul-

Mina Fonda Ochtman, *The Evening Lamp*, ca. 1912, watercolor on paper, 13 x 17 in. Bruce Museum, Greenwich, Conn., 83.09.02.

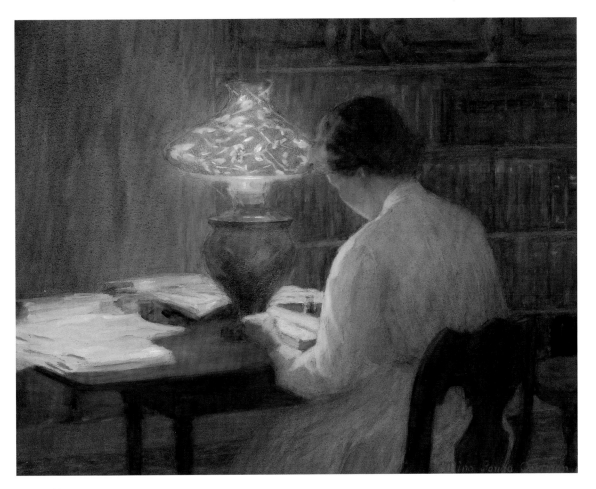

88

tured home, while the skillful interpretation of lamplight, glowing through the glass shade and outlining Dorothy's face, demonstrates the artist's mastery of the watercolor medium.

Hassam's Images of Women and Girls

Unlike Mina Ochtman and Mary Ebert, Hassam was not a parent, but he was a playful and affectionate family friend to the children of other art colonists. He depicted two of the Twachtman youngsters inside their home (see fig. 16). A young girl, her long hair in pigtails, bends over books spread on a table before a sunny window while a baby in a blue dress watches from a high chair. Dated 1897, *The Children* anticipates the "Window" paintings Hassam began in New York about 1909. As in the later works, which depict idle women in genteel interiors, a window establishes the geometric framework for a figural composition that includes a prominent still-life element. Whereas some of the twentieth-century Windows appear excessively staged, *The Children* possesses convincing slice-of-life immediacy.

For Hassam, more than any of the other Cos Cob Impressionists, the female figure was a major theme. On visits to the Holley House between 1902 and 1917, he produced at least twenty-three images of women (eleven oils and twelve etchings). Those works, the country cousins of the New York Windows, have been erroneously lumped with the city group, if not overlooked entirely. But just as Hassam alternated Manhattan cityscapes with Cos Cob villagescapes, he also shifted between images of women in urban and rural interiors. Like two sides of a coin, Hassam's images of women in New York and in Cos Cob reveal his contrasting views of city and country and illuminate his attitudes about nature, modernity, gender, and class.

In the earliest of Hassam's Cos Cob figure paintings, *Listening to the Orchard Oriole* (fig. 89), an auburn-haired young woman stands on the upper porch of the Holley House, gazing out over the millpond and the tree-shaded village. The appeal of that elevated prospect—and the contrast between city and country—is revealed in a letter that Twachtman wrote to Josephine Holley from New York: "In the morning I shall wake up and—no—not walk out onto the upper porch to see what the day is like—but look down into an air-shaft."[9]

146

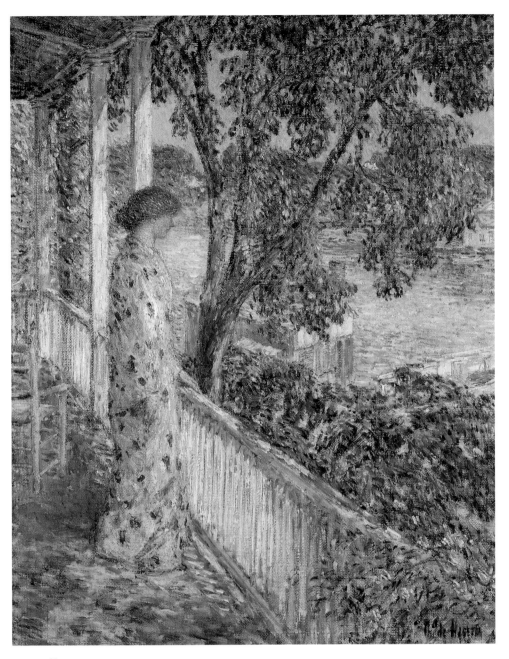

89

Childe Hassam, *Listening to the Orchard Oriole*, 1902, oil
on canvas, 32 x 26 in. Diplomatic Reception Rooms, United
States Department of State, Washington, D.C.

In Hassam's painting, the woman's ease in the built and natural environment is expressed in composition, brushwork, and palette. No barriers obstruct her view; her body overlaps and unites the space of the house and the space of the world beyond. Figure and setting are further integrated through brushwork and color. The same short brushstrokes describe the woman in her patterned kimono and the sun-dappled landscape; the same high-keyed colors link figure, architecture, and nature.

Standing on the porch, Hassam's model enjoys not only the sight of nature but also its sounds—she listens, the title tells us, to an orchard oriole.[10] Hassam did not depict the bird, which is more easily heard than seen. The orchard oriole nests near houses, but its small size, darting flight, and preference for the dense foliage of treetops make it difficult to spot. For Hassam's contemporaries, however, the orchard oriole's cheerful song elicited memories of country life. One birdwatcher wrote nostalgically, "The old house with its cluster of farm buildings, the rows of gnarled . . . apple trees, . . . the warm sunshine of early summer and the song of the Orchard Oriole—all are ever closely intermingled in my memory."[11] This reminiscence, written by a person who had returned to the city, reflects the appreciation of nature ascribed to cultured urbanites. Liberty Hyde Bailey, for one, declared that it was imperative to teach farmers "to hoe potatoes and to hear the birds sing at the same time."[12] Communing with nature, as the model does in this painting, was the prerogative of the city dweller on vacation in the country. In his treatment of the pictorial space, uniting the spheres of home and nature, Hassam promoted the Arcadian ideal of a cosmopolitan man of the city.

To enhance that ideal, Hassam edited his composition, eliminating the intrusion of modern technology. A photograph of the Cos Cob mill (see fig. 10) reveals that a utility pole stood just beyond the small building in the background of *Listening to the Orchard Oriole*. Hassam did not always avoid evidence of industrialization, even in Connecticut. The same year he painted *Listening to the Orchard Oriole*, he also painted *The Mill Pond, Cos Cob* (see fig. 27), depicting construction work on the Mianus River railroad bridge. In his painting of a woman in a country home, however, he suppressed evidence of technological innovation to create a pre-industrial landscape.

The kimono that appears in *Oriole* is another device for mitigating change. Appearing in at least five more Cos Cob images by Hassam over the next fourteen years, that kimono served varied, sometimes contradictory functions.[13] First, because it avoided the time-specificity of Western fashion, it reinforced the artist's representation of country life as unchanging. Unlike the vaguely classical costumes favored in portrayals of women during the 1880s, however, the kimono also suited the Impressionists' interest in modern life; because American women had adopted the Japanese garment as their own, it could simultaneously convey timelessness and modernity.

The kimono also signified a refined aesthetic taste. At the Holley House, art colonists occasionally dressed up in kimonos. Constant Holley MacRae, who staged "tea ceremonies" for local organizations, was photographed wearing an authentic-looking padded kimono. In another snapshot, Japanese artist Genjiro Yeto is surrounded by kimono-clad American women in a scene replete with Oriental paraphernalia (see fig. 29). Paper lanterns and parasols, folding fans, hanging scrolls, a musical instrument, porcelains: all identify the women as sophisticated initiates in the cult of Japanism. In the enthusiasm for Japanese culture that gripped Europe and America in the second half of the nineteenth century, many artists depicted women in a kimono. James McNeill Whistler, for example, portrayed a European beauty in a flowing kimono in *La Princesse du pays de la porcelaine* (fig. 90). Whistler's model assumed not only the garment but also the graceful S-curve posture familiar to admirers of Japanese prints; Siegfried Wichmann writes of this painting that "the tilt of the head, the long curve of the back, the bell-shaped line of the hem, are plainly borrowed from Japanese woodcuts."[14] In *Listening to the Orchard Oriole*, by contrast, Hassam's model stands erect and the kimono falls straight from shoulder to hem. Even her posture reiterates the essentially American character of the setting.

While the kimono signified refinement and culture, it also conveyed a discreet eroticism to Hassam's contemporaries. Fictional and journalistic accounts of the geisha fostered the notion that Japanese women were both sexually sophisticated and utterly subservient to men. Few ukiyo-e prints showed the garment as worn by "proper" Japanese women; instead, they depicted professional beauties in alluring

James McNeill Whistler, *La Princesse du pays de la porcelaine*, 1864–65, oil on canvas, 78 ³/₄ x 45 ³/₄ in. Courtesy of the Freer Gallery of Art, Smithsonian Institution, Washington, D.C.

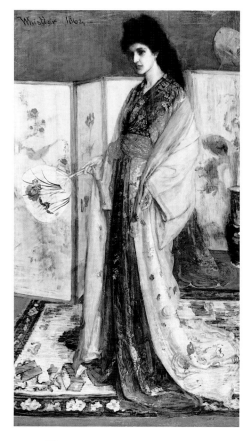

90

dishabille (fig. 91).[15] And although the tubular shape of the authentic kimono restricts movement, the garment had been assimilated into American wardrobes as a loose-fitting dressing gown. The Sears, Roebuck catalogue offered ready-made "Long Kimonas or Negligees," which it described as "very handy house garments." The fashion magazine *The Delineator* announced in 1902 that "the kimono has firmly established its popularity as a wrapper or lounging robe."[16] Robert Reid exploited the kimono's eroticism by depicting a model, whose kimono loosely covers her undergarments, posing in her boudoir (fig. 92). Hassam allowed the mere presence of the kimono to lend an erotic overtone to *Listening to the Orchard Oriole*.

Hassam's model wears the same kimono in *Bowl of Goldfish* (fig. 93). In 1912, the same year that Hassam painted this canvas in Cos Cob, he completed a similar work in Manhattan, *The New York Window* (fig. 94). As if to invite critical comparison of this country-city pair, he sent them to the prestigious *Fourth Annual Exhibition of Contemporary American Oil Paintings* at the Corcoran Gallery in Washington, D.C. Had they been hung side by side, as Hassam no doubt intended, their strong formal similarities would not have escaped notice.[17] Both use the window format to play off the tension between interior and exterior. Both include a prominent still-life element, and in both, the woman's individuality is muted in a turn of the head, a blurring of the features.

These similarities make the differences between the two images more noticeable, like variations on a musical theme. The crucial distinction is the treatment of space. In *The New York Window*, the sheer curtains and tightly closed windows completely separate the woman from the world outside. Absorbed in reverie, she turns inward mentally as well as physically. Even her posture, slumped in the chair, contrasts with the vigorous verticals of the skyscrapers glimpsed through the curtains. This emphatically divided space suggests additional oppositions: between private and public, feminine and masculine, tradition and modernity.

Whereas interior and exterior are opposed in the New York painting, they are continuous and interpenetrating in the Cos Cob scene. The windows are wide open, the casements thrust outward. The model turns her head to look out the window, contemplating nature.

Chokosai Eisho, *The Courtesan Waka Murasaki*, ca. 1798,
polychrome woodblock print, 14^{15}/$_{16}$ x 10 in.
The Metropolitan Museum of Art, New York, Fletcher
Fund, 1925 (JP1477).

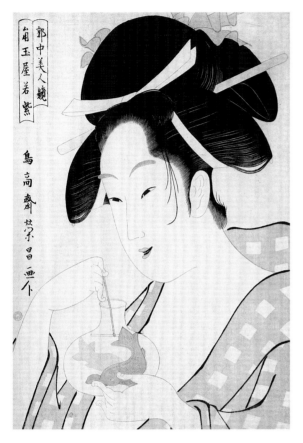

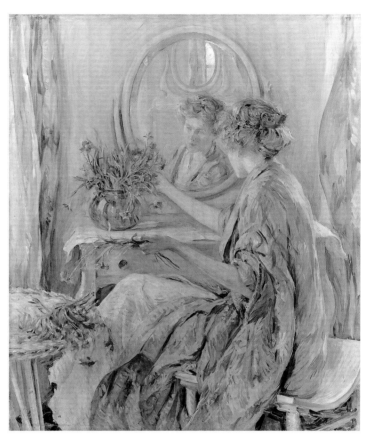

91

92

Robert Reid, *The Violet Kimono*, ca. 1910, oil on canvas,
29 x 24^3/$_4$ in. National Museum of American Art, Smithsonian
Institution, Gift of John Gellatly.

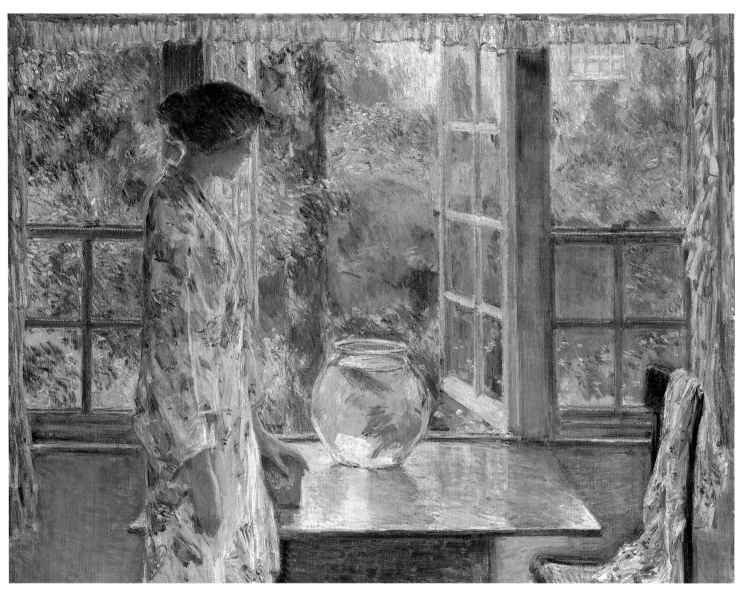

93

Childe Hassam, *Bowl of Goldfish*, 1912, oil on canvas,
25 1/8 x 30 1/4 in. Ball State University Museum of Art, Muncie,
Indiana. Frank C. Ball Collection, partial gift and
promised gift of the Ball Brothers Foundation, 95.035.073.

No curtains screen her view of a flower-bordered lawn rising to a neighboring building.[18] Her patterned kimono echoes the flowers blooming below the window, while her posture repeats that of the slender sapling that grows within her reach. Space flows freely from indoors to out, and the woman belongs to both worlds.

The easy access to the outdoors offers the Connecticut model the uplifting influence of nature. Morality and a love of the natural world were intertwined in turn-of-the-century thought, as reflected in a poem published in 1906:

> All the woods of April show
> Wisdom we should heed and know.
> Seed and root and fibre fine
> Have a message half divine.[19]

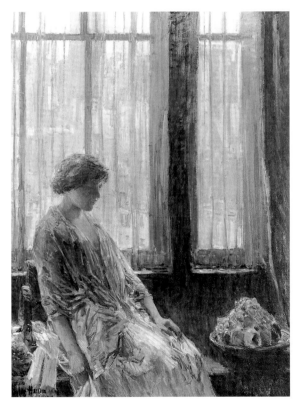

Childe Hassam, *The New York Window*, 1912, oil on canvas, 45 1/2 x 35 in. In the Collection of The Corcoran Gallery of Art, Washington, D.C. Museum Purchase, Gallery Fund, 12.10.

94

Urban life did not possess the same uplifting qualities; in 1907 a clergyman explained that he had moved from the city because "a noble grove of pines is more apt to remind me of their Maker than a sky-scraper."[20] In the city, a woman risked corruption by the world outside her window; in the country, she would be improved by it.

The still-life elements—a stiff pyramid of fruit in the Manhattan work, a bowl of goldfish in Cos Cob—are both decoration and symbol. In *The New York Window*, the red and yellow fruit commands attention in the predominantly blue-toned canvas. Set beside the model, it is a conventional emblem of female sensuality and fruitfulness. The Cos Cob still life, the bowl of goldfish, contains layers of meaning. On one level, it exemplifies the Japanism that was so pronounced in the art colony. Goldfish, a familiar motif in Japanese and Chinese art, are often associated with beautiful women, as in the woodblock print depicting a courtesan holding a flask of the bright-colored swimmers (see fig. 91). Japanese connoisseurs would have recognized the goldfish as a symbol of fertility and sexual harmony, but for Hassam and his contemporaries, the motif simply demonstrated a fashionable interest in Japan.[21]

The goldfish bowl also enabled Hassam to demonstrate his virtuosity in rendering light, but it is more than a mere visual device. Instead, Hassam used the motif to unite home and nature. The bowl serves as a lens, magnifying the natural world and bringing it indoors. The fish swirling through the water animate the center of the composition; this unstill life lives.

Whereas the goldfish represent nature, it is nature confined and domesticated. During the nineteenth century, people kept these popular pets in one of two ways: either they duplicated a complete ecosystem in an aquarium stocked with plants and other creatures or they isolated the fish in a glass globe. The second course—the one portrayed in Hassam's oil—transforms the fish into a decorative object.[22] Divorced from its habitat, it exists solely as an amusing spectacle for its owners.

As the object of the unremitting gaze, the goldfish bowl had become slang for a lack of privacy by 1904, when a character in a short story complained, "I might have been a goldfish in a glass bowl for all the privacy I got."[23] Hassam may have intended the motif

as a witty allusion to the communal life of the boardinghouse. More profoundly, the goldfish in their bowl are a metaphor for the beautiful woman in the aesthetic home. One writer's description of the pleasure of watching goldfish reveals the gender bias of that activity. Writing of the young, the old, the ill, and the women who nurtured them, Thomas M. Earl advised in 1896: "Since home-life must constitute for many the greater part of their earthly existence, it is natural and proper that all reasonable efforts be made to embellish the home with objects of interest and pleasure. Among the many ornaments from which one may choose for this purpose, what can give rise to more real enjoyment than the aquarium! How many hours can be passed in delightfully contemplating the actions of its finny inhabitants, busying themselves in the regulation of their household affairs."[24] With the phrase "busying themselves in the regulation of their household affairs," Earl feminizes the goldfish, evoking images of dutiful housewives. Watching goldfish was a pastime for women; watching women watch goldfish was a theme for artists. In Hassam's *Bowl of Goldfish*, the decorative, confined fish are analogous to the woman, whose only role is ornamental. Although she lives in the country, enjoying easy access to the natural realm, the domestic sphere contains her as surely as the glass globe does the swimming fish.

In *The Dutch Door*, an etching executed at the Holley House (fig. 95), Hassam employed a motif comparable to the goldfish bowl: a birdcage. Carl Zigrosser praised the etching as an image of feminine absorption in nature. "What poetic charm there is in the conception of *The Dutch Door*," he wrote, "the girl standing at the door and drinking in with her fresh young nature the radiant summer that is jubilantly singing and caroling out of doors."[25] The singing and caroling emerge from a caged bird, however. The bird was kept for aural pleasure, the goldfish for visual pleasure. Birdcage, fishbowl, domestic chamber: each contains a living ornament.

Just as Hassam had paired a Cos Cob and a New York window in the 1912 Corcoran exhibition, he juxtaposed another such pair in the 1922 monograph on his work.[26] There, *The Goldfish Window* of 1916 (fig. 96), a variant of *Bowl of Goldfish*, appears opposite *The New York Winter Window* of 1918–19 (fig. 97). Formally, the paintings are almost mirror images of one another. Each depicts a woman standing

in profile before a polished table, on which she rests the fingers of one hand. Each room contains a chair or two, a still life centered on the table, and windows that offer a view outdoors. In the New York painting, the skyscrapers glimpsed through gauzy curtains seem as flat as a theatrical backdrop. The Connecticut window, by contrast, opens onto an inviting landscape whose depth is intensified by the vector formed by the open casements and the gable's shadow on the lawn. The small book the model held in *The Bowl of Goldfish* has been replaced by a blossom, which she holds to her breast in a gesture signifying her emotional bond with nature. A patch of sky, refracted in the water, seems to rest on the tabletop, whose nearly iridescent surface shimmers with sunlight. The model's hair glints with orange high-

Childe Hassam, *The Dutch Door*, 1915, etching, 8 ³/₈ x 9 ⁷/₈ in. The Metropolitan Museum of Art, Gift of Mrs. Childe Hassam, 1940 (40.30.24).

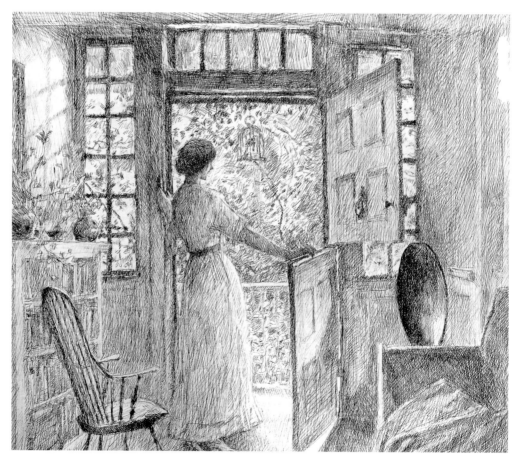

95

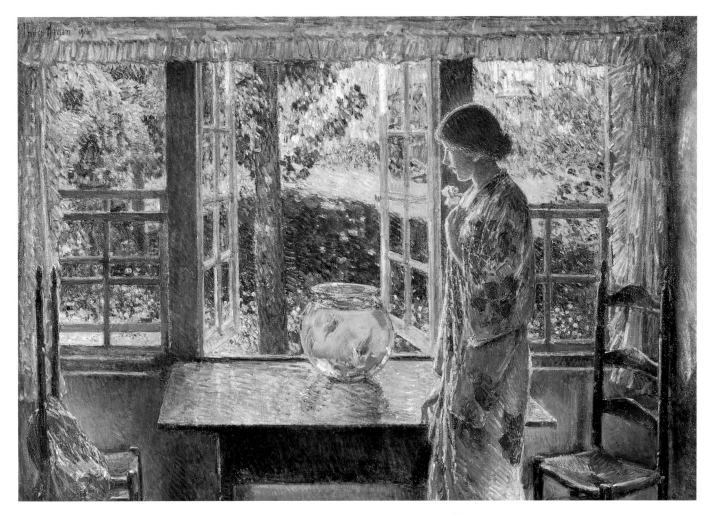

96

Childe Hassam, *The Goldfish Window*, 1916,
oil on canvas, 33 ¹/₂ x 49 ¹/₂ in. The Currier Gallery of Art,
Manchester, N.H., Currier Funds, 1937.2.

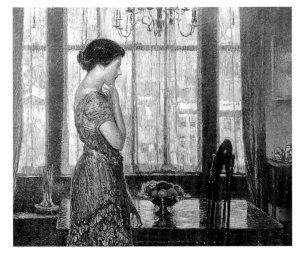

97

Childe Hassam, *The New York Winter Window*, 1918–19,
oil on canvas, 47 ¹/₂ x 57 ¹/₂ in. Private collection, photograph
courtesy of David David Gallery, Philadelphia.

lights that link her to the goldfish. Hassam has constructed an almost pantheistic union between woman, country home, and nature.

The artist's attitudes about the differences between city and country life are also revealed in the furniture. Apart from antiquity, the furnishings in the two interiors have little in common. The New York table is highly polished and elegant; the Cos Cob one, which remains in the Bush-Holley House, is a simple country piece with the wide overhang typical of Connecticut tables. The chair in the city dining room appears to be a William and Mary piece, a prized example of Pilgrim Century furniture. Its counterparts in Cos Cob are two rush-seated, slat-back chairs, a type so common in New England that antiquarian Luke Vincent Lockwood observed that "there was hardly a household that did not own one or more."[27] The rustic chair would have been out of place in the urban dining room. In Cos Cob, however, it evoked an American past that was simple, unsophisticated, and rural.

Hassam hired a local girl, Helen Burke, to pose for the two goldfish paintings and several other images.[28] Her youth (she was fourteen when she posed for *Bowl of Goldfish*) and the tight social network of the village imposed a strict propriety on the artist-model relationship from the moment the modeling session was scheduled. Hassam did not approach Helen; instead, Constant Holley MacRae arranged the appointment with her mother.

Helen was not Hassam's only model in Cos Cob. He was surrounded by women at the Holley House, and he depicted many of them. An unidentified woman relaxes with a book in *Couch on the Porch* (see fig. 67). Josephine Holley appears in a small panel (ca. 1902, collection of Mr. and Mrs. Hugh B. Vanderbilt); Constant Holley MacRae, carrying a basket of flowers up the steps of the old house, appears in an etching (fig. 98). Some of the women artists posed for Hassam, but he depicted them either idle or engaged in amateur activity.[29] Accomplished women novelists and playwrights also frequented Cos Cob, but Hassam depicted only one woman in the act of writing: his wife, Maude Doan Hassam, absorbed in social correspondence at *The Writing Desk* (fig. 99).

Mrs. Hassam posed in the north bedroom of the Holley House for *Morning Light* (fig. 100), another work in the Window series. The differences between *Morning Light* and the two goldfish paint-

Childe Hassam, *The Steps*, 1915, etching, 10¹⁄₂ x 7¹⁄₂ in.
The Metropolitan Museum of Art, Gift of Theodore De Witt,
1923 (23.65.78).

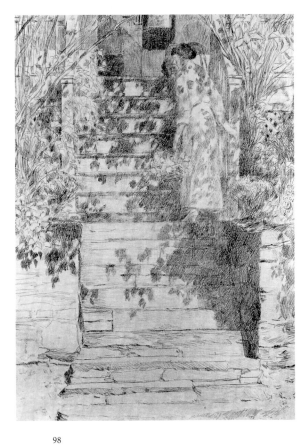

98

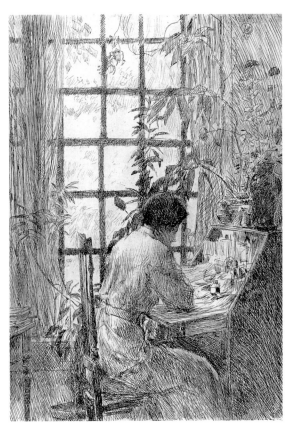

99

Childe Hassam, *The Writing Desk*, 1915, etching,
10 x 7 in. Library of Congress, Washington, D.C., FP—
XIX—Hassam (C.), no. 54 (A size) [P&P].

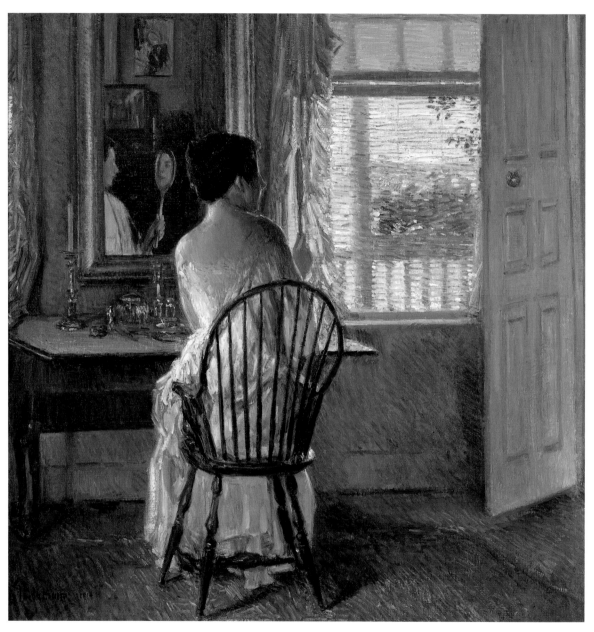

Childe Hassam, *Morning Light*, 1914, oil on canvas,
34 x 34 in. Private collection, photograph courtesy of Adelson
Galleries, New York.

ings are significant. The erotic element, implied only by the kimono in the canvases for which the teenager had posed, is more pronounced in *Morning Light*. The woman's peignoir slips from her shoulder, and the atmosphere of the boudoir perfumes the image.

The model's identity sets *Morning Light* apart from the other Cos Cob paintings in additional ways. The setting, nearly as enclosed as those in the New York Windows, shelters an intimate activity and implicitly declares the artist's unique sexual claim to his model. Mrs. Hassam's body is confined to the interior space, her view filtered through a bamboo blind. The composition is anchored by the graceful Windsor chair that was the Holleys' finest heirloom. An unmistakable emblem of tradition, it supports and shields the woman and ties together the four quarters of the composition. The window—the smallest in the Cos Cob series—reveals not a landscape but merely a window box of geraniums. The artifice implied in those cultivated plants is heightened by the facture; Hassam's parallel horizontal brushstrokes flatten the window into a scrap of patterned fabric.

The twinned rectangles of window and mirror represent two varieties of seeing. Like the artist, the model is engaged in the creation of an image. We do not see her whole but piece her together from mirrored fragments.[30] Standing behind her, we see her "real" back and right profile. Gazing over her shoulder into the large looking glass, we view her left profile and, in the reflection of her reflection in the hand mirror, the right half of her face. Further complicating the game of mirrors is the small looking glass atop a chest of drawers on the opposite wall of the room. Reflected in the large mirror, this glass might have revealed the artist painting the woman painting herself. Hassam obscured the ultimate reflection, however, sealing off the potential intrusion of the masculine realm in a scribble of illegible brushstrokes, just as he screened the window with the bamboo blind.

The still-life elements—the gleaming silver and glass objects on the dressing table—are uniquely sophisticated for a Cos Cob work; they probably belonged to Mrs. Hassam. Her elegant gesture sets her apart from the simple stance of the girl in the goldfish window. She is obviously urbane, even if the setting is not urban. The patrician elegance that Hassam accorded his wife in *Morning Light* marks her as a sophisticated lady of the upper class, which in fact she was. Like

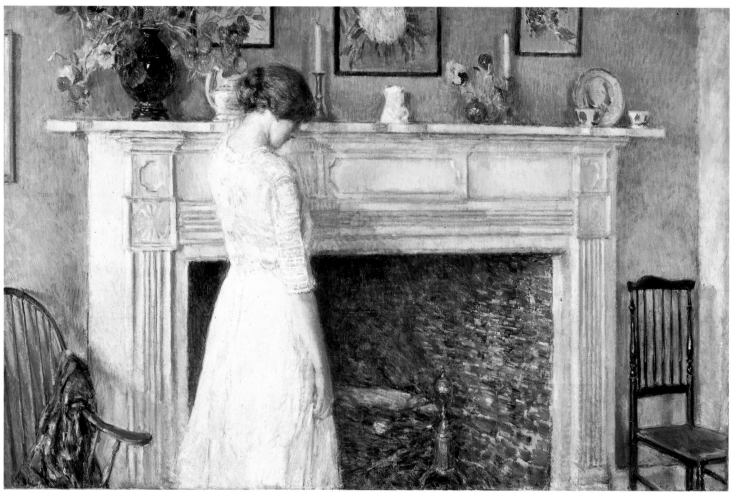

Childe Hassam, *In the Old House*, 1914, oil on canvas, 31 1/4 x 48 in. Private collection, photograph courtesy of Sotheby's, Inc.

her husband, Maude Doan Hassam came from a prosperous family long established in Massachusetts; like him, she took great pride in her ancestry.[31] In *Morning Light*, Hassam encoded his wife's social status, portraying her as an American aristocrat.

Helen Burke, in contrast, was a screen for Hassam's projections about gender, class, and tradition. This masking is nowhere more evident than in the painting entitled *In the Old House* (fig. 101), for which Helen posed in the Holley House dining room the same summer that Hassam painted *Morning Light*. A decade earlier, Wallace Nutting had photographed a model in eighteenth-century costume before the same fireplace (fig. 102). A shrewd businessman, Nutting recognized the popular appeal of a woman in a traditional interior as "a visual reminder of the good taste of the past . . . full of sentiment and historical suggestion."[32] In the summer of 1914, the ancestral hearth had special poignancy. Europe was at war, and Americans were anxious. Immigration that year swelled to a near-record high. The influx troubled Hassam, who lamented that his hometown, Dorchester, Massachusetts, had been taken over by "mongrels."[33] Professionally, he had watched artistic leadership pass to the modernist Europeans introduced by the Armory Show the year before. Even the definition of womanhood was undergoing dramatic transformation, as the

Wallace Nutting, *Reflections Are Ever Best*, 1904, photograph, 7$\frac{1}{2}$ x 9$\frac{1}{2}$ in. Historical Society of the Town of Greenwich.

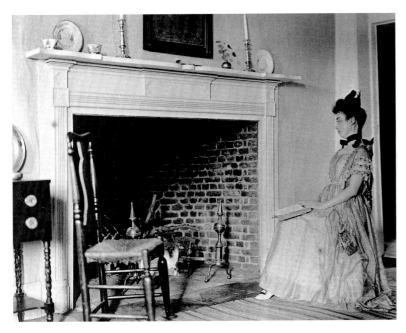

102

outgoing Gibson Girl and the career-oriented New Woman successively challenged conventions of female dress and deportment.[34] In that turbulent climate, the image of a demure woman at the hearth of an old house offered reassurance of the endurance of cherished values. Hassam's punning title declares his intention that the image be regarded as a cultural icon. The Holley House was commonly called the Old House, but most of Hassam's audience would have assumed that the phrase signified not one specific building but rather the paradigmatic American home.

Unlike Nutting, Hassam celebrated the survival of traditional values in the present era. His model, unlike the photographer's, wears twentieth-century clothing. No spinning wheel, bed warmer, or other obsolescent prop (which Nutting employed in many of his "Colonial pictures") appears in Hassam's composition. Several of the same objects are found in both the oil and the photograph: the pink lusterware tea set, the small round vase of nasturtiums, and the brass andirons (minus their steeple finials in the oil). In the decade between the photograph and the painting, however, the needlework sampler lost its privileged position over the mantelpiece to a group of Japanesque flower

Childe Hassam, *The White Kimono*, 1915, etching, 7 3/8 x 10 7/8 in. The Metropolitan Museum of Art, Harris Brisbane Dick Fund, 1917 (17.3.494).

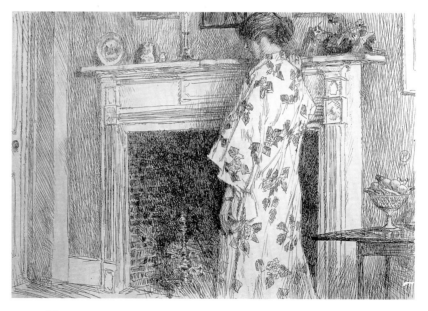

103

studies by MacRae, and some of the old china was replaced by a large aubergine vase, probably by art potter Leon Volkmar.[35] Although the watercolors and the vase were new, they were handmade by persons of taste close to the family, in keeping with the principles of the Arts and Crafts movement. By grouping them with the heirlooms around the mantelpiece, the Holleys expressed—and Hassam documented—continuity in tradition. Hassam combined tradition and cosmopolitanism in the etching *The White Kimono* (fig. 103), also set before the fireplace, in which Helen wears the familiar, time-defying kimono rather than the contemporary white dress shown in the painting.

In his two images of Helen at the hearth, Hassam combined the homespun quality of Nutting's photograph with the aestheticism of Whistler's *Symphony in White, No. 2* (fig. 104). For all three artists, the mantelpiece served as a display shelf for carefully selected objects. Only Hassam, however, aligned his model's head with the ornaments on the mantelpiece. Like them, she is an objet d'art. Unlike Whistler, Hassam revealed the interior of the fireplace, whose large size manifests its age and importance for cooking and heating. The hearth in this room dates to about 1732, when the house was built. The Federal-style mantel was added about one hundred years later. In giving such prominence to the fireplace opening, Hassam evoked the age-old equation between hearth and home. Helen faces the fireplace, obscuring her individuality and concentrating her attention, and ours, on the home's focus, the hearth.

Hassam seems originally to have planned to use his wife as the model for *In the Old House*. A small oil sketch for the painting (*The Mantelpiece*, Mr. and Mrs. Hugh B. Vanderbilt) portrays an older woman resembling Mrs. Hassam, a wedding ring gleaming on her left hand. Instead, Hassam hired Helen Burke. The role he assigned to Helen denied her ancestry, class, and personality. Unlike Mrs. Hassam, Helen was not born to such a genteel setting but lived over the tavern owned by her Irish immigrant parents. A gregarious and entrepreneurial young woman much in demand to play the latest songs at parties, she established her own business (a secretarial service) soon after she graduated from high school.[36] None of her vibrant self-assertiveness emerges in Hassam's painting, where every line of her posture conveys "feminine" diffidence.

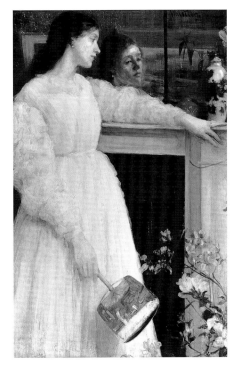

James A. McNeill Whistler, *Symphony in White, No. 2: The Little White Girl*, 1864–65, oil on canvas, 30⅛ x 20⅛ in. Photograph © Tate Gallery, London, 2000.

104

A comparison of *In the Old House* and another preparatory study (fig. 105) reveals the evolution of the painting. Some revisions enhanced the sense of enclosure and antiquity. In the oil panel, the model looks toward a door, which suggests a world beyond this quiet room. On the canvas, Hassam eliminated the door and bracketed both sides of his composition with chairs, replacing the common, rustic ladder-back that appears in the panel with a finer antique at the right of the fireplace and adding the Holleys' prize Windsor to the left. Other revisions promote more strongly a feminine ideal. In the oil sketch, the model wears a long-sleeved, high-necked shirtdress that leaves only her face and hands bare; in the canvas, Helen's lacy frock exposes her forearms and neck. Whereas the first model's dark hair contrasts starkly with the room's golden tonality, Helen's auburn tresses harmonize with the

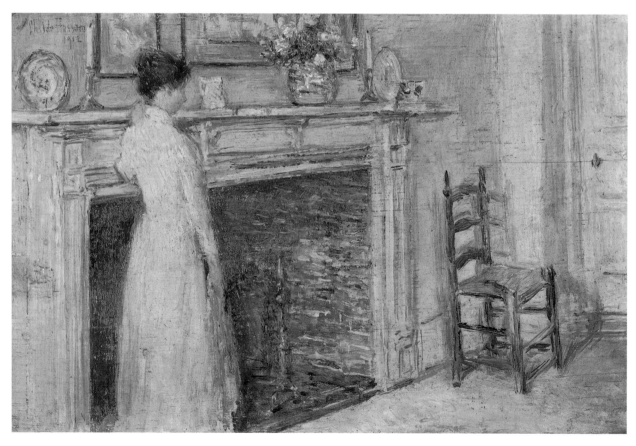

105

Childe Hassam, *The Fireplace*, 1912, oil on panel, 5 1/2 x 8 1/4 in. Private collection, photograph courtesy of Sotheby's, Inc.

apricot-colored walls, the old bricks, and the warm wood. Together with the white dress, which links her to the classical mantelpiece, this chromatic harmony expresses the identity of woman and home. The most significant change is in the model's posture. In the small panel, she stands erect, head up and eyes straight ahead. But on the canvas, with bowed head and downcast eyes, she seems reflective, even submissive.

In the Old House was used to suggest Hassam's own distinguished ancestry in a nativist appreciation of the artist published in 1923. Over a large reproduction of the painting, Frederic Newlin Price began his essay by contrasting Hassam's family with those of two colleagues whose working-class fathers were immigrants: "Phoenix-like, they rise out of the human fire—Twachtman's father, a Cincinnati policeman, Murphy's, a Chicago night-watchman. . . . The parentage of Childe Hassam is very different—from erudite Boston, from Stephen Hassam, clock maker and portrait painter."[37] Ironically, the bartender's daughter lent visual weight to the critic's class-conscious glorification of the artist's genealogy.

Like most Colonial Revival images, *In the Old House* celebrates an upper-middle-class ideal of American tradition. Knowing the identity of Hassam's model, we are able to measure the gap between real and ideal. *In the Old House*, which seems to represent the privileged proprietor at the hearth of her ancestral manse, actually depicts an Irish-American teenager in a boardinghouse that was neither her home nor the artist's. Hassam's art glorifies the rootedness of the Yankee gentility, but the creation of that art—his own seasonal wanderings, his reliance on a first-generation American model—involved the social transitions so troubling to conservatives of his day.

Hassam used the Holley House as the setting for some of his most sensitive figural works; in paintings like those discussed in this chapter, the rooms are gendered spaces, both setting and metaphor for the life of women. Surprisingly, the artist portrayed himself in one of the same rooms, but the differences between his images of women and his *Self-Portrait* (fig. 106) are telling. The setting of the self-portrait is almost entirely enclosed, but the composition and pose preclude any suggestion that Hassam has withdrawn into the domestic realm. He confronts the viewer's gaze, as do none of his female models. While the women occupy only about one-quarter of the pictorial

Childe Hassam, *Self-Portrait*, 1914, oil on canvas, 32 13/16 x 20 3/4 in. Courtesy of the American Academy of Arts and Letters, New York City.

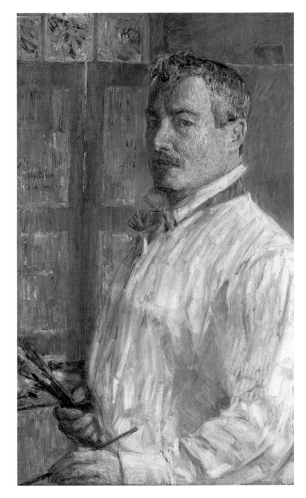

106

space, Hassam commands most of it. He does not belong in the room, as the women do; to the contrary, it belongs to him. And although he depicted his female models doing nothing, or nothing much, Hassam portrayed himself in the act of painting. Clutching a palette and a fistful of brushes in his right hand, wielding another brush with his left, he is an artist engaged in his work. The conventions of portraiture do not fully explain the differences between Hassam's *Self-Portrait* and such paintings as *Bowl of Goldfish* (see fig. 93). Instead, a comparison of the paintings reveals how the artist invested the same basic elements with contrasting, gendered meanings.

In the last decade of the nineteenth century and the first decade of the twentieth, the Cos Cob Impressionists expressed their ideals of home and family life in affectionate images of women and children. In *Stepping Stones* (see fig. 15), Robinson claimed a more active role for girls than his contemporaries usually did, but most of the figural images by Twachtman, Weir, and their circle promote the then-accepted cultural attitudes about female deportment. As changes in American society accelerated in the century's second decade, reality required further manipulation to sustain those nostalgic ideals. Hassam's paintings and etchings of women in the Holley House—and the parallel works he was producing in New York—encode attitudes about gender, class, and nationality that became more deeply entrenched the more they were threatened.

In 1894 the *Greenwich Graphic* ran a series of columns describing scenic buggy rides, one of which passed the Twachtman place. Adopting the rhythmic cadence of a trotting team, the columnist wrote: "On we go through Hangroot. . . , a locality filled with rocks and trees and Horse Neck brook making its way between, to the delight of that famous artist, J. H. Twachtman, who some years ago became so enamored of the spot that he settled there in a house that you will recognize immediately as the home of an artist. And it has been said that his pictures of these artistic nooks and rugged rocks have brought him, in hard cash, much more than all the land about them is worth."[1] The column was signed Ezekiel Lemondale, a name that conjures up a no-nonsense Yankee farmer, but in fact the author was lawyer Frederick A. Hubbard, a New Hampshire native who had grown up in Greenwich, graduated from the New York University Law School, and returned home to become active in civic affairs.[2] Despite his education and urban experience, Hubbard's comments betray the countryman's practical view of nature. "Lemondale" did not weigh the artistic merits of Twachtman's paintings; instead, he observed respectfully that they had earned more "in hard cash" than the real-estate value of their subject. He considered Twachtman's crop (his canvases) a clever alternative method of profiting from the land. For Lemondale/Hubbard and his neighbors, nature was primarily an economic resource. For Twachtman and the other art colonists, nature—whether shaped by humans or appar-

ently wild—was an aesthetic, recreational, and emotional resource. The Impressionists of Cos Cob sought in their lives and expressed in their art a personal response to their familiar natural environment—the intimate landscape that they knew, loved, and, in many cases, owned.

The paintings and drawings of the Cos Cob Impressionists portray three types of relationship with nature: the agrarian landscape, in which the land has been altered to support humans; the domestic landscape, in which the land has been altered to shelter and please humans; and the "natural" landscape, in which the land, presumably untouched, is appreciated for its own sake. The boundaries between these categories are fluid. Because many of the artists lived on the land they painted, an agrarian landscape might be, in a sense, domestic. And some of the "natural" areas were as deliberately cultivated as a perennial border.

The Agrarian Landscape

Images of the agrarian landscape are more plentiful in American Impressionism than historians have acknowledged. Twachtman, Hassam, Robinson, and especially Weir are among those who treated the theme, but its importance in their oeuvre has been largely overlooked, possibly for two reasons: it undermines the link with the French Impressionists, who focused on modern leisure, and it muddies the distinction between the Impressionists and earlier generations of American artists, for whom the agrarian landscape was a major subject. Views of fertile farmland have a long history in American art. They appeared in the background of colonial and federal portraits and decorated the overmantel panel in fine eighteenth- and early nineteenth-century homes. Prosperous farmers commissioned itinerant limners to paint estate portraits that inventoried their barns, stables, fields, and livestock. Between 1825 and about 1875, Frederic Edwin Church, George Inness, and others painted sweeping vistas of abundant farmland.

By the 1890s, agriculture—and its representation in the arts—had changed dramatically in the Northeast. The expanding railway network enabled midwestern farmers, whose flat fields were ideally suited to large-scale mechanized cultivation, to deliver their crops to markets in the East as speedily as their counterparts in New Eng-

land, where the hilly terrain and rocky soil made mechanization un-
profitable. The increased competition accelerated the flight of Yan-
kee youth to the cities, leaving farms to be subdivided for housing lots
and old farmhouses to be converted to vacation retreats for city
dwellers. The arts responded to these socioeconomic changes. Country
life was idealized in sentimental ballads about "The Dear Old Farm"
or "A Little Farm Well-Tilled." Stylish young people with no intention
of returning to the country gathered around pianos in city apart-
ments to croon such songs as "Go Back to the Rugged Old Farm, Boys"
or "The Reason We Mortgaged the Farm." [3]

In the visual arts, the changed cultural attitude is revealed in
a comparison of agrarian landscapes by representatives of the Hud-
son River School and the Cos Cob Clapboard School. In *West Rock, New
Haven* (fig. 107), Frederic Edwin Church depicted farmers loading
wagons with golden hay harvested from a field watered by a placid, wind-
ing stream. Tall hardwood trees (another valuable natural resource)
fill the middle ground and distance, which is punctuated by a white
church spire. Crowning the pastoral vista with sublime grandeur is West
Rock, a massive geological formation visible from miles around.
The high vantage point and expansive view suggest an inexhaustibly fer-
tile land, while steeple and rock endow the landscape with spiritual
and cosmic significance. Furthermore, as Franklin Kelly has established,
the place was hallowed by its association with an episode in Ameri-
can colonial history. [4] In this, his first masterpiece, Church used the agrar-
ian landscape to promote national ideals. He painted this scene in 1849,
not in the wide-open West but in New Haven, Connecticut.

About fifty years later and forty-seven miles to the southwest,
Twachtman took an entirely different approach to the subject of
haying. To create *Haystacks at Edge of Woods* (fig. 108), he positioned
himself in a nondescript field that lacked any landmarks to define
it as a remarkable place and selected a medium—pastel—suited to a
small scale, sketchy handling, and ultimately, private appreciation.
Instead of a vast panorama, Twachtman depicted a shallow space, parti-
tioned by a silvery split-rail fence and enclosed by the woods in the
background. Instead of haymakers at work, he sketched the results of
their labor: twinned haystacks, which seem as indigenous and inevi-
table in this landscape as boulders or oaks. The artist (and, by extension,

Frederic Edwin Church, *West Rock, New Haven*, 1849, oil on canvas, 26 ¹/₂ x 40 in. New Britain Museum of American Art, New Britain, Conn., John Butler Talcott Fund. Photo: E. Irving Blomstrann.

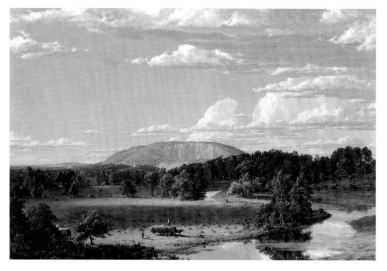

107

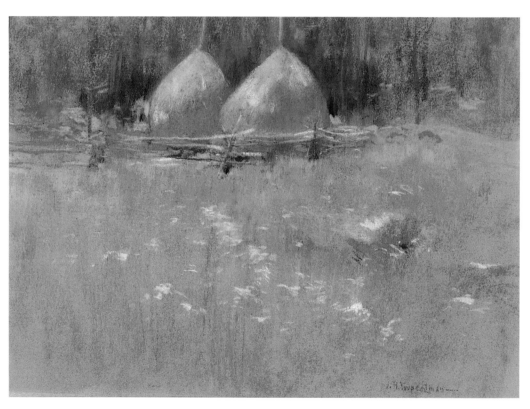

108

John H. Twachtman, *Haystacks at Edge of Woods*, ca. 1895, pastel on paperboard, 9¹/₂ x 14 in. National Museum of American Art, Smithsonian Institution, Gift of John Gellatly.

the viewer) is alone in this quiet corner; the overgrown field, sprigged
with wildflowers, is a place of intimate beauty.[5]

Twachtman's student Allen Tucker took a similar approach
in *October Cornfield* (fig. 109). Tucker's corn shocks, like Twacht-
man's haystacks, are represented as objects for contemplation, much
like the distant hills and trees. In a period of nostalgia for the old-
fashioned family farm, these products of hand labor were accorded a
veneration previously reserved for nature. Tucker's warm palette
captures the glow of evening light over the cornfield, while his vigorous
brushwork and evident delight in the juicy paint reinforce the impact
of a personal, emotional response to the subject.

By excluding the human figure from their agrarian landscapes,
Twachtman and Tucker muted the association with labor, thus support-
ing their view of nature as artistic inspiration and emotional solace.
Weir, by contrast, often included figures in his paintings of farmland, but
he, too, avoided any connotation of backbreaking drudgery. Work has
stopped in *Midday Rest in New England* (fig. 110); two men relax in the
shade, while a yoke of oxen, unhitched from the wagon just beyond
them, switch their tails sleepily in the noonday sun. Released from their

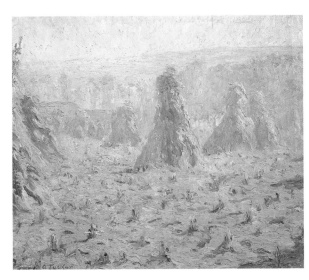

109

Allen Tucker, *October Cornfield*, 1909, oil on canvas,
25 x 30 in. Permanent Collection of The Art Students League
of New York. Copyright The Art Students League of
New York.

labors, men and beasts enjoy the fresh air and sunlight of a day in the country—a pleasure with which Weir's potential patrons could readily identify. By the late nineteenth century, oxen like those in *Midday Rest* had largely been replaced by draft horses on Connecticut farms, but Weir cherished the picturesque, antiquated aspects of agriculture.[6]

The Ice Cutters (fig. 111) also captures a scene of vanishing rural ways of life: two men cutting ice from a frozen pond. Such small-scale ice harvesting was old-fashioned by 1895, when Weir painted this canvas; large commercial icehouses on lakes and rivers from New York to Maine not only supplied the northeastern United States but also shipped ice to ports as remote as Calcutta.[7] But Weir depicted ice cutting as the farmer's traditional winter chore. By distancing the figures, minimizing the visible tools, and focusing on the natural setting, he avoided the implication of hard, cold labor. Instead, he employed the theme in a novel interpretation of the winter landscape. The glistening surface of the ice—smooth in some areas, rough in others—and the small figures in dark clothing recall seventeenth-century Dutch paintings of skaters on glassy canals.

With or without figures, Weir's paintings of the agrarian landscape convey his delight in his farms at Branchville and Windham, Connecticut, where he enjoyed scything and raking as much as

J. Alden Weir, *Midday Rest in New England*, 1897, oil on canvas, 39 5/8 x 50 3/8 in. Courtesy of the Pennsylvania Academy of the Fine Arts, Philadelphia. Gift of Isaac H. Clothier, Edward H. Coates, Dr. Francis W. Lewis, Robert C. Ogden, and Joseph G. Rosengarten.

174

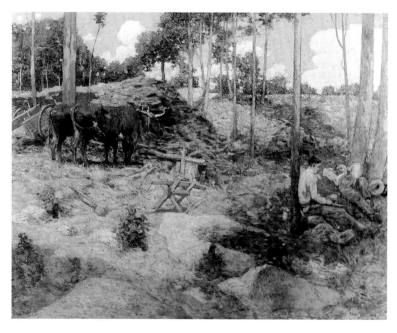

110

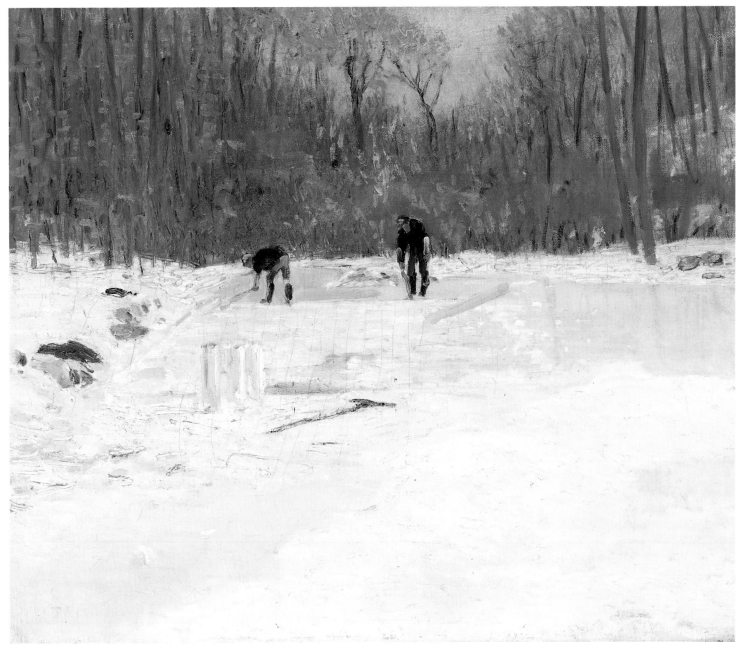

111

112

J. Alden Weir, *Midday*, 1891, oil on canvas, 34 x 24¹/₂ in.
Private collection.

fishing and hunting. While the red barn and fenced yard in *Midday* (fig. 112) are functional, commonplace structures, their small scale suggests that this is agriculture as recreation—a New World version of Marie Antoinette's *hameau* at Versailles. Weir rendered the barnyard decorative by using bright colors and a broken brushstroke and embellishing the top of the modest scene with a leafy branch.

For Matilda Browne, a long-time member of the Cos Cob art colony who also sojourned in Old Lyme, the agrarian landscape was an essential component of the cattle paintings that were her specialty. (When Browne's work was included in exhibitions at Old Lyme, her male colleagues there would tease her by saying to one another, "Let's go look at Tilly's calves.")[8] Browne's early work is in the rustic Barbizon tradition she developed during her studies under animal painters Julian Dupré in Paris and Henry Bisbing in Holland.[9] Eventually, however, she shifted to a more lyrical style in which the cattle are set at a distance from the viewer within an atmospheric landscape. In *August Morning* (fig. 113), the cows are depicted with convincing

Matilda Browne, *August Morning*, 1919, oil on canvas, 24 x 32 in. Bruce Museum, Greenwich, Conn., 00026.

113

anatomical accuracy, but the primary focus is the gentle light, which slants through a break in the trees and shimmers over the pasture. The cows, more than mere livestock, enhance the dreamy mood.

The Domestic Landscape

Whereas the agrarian landscape's significance in the work of the American Impressionists has been slighted, the domestic landscape has long been recognized as one of their signature themes. Home and garden provided endless inspiration to Twachtman and his circle, as it did to Monet and the other French painters of modern life. The Americans did not simply take their cues from their slightly older French counterparts, however; cultural currents in late nineteenth-century American life also shaped their preference for the intimate landscape. In the widely read *Nature for Its Own Sake* (1898), John C. Van Dyke celebrated the beauties of a mountain brook while dismissing Niagara Falls— by then the destination of generations of American tourists and the inspiration of countless paintings—as "merely a great horror of nature." [10] The local-color movement in literature, which emerged just after the Civil War and continued into the early twentieth century, marked a heightened interest in regional material. Sarah Orne Jewett's stories of the coast of Maine, Willa Cather's novels about prairie farms, and Irving Bacheller's narratives of the St. Lawrence River Valley are all aspects of a preference for the familiar, specific, and American. [11]

The new taste for the modest and commonplace corresponded to an increased nationalism—characteristics Americans shared with artists from other countries. In the last two decades of the nineteenth century, art students left Paris to return to England, Scandinavia, Australia, Russia, Spain, and the United States, most of them determined to translate into the idioms of their homelands the lessons of the ateliers and the example of the nonacademic artists whose work they had seen in exhibitions. Hamlin Garland's rallying cry in 1894 for American painters to take up native themes was a manifesto for a movement then well under way. [12]

In that cultural climate, it is no surprise that Weir could find inspiration in something as simple as a line of bleached laundry drying outside his barn-red farmhouse (fig. 114). Although the picture

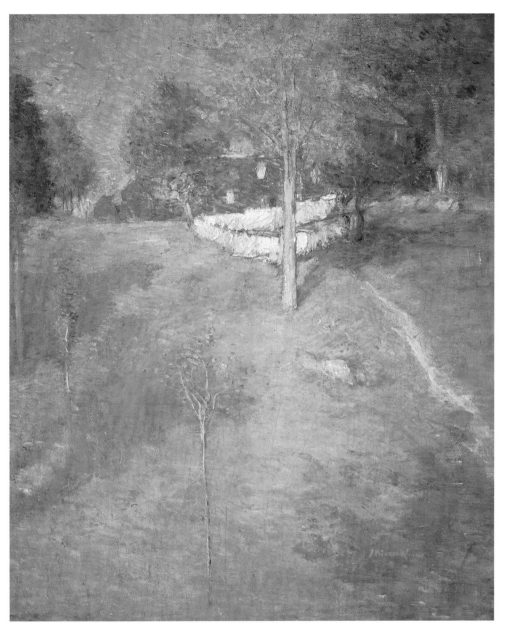

114

J. Alden Weir, *The Laundry, Branchville*, ca. 1894, oil on canvas, 30⅛ x 25¼ in. Weir Farm Trust, gift of Anna Weir Ely Smith and Gregory Smith.

depicts his home in Branchville, it exemplifies the aesthetic that Weir shared with his colleagues in Cos Cob. The homely subject matter is invigorated by modernist elements: a high horizon line, tilted ground plane, flattened forms, and nearly empty foreground enlivened with the Art Nouveau grace notes of saplings.

Weir, convinced that familiarity with one's subject matter was essential, urged Robinson to follow his and Twachtman's example. "He thinks I ought to have a place of my own and get acquainted with it—grow up with it. I must think of this—Coscob perhaps," Robinson noted in his diary on April 11, 1895. The idea had occurred to Robinson before. The previous summer, he had made the rounds with a Greenwich realtor and found a small house that he liked, "with trumpet-flowers over the stoop" and "some good apple-trees."[13] But perhaps for financial reasons, Robinson never became a homeowner. (Nor did Hassam, who could have afforded it, buy any property until late in life.) Robinson had, however, depicted a home he knew well: that of his friend Twachtman. During a visit in January 1892, he captured a view of the house in a photograph (fig. 115) and a painting (see fig. 13). A comparison of the two reveals that in his painting, Robinson was faithful to the visual facts. He tightened his focus on the house by eliminating the area to its left, but otherwise made a nearly literal transcription of the scene, down to the exact branching pattern of the trees. The only significant difference between the two is that more snow is visible in the painting than in the photograph. Robinson may have added it for aesthetic reasons, or he may simply have continued work on the canvas after another snowfall.

Twachtman painted two winter views of his house— *Snowbound* (fig. 116) and *Last Touch of Sun* (fig. 117)—from the same vantage point, under the same conditions, and possibly at the same time as Robinson. A comparison of Robinson's and Twachtman's oils offers rare insight into the effect of familiarity on the emotional content of the paintings. Whereas Robinson's portrayal of the house is coolly objective, Twachtman's are imbued with the warm affection of a proud homeowner. *Last Touch of Sun* conveys the sense of security the simple farmhouse represented to Twachtman. The composition is bracketed by Round Hill Road, curving into the distance at the left, and a birdhouse set atop a tall pole at the right. The house, a cozy

retreat from the busy world implied by the road, nestles into its setting, its white walls and snow-covered roof merging with the snowy land-scape. The row of corn shocks at the left is a vestige of the agrarian landscape, while the saplings in the foreground, neatly planted in parallel rows, mark Twachtman's endeavor to provide a sense of enclosure from the open farmland that surrounded his domain. The bird-

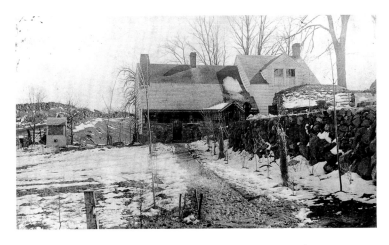

115

Theodore Robinson, *Snow Scene with House*, ca. 1892, photograph, 5$\frac{1}{2}$ x 9$\frac{1}{4}$ in. Terra Museum of American Art, Chicago. Gift of Ira Spanierman (c1985.1.24).

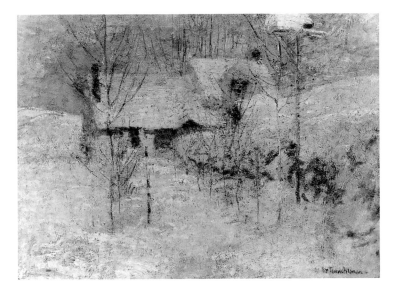

116

John H. Twachtman, *Snowbound*, early 1890s, oil on canvas, 22 x 30 in. The Montclair Art Museum, Montclair, N.J. Museum Purchase, Lang Acquisition Fund, 1951.33.

117

John H. Twachtman, *Last Touch of Sun*, ca. 1893, oil on canvas, 25 1/8 x 29 7/8 in. Manoogian Collection.

house, a miniature version of the human habitation, represents the mediation between nature and culture that was characteristic of Twachtman's landscaping (both literal and painterly). Setting a birdhouse near his home enabled Twachtman to observe its occupants day to day, becoming as familiar with them as with the trees he had planted nearby. The birdhouse is both a playful twist on the theme of home as haven and evidence of Twachtman's desire to know every aspect of his home ground.

In combination with the birdhouse, the snowy setting heightens the sense of security that radiates from *Last Touch of Sun*. Although the scene is bathed in sunlight, the day is cold. Recalling the time he had painted his view of Twachtman's house, Robinson wrote, "It was painted quickly as I was obliged to hurry—the day being a very cold one."[14] To the painter working at his easel in the open air, and to the viewer of the completed canvas, the house promises warmth and shelter—as the birdhouse does to its feathered occupants.

Twachtman exhibited *Last Touch of Sun* and a painting titled *Snowbound* in his joint exhibition with J. Alden Weir in May 1893. The second painting was most likely either the variant of *Last Touch of Sun* now at the Montclair Art Museum (see fig. 116) or another winter view of his house now in the collection of Scripps College (fig. 118).[15] In calling his painting *Snowbound*, Twachtman evoked powerful literary associations. To his contemporaries, the title would inevitably have recalled the famous narrative poem by John Greenleaf Whittier. Published to immediate acclaim in 1866, *Snow-Bound: A Winter Idyl* ran through numerous editions for the rest of the century. Whittier tapped the popular nostalgia for farm life in his reminiscence of a blizzard that confined an extended family to their cozy fireside:

> Shut in from all the world without,
> We sat the clean-winged hearth about,
> Content to let the north-wind roar
> In baffled rage at pane and door,
> .
> What matter how the north-wind raved?
> Blow high, blow low, not all its snow
> Could quench our hearth-fire's ruddy glow.[16]

Twachtman's title links his image of his home to Whittier's idealized evocation of traditional family life in the country.

In the Scripps College *Snowbound*, Twachtman used snow to reduce the view to its essentials. He set his easel on the edge of Round Hill Road across from his home. The snow-covered road, rushing past the house on a strong diagonal, dominates the foreground. Beside the road, a stone wall swings from lower right to center left in a compelling calligraphic line. Formally, the wall establishes the structure of the composition. Metaphorically, it represents New England. According to the 1871 report of the United States Commissioner of Agriculture, stone wall was the principal type of farm fencing in Maine, New Hampshire, Massachusetts, Rhode Island, and Connecticut. (In Vermont, a combination of stone and wood fencing predominated.)[17] Built by farmers clearing their fields before planting, and repaired and extended over the generations, many of the mortarless stone walls were disappearing by the 1890s. As Greenwich farms were divided for housing sites, numerous old walls tumbled into ruin in second-growth forest. On the remaining farms, walls were torn down to accommodate agricultural machinery, which demanded larger fields.

John H. Twachtman, *Snowbound*, 1890s, oil on canvas, 22 x 30⅛ in. Scripps College, Claremont, Calif., gift of General and Mrs. Edward Clinton Young, 1946.

184

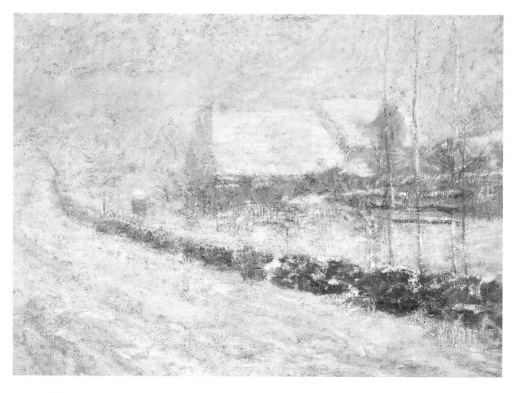

Meanwhile, a different type of wall was marking the boundaries of the new suburban plots. Constructed of quarried stone transported to the site and set in mortar by skilled Italian stonemasons, those precise walls retained the same rigid form indefinitely. The fashionable new style was not for Twachtman. He so admired the indigenous dry-stone masonry that he built new walls in the old manner to define the spaces in his garden. In an article on Twachtman's home published in *Country Life* in 1905, photographs show his handiwork in garden stairs, retaining walls, and edgings for perennial borders (fig. 119). The caption calls attention to the way "an artist handled native stone work," noting the random pattern of stones and the way they were fitted without mortar.[18] In the Scripps *Snowbound*, a traditional stone wall separates home ground from the public road.

Summer (fig. 120) also shows segments of dry-stone walling. Whether relics of the land's agricultural past or replicas built by Twachtman, they lie on the land as naturally as the rock outcroppings in the foreground. Painted after Twachtman had enlarged the house, *Summer* records his progress in integrating it with the landscape. The format, unusual for the artist, is a long horizontal that splits into two

John H. Twachtman, *Summer*, late 1890s, oil on canvas, 30 x 52 1/16 in. Acquired 1919. The Phillips Collection, Washington, D.C.

119

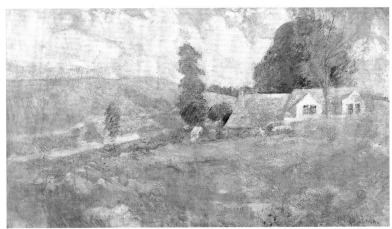

120

Stone wall and steps built by Twachtman on his Greenwich property. Photograph by Henry Troth. Reproduced from Alfred Henry Goodwin, "An Artist's Unspoiled Country Home," *Country Life in America* 8 (October 1905), p. 629. Photograph, The New York Public Library, Astor, Lenox and Tilden Foundations.

near-squares along the columnar central tree. The left half includes a neighbor's pasture, edged by a cow path meandering along Round Hill Road; the right half shows Twachtman's place. Large trees shade the house front and back, with smaller ones providing privacy along the road. The house hugs the hillside, its roofline a continuation of the land's contours, its dormered windows like eyes on the earth. The painting offers a broader vista and greater expanse of sky than is usual in Twachtman's Greenwich paintings. In *Summer*, he deviated from his usual format in order to relate his house to earth, trees, and sky.

Twachtman and the other Cos Cob Impressionists also integrated their homes with nature through the act of gardening; the gardens, in turn, provided subjects for more paintings. Weir captured the simple beauties of his vegetable garden at Branchville in *The Grey Trellis* (fig. 121). At the left, pole teepees provide support for the neat rows of bean plants. The unadorned trellis in the foreground indicates that one crop, probably peas, is finished for the season. Weir employed the geometric framework of the trellis in a sophisticated game of surface versus depth. Paralleling the picture plane, the larger part of the structure, together with the fan-shaped shrub at the right, forces recognition that the canvas is a two-dimensional, flat surface. That effect is challenged by the smaller section of trellis that angles into the pictorial space, its horizontals doubling as perspective lines. Above and through the interstices of trellis and shrub, the viewer glimpses a blossoming fruit tree, a birdhouse, the cultivated soil of the garden, a rustic fence, and the woods beyond. Weir borrowed the technique of a screening device from Japanese prints, but he domesticated the cosmopolitan influence in an engaging image of his home ground.

In the Garden (fig. 122) documents how Twachtman lined the path to his front door with perennial borders and set containers of flowering plants on either side of the steps. Here, close to the house, the landscape design is formal and symmetrical; the straight lines and right angles of the roof and pillars are echoed in the path, steps, and strip of lawn edging the border. For *The Peony Garden* (fig. 123), by contrast, D. Putnam Brinley chose a vantage point that obscures such edges. Brinley's palette links the cottage in Silvermine, Connecticut, where he settled about 1909, with the pink, red, and white peonies. The steeply pitched roof picks up the rosy tones and violet shadows of the flowers,

J. Alden Weir, *The Grey Trellis*, 1891, oil on canvas, 26 x 21 ½ in.
Private collection, photograph courtesy of Weir Farm.

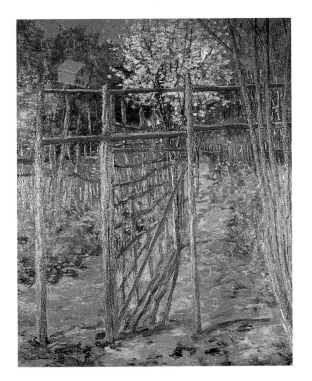

121

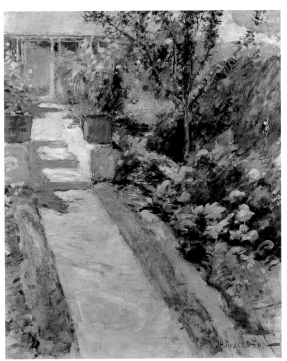

122

John H. Twachtman, *In the Garden (A Garden Path)*,
ca. 1895–1900, oil on canvas, 30 x 25 in. Private collection,
photograph courtesy of Vose Galleries of Boston.

which seem to spill from the house and rush toward the viewer in a cascade of color.[19]

The blossoms in the foreground of Brinley's *Peony Garden* form a decorative two-dimensional pattern, an effect that Elmer MacRae took a step further in his painting of the old-fashioned single hollyhocks that flourished near the Holley House (fig. 124). Mac-Rae painted *Hollyhocks* in 1914, and its flat, stylized, black-outlined forms reveal his indebtedness to the Post-Impressionist European paintings he had seen the previous year in the Armory Show. The allover design of *Hollyhocks* relates both to contemporary textile design and to early modernist abstractions, but Twachtman had created a comparable effect about two decades earlier. *Meadow Flowers* (fig. 125) depicts goldenrod and joe-pye weed, native American wildflowers that in late

D. Putnam Brinley, *The Peony Garden*, ca. 1912, oil on canvas, 45¼ x 40½ in. Virginia Museum of Fine Arts, Richmond. The Adolph D. and Wilkins C. Williams Fund. Photo: Ann Hutchison, © Virginia Museum of Fine Arts.

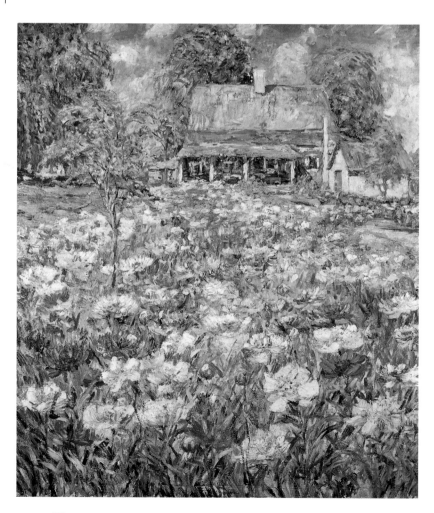

123

Elmer MacRae, *Hollyhocks*, 1914, oil on canvas, 32 x 24
in. Hirshhorn Museum and Sculpture Garden, Smithsonian
Institution, The Joseph H. Hirshhorn Bequest, 1981.
Photograph by Lee Stalsworth.

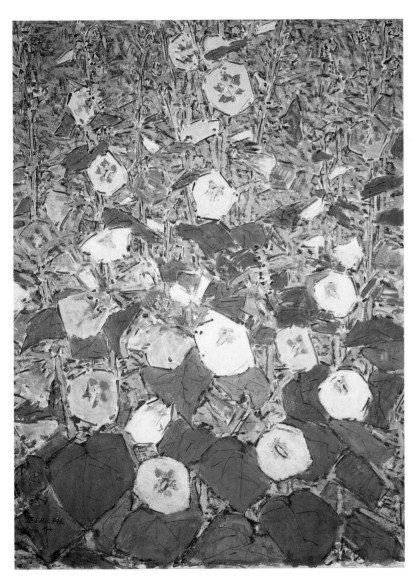

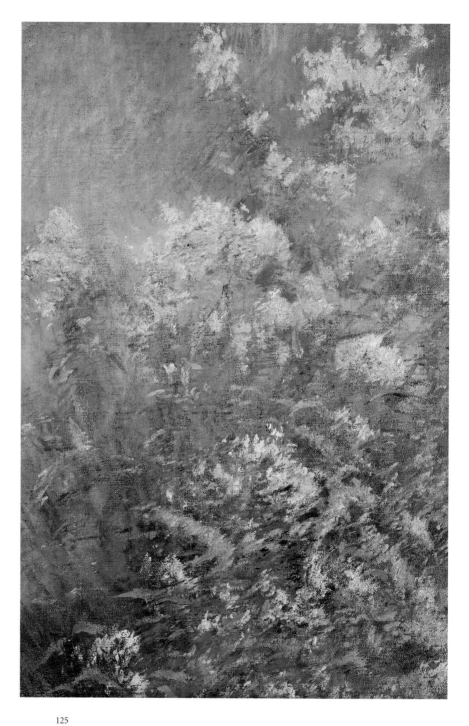

John H. Twachtman, *Meadow Flowers*, early
1890s, oil on canvas, 33 $^1/_{16}$ x 22 $^1/_{16}$ in. Brooklyn Museum
of Art, Polhemus Fund, 13.36.

summer flourish along the roadsides, in overgrown fields, and on the edges of woods. Omitting a horizon line and blocking spatial recession with a scumbled background of variegated green, Twachtman disposed the flowers on the upright rectangle of canvas as if on a curtain. He created an airy, loose pattern of the tasseled forms of the goldenrod and the globular blooms of the joe-pye weed. The horizontal swipes of paint with which he described the goldenrod's leaves combine with the plants' blurred forms to suggest that they are stirring in a gentle breeze.

The "Natural" Landscape

Meadow Flowers is an example of Twachtman's attraction to the apparently uncultivated parts of his property. The "natural" landscape is more closely associated with Twachtman than with any of the American Impressionists because he so frequently depicted the brook that rippled past his house. In fact, however, Twachtman had shaped the "wild" areas of his property as decisively as the straight paths and perennial beds near the house. When he acquired the place, it had been farmed to the edges of the stream. A turn-of-the-century photograph of Horseneck Falls shows only three or four tall trees and no understory of shrubs (fig. 126). By the time it was photographed for the *Country Life* article published in 1905 (fig. 127), the same site was lush and shady. Commenting on Twachtman's improvements, the essayist observed that "left to run unprotected and bare to the sun, as for other stretches of its length, the brook . . . might as well be a piece of irrigation"—as indeed it was for neighboring farmers. But, he reported approvingly, Twachtman had devised "mysteries and quaint nooks" for the brookside.[20] The artist had planted willows on the banks, sowed flowers in some areas, and even dammed the stream to create a swimming pool and a boating pond for his children. In short, Twachtman's gardening activities encompassed not just the ornamental borders near the house but also the "wild" area along the brook.

 A white footbridge was a transition between the domestic and the "natural" parts of Twachtman's garden.[21] *The Little Bridge* (fig. 128) harmonizes with the surrounding vegetation. Its latticed sides refract the sunlight as the foliage does; its slender supports echo the trunks

191

of the trees that shade it. By painting the bridge white instead of an earthy brown, green, or gray, however, Twachtman ensured that it would not disappear into the setting but would accent it.

Contrary to popular assumption, Twachtman probably did not model his bridge on Monet's in Giverny (fig. 129). Twachtman is unlikely to have built a bridge before spring 1892, after his purchase of an additional 13.4 acres in December 1891 provided him with land on both banks of Horseneck Brook. Monet's famous "Japanese bridge" over his waterlily pond was not in place until October 1893.[22] Monet first depicted it in 1895, but none of his bridge paintings were exhibited in the United States or reproduced anywhere during Twachtman's lifetime.[23] In fact, Twachtman may have depicted his little white footbridge as early as 1896 — years before collectors Henry and Louisine Havemeyer, who had a home in Greenwich, brought two of Monet's bridge paintings back to New York.[24] Furthermore, Twachtman's bridges

Horseneck Falls on Twachtman's Greenwich property, ca. 1890, photograph. Historical Society of the Town of Greenwich.

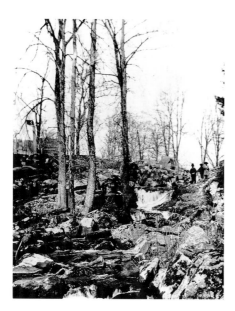

126

127

Horseneck Falls on Twachtman's Greenwich property, ca. 1905. Photograph by Henry Troth. Reproduced from Alfred Henry Goodwin, "An Artist's Unspoiled Country Home," *Country Life in America* 8 (October 1905), p. 625. Photograph, The New York Public Library, Astor, Lenox and Tilden Foundations.

128

John H. Twachtman, *The Little Bridge*, ca. 1896, oil
on canvas, 25 x 25 in. Georgia Museum of Art, University of
Georgia; Eva Underhill Holbrook Memorial Collection
of American Art, gift of Alfred H. Holbrook, GMOA 45.90.

bear only a general resemblance to Monet's. Still, as Hassam later disclosed, Twachtman's friends realized with dismay that people would assume he had been imitating the French master.[25]

Instead, Twachtman, like Monet, found his inspiration in Asian culture. Bridges are a common motif in Chinese paintings, Japanese woodblock prints, and the decorative arts of both countries.[26] Twachtman's aesthetic in using the bridge to ornament his garden resembles that of Japanese gardeners, as described by Edward S. Morse in his influential book *Japanese Homes and Their Surroundings* (1886). According to Morse, Japanese landscapers balanced the ephemeral beauties of blossoms and foliage with "enduring points of interest in the way of little ponds and bridges. . . . even the smallest pond will have a bridge of some kind thrown across." [27] Like his Asian counterparts, Twachtman contrasted the built forms of architecture with the softer forms of the surrounding vegetation.

Besides drawing inspiration from the principles of Asian gardens, Twachtman seems to have borrowed from them specific design ideas. The canopied central section of his little white bridge recalls the bridge-pavilions that appear in Chinese landscape paintings.[28] The canopy on Twachtman's bridge invited one to linger in its shade to enjoy the views of the brook, upstream and down. It also enabled the artist to paint in the open air protected from winter's snow or summer's blazing sun.

In another painting of the bridge (fig. 130), a zigzag jut in the span is more readily apparent than in the version now in the Georgia Museum of Art (see fig. 128). A zigzag span, which slows the pedestrian's pace and insistently reorients the gaze, is also derived from Asian models. The most famous example is the Eight-Plank Bridge, celebrated in Japanese literature, paintings, decorative arts, and woodblock prints (fig. 131), where nature lovers came every spring to meander above the blooming irises.[29] Instead of eight changes of direction, Twachtman's diminutive footbridge permitted only one, but that was sufficient to direct the gaze upstream and down.

In two other paintings (fig. 132 and a painting in the Minneapolis Institute of Arts), Twachtman depicted an arched bridge. That design, too, was identified with Asian gardens. Twachtman and his contemporaries would have seen examples in ukiyo-e prints and on the

Claude Monet, *Bridge over a Pool of Water Lilies*, 1899, oil on canvas, 36 ¹/₂ x 29 in. The Metropolitan Museum of Art, H. O. Havemeyer Collection, Bequest of Mrs. H. O. Havemeyer, 1929 (29.100.113).

129

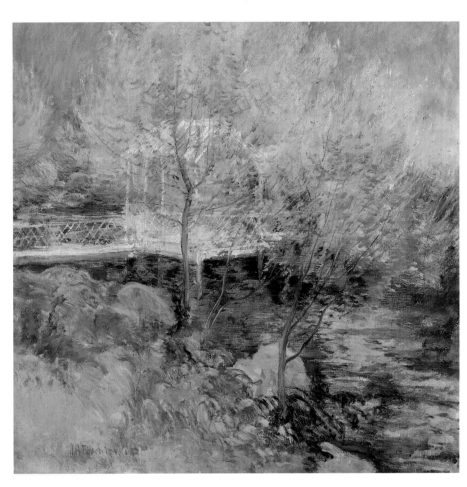

130

John H. Twachtman, *The White Bridge*, after 1895, oil on canvas, 29 ¹/₂ x 29 ¹/₂ in. Art Institute of Chicago, Mr. and Mrs. Martin A. Ryerson Collection, 1937.1042.

Blue Willow china so popular in their day. The arch provided an elevated vantage point for admiring the brookside landscape. It may also have had practical advantages. The forceful, direct paint application in the bridge painting now in Rochester (see fig. 132) indicates that it was painted at a later date than those in Georgia and Chicago (see figs. 128 and 130). If the earlier bridge washed away in seasonal flooding, the arched span would have provided an added measure of protection— and it would also permit the small rowboat pictured in Twachtman's painting to glide under it.

As ornament and vantage point, the bridge centered attention on Horseneck Brook. Twachtman's views of the stream and its cascade seem at first to betray no hint of human presence. On closer inspection, however, many images reveal the artist's efforts to reshape the once agricultural landscape to his own vision. In *Horseneck Falls, Greenwich, Connecticut* (fig. 133), for example, the rivulet is edged by two trees whose small size, symmetrical form, and careful spacing expose the gardener's hand. The brookside landscape, neither wilderness nor farmland, epitomizes nature and culture artfully balanced for human pleasure. It is, in a word, a garden.

Katsushika Hokusai, *Ancient View of Yatsuhashi in Mikawa Province*, ca. 1834, color woodblock print, 9⅞ x 15¼ in. Honolulu Academy of Arts, Gift of James A. Michener, 1970 (15,935).

131

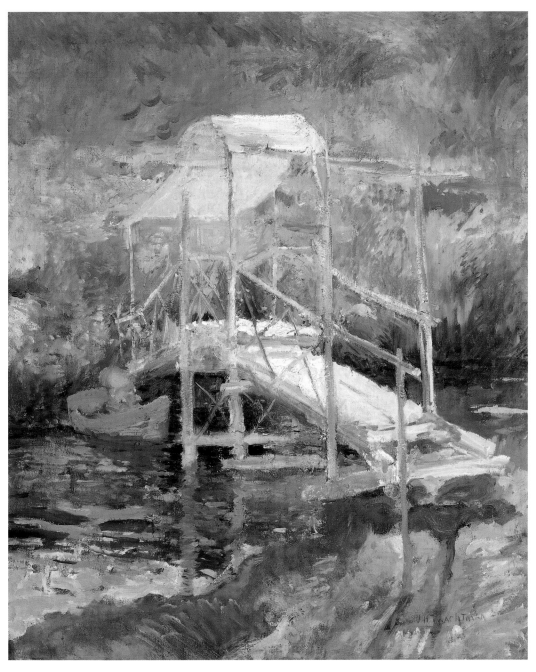

John H. Twachtman, *The White Bridge*, ca. 1900,
oil on canvas, 30¼ x 25⅛ in. Memorial Art Gallery of the
University of Rochester, Rochester, N.Y., Gift of
Emily Sibley Watson.

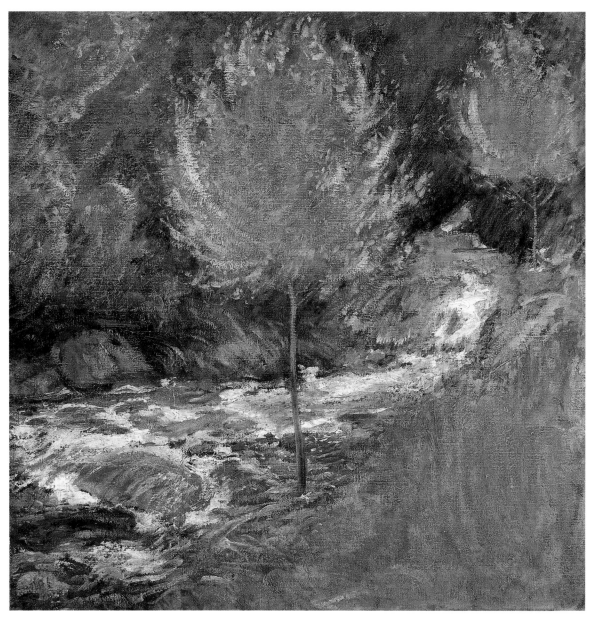

133

John H. Twachtman, *Horseneck Falls, Greenwich, Connecticut*, ca. 1890–1900, oil on canvas, 25 1/4 x 25 1/4 in. The Fine Arts Collection of The Hartford Steam Boiler Inspection and Insurance Company, Hartford, Conn.

A garden, regardless of its varied cultural expressions, was defined by the architects Charles Moore, William J. Mitchell, and William Turnbull, Jr., in 1988 as a place "where the streams and trees and flowers of the fields, and the rocks of the mountains, have been collected, or remembered, and ordered into an extension of ourselves onto the face of the earth. . . . Nature's places, no matter how beautiful and moving we may find them to be, are not yet gardens; they become gardens only when shaped by our actions and engaged with our dreams."[30] Twachtman's images of his property, both domestic and wild, record how he shaped the land, making it an extension of himself on the earth. The setting offered surprising variety within a small area. Just a few yards off Round Hill Road, Horseneck Brook tumbled down a rocky ravine, forming a series of small cascades as it splashed over the boulders in its path (see figs. 126 and 127). At the base of the falls, and for most of its course through Twachtman's property, the brook was (and is) shallow and narrow, rippling over mossy pebbles and between lichened outcroppings of quartz and granite. In one stretch, however, it expands to form a placid pool about twenty feet wide and four feet deep; Twachtman called this the Hemlock Pool and made it the subject of a masterly series of paintings.

In *The Hidden Pool* (fig. 134), Twachtman depicted the brook engulfed by lush foliage. He increased the sense of intimacy by hiding the horizon line and enclosing the viewer in a private glade. Centering his vortex-like composition on the point where the brook emerges from the woods, he wove a nearly abstract tapestry of greens and yellows. Generally, however, Twachtman found summer less inspiring than the other seasons. When he was staying in Branchville in December 1888, he wrote to a friend that "this is the finest time to be here. . . . The summer was rather green but now things are grey, subdued and refined."[31]

That "grey, subdued and refined" palette characterizes *Winter Harmony* (fig. 135), whose title and silvery tonality recall Twachtman's debt to Whistler. In other winter landscapes, however, Twachtman awakened dormant nature with bold, strongly contrasting colors. For *Icebound* (fig. 136), he employed a combination often seen on Asian porcelains: blue, white, and orange. The artist exploited the snow to simplify his palette, which he reduced still further by using tones of blue for the brook, rocks, tree trunks, and evergreens. He heightened to

a vivid orange the rusty brown of the leaves that cling to oaks through the winter, thus intensifying the blues by accenting them with their complementary color.

The familiar landscape appears in yet another guise in *Hemlock Pool* (fig. 137). The weather conditions that Twachtman portrayed on this canvas would have defeated most painters: the snow has nearly melted, leaving most of the earth exposed and no doubt muddy. But Twachtman captured the fleeting beauty of this transitional phase in an elegant palette of gold, violet, mauve, rose, warm gray, and gray-greens. His dynamic brushwork creates a pleasingly varied texture. The distant trees are thinly painted; heavy, painterly strokes define patches of snow; on the brook, a few flecks of violet predict a clearing sky.

In 1913 *Hemlock Pool* was one of the few paintings by a nonliving American to be included in the Armory Show. To provide a context for the daring new works they were featuring, the exhibi-

John H. Twachtman, *The Hidden Pool*, ca. 1899, oil on canvas, 22 x 27 ¹/₈ in. Freer Gallery of Art, Washington, D.C. Gift of Charles Lang Freer.

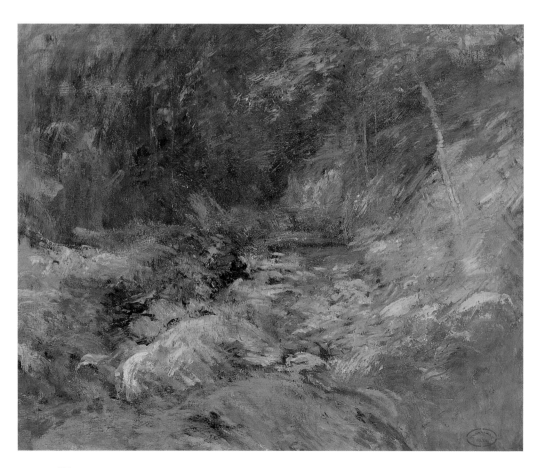

134

tion's organizers devoted four of the eighteen galleries to work by artists they considered predecessors of the modern movement. The Europeans represented in the historical survey included Monet, Renoir, and Degas—all of whom were still active—as well as Cézanne, Gauguin, Seurat, Toulouse-Lautrec, Van Gogh, and, going farther back, Corot, Courbet, Daumier, Delacroix, Goya, Manet, and Puvis de Chavannes. Only five Americans were presented as Old Masters. Mary Cassatt's work was hung with the French Impressionists, while paintings by Whistler, Albert Pinkham Ryder, Robinson, and Twachtman were exhibited with an assortment of nineteenth-century European artists.[32] The Cos Cob art colony had come full circle. In an exhibition that originated, in part, from the commitment to experimentation that had marked Twachtman's art, teaching, and exchanges with colleagues at his home and the Holley House, *Hemlock Pool* was installed as a precursor of American modernism.

John H. Twachtman, *Winter Harmony*, ca. 1890–1900, 25 3/4 x 32 in. National Gallery of Art, Washington, D.C., Gift of the Avalon Foundation.

201

136

John H. Twachtman, *Icebound* (also called *Snowbound*), ca. 1889, oil on canvas, 25 1/4 x 30 1/8 in. Art Institute of Chicago, Friends of American Art Collection, 1917.200.

John H. Twachtman, *Hemlock Pool*, ca. 1900, oil on canvas, 29 7/8 x 24 7/8 in. © Addison Gallery of American Art, Phillips Academy, Andover, Mass. All rights reserved. Gift of anonymous donor, 1928.34.

137

The intimate landscapes of the Cos Cob Impressionists express their emotional response to the environments they had chosen with careful deliberation. True, they painted what was before them, but only after they had searched out a setting that would sustain and inspire them. Those who were homeowners went further, remodeling their houses and planting their gardens until, as the *Country Life* essayist wrote of Twachtman's place, their home ground was "a piece of autobiography." When they painted their familiar places, the artists adjusted their viewpoints and modified their techniques to enhance the sense of intimacy. Historian Simon Schama has observed that "landscapes are culture before they are nature; constructs of the imagination projected onto wood and water and rock." [33] The Cos Cob Impressionists drew on an array of sources, Asian, European, and American, to express their response to their familiar landscapes.

Taken as a whole, the work of the Cos Cob Impressionists—intimate landscapes, images of women and children, architectural images, and nautical landscapes—evokes the sense of change that permeated life in Greenwich, Connecticut, at the end of the nineteenth century and the beginning of the twentieth. Yet the iconographical significance of the Cos Cob pictures emerges less from individual works than from clusters of images. To consider Robinson's yacht-club paintings while ignoring those of the shipyard, for example, would be to miss half the point of his carefully balanced study of Cos Cob's nautical landscape. Hassam's images of women at the Holley House demand comparison with the contemporaneous works he was producing in New York. And the "natural" landscapes for which Twachtman is best known acquire greater complexity when considered as one aspect of the garden, a concept that also encompasses such domestic images as his paintings of his house and the plantings with which he surrounded it.

The paintings of the Cos Cob Impressionists are more popular today than they were in the artists' lifetimes, largely because they seem to offer respite from the stresses of modern life. But a thoughtful study of the Cos Cob artists' themes reveals a profound resonance with our own hectic times. At both turns of the century we find technological change of breathtaking speed and far-reaching implications, widespread anxiety about immigration and its challenge to the status quo,

the creation of enormous new fortunes, and a widening gap between rich and poor. To recognize the dynamic ambiguity of the work of the Cos Cob artists is to discover a richer complexity than any wishful escape to a past that never was. Writing of Impressionism's enduring appeal, Robert Herbert observed, "the only history that we feel deeply is the kind that is useful to us."[34] A truer understanding of the Cos Cob Impressionists enables us not to construct the past of our day-dreams but to examine more thoughtfully the tensions and ambivalence that marked both their times and ours.

Chronology

1848

December 27: The first train crosses the Mianus River bridge, completing the railroad link between New York and Greenwich.

1870

The first Cos Cob train station opens to accommodate the increasing numbers of New Yorkers spending all or part of the summer in Greenwich.

1873–74

Edward P. Holley and his wife, Josephine Lyon Holley, build a large boardinghouse on Stanwich Road in Greenwich. The establishment is known as Holly Farm.

1876

July: Robert W. Weir retires from West Point. He and his wife begin boarding occasionally at Holly Farm.

1877

The bank forecloses on Edward P. Holley, but he and Josephine continue to operate the boardinghouse.

September: Charles Stanley Reinhart paints near Holly Farm.

October: J. Alden Weir returns from study in Europe.

1878

J. Alden Weir and John H. Twachtman have studios in the University Building on Washington Square in New York. According to the later reminiscences of Constant Holley MacRae, they boarded at Holly Farm in 1878 and 1879.

David Johnson paints *View near Greenwich, Connecticut*. Other canvases by Johnson with Greenwich or Cos Cob titles are dated 1880 and 1889.

1879

Summer: Twachtman and Weir board at Holly Farm.

Autumn: Twachtman moves back to his hometown, Cincinnati.

1880

October 1: J. Alden Weir writes to his half-brother John F. Weir from Holly Farm, where he has been painting landscapes and still lifes.

1881

Summer: Newlyweds John and Martha Twachtman paint in Holland with J. Alden Weir and John Ferguson Weir.

1882

March 4: The local newspaper reports that Edward P. Holley has rented an old house in Cos Cob and is preparing for summer boarders.

May: "Holly House" in Cos Cob is listed among boardinghouses ready to accept guests for the season.

July: J. Alden Weir acquires a farm at Branchville, Connecticut, about twenty-five miles from Greenwich. He will spend part of each year at Branchville for the rest of his life.

1883

April 24: Weir marries Anna Dwight Baker.

1884

The Holleys buy the old house in Cos Cob where they have been living and accommodating boarders since 1882.

1886

The first major exhibition of French Impressionist paintings and pastels in the United States, organized by the Parisian dealer Paul Durand-Ruel, is shown in New York at the American Art Association and the National Academy of Design.

1888

Spring: Art collectors Henry and Louisine Havemeyer buy the property near the Mianus River where they will build their country home, Hilltop.

June: The *Greenwich Graphic* reports that an artist boarding in Cos Cob is building a studio.

Summer to the end of the year: Twachtman boards near Weir's farm in Branchville; the two artists experiment with pastels and etchings. Twachtman also creates oils, pastels, watercolors, and etchings in Bridgeport, Connecticut, twenty-nine miles up the coast from Greenwich.

1889

February: Twachtman and Weir have a joint exhibition and sale in New York.

Summer: Twachtman, who is certainly settled in Greenwich by June, teaches in Newport, Rhode Island.

Autumn: Twachtman begins teaching at the Art Students League. He joins the Players Club, which will be his New York base for the rest of his life. Childe Hassam and his wife, recently returned from Paris, settle in New York.

1890

Hassam meets Twachtman and Weir in New York.

February 18: Twachtman buys three acres and the house on Round Hill Road where he has been living as a renter.

June: the Havemeyers' Greenwich house, Hilltop, is ready for occupancy.

Summer: Twachtman likely begins teaching summer classes at the Holley House, possibly in collaboration with Weir.

Leonard Ochtman paints in the Mianus section of Greenwich (now Riverside) from early June to late October.

Charles Warren Eaton boards and paints in the Stanwich section of town.

1891

Spring: Henry C. White visits Twachtman, sketches in Greenwich.

May: Ochtman buys a house and land on Sheephill Road in Riverside, near the Havemeyers.

June 23: Ochtman and Mina Fonda are married and settle in Riverside.

Summer: Twachtman conducts classes in Cos Cob, possibly with Weir.

December 2: Twachtman buys an additional 13.4 acres near his home.

1892

January: Theodore Robinson visits Twachtman in Greenwich and paints a view of his house in the snow before returning to Giverny, France.

February 8: Anna Baker Weir dies about one week after birth of her third daughter.

Summer: Twachtman and Weir teach in Cos Cob. Ernest Lawson and Allen Tucker are among the students.

July 16: The *Greenwich Graphic* reports, "The artists boarding at Mrs. Holly's [*sic*] gave an entertainment on Monday evening consisting of tableaux, after which there were refreshments and dancing."

December: Robinson, newly returned from France, spends Christmas with the Twachtmans.

1893

May: An exhibition of works by Twachtman, Weir, Claude Monet, and Paul-Albert Besnard is held at the American Art Galleries in New York.

Mid-May–mid-July: Robinson and Henry Fitch Taylor board at the farmhouse of Captain Lewis Augustus Merritt, across Round Hill Road from Twachtman's.

Summer: Twachtman and Weir teach in Cos Cob.

October 29: Weir marries Ella Baker, his first wife's older sister, in Boston. Twachtman is best man; he sees Japanese prints at the Museum of Fine Arts, Boston.

October 31–November 8: Robinson boards at the Merritt farmhouse.

November: Twachtman and Weir have a joint exhibition at Saint Botolph Club, Boston.

1894

Summer: Robinson spends most of the summer in Greenwich and Cos Cob. Taylor is with him for much of

his stay. During the summer, Robinson visits Weir at Branchville, the Ochtmans at Riverside, and frequently sees Twachtman, who is teaching summer classes in Cos Cob without Weir's assistance. Hassam visits the Twachtmans.

July and August: Walter Nettleton teaches an outdoor painting class in the Belle Haven section of Greenwich.

August 25: Lawson and Allen Butler Talcott are in Cos Cob after a sojourn in France. Lawson lives in the area until early November.

1895

Summer: Twachtman teaches at Cos Cob. His summer classes this year are affiliated with the Brooklyn Art Association.

Robert Reid exhibits *Twachtman's Valley at Sunset* at the Society of American Artists. In reviewing the exhibition, the critic for *Art Amateur* remarks that Twachtman's place is "a regular rendezvous for Impressionists."

Novelist Irving Bacheller and publisher Charles Day Lanier settle in Greenwich.

1896

April 2: Robinson dies in New York.

Hassam paints five oils in Cos Cob.

Summer: Twachtman teaches in Cos Cob; among his students are Elmer MacRae and Genjiro Yeto. The Ochtmans, now with three children, move from Riverside to Grayledge, the house they built on Valley Road in Cos Cob, about two miles from the Holley House. Leonard Ochtman teaches outdoor painting near his home; his students, who include Clark Voorhees, board in the neighborhood.

1897

Summer: Twachtman teaches in Cos Cob; among the students are MacRae, Yeto, Mary Roberts, and Alice Judson.

Hassam paints *Sunlight on an Old House, Putnam Cottage* and *The Children*.

December: The "Cos Cob Exhibition" of summer students' work is held at the Art Students League. Twachtman, Hassam, and Weir organize Ten American Painters ("The Ten") to mount independent exhibitions of their work free from the conservative juries of the National Academy of Design and the Society of American Artists.

1898

March 30–April 16: The first exhibition of Ten American Painters is held at Durand-Ruel Galleries in New York. The organization remains active until 1919.

Summer: Twachtman and Bryson Burroughs conduct the Art Students League's first official summer school in Norwich, Connecticut. Instead of going to Norwich, some former summer students work together in Cos Cob.

Autumn: Hassam is at the Holley House.

1899

Early January: Twachtman holds classes at the Holley House for thirty to thirty-five students.

January 28–29: Fire destroys the Cos Cob mill and several adjacent buildings.

Summer: Twachtman teaches in Cos Cob. MacRae and Blondelle Malone are among the students; both stay on at the Holley House after classes end.

July 22: The article "A Small Art Colony," on the first page of the New York *Commercial Advertiser*, describes the art colony without divulging its location, remarking, "Never mind where it is; if all the world knew, the old place would be spoiled."

September: The article "An Art School at Cos Cob," in the *Art Interchange*, quotes Twachtman's advice to his students.

Autumn: Hassam paints *Indian Summer in Colonial Days*, depicting Putnam Cottage, a Revolutionary landmark about one mile from the Holley House.

By December 9: The Twachtmans store most of their possessions, lease their home, and move to Putnam Cottage. Twachtman will never again live in his house on Round Hill Road.

1900

Ernest Thompson Seton buys land in Cos Cob.

Charles Ebert lives in Cos Cob, in or near the Holley House, until his marriage to former Twachtman student Mary Roberts in 1903.

February–March: A joint exhibition of John H. Twachtman and his son Alden Twachtman is held at Saint Botolph Club, Boston; it travels to the Cincinnati Art Museum in April.

Summer: Twachtman is in Gloucester. MacRae attempts to organize a summer class in Cos Cob, but his account books record tuition from only one student.

July 14: *Harper's Bazaar* carries a feature on the art colony, "Midsummer Days at Cos Cob," by Elizabeth Young.

October 16: MacRae marries Constant Holley at the Holley House, where they will spend their entire married life.

1901

Twachtman conducts summer school in Gloucester, then moves into the Holley House, which will be his primary residence until May 1902 (his wife and most of their children are in France, where the eldest, Alden, is studying art on a fellowship). Other artists living at the Holley House for all or part of that time include MacRae, Taylor, Ebert, Roberts, Yeto, and Carolyn Mase.

Lincoln Steffens, a regular at the Holley House, buys seventy acres in North Mianus.

1902

February: August Jaccaci buys ninety-two acres adjoining Steffens's property.

Twachtman is at the Holley House with few interruptions until May, when he goes to Gloucester, where he dies on August 8.

Hassam spends extended time in Cos Cob from early summer into the autumn, producing more than twenty pastels and at least five oils.

Steffens rents a house near the Holleys' from 1902 until 1905.

Improvements are made to the Holley House, including the installation of an indoor bathroom, the addition of skylights, and the enlargement of the north bedroom and the dining room, with a wall of windows added to the dining room.

September 2: Sculptor Edward Clark Potter buys a house on North Street.

1903

The Art Students League publishes a brochure announcing "The Cos Cob Summer School," under instructors Frank DuMond and Will Howe Foote, to be held from June 1 to October 3. At a meeting of the League's Board of Control on May 8, however, it is decided to change the school's location from Cos Cob to Old Lyme.

Hassam visits Cos Cob and the Isles of Shoals. He also visits Old Lyme for the first time.

Will Howe Foote paints a view of the Palmer & Duff Shipyard.

Charles Ebert marries Mary Roberts; they settle in Greenwich.

October 31: A Halloween party at the Holley House is attended by Taylor, Steffens, Mase, Katherine Metcalf Roof, Winfield Scott Moody, and others.

1904

October 31: Constant Holley MacRae gives birth to twins Clarissa and Constant at the Holley House.

1905

May: Steffens buys Little Point, a house near the Riverside Yacht Club, where he lives for much of each year until 1911. An article on Steffens in the *Greenwich Graphic* ("The Great Writer on Graft," August 26, 1906, p. 1, cols. 1–3) mentions other "literary workers who make Greenwich their home": Wallace Irwin, Richard Le Gallienne, Don Seitz, Bert Leston Taylor, Gilman Hall, Ray Brown, James McArthur, and Harry Leon Wilson, who is there with his wife, illustrator Rose O'Neill. Other writers and editors not named in the article who were then spending at least part of each year in Greenwich were Viola Roseboro', Clyde Fitch, Ridgely Torrence, Winfield Scott Moody, and William Vaughn Moody.

1906

Henry Winslow produces the etching *Cos Cob* (Boston Public Library), depicting the Palmer & Duff Shipyard.

1907

Hassam paints *The Fishermen, Cos Cob*.

The Palmer & Duff Shipyard shuts down.

The Cos Cob power plant begins operation, supplying electric power to the New Haven line and showering the neighborhood with soot.

1908

October 9–31: MacRae mounts his first solo exhibition, at the Holley House. The *New York World* covers the exhibition, and more than two hundred visitors come.

December 4: Robert M. Bruce bequeaths his home to the town of Greenwich to be used as a museum of natural history, history, and art. (Bruce dies on February 25, 1909.)

1909

Steffens lives in Riverside year-round during his wife's terminal illness in 1909–10.

Birge Harrison visits Cos Cob periodically until about 1915.

October 6–13: MacRae's second exhibition at the Holley House is featured in the *New York Herald*.

1910

Sculptor Lila Wheelock Howard and her husband, cartoonist Oscar F. Howard, live in Cos Cob until about 1916.

Summer: Leonard Ochtman teaches the New York Summer School in Mianus. Harriet Randall Lumis is among his students this year and next.

July: Walter Lippmann lives at the Riverside Yacht Club while working as Steffens's assistant.

October 5–10: MacRae's third exhibition at the Holley House merits a lengthy column in the *New York Evening World*.

December 7: In a speech in New Britain, Connecticut, Steffens accuses the Greenwich town government of corruption. His accusation provokes resentment in Greenwich, although many residents concede that what he says is true.

December 30: Steffens defends his statement at a heated public meeting in Greenwich.

1911

January 7: Steffens's wife, Josephine Bontecou Steffens, dies. He spends less time at Little Point after this, but he doesn't sell the property until 1921.

Spring: The Greenwich Society of Artists is organized.

Summer: The Hassams are in Cos Cob. Leonard Ochtman teaches the New York Summer School in Mianus.

November: A public appeal is made for cash and collections for the new Bruce Museum; local newspapers run adverse editorials; selectmen and the public are apathetic.

Early December: MacRae, Taylor, Walt Kuhn, and Jerome Myers initiate the concept of an international exhibition of modern art.

December 19: The Association of American Painters and Sculptors, the organization that will sponsor the Armory Show of 1913, holds its first meeting.

1912

Sometime around 1912, painter Lucia Fairchild Fuller is at the Holley House, together with the Hassams, their niece, and several magazine writers.

January: The Greenwich Society of Artists adopts a constitution.

Hassam works in Cos Cob, producing at least three oils.

September 28–October 26: The Greenwich Society of Artists holds its first annual exhibition at the Bruce Museum, which opens to the public for the first time.

December 5–22: A GSA exhibition of watercolors, pastels, and drawings is held at the Bruce Museum.

1913

Hassam paints *Clarissa's Window* at the Holley House.

Kerr Eby rents an apartment on the Lower Landing, where he lives until 1917.

February 15–March 15: The *International Exhibition of Modern Art* (the Armory Show) is held at the 69th Regiment Armory, New York.

September 15–October 15: The GSA's second annual exhibition is held at the Bruce Museum.

December 15–January 15, 1914: A GSA exhibition of watercolors and pastels is held at the Bruce Museum.

1914

June 20–August 2: The third annual exhibition of the GSA includes work by Hassam and Weir. No further exhibitions are held until 1919 because of World War I.

Summer: Hassam paints in Cos Cob; results include *Couch on the Porch, In the Old House, Morning Light* (all depicting women) and *Self-Portrait*, dated June 7, 1914.

Willa Cather works this year and next on the novel *The Song of the Lark*, which contains a reference to Cos Cob.

1915

Hassam takes up etching in Cos Cob; with help from Kerr Eby, he produces thirty prints depicting people and buildings in the village.

Jean Webster's novel *Dear Enemy* is published. A sequel to her highly successful *Daddy-Long-Legs* (1912), it features Dr. Sandy MacRae, whose name (and possibly personality) is borrowed from Elmer ("Sandy") MacRae.

1916

April 20: Josephine Holley dies of pneumonia in Greenwich Hospital.

Hassam produces at least two oils and a suite of watercolors at the Holley House. He exhibits the watercolors in 1917 as "the Cos Cob Set."

Other residents or guests at the Holley House include artists Carolyn Mase and Mary Roberts Ebert, poet Ridgely Torrence and his wife Olivia Dunbar Torrence, cartoonist Oscar Howard and his wife, sculptor Lila Howard, and singer Greta Torpadie.

1917

Hassam produces etching *Helen Burke*, showing his favorite Cos Cob model under an apple tree.

After Irving Bacheller's Riverside house is destroyed by fire, he moves to Winter Park, Florida.

Kerr Eby enlists in the army; later, he translates his wartime sketches into powerful etchings and lithographs.

1919

Prohibition forces Tobias Burke to close his tavern in Cos Cob.

The Eberts move to Old Lyme.

May 18–October 18: The GSA's exhibition at the Bruce Museum, its first since 1914, is distinguished by prominent guest exhibitors, including Hassam. (Perhaps because of the uncertainty engendered by the long hiatus, the exhibition is not designated an "annual.")

By August: Hassam buys a house in East Hampton, Long Island. Henceforth, he divides his time between East Hampton and New York, abandoning the seasonal wanderings that had often led to Cos Cob.

1920

June 19–October 3: The GSA's fourth annual exhibition at the Bruce Museum. The GSA mounts annual exhibitions there until 1926.

1921

Steffens sells Little Point.

1922

Georgia O'Keeffe paints *Skunk Cabbage (Cos Cob)* (Williams College Museum of Art), after visiting a friend in Cos Cob.

1927

The GSA does not mount an exhibition, probably because its principal organizers, Leonard Ochtman and his daughter Dorothy Ochtman, are in Europe.

1928

The GSA's exhibition is held at the Greenwich Library, where the organization continues to exhibit for many years.

1930

Dorothy Ochtman writes in *The American Magazine of Art:* "Greenwich can hardly be called a summer art colony, as most of the artists have their permanent homes and studios there and live there all the year."

1931

The Autobiography of Lincoln Steffens is published and becomes a best-seller. One chapter is devoted to the Cos Cob art colony.

1934

October 27: Leonard Ochtman dies at Grayledge.

1953

April 3: Elmer MacRae dies in Greenwich.

1957

July 1: The Historical Society of the Town of Greenwich buys the Holley House, assuming the $7,500 mortgage, which had been outstanding for seventy-three years. The house is renamed the Bush-Holley House to commemorate its first known and last private owners.

The original plan for the new interstate highway, I-95, had required that the house be razed. Under pressure from the HSTG, the route is shifted slightly to spare the house.

1958

Interstate 95 is dedicated. The highway's bridge over the Mianus River passes directly in front of the Bush-Holley House.

1959

Art collector Joseph H. Hirshhorn purchases MacRae's Armory Show papers from the HSTG, along with several of his oils and pastels. Milton Brown employs the MacRae papers (among others) in writing *The Story of the Armory Show* (published in 1963).

1965

November 18: Constant Holley MacRae dies, aged ninety-four.

Appendix A

Artists of the Cos Cob Art Colony

C	craftsperson
E	etcher, printmaker
I	illustrator
P	painter
S	sculptor
T	teacher
GSA	Greenwich Society of Artists

Adams, John Wolcott
(1874–1925) I
In Cos Cob periodically ca. 1912.

Anderson, A[braham] A[rchibald]
(1846–1940) P
In Greenwich from 1877 onward. GSA charter member; member of first council.

Brinley, D. Putnam
(1879–1963) P
Riverside resident 1879–ca. 1900.

Browne, Matilda
(1869–1947) P, S
Greenwich resident ca. 1895–1947 except for a period during the 1920s. GSA charter member and regular exhibitor from 1912.

Bucklin, William Savery
(1851–1928) P
Riverside resident by the 1920s. Exhibited with GSA 1912, 1923.

Carlsen, Emil
(1853–1932) P
In Greenwich periodically from the 1890s. Exhibited with GSA 1919, 1920, 1924, 1925.

Carr, Lyle

(1857–1912) P, I

In Greenwich June 1893.

Clark, Eliot Candee

(1883–1980) P

Probably in Greenwich with his father, Walter Clark, in 1893; possibly later as summer student.

Clark, Walter

(1848–1917) P

In Greenwich periodically from 1890; dated paintings in 1893.

Clark, W[alter] Appleton

(1876–1906) I

In Greenwich frequently 1902–6. Apparently no relation to Walter Clark.

Collins, Alfred Q.

(1855–1903) P

At Holly Farm before 1882; in Greenwich and Cos Cob periodically thereafter.

Davidson, Florence

See Lucius, Florence.

Duffy, Richard H.

(1881–1953) S

In Cos Cob summer and Halloween 1903.

Eaton, Charles Warren

(1857–1937) P

In Stanwich section of Greenwich summer 1890.

Ebert, Charles H.

(1873–1959) P

Probably a summer student ca. 1894. Married Mary Roberts 1903. Cos Cob (probably Holley House) resident ca. 1900–1902; Greenwich resident 1903–19. GSA charter member; member of first council. Exhibited with GSA 1912–14, 1928–31.

Ebert, Mary Roberts

(1873–1956) P

In Cos Cob frequently ca. 1897–1902; Greenwich resident 1903–19. GSA charter member.

Eby, (Harold) Kerr

(1889–1946) E, I

Cos Cob resident 1913–17.

Edwards, George Wharton

(1869–1950) P, I, writer

Greenwich resident most of his life. GSA charter member; secretary 1919–26.

Fiske, Charles A.

(1837–1915) P

Greenwich resident ca. 1872–1915. GSA member from 1913.

Fitch, Walter A.

(1861–1910) P

In Cos Cob most summers from 1900; year-round ca. 1906–9.

Foote, Will Howe

(1874–1965) P, T

In Cos Cob summer 1903.

Fuller, Lucia Fairchild

(1870–1924) P

In Cos Cob ca. 1912.

Gotthold, Florence Wolf

(1858–1930) P

In Cos Cob summers 1903–ca. 1923. GSA charter member; on council 1912–23.

Harrison, (Lovell) Birge

(1854–1929) P, T

In Cos Cob periodically ca. 1909–15 or longer.

Hassam, (Frederick) Childe

(1859–1935) P, E, I

In Greenwich or Cos Cob for parts of the years 1894, 1896–99, 1902, 1903, 1907, 1911–16, probably 1917. Exhibited with GSA 1914, 1919, 1922.

213

Hawley, Theodosia de Riemer
(1870–1937) P, T
In Cos Cob summer and Halloween 1903.

Haynes, Caroline Coventry
(1858–1951) P
In Cos Cob 1894 and 1895.

Hewitt, Edward S.
(1877–1962) architect, P, E
In Cos Cob sometime between 1911 and 1914.

Howard, Lila Wheelock
(1890–1986) S
In Cos Cob (possibly as year-round resident) ca. 1910–16. Married to Oscar F. Howard.

Howard, Oscar F.
(1888–1942) I, cartoonist
In Cos Cob (possibly as year-round resident) ca. 1910–16. Married to Lila Wheelock Howard.

Insley, Albert Babb
(1842–1937) P
In Cos Cob 1905.

Jaccaci, August Florian
(1856–1930) P, art editor
In Cos Cob by 1901; owned house and property on Bible Street from 1902 until after 1909.

Jacobs, Hobart B.
(1851–1935) P, S, T
Greenwich resident 1894 (or earlier) to 1935. GSA charter member.

Johnson, David
(1827–1908) P
Dated pictures in Greenwich and/or Cos Cob in 1878, 1880, and 1889.

Jones, (Hugh) Bolton
(1848–1927) P
In Cos Cob periodically by 1899.

Judson, Alice
(1869–1948) P
In Cos Cob summers 1897 and 1898.

Lachman, Harry
(1886–1975) P, I, film director
In Cos Cob summer 1909; lived in the Brush House.

Lawson, Ernest
(1873–1939) P
In Cos Cob periodically in 1892, 1893, 1894, 1898, ca. 1900, 1913.

Lucius, Florence
(1888–1962) P, S
In Cos Cob ca. 1910–16 with the Howards. Married sculptor Jo Davidson in 1941.

Lumis, Harriet Randall
(1870–1953) P
Studied with Leonard Ochtman summers 1910 and 1911.

MacRae, Elmer Livingston
(1875–1953) P, C
In Cos Cob summers 1896–98; permanently 1899–1953. GSA charter member; first secretary.

Malone, Blondelle
(1879–1951) P
In Cos Cob summer 1899.

Maples, Anna Comly
(dates unknown) P
In Cos Cob summer and Halloween 1903. GSA member 1913–19.

Mase, Carolyn Campbell
(ca. 1868–1948) P
In Cos Cob by summer 1898; Holley House resident for long periods ca. 1900–1903, 1910, probably 1915. GSA charter member.

Murphy, Henry Cruse, Jr.
(1886–1931) P
Cos Cob resident from ca. 1919 or earlier; lived on Cat Rock Road. GSA associate member 1919–24; exhibited with GSA 1919, 1920.

Murphys, the

In his autobiography, Lincoln Steffens described Cos Cob as "a paintable spot frequented by artists who worked, painters who actually painted: Twachtman and the Murphys, Childe Hassam and Elmer MacRae" (*The Autobiography of Lincoln Steffens* [1931; reprint, New York: Harcourt Brace Jovanovich, 1958], vol. 2, p. 436). In a letter about Cos Cob dated June 30, 1910, he wrote, "Twachtman, Childe Hassam, Murphy, Octman [*sic*]—these are some of the names of the Cos Cob school" (Ella Winter and Granville Hicks, eds., *The Letters of Lincoln Steffens* [New York: Harcourt Brace, 1938], vol. 1, p. 247). Frustratingly, Steffens supplied the first name of Hassam—the only artist of that surname painting then or since—but provided only the common last name of the mysterious "Murphy." Two eminent turn-of-the-century artists named Murphy were both married to artists and so might have been referred to as "the Murphys."

John Francis Murphy

(1853–1921)

a Tonalist landscape painter, was married to Ada Clifford Murphy (dates unknown), a landscapist and illustrator. They lived in Arkville, New York, for most of each year from 1887, but artists frequently visited other art colonies for a change of scenery. J. Francis Murphy was a friend of Ochtman's, whom he proposed for membership in the Salmagundi Club.

Hermann Dudley Murphy

(1867–1945)

was married to two artists: Caroline Bowles (m. 1895, div. 1915) and Nellie Littlehale Murphy (1867–1941, m. 1916). Hermann Dudley Murphy knew both Ochtman and Birge Harrison through their association with Byrdcliffe, where Ochtman was director of the summer school in 1905, Murphy ran a frame shop, and Harrison taught painting. Anya Seton, daughter of Ernest Thompson Seton, named Hermann Dudley Murphy as a member of the Cos Cob group; however, her reminiscences of the art colony are not entirely reliable. Steffens might have meant that both Murphy men, or both couples, painted in Cos Cob, but no concrete evidence links either of the possible pairs to the art colony. The weight of the evidence seems to fall on Hermann Dudley Murphy, however.

Henry Cruse Murphy, Jr.

(see above)

was only sixteen when Twachtman died. It is highly unlikely that Steffens would have mentioned this obscure artist in his autobiography and letters.

Nettleton, Walter

(1861–1936) P, T

Offered outdoor painting classes in the Belle Haven section of Greenwich in summer 1894.

Ochtman, Dorothy

(1892–1971) P

Lifelong Greenwich resident. Exhibited with GSA 1919–64; joined 1923.

Ochtman, Leonard

(1854–1934) P, T

In Riverside by summer 1890, year-round 1891–96; Cos Cob resident 1896–1934. GSA charter member; vice-president 1912–15; president 1916–33.

Ochtman, Mina Fonda

(1862–1924) P

Riverside resident 1891–96; Cos Cob resident 1896–1924. GSA charter member.

O'Neill, Rose Cecil

(1875–1944) I

Cos Cob resident ca. 1905; at the time, she was married to Harry Leon Wilson (see appendix B).

Owen, Robert Emmett

(1878–1957) P, I

In Cos Cob as student of Leonard Ochtman ca. 1910. GSA member 1913–19. Stamford resident 1910–20.

Parker, Cora

(1859–1944) P, T

Greenwich resident by 1905–ca. 1931. GSA charter member.

Potter, Edward Clark

(1857–1923) S

Greenwich resident 1902–23. GSA charter member; president 1912–15; vice-president 1921–23.

215

Potter, Nathan Dumont

(1893–1934) s, p

Son of Edward Clark Potter. Greenwich resident 1902–ca. 1925. GSA member 1920–24.

Reid, Robert

(1862–1929) p

In Greenwich periodically by 1895. Exhibited with GSA 1919–26.

Reinhart, Charles Stanley

(1844–1896) I

In Greenwich (most likely at Holly Farm) in 1877.

Roberts, Mary

See Ebert, Mary Roberts.

Robinson, Theodore

(1852–1896) p

In Greenwich for short visits 1892–96 and mid-May to mid-July 1893; in Cos Cob summer 1894 and short visits thereafter.

Rowe, Clarence H.

(1878–1930) I, E

Married to M. L. Arrington Rowe. Cos Cob resident. Joined GSA 1913.

Rowe, M[ary] L[ouise] Arrington

(d. 1932) p

Cos Cob resident. Joined GSA 1914.

Schenck, Phoebe

(b. 1883) p, s

Cos Cob summer resident ca. 1915. Exhibited with GSA 1919.

Selden, Henry Bill

(1886–1934) p, t

Greenwich resident 1900–1915. Married Edward C. Potter's daughter Hazel in 1913. GSA charter member.

Seton, Ernest Thompson

(1860–1946) I, writer

In Cos Cob before 1900; Cos Cob resident 1900–1912; Greenwich resident 1912–30. GSA charter member.

Smith, Albert E.

(1862–1940) p

Cos Cob resident ca. 1904–37.

Smith, E. Boyd

(1860–1943) I, p, writer

Cos Cob resident ca. 1906–9.

Snead, Louise Willis

(dates unknown) p, I, c

Greenwich resident. Joined GSA 1914.

Strazza, Emilio

(1892–1989) s

Lifelong Greenwich resident. Exhibited with GSA from 1919; joined 1930.

Talcott, Allen Butler

(1867–1908) p

In Cos Cob summers 1894 and 1895.

Taylor, Henry Fitch

(1853–1925) p

In Greenwich before 1893; summers 1893 and 1894 with Robinson; owned poultry farm on Glenville Road 1898–1904; Cos Cob resident as late as 1912–13, sometimes at the Holley House, sometimes at the neighboring Brush House. GSA charter member.

Tracy, John M.

(1844–1892) p

Settled in Greenwich in 1885.

Tucker, Allen

(1866–1939) P, T

In Cos Cob as art student under Twachtman and Weir in 1892.

Twachtman, Alden

(1882–1974) P, architect

Son of John H. Twachtman. Greenwich resident 1889–1969. GSA charter member; on council 1913; vice-president 1929–40.

Twachtman, John Henry

(1853–1902) P, T, E

At Holly Farm 1878 and 1879; Greenwich resident 1889–1899; semi-permanent Holley House resident 1900–1902.

Tyler, James Gale

(1855–1931) P

Greenwich resident most of his life. Joined GSA 1913.

Volkmar, Leon Gambetta

(1879–1959) art potter, P

In Greenwich periodically from ca. 1911; resident during World War II. Exhibited with GSA beginning 1924; joined 1929.

Voorhees, Clark (Greenwood)

(1871–1933) P

In Greenwich and Cos Cob summers 1894, 1896, 1897; family roots in Greenwich.

Walkley, David Birdsey

(1849–1934) P

In Cos Cob periodically in the 1890s.

Walter, Louise Cameron

(active in Pittsburgh ca. 1907–9) P

In Cos Cob summer and Halloween 1903.

Weir, Julian Alden

(1852–1919) P, T, E

At Holly Farm 1878 and 1879; in Cos Cob summers 1892 and 1893, possibly also 1890 and 1891; periodic visits to Twachtmans in Greenwich. Exhibited with GSA 1914.

Weir, Robert W.

(1803–1889) P, T

At Holly Farm in late 1870s.

Williams, Kate A.

(d. 1939) P, T

Titled painting *Cos Cob Inlet* (n.d.; Connecticut Bank and Trust).

Winslow, Henry

(1874–after 1953) E

In Cos Cob 1906.

Yeto, Genjiro

(1867–1924) P, I

Also known as Gaingero Yeto, Genjiro Kataoka, Genjiro Ezoe. In Cos Cob frequently 1896–1901; lived at the Holley House for long periods.

Young, Mary Louise

(active ca. 1896–1925 in Connecticut, Massachusetts, and New York) P

Greenwich resident 1896–97; Cos Cob resident ca. 1909–ca. 1913. Joined GSA 1913.

Appendix B

Writers and Performing Artists of the Cos Cob Art Colony

A	actor
C	critic
D	dramatist, playwright
E	editor
F	fiction writer
H	humorist
J	journalist
L	lecturer
M	musician
NF	nonfiction writer
P	poet
PB	publisher

Bacheller, (Addison) Irving
(1859–1950) F, J, E, H, L
Riverside resident ca. 1895–1917. Wrote popular local-color fiction including the best-seller *Eben Holden* (1900). Used a fictionalized Greenwich setting for *Keeping Up with Lizzie* (1910).

Brown, Raymond J.
(1865–1944) J, E
In Greenwich ca. 1905. On staff of *Everybody's*; editor at *Popular Science Monthly*.

Bursch, Frederick C.
(1874–after 1949) PB
Book designer, art printer, and publisher; ran the Literary Collector Press in Greenwich (1902–6) and the Hillacre Bookhouse in Riverside (1908–18).

Cather, Willa
(1873–1947) F, P, E
In Cos Cob before 1915; possibly also ca. 1924–25. Cather mentioned Cos Cob in her novel *Song of the Lark* (1915) and inscribed two books to Constant Holley MacRae in 1924 and 1925. Dorothy Weir Young (*The Life and Letters of J. Alden Weir* [New Haven: Yale University Press, 1960]) listed Cather as a member of the art colony but

did not specify at what period; Katherine Seymour Lowell, who grew up near the Holley House, recalled "Willa Cather in her cape passing the house, extending a courteous 'good morning'" (Harry M. Lounsbury and Katherine L. S. Lowell, *The Strickland Road Area* [Greenwich, Conn.: Friends of the Greenwich Library Oral History Project, 1978], p. 81).

Croly, Herbert

(1869–1930) E, NF

In Cos Cob 1914. Co-founder of the *New Republic* with Lippmann, Littell, and others.

Dunbar, Olivia Howard

See Torrence, Olivia Howard Dunbar.

Fitch, (William) Clyde

(1865–1909) D

Had a country home, called Quiet Corner, in Greenwich from 1902 until his death. In numerous plays he captured the drawing-room chatter and social nuances of his day.

Hall, Gilman

(dates unknown) E

In Greenwich ca. 1905–10 or longer. Editor at *Ainslee's; Everybody's.*

Hartley, Emily Wakeman

(ca. 1873–1935) A

Cos Cob resident most of her adult life. Founder-director of the Stamford Theatre (1914–28). Married to Randolph Hartley.

Hartley, Randolph

(dates unknown) J, P, D, C

Resident of Cat Rock Road in Cos Cob most of his adult life. Married to Emily Hartley.

Irwin, Wallace

(1875–1959) F, H

Greenwich resident ca. 1905. Wrote for *McClure's, Collier's,* and the *Saturday Evening Post;* author of numerous books.

Jordan, Kate

(1862–1926) D, F, P

In Cos Cob summer and Halloween 1903; by that time, she had published two novels and had two plays in production.

Lanier, Charles Day

(1868–1945) E, NF, PB, C

Greenwich resident 1895–1945. Son of the poet Sidney Lanier; publisher, *American Review of Reviews;* assistant editor, *Cosmopolitan;* author of nature and sports stories for *Scribner's* magazine. After a successful career in publishing, Lanier made his fortune in real-estate, industrial, and mining ventures.

Lanier, Henry Wysham

(1873–1958) E, F, PB

Greenwich resident ca. 1906–11. Brother of Charles Day Lanier; secretary of Doubleday, Page and Company; founding editor of the literary magazine *Golden Book;* author of twelve books and numerous stories and articles.

Le Gallienne, Richard

(1866–1947) P, NF, E

Cos Cob resident ca. 1905. The widely published poet was also associated with the Roycroft community and the Woodstock art colony.

Lippmann, Walter

(1889–1974) NF, E, J

In Riverside ca. 1910–11 as assistant to Lincoln Steffens.

Littell, Philip

(1868–1943) NF, E

In Cos Cob 1914. A founding editor of the *New Republic* with Lippmann, Croly, and others; on the magazine's staff 1914–23.

MacArthur, James

(1866–1909) E, D, C, A

In Greenwich ca. 1900–1905. Harry Thurston Peck's junior editor on *The Bookman* and, later, literary adviser to Harper Brothers publishers.

Moody, William Vaughn

(1869–1910) D, P

In Cos Cob ca. 1900–1910. His play *The Great Divide* (1906) was a hit in Chicago, New York, and London and was made into a movie in 1929.

Moody, Winfield Scott

(1856–before 1922) NF, E, J, C

In Greenwich ca. 1900–1907. An editor of the *Evening Sun* and contributor to other periodicals. In "Daisy Miller and the Gibson Girl" (*Ladies' Home Journal* 21 [September 1904], p. 17), he lamented the decline in what he considered proper feminine deportment.

Peck, Harry Thurston

(1856–1914) E, NF

In Cos Cob ca. 1897–1907. Professor of Latin at Columbia University, literary editor of the *Commercial Advertiser*, and editor of *The Bookman*.

Roof, Katherine Metcalf

(dates unknown) C

At the Holley House summer and Halloween 1903; also ca. 1908. Roof, best remembered as the biographer of William Merritt Chase, also wrote "The Work of John H. Twachtman" (*Brush and Pencil* 12 [July 1903], pp. 243–46).

Roseboro', Viola

(ca. 1858–1945) E, F, NF

At the Holley House periodically ca. 1904–20. As the fiction editor of *McClure's*, she published Cather's first nationally circulated stories, as well as stories by Rudyard Kipling, Booth Tarkington, Jack London, and O. Henry.

Seitz, Don Carlos

(1862–1935) NF, J

Cos Cob resident (May–November) 1895–1933. Business manager of the *New York World*, manager of the *Evening World*, associate editor of *The Outlook*, and author of more than twenty books, including a biography of his mentor, Joseph Pulitzer.

Seymour, Frank

(1856–1942) J

Cos Cob resident 1880–1942. Seitz's colleague at the *New York World* and an amateur photographer (his glass-plate negatives are in the collection of HSTG). He lived in the house that Hassam depicted in *Colonial Cottage, Cos Cob* (1902, White House).

Steffens, Lincoln

(1866–1936) J, E

Summered in Cos Cob ca. 1901–5; Riverside resident 1905–11; owned a home in Riverside until 1920. Was called a "muckraker" because of his exposés of government and business corruption. He devoted a chapter of his autobiography to the art colony.

Taylor, Bert Leston

(1866–1921) E, F, H, J

Cos Cob resident ca. 1905; humor columnist; assistant editor of *Puck*.

Torpadie, Greta

(dates unknown) M

In Cos Cob ca. 1902–16. Swedish coloratura soprano; sang at Carnegie Hall in 1915, at Louis Comfort Tiffany's Egyptian Fête in 1913, and at opéra comique benefits for French war charities throughout the United States during World War I.

Torpadie-Björksten, Madame Hervor

(dates unknown) M

In Cos Cob ca. 1902–16. Mother of Greta Torpadie; singer; gave vocal instruction at Carnegie Hall.

Torrence, Olivia Howard Dunbar

(1894–1953) NF, J

In Cos Cob 1907 and 1914–24. Married Ridgely Torrence in 1914.

Torrence, Ridgely

(1874–1950) P, D, E, NF

In Cos Cob ca. 1905–24. Author of *Plays for a Negro Theatre* (1917), poetry editor of the *New Republic* (1920–34).

Webster, Jean

(1876–1916) F

In Cos Cob ca. 1915. Her novel *Daddy-Long-Legs* (1912) was produced twice as a play and three times as a movie. The sequel, *Dear Enemy* (1915), concerns the romance between a young woman and Dr. Sandy MacRae, whose name was borrowed from the Cos Cob artist Elmer MacRae.

Whiting, Arthur

(1861–1936) M

In Cos Cob 1914. Composed orchestral and chamber music, songs, and piano pieces.

Wilson, Harry Leon

(1867–1939) E, F, H

Cos Cob resident ca. 1905; married at the time to Rose Cecil O'Neill (see appendix A). He was an editor of *Puck* (1896–1902), a frequent contributor to the *Saturday Evening Post*, and author of the popular fiction serial "Merton of the Movies."

Young, Elizabeth

(dates unknown) J

Wrote an article on the art colony for *Harper's Bazaar* in 1900.

Zigrosser, Carl

(1891–1975) C

In Cos Cob ca. 1915. Director of the Weyhe Gallery, New York, 1919–40; curator of prints and drawings, Philadelphia Museum of Art, 1941–47; author of essays on Hassam and other artists.

Notes

Introduction

1 Varied explanations of the origins of the name *Cos Cob* have been offered, but the most convincing is that it is a corruption of Coe's Cob, commemorating the breakwater, or cob, that settler John Coe built in the Mianus River about 1659.

2 J. Alden Weir to his parents, August 29, 1878, quoted in Dorothy Weir Young, *The Life and Letters of J. Alden Weir* (New Haven: Yale University Press, 1960), p. 144.

3 John H. Twachtman to J. Alden Weir, June 29, 1880, Weir Family Papers; transcript in Lisa N. Peters, "John Twachtman (1853–1902) and the American Scene in the Late Nineteenth Century: The Frontier within the Terrain of the Familiar" (Ph.D. diss., City University of New York, 1995), p. 537.

4 For Chase's own work on Long Island, see D. Scott Atkinson and Nicolai Cikovsky, Jr., *William Merritt Chase: Summers at Shinnecock, 1891–1902* (exh. cat., Washington, D.C.: National Gallery of Art, 1987). For Chase's summer school, see William H. Gerdts, "The Teaching of Painting Out-of-Doors in America in the Late Nineteenth Century," in Bruce Weber and William H. Gerdts, *In Nature's Ways* (exh. cat., West Palm Beach: Norton Gallery of Art, 1987), p. 33; and Ronald G. Pisano, "The Shinnecock Summer School of Art, 1891–1902," in *The Students of William Merritt Chase* (exh. cat., Huntington, N.Y.: Heckscher Museum; Southampton, N.Y.: Parrish Art Museum, 1973).

5 The quotation is from the diary of Theodore Robinson (New York), January 8, 1893. Robinson's diary from March 29, 1892, to March 30, 1896, can be consulted at the Frick Art Reference Library, New York. On the Cos Cob exhibition, see, e.g., Elmer MacRae (New York) to Constant Holley (Cos Cob), December 3, 1897, MacRae Papers, Historical Society of the Town of Greenwich.

6 See Barbara J. MacAdam, *Clark G. Voorhees, 1871–1933* (exh. cat., Old Lyme, Conn.: Florence Griswold Museum, 1981); and Jeffrey W. Andersen, "The Art Colony at Old Lyme," in Harold Spencer, Susan G. Larkin, and Jeffrey W. Andersen, *Connecticut and American Impressionism* (exh. cat., Storrs, Conn.: University of Connecticut, 1980), pp. 114–41.

7 For an overview of Hassam's work in Cos Cob, Old Lyme, and Branchville, see Kathleen Burnside, *Childe Hassam in Connecticut* (exh. cat., Old Greenwich and Old Lyme, Conn.: Historical Society of the Town of Greenwich and Florence Griswold Museum, 1987). Subsequent research has expanded the knowledge of Hassam's work in Connecticut, so that there are some discrepancies between Burnside's account and later ones, including this book.

8 Contrary to the statements of some sources, there is no evidence that Twachtman, Robinson, and Weir ever worked in Old Lyme. Browne lived in Greenwich most of her life. Talcott visited Cos Cob in 1894 and

1895; he later bought a house in Old Lyme. Foote painted in Cos Cob in 1903, the same summer he taught with Frank DuMond in Old Lyme. Selden moved to New London and the Eberts to Old Lyme after they had all spent years in Greenwich. For more on Browne and Talcott, see Jeffrey W. Andersen and Barbara J. MacAdam, *Old Lyme: The American Barbizon* (exh. cat., Old Lyme, Conn.: Florence Griswold Museum, 1982).

9 For the Isles of Shoals see David Park Curry, *Childe Hassam: An Island Garden Revisited* (New York: Denver Art Museum in association with Norton, 1990). For Gloucester see William H. Gerdts, "John Twachtman and the Artistic Colony in Gloucester at the Turn of the Century," in John Douglass Hale, Richard J. Boyle, and William H. Gerdts, *Twachtman in Gloucester* (exh. cat., New York: Ira Spanierman Gallery, 1987). For Monhegan see Sarah L. Fasoldt, "Monhegan: One Hundred Years of Island Painting," *Down East* 31 (August 1984): 78–88, 120, 122. The best published history of the Silvermine art colony is in Elizabeth M. Loder, *D. Putnam Brinley, Impressionist and Mural Painter* (published for the New Canaan, Conn., Historical Society and the Silvermine Guild of Artists by University Microfilms International, Ann Arbor, Mich., 1979), p. 13 ff. Brinley's papers are on microfilm at the Archives of American Art, Smithsonian Institution, Washington, D.C. They cover the Silvermine Guild (est. 1922) but include no information on its predecessor, the Knockers' exhibitions (1907–22). For Byrdcliffe and Woodstock see Karal Ann Marling, *Woodstock: An American Art Colony, 1902–1977* (exh. cat., Poughkeepsie, N.Y.: Vassar College Art Gallery, 1977); and Tom Wolf, "Historical Survey," in *Woodstock's Art Heritage: The Permanent Collection of the Woodstock Artists Association* (Woodstock, N.Y.: Overlook Press, 1987). For Lawrence Park see Barbara Ball Buff, *The Artists of Bronxville, 1890–1930* (exh. cat., Yonkers, N.Y.: Hudson River Museum, 1989); and Loretta Hoagland, *Lawrence Park: Bronxville's Turn-of-the-Century Art Colony* (Bronxville, N.Y.: Lawrence Park Hilltop Association, 1992). For Westport see Dorothy Tarrant and John Tarrant, *A Community of Artists: Westport-Weston, 1900–1985* (Westport, Conn.: Westport-Weston Arts Council, 1985).

10 From a manuscript (author and date unknown) of an interview conducted with Constant Holley MacRae and Elmer MacRae on behalf of J. Alden Weir's daughter, Dorothy Weir Young (Dorothy Weir Young research papers, Weir Farm National Historic Site, Wilton, Connecticut).

1 | The Genteel Bohemians of Cos Cob

1 J. Alden Weir to John Ferguson Weir, J. Alden Weir Papers, Archives of American Art, reel 71, frame 1028. Weir added that he had painted three landscapes and a floral still life at Holly Farm. Efforts to identify the paintings to which he refers have so far been unsuccessful.

2 "Connecticut News," *Port Chester Journal*, November 12, 1874, and July 8, 1875, Hubbard Scrapbook 1, William E. Finch, Jr., Archives, Historical Society of the Town of Greenwich (hereafter HSTG). Population growth is based on U.S. Census figures summarized in Elizabeth W. Clarke, ed., *Before and after 1776: A Comprehensive Chronology of the Town of Greenwich, 1640–1976* (Greenwich: Historical Society of the Town of Greenwich, 1976), p. 161.

3 Nathaniel P. Willis, *Hurry-Graphs, or Sketches of Scenery, Celebrities, and Society* (Auburn, N.Y.: Alden, 1853), quoted in John Stilgoe, *Borderland: Origins of the American Suburb, 1820–1930* (New Haven: Yale University Press, 1988), p. 68. For a valuable national analysis of suburbanization, see Kenneth T. Jackson, *Crabgrass Frontier: The Suburbanization of the United States* (New York: Oxford University Press, 1985).

4 Spencer P. Mead, *Ye Historie of Ye Town of Greenwich* (1911; reprint, Camden, Maine: Picton Press, 1992), p. 340.

5 See William H. Truettner and Roger B. Stein, eds., *Picturing Old New England: Image and Memory* (Washington, D.C., and New Haven: National Museum of American Art, Smithsonian Institution, in association with Yale University Press, 1999).

6 The quotation is from "Fair Greenwich," *New York World*, August 7, 1892, Hubbard Scrapbook 2, HSTG. For more on the Colonial Revival, see Alan Axelrod, ed., *The Colonial Revival in America* (New York: W. W. Norton, 1985).

7 Sarah Orne Jewett, *Novels and Stories* (New York: Library of America, 1994), p. 377.

223

8 A. E. Ives, "Suburban Sketching Grounds," *Art Amateur* 25 (September 1891): 82; Ezekiel Lemondale [Frederick A. Hubbard], "Connecticut News," *Port Chester Journal*, August 13, 1874, Hubbard Scrapbook 1, HSTG; "Our Neighbors," *Stamford Herald*, September 20, 1877, Hubbard Scrapbook 3, HSTG. The artist W. B. Cox was born in Missouri and was active in Brooklyn 1865–78. He exhibited at the National Academy of Design in 1874. (Clark S. Marlor, *Brooklyn Artists Index* [Brooklyn: Clark S. Marlor, 1993], p. 82.)

9 The paintings are *At Linwood, Greenwich, Conn.* (date and collection unknown), *Cos Cob, Connecticut* (date and collection unknown), *October—Cos Cob, Connecticut* (1878, Huntington Museum of Art, West Virginia), *Riverside at Cos Cob, Conn.* (1880, private collection, Washington, D.C.), *View near Greenwich, Conn.* (1878, Hartford Steam Boiler Inspection and Insurance Company), and *View of Linwood, Conn.* (1889, collection unknown). Information from "A Working List of Paintings by David Johnson," in Gwendolyn Owens, *Nature Transcribed: The Landscapes and Still Lifes of David Johnson (1827–1908)* (exh. cat., Ithaca, N.Y.: Herbert F. Johnson Museum of Art, 1988). Linwood was the estate of William Marcy ("Boss") Tweed from 1865 until his death in 1878. The following year, his widow sold it to Jeremiah Milbank.

10 Other branches of the family continued to use the original spelling, Holly, and nonrelatives often omitted the *e*. The farm on Stanwich Road was called Holly Farm, whereas the boardinghouse in Cos Cob was called the Holley House, except on the frequent occasions that it was misspelled as Holly House.

11 Undated newspaper clipping, HSTG. The handwritten first draft for this advertisement also survives in the same archives.

12 For a useful overview of the nineteenth-century institution of the boardinghouse, see chapter 4 in Russell Lynes, *The Domesticated Americans* (New York: Harper and Row, 1963).

13 The address books of novelist Josephine Bontecou Steffens, for example, are filled with the names and addresses of boardinghouses, annotated with the names of the friends who had recommended them. Lincoln Steffens Papers, Rare Book and Manuscript Library, Columbia University.

14 Catherine Van Dyke, "Boarding Houses I Have Met," *Ladies Home Journal* 34 (January 1917), p. 12; quoted in Lynes, *The Domesticated Americans*, p. 50.

15 Mead, *Ye Historie of Ye Town of Greenwich*, genealogy of the Holly family, p. 564; "Mrs. Edward P. Holley," obituary, *Greenwich News and Graphic*, April 25, 1916, p. 5.

16 Elizabeth Stillinger, *The Antiquers* (New York: Alfred A. Knopf, 1980), p. 74. Stillinger writes (p. 70) that "no other early furniture scholar's work has the same continuing validity" as Lyon's book, *The Colonial Furniture of New England* (1891). Many of Lyon's prize pieces are now in the famous Garvan Collection of the Yale University Art Gallery.

17 For more on Robert W. Weir, see William H. Gerdts, *Robert Weir: Artist and Teacher of West Point* (exh. cat., West Point, N.Y.: West Point Museum, 1976); and Jacob Edward Kent Ahrens, "Robert Walter Weir (1803–1889)" (Ph. D. diss., University of Delaware, 1972). The information on the Weirs' visits to Holly Farm is based on the manuscript (author and date unknown) of an interview conducted with Constant Holley MacRae and Elmer MacRae on behalf of J. Alden Weir's daughter, Dorothy Weir Young (Dorothy Weir Young research papers, Weir Farm National Historic Site, Wilton, Connecticut). In *The Life and Letters of J. Alden Weir* (New Haven: Yale University Press, 1960), Dorothy Weir Young writes that J. Alden Weir sometimes painted "at Holly Farm in Cos Cob" as early as the summers between 1878 and 1883 (p. 142). However, her research papers for the book clearly distinguish between Holly Farm on Stanwich Road and the Holley House in Cos Cob. Her blurring of that distinction unfortunately obscured the earlier history of the art colony until now.

18 MacRae interview, Dorothy Weir Young research papers. The principal sources on Weir are Young, *The Life and Letters of J. Alden Weir*; Doreen Bolger Burke, *J. Alden Weir: An American Impressionist* (Newark: University of Delaware Press, 1983); Hildegard Cummings, Helen K. Fusscas, and Susan G. Larkin, *J. Alden Weir: A Place of His Own* (exh. cat., Storrs, Conn.: William Benton Museum of Art, 1991); and Nicolai Cikovsky, Jr., Elizabeth Milroy, Harold Spencer, and Hildegard Cummings, *A Connecticut Place: Weir Farm, An American Painter's Rural Retreat* (Wilton, Conn.: Weir Farm Trust, 2000). The most recent study of Twachtman is Lisa N. Peters, *John Henry Twachtman: An American Impressionist* (exh. cat.,

Atlanta: High Museum of Art, 1999). See also Peters, "John Twachtman (1853–1902) and the American Scene in the Late Nineteenth Century: The Frontier within the Terrain of the Familiar" (Ph.D. diss., City University of New York, 1995). Extensive bibliographies on both artists are given in these sources.

19 According to Weir's daughter, Dorothy Weir Young, the two men had studios in the University Building in the autumn and winter of 1878. (Dorothy Weir Young, "Friendships," manuscript, Archives, Brigham Young University; courtesy Hildegard Cummings.) Peters writes that Twachtman had a studio at the University Building by early 1879. (Peters, "John Twachtman and the American Scene," pp. 61–62 and p. 112 nn. 56 and 57.)

20 The foreclosures, dated Feb. 27, March 19, Sept. 12, and Dec. 11, 1877, are in Greenwich Land Records, book 45, pp. 187, 198, and 308. Deed research by Nils Kerschus for HSTG.

21 "Cos Cob and Mianus," *Greenwich Graphic*, March 4, 1882, p. 3; "The Summer Season," *Greewich Graphic*, May 6, 1882, p. 3. The Holleys may have lived first in the neighboring George W. Brush house. A rent receipt from Brush dated September 17, 1881, is in the Holley financial records, HSTG.

22 Three ships' carpenters boarded in the house in 1850, according to the census report for that year (census research by Nils Kerschus for HSTG). Elderly Cos Cob residents recall hearing that railroad workers boarded at the house. Although the railroad never owned the house, one of its previous owners, George Jackson Smith, was a railroad clerk during part of his occupancy (ca. 1850–before 1880) and may well have found boarders among his co-workers. For information on Smith and other owners of the house before the Holleys, see Susan Tritschler, "Filling In," *Newsletter of the Historical Society of the Town of Greenwich* (Fall 1993): 10–11.

23 Unidentified newspaper advertisement, HSTG.

24 Ezekiel Lemondale [Frederick A. Hubbard], "Our Summer Drives," *Greenwich Graphic*, May 19, 1894, p. 1.

25 "An Art School at Cos Cob," *Art Interchange* 43 (September 1899): 56–57.

26 Constant Holley MacRae was so gifted in flower arranging that, from an early age, she was commissioned to create decorations for weddings and other

events. She won first prize in what may have been the first American flower-arranging competition, at the First International Garden Show in New York in 1921, and numerous awards thereafter, and she taught flower arranging for many years. According to one reporter, she was considered "the first person in the U.S. to elevate flower arranging to the status of an art and to get it accepted as an integral part of flower shows." (Stuart Saunders, "Medal for Arrangements at Flower Show This Fall to Honor Mrs. Elmer MacRae," unidentified Greenwich newspaper, 1952, Holley-MacRae Papers, box G, HSTG.)

27 "Cos Cob Cutlets," *Greenwich Graphic*, June 16, 1888, p. 2.

28 "An Art School at Cos Cob," p. 56; "A Small Art Colony," *Commercial Advertiser*, July 22, 1899, p. 1. "Coscob" was the spelling used by the U.S. Post Office from 1895 to 1939, when it reverted to an earlier form.

29 Deed research on Cos Cob Landing by Nils Kerschus for HSTG, 1994. The mill and the adjacent commercial buildings were destroyed by fire in January 1899.

30 "A Small Art Colony."

31 Anna Dwight Baker to J. Alden Weir, August 6, 1882, Archives of American Art, J. Alden Weir Papers, roll 125, frame 10. For chronologies of both artists, see Burke, *J. Alden Weir*, pp. 293–99; and Peters, "John Twachtman and the American Scene," pp. 526–34.

32 For Twachtman's influence on Weir's pastels and prints during this period see Burke, *J. Alden Weir*, pp. 168–70 and 178–80. Twachtman wrote from New York to fellow artist William Langson Lathrop (1859–1938) in a letter begun on April 19, 1888, and continued on April 23 that he and Weir planned to return to Branchville, where they had been the previous week, "to have another look at the country." On December 10, 1888, he wrote to Lathrop from Branchville, saying, "I'm up here until after the holidays and this is the finest time to be here too. The summer was rather green but now things are grey, subdued and refined. I live in an old fashioned house with regular New Englanders who have two pretty daughters." I am grateful to Hildegard Cummings for sharing these letters, which she obtained from Brian H. Peterson, senior curator, James A. Michener Art Museum, Doylestown, Penn. The letters were provided to Mr. Peterson by Lathrop descendants William Bauhan and Julian Karhumaa.

33 Twachtman expressed his delight with the property in an undated letter to Weir headed with the

225

return address "Willow Brook." (John H. Twachtman [Greenwich, Conn.] to J. Alden Weir [probably Branchville, Conn.], spring 1889 or before, J. Alden Weir Papers [WEFA 350], Weir Farm National Historic Site, Wilton, Connecticut.) For a transcript of this and four other previously unpublished letters from Twachtman, see Susan G. Larkin, "'A Regular Rendezvous for Impressionists': The Cos Cob Art Colony, 1882–1920" (Ph. D. diss., City University of New York, 1996), appendix 6. The letter alludes to Weir's desire to build a country house in "the wilderness." Weir finally sold his Adirondacks property on June 4, 1889, after it had been on the market for some time. It seems, therefore, that Twachtman had settled on Round Hill Road as a renter by that date.

34 Property records, Greenwich Town Hall, book 61, p. 165. Twachtman transferred title to the three-acre property to his wife, Martha (identified in these documents as Mattie S. Twachtman), in two transactions on March 7, 1890 (book 61, p. 174, and book 60, p. 236). On December 2, 1891, he bought an additional 13.4 acres from his neighbor, David S. Husted (book 61, p. 488, and book 63, p. 292). In two transactions on April 28, 1893, Twachtman transferred title of the second parcel of land to his wife (book 65, p. 379, and book 66, p. 260).

35 Weir told an audience at the Salmagundi Club in 1913 that when he and Twachtman visited a collector who had bought a painting by Twachtman from their 1889 exhibition and sale, they discovered that the painting had been hung upside down. ("Artists Give Dinner to J. Alden Weir, *New York Times*, November 26, 1913, p. 5.) I am grateful to Hildegard Cummings for this citation.

36 For insight into Twachtman's personality, see John Douglass Hale, "The Life and Creative Development of John H. Twachtman" (Ph. D. diss., Ohio State University, 1957). Hale interviewed several of Twachtman's friends and former students. Transcripts of Twachtman's letters to J. Alden Weir and Josephine Holley are provided in Peters, "John Twachtman and the American Scene," appendix 1. The transcripts of an additional letter to J. Alden Weir and four letters to John Ferguson Weir are provided in Larkin, "Regular Rendezvous for Impressionists," appendix 6. Theodore Robinson's diary not only reveals his friendship for Twachtman but also testifies to that between Twachtman and other artists. Robinson's diaries from March

29, 1892, to March 30, 1896, are in the collection of the Frick Art Reference Library, New York.

37 "The Society of American Artists," *Art Amateur* 32 (May 1895): 158.

38 Probably for financial reasons, the Twachtmans stored their belongings and rented their house on Round Hill Road by December 1899. Thereafter they lived in various places, including Putnam Cottage in Greenwich. At least part of the family accompanied Twachtman to Gloucester in the summer of 1900, but when his oldest child, Alden, received the Winchester Fellowship to study art in Paris from June 1, 1900, to June 1, 1902, Mrs. Twachtman and some of the children accompanied Alden to France (the terms of the fellowship are given in a letter from John Ferguson Weir to Alden Twachtman, October 1, 1900, J. F. Weir papers, Yale University Library). From the winter of 1900–1901 until the spring of 1902, the Holley House was Twachtman's primary residence. During that period, he also spent time at the Players Club in New York; traveled to Boston, Chicago, and elsewhere; visited his family in France; and spent the summers in Gloucester, where he died on August 8, 1902.

39 John H. Twachtman (Greenwich) to J. Alden Weir (New York?), December 16, 1891, Weir Family Papers, transcript in Peters, "John Twachtman and the American Scene," p. 545.

40 For Twachtman's and Robinson's influence on Weir, see Burke, *J. Alden Weir*, pp. 189, 208, and passim; and Susan G. Larkin, "A Curious Aggregation: J. Alden Weir and His Circle," in Cummings, Fusscas, and Larkin, *J. Alden Weir: A Place of His Own*, pp. 60–71.

41 "St. Botolph's Exhibition," unidentified clipping, Archives of American Art, Mrs. Page Ely Papers, roll 70, frame 192.

42 John Rewald, *The History of Impressionism*, 4th revised ed. (New York: Museum of Modern Art, 1973), pp. 226–32.

43 Robinson's diary (New York), April 11, 1894. For more on Robinson, see John I. H. Baur, *Theodore Robinson, 1852–1896* (exh. cat., Brooklyn: Brooklyn Museum, 1946; reprinted in *Three Nineteenth Century American Painters* [New York: Arno Press, 1969]); Sona Johnston, *Theodore Robinson, 1852–1896* (exh. cat., Baltimore: Baltimore Museum of Art, 1973); Bev Harrington, ed., *The Figural Images of Theodore Robinson, American Impressionist*, intro. William Kloss (exh. cat., Oshkosh, Wis.: Paine Art Center and Arboretum, 1987); and Susan G. Larkin,

"Light, Time and Tide: Theodore Robinson at Cos Cob," *American Art Journal* 23, no. 2 (1991): 74–108.

44 Robinson's diary (Greenwich), December 24, 1892.

45 William H. Gerdts, *Monet's Giverny: An Impressionist Colony* (New York: Abbeville Press, 1993), pp. 30 and 36. The studio in the garden behind the Hotel Baudy, which became the focus of the Giverny art colony, displayed a photograph of Taylor there in the summer of 1998. In 1910 Taylor, one of the original members of the Giverny art colony, presented exhibitions of the work of the art colony's second generation in the Madison Gallery in New York City. For information on the little-known Taylor and on the Madison Gallery, which also exhibited work by several members of the Cos Cob art colony, see Christine Oaklander, "Clara Davidge and Henry Fitch Taylor: Pioneering Promoters and Creators of American Modernist Art" (Ph.D. diss., University of Delaware, 1999).

46 Robinson's diary (Greenwich), May 28, May 30, June 5, and June 11, 1893. The obituary of the little-known Carr appeared in the *New York Times*, February 18, 1912, sec. 2, p. 13. Susan Hinckley Bradley was the sister of Robert Hinckley, who had been Weir's classmate in the studio of Charles-Emile-Auguste Durand (Carolus-Duran) in Paris. She was a member of Twachtman's summer class in 1894 and a member of Robinson's class at the Pennsylvania Academy of the Fine Arts in 1895. For more on this artist, see Laura E. Richards, "Susan H. Bradley," *American Magazine of Art* 15 (July 1924): 370–74.

47 For example, in his diary entry for June 30, 1894, when he was staying in Cos Cob, Robinson records receiving "a charming letter from T. S. Perry from Giverny, telling of Monet and others." Thomas Sargent Perry and his wife, the American painter Lilla Cabot Perry, spent nine summers in Giverny over a span of two decades.

48 Robinson's diary (Giverny, France), November 30, 1892.

49 The Twachtmans had seven children, two of whom died before their father.

50 For catalogues of the prints by the two artists, see Royal Cortissoz and the Leonard Clayton Gallery, *Catalogue of the Etchings and Dry-Points of Childe Hassam, N.A.* (originally published 1925 and 1933; rev. ed., San Francisco: Alan Wofsy Fine Arts, 1989); and Bernadette Passi Giardina, *Kerr Eby: The Complete Prints* (Bronxville, N.Y.: M. Hausberg, 1997).

51 Childe Hassam, interview by DeWitt Lockman, February 2, 1927, Lockman Papers, Archives of American Art.

52 *Exhibition of Pictures by Childe Hassam* (exh. cat., New York: Montross Gallery, 1917).

53 Royal Cortissoz, "Mr. Childe Hassam's Work in Different Mediums," *New York Tribune*, January 7, 1917, sec. 3, p. 3.

54 A letter to a potential student dated May 22, 1891, states that "the class will be [in Cos Cob] June, July and I feel quite sure, Aug." H. W. Methven (Art Students League, New York) to Mr. C. G. Osgood, Jr., HSTG. For 1895, see Clark S. Marlor, *A History of the Brooklyn Art Association with an Index of Exhibitions* (New York: James F. Carr, 1970), p. 65.

55 For a list of summer students, see Larkin, "Regular Rendezvous for Impressionists," pp. 275–76. Charles Ebert, who was inadvertently omitted from that list, was probably a student in 1894.

56 MacRae interview, Dorothy Weir Young research papers.

57 Figures for room and board and the 1896 tuition are from the ledger of Charles MacRae (1878–99), whose son Elmer Livingston MacRae was enrolled in the summer school in 1896 and 1897; HSTG, courtesy of archivist Susan Richardson. Robinson's diary (New York), December 17, 1895, refers to Twachtman's income from teaching four days a week in New York and "three months last summer."

58 "An Art School at Cos Cob," pp. 56–57.

59 Allen Tucker, *John H. Twachtman* (New York: Whitney Museum of American Art, 1931), pp. 7–8.

60 Frederic Newlin Price, *Ernest Lawson, Canadian-American* (New York: Feragil, 1930), n.p.

61 Robinson's diary (Cos Cob), August 25, 1894.

62 For more on MacRae, see Susan G. Larkin, *On Home Ground: Elmer Livingston MacRae at the Holley House* (exh. cat., Greenwich, Conn.: Historical Society of the Town of Greenwich and Bruce Museum, 1990). In the essay and chronology in that catalogue, I wrote that MacRae joined the summer class in 1897. However, the ledger kept by his father, Charles MacRae, indicates that Elmer

MacRae was a member of the class in 1896. I am grateful to HSTG archivist Susan Richardson for bringing that document to my attention.

63 For more on Yeto, see Susan G. Larkin, "Genjiro Yeto: Between Japan and Japanism," *Greenwich History* 4 (2000).

64 Robinson diary (New York), December 10, 1893. See Doreen Bolger, "American Artists and the Japanese Print: J. Alden Weir, Theodore Robinson, and John H. Twachtman," in Doreen Bolger and Nicolai Cikovsky, Jr., eds., *American Art around 1900* (Washington, D.C.: National Gallery of Art, 1990).

65 For the two possible direct sources, see Burke, *J. Alden Weir*, pp. 211, 271 nn. 49 and 50.

66 Elmer MacRae (NYC) to Constant Holley (Cos Cob), December 3, 1897, MacRae Papers, HSTG.

67 See Peters, "John Twachtman and the American Scene," p. 347.

68 Elmer MacRae (New York) to Constant Holley (Cos Cob), December 3, 1897, MacRae Papers, HSTG. MacRae also refers to the exhibition in his letters of December 1 and 2. For more on the Shinnecock classes, see Ronald G. Pisano, "The Shinnecock Summer School of Art, 1891–1902," in *The Students of William Merritt Chase* (exh. cat., Huntington, N.Y.: Heckscher Museum; Southampton, N.Y.: Parrish Art Museum, 1973).

69 The authoritative study of that exhibition is Milton Brown, *The Story of the Armory Show* (1963; 2d ed., New York: Abbeville Press, 1988). For more on the Cos Cob art colony's involvement, see Larkin, "Regular Rendezvous for Impressionists," pp. 92–93. For more on the Madison Gallery, see Christine I. Oaklander, "Clara Davidge's Madison Art Gallery: Sowing the Seed for the Armory Show," *Archives of American Art Journal* 36, nos. 3–4 (1996): 20–37; and Oaklander, "Clara Davidge and Henry Fitch Taylor."

70 James W. Lane, "Vincent in America: Allen Tucker," *Art News* 38 (December 16, 1939): 17–18. Although it is commonly assumed that Tucker's expressive paint handling followed the Armory Show, it can be seen in his 1909 painting *October Cornfield* (see fig. 109).

71 The Voorhees diary, available on microfilm at the Archives of American Art, is in the archives of the Florence Griswold Museum, Old Lyme, Connecticut. I am grateful to Museum Director Jeffrey Andersen for

putting it at my disposal. "An Art School at Cos Cob" refers to Ochtman's classes as if they are regular events. In 1910 and 1911 Ochtman conducted the "New York Summer School" in Mianus; his students that year included Harriet Randall Lumis. He also taught at the Byrdcliffe colony in Woodstock, New York, where he was named director of the summer school in 1905. For more on Ochtman; his wife, Mina Fonda Ochtman; their daughter, Dorothy; and their son, Leonard, Jr., see Susan G. Larkin, *The Ochtmans of Cos Cob* (exh. cat., Greenwich, Conn.: Bruce Museum, 1989).

72 Leonard Ochtman, "A Few Suggestions to Beginners in Landscape Painting," *Palette and Bench* I (July 1909): 231–32 and (August 1909): 243–44. The quotations are from pp. 231–32 and p. 243.

73 In 1910 Steffens provoked hostility in Greenwich by declaring that the town was "as corrupt as any city in the United States." For an analysis of that controversy, see Susan Larkin, "The Muckraking of Greenwich," *Greenwich Review* 36 (October 1983): 50–53, 70.

74 Lincoln Steffens, *The Autobiography of Lincoln Steffens* (2 vols., 1931; reprint, New York: Harcourt Brace Jovanovich, 1958), vol. 2, pp. 437–38. The debates remained a staple at the Holley House even after Twachtman's death.

75 The comment, by *McClure's* fiction editor Viola Roseboro', is recorded in the Dorothy Weir Young Papers, Weir Farm National Historic Site.

76 Harry M. Lounsbury and Katherine L. S. Lowell, *The Strickland Road Area* (Greenwich, Conn.: Friends of the Greenwich Library, Oral History Project, 1978), p. 81. For a summary of the documentation of Cather's connections to Cos Cob, see appendix B in this book.

77 Virginia Gerson, entry on William Clyde Fitch in *Dictionary of American Biography*, vol. 3, pp. 428–31. (Gerson was the sister-in-law of painter William Merritt Chase.)

78 Milton W. Brown, *American Painting from the Armory Show to the Depression* (Princeton: Princeton University Press, 1955), p. 7.

79 The anonymous poem written on the forty-second anniversary of Edward and Josephine Lyon Holley (October 16, 1908) is in the Holley-MacRae papers HSTG. Twachtman's letters to Josephine ("Joe") Holley

are reprinted in Peters, "John Twachtman and the American Scene," pp. 549–52. Josephine Holley (1848–1916) was five years older than Twachtman.

80 See the letter from Edward Holley (La Gloria, Cuba) to Josephine Holley (Cos Cob), December 15, 1906; undated letter from T. Deanier (S. S. Cedric) to "Fellow Freaks"; and letter from Ella Merchant and Mary B. Mullett (Minnewaska, N.Y.) to "Freak House Co., Cos Cob, Conn.," July 9, 1909; all in Holley-MacRae Papers, HSTG. Artist Nelson C. White reported Hassam's nickname for the Griswold House; see Jeffrey W. Andersen, "The Art Colony at Old Lyme," in Harold Spencer, Susan G. Larkin, and Jeffrey W. Andersen, *Connecticut and American Impressionism* (exh. cat., Storrs, Conn.: University of Connecticut, 1980), pp. 125 and 136 n. 36.

81 Steffens, *Autobiography*, pp. 436–7.

82 Ibid., p. 437. The woman was probably Mrs. Edward H. Johnson, whose husband was president of the Edison Electric Company. Their property on North Street, called Electric Hill, was clearly visible from Holly Farm on Stanwich Road, so that Steffens's comment that "our painters used to paint" the hill constitutes additional evidence of a nascent art colony there in the late 1870s. Johnson's efforts to introduce street lighting to Greenwich met with suspicion and resistance, which may have colored Constant MacRae's hostility to Mrs. Johnson (see "History of Electric Light in Greenwich Goes Back 50 Years," unidentified newspaper clipping, November 22, 1928, Hubbard Scrapbook 7, HSTG). I am grateful to HSTG archivist Susan Richardson for information about Electric Hill.

83 See Junior League of Greenwich, *The Great Estates: Greenwich, Connecticut, 1880–1930* (Canaan, N.H.: Phoenix Publishing, 1986).

84 According to the late Nelson White, Twachtman made this comment to his father, Henry C. White, during a visit that the latter made to Greenwich in 1891. (Telephone interview with Nelson White, January 1981.)

85 For the sequence of additions to Twachtman's house, see Peters, "John Twachtman and the American Scene," pp. 290–93.

86 Alfred M. Githens, "The Farmhouse Reclaimed II," *House and Garden* 18 (July 1910): 10. The Eberts' former home stands near the intersection of Doubling and Hill Roads in Greenwich.

87 Tucker, *Twachtman*, p. 8.

88 For a stimulating discussion of this phenomenon among French Impressionists, see Harrison C. White and Cynthia A. White, *Canvases and Careers: Institutional Change in the French Painting World* (Chicago: University of Chicago Press, 1993), especially pp. 129–40.

89 For Twachtman's income, see Robinson's diary (New York), December 17, 1895. For Robinson's income, see his diary on December 31 of each year. On December 31, 1892, he noted that his income, $2,852, was "more money than ever I made in one year." He exceeded that figure in 1893 but fell back in subsequent years.

90 "Series D 779–793, Average Annual Earnings in All and Selected Industries and in Occupations: 1890 to 1926," in *Historical Statistics of the United States, Colonial Times to 1970* (Washington, D.C.: U.S. Government Printing Office, 1975), pt. 1, pp. 151–52 and 168.

91 Quoted in Carolyn C. Mase, "John H. Twachtman," *International Studio* 72 (January 1921): lxxi.

92 Among them were the Holleys, Brushes, Marshalls, Lockwoods, Palmers, and Ferrises, all of whom are listed in Mead, *Ye Historie of Ye Town of Greenwich*, chap. 15, "Alphabetic List of Landowners from the First Indian Deed, 1640, to 1752." Mead's genealogies in the same volume link the early landowners with their descendants in Cos Cob in the late nineteenth century.

93 "A Small Art Colony," p. 1.

94 Thomas Whipple Dunbar, "The Art of Leonard Ochtman, N.A.," *Guide* (December 1921), reprinted in *Art World Magazine* (December 30, 1924): 19.

95 Steffens to Mrs. Robert La Follette, in Ella Winter and Granville Hicks, eds., *The Letters of Lincoln Steffens*, vol. 1 (New York: Harcourt, Brace and Company, 1938), p. 258; Hale, "Life and Creative Development," p. 116.

96 Steffens, *Autobiography*, p. 440; Mina Fonda (Laconia, N.H.) to Leonard Ochtman (Mianus, Conn.), June 22 and July 21, 1890, Ochtman letters, Bruce Museum. For a discussion of antiquarianism as an aspect of the idealization of New England, see Truettner and Stein, *Picturing Old New England*, pp. 88–91.

97 Irving Bacheller, "Keeping Up with Lizzie," *Harper's* 121 (October 1910): 688–703; the quotation is from page 690. The story is anthologized, in a slightly longer

version, in Bacheller, *From Stores of Memory* (New York: Far-rar and Rinehart, 1938), pp. 171–99. The novel-length version, published by Harper and Brothers in 1911, is set in Pointview rather than Fairview and has additional characters, including the Smeads (a twist on the prominent Meads of Greenwich). The book, which also concerns the new phenomenon of the automobile, contributed the phrase "tin Lizzie" to American slang.

98 Bacheller, "Keeping Up with Lizzie," *Harper's* version, p. 703.

99 Two Irish women, Mary and Margaret Smith, lived at the Holley House at the time of the 1900 census; an African American woman, Sally Hudson, lived there in 1910, possibly with her family. (Nils Kerschus, "Synopsis of the George J. Smith Family and Bush-Holley House," HSTG.)

100 The two families settled in Riverside, across the Mianus River from Cos Cob, in 1893. Rioichiro Arai's granddaughter Haru married Edwin O. Reischauer, the American ambassador to Japan from 1961 to 1966. See Haru Matsukata Reischauer, *Samurai and Silk* (Cambridge: Harvard University Press, 1986).

101 "An Art School at Cos Cob," p. 56; Robinson's diary (Cos Cob), July 1, 1894.

102 The artists were friendly with the immi-grant and African American villagers. Robinson referred to John Kalb as "a nice old Alsatian shoe maker" (diary, June 25, 1894). Although Steffens used an offensive word, "Chink," to describe the Chinese laundryman (*Auto-biography*, p. 439), such language was common in his day and he does not otherwise manifest bigotry toward the Asian entrepreneur. Mrs. Mabel Burke Delage (born 1901) and Mr. Max Taylor (1904–2000), who grew up in Cos Cob as the children of Irish and Russian Jewish immi-grants, respectively, recalled only cordial relations with the art colony. Mrs. Delage remembered prejudice from Yankee villagers, however, and Mr. Taylor said of the Yankees' attitude, "Nobody was an American. You were a square-head, a sheeny, a wop." (Telephone interview with Mrs. Delage, February 1994; personal interview with Mr. Taylor, January 1995.)

103 Eby's use of the term *coon*, while undeniably racist, was probably not intentionally malicious. The term was used ironically by African Americans themselves (Clarence Major, *Juba to Jive: A Dictionary of African-American Slang* [New York: Viking, 1994], p. 112). A search of the database *African-American Sheet Music, 1850–1920: Selected from the Collections of Brown University* pro-duced 206 titles that include the word *coon*—four times as many as other terms that are now considered racial slurs. "Coon song" was a common designation for African American music. A spot-check of sheet-music illus-trations in this database reveals that whereas some represent African Americans in an offensive, stereotypical manner, others, like "Rock-a-bye, don't you cry: coon lullaby," depict them in sensitive, even idealized, fashion (the database can be found online at http://memory.loc.gov/ammem/award97/rpbhtml/).

104 Mrs. Mabel Burke Delage recalls that during the time that Eby lived in the warehouse, the other second-floor apartment was occupied by Mr. and Mrs. Les Carpenter, and the street-level space, which once housed the Chinese laundry, was home to Mary and Andy Ford. The Carpenters and the Fords were African Ameri-can. (Telephone interview, February 4, 1994.)

105 "A Jolly Time at Cos Cob," *Greenwich Graphic*, November 7, 1903, p. 1. The guests included painters Henry Fitch Taylor, Carolyn Mase, Theodosia de Riemer Hawley, and Anna Comly Maples; sculptor Richard Duffy; and miniaturist Louise Cameron Walter. The colony's literary component was represented by Steffens, edi-tor Gilman Hall, playwright Kate Jordan, and writers Katherine Metcalf Roof and Winfield Scott Moody.

106 See William H. Gerdts et al., *Ten American Painters* (exh. cat., New York: Spanierman Gallery, 1990).

107 "Passing of the Long-Haired Artist," *Vogue* 39 (May 15, 1912): 29. For Twachtman, see Alfred Henry Goodwin, "An Artist's Unspoiled Country Home," *Country Life in America* 8 (October 1905): 625–30. For Bacheller, see E. Bell, "Home of a Connecticut Author," *Country Life in America* 20 (July 1, 1911): 43–45. For Ebert, see Githens, "The Farmhouse Reclaimed." The home of Ernest Thompson Seton (formerly Ernest Seton-Thompson) was featured in several articles; see, e.g., "Mr. and Mrs. Seton-Thompson at Home," *Harper's Bazaar* 33 (February 3, 1900): 89.

108 "New Yorkers to Attend Art Exhibit at Cos Cob," *New York World*, October 9, 1908, MacRae Papers,

HSTG; "Society Views Works of Art Hung in Old Dutch Colonial Mansion," *New York Herald*, October 13, 1909, unpaged clipping, HSTG; Henry Tyrell, "Mr. Macrae's [*sic*] Art During Past Year Shown at Cos Cob," *New York Evening World*, October 8, 1910, unpaged clipping, HSTG.

109 For a more detailed discussion of the Greenwich Society of Artists and the Bruce Museum, see Larkin, "Regular Rendezvous for Impressionists," especially pages 82–92. See also Sue Dunlap, *The History of the Greenwich Art Society* (Greenwich: Greenwich Art Society, 1976). The organization, which changed its name to the Greenwich Art Society in 1958, is still active. The society's catalogues and memorabilia are in the HSTG Archives. Some additional material is in the Bruce Museum archives.

110 See Larkin, "Regular Rendezvous for Impressionists," pp. 83–85; and Junior League, *Great Estates*.

111 "Artists Organize," *Greenwich News*, February 16, 1912, GSA Papers, HSTG.

112 Bruce's deed of trust, dated August 4, 1908, was accepted by the town meeting on October 16, 1909, eight months after his death.

113 "The Artists' Exhibit," *Greenwich Press*, October 4, 1912, p. 8, GSA Papers, HSTG.

114 "Artists' Exhibition Proves Grand Success," *Greenwich Press*, October 4, 1912, p. 1, GSA Papers, HSTG.

115 "Permanent Gallery Collection Greenwich Artists Hope," *Christian Science Monitor*, October 18, 1913, GSA Papers, HSTG; "Artist's Exhibit," *Greenwich Graphic*, September 19, 1913, pp. 1 and 4.

116 The most complete account of the exhibition is "Exhibit of Designs by Architects," *Greenwich Graphic*, November 7, 1913, p. 1.

117 According to the *Greenwich News*, "All the paintings except a very few are for sale and those who desire to buy will be furnished with the price by Perk Van Lith, who is well known to all who attend gallery exhibits in New York, and who will be in charge of the present exhibit at all times." ("Art Exhibit," *Greenwich News*, June 19, 1914, GSA Papers, HSTG.)

118 "The Art Exhibit," *Greenwich News and Graphic*, September 12, 1919, GSA Papers, HSTG.

119 "Pictures for Bruce," *Greenwich News and Graphic*, October 17, 1919, GSA Papers, HSTG.

120 The GSA's last exhibition at the Bruce Museum was held in 1926. The society did not exhibit in 1927. The following year, its annual exhibitions were moved to the skylit gallery of the renovated Greenwich Library. The Bruce Museum was heavily oriented toward natural history and anthropology until recent years. While maintaining its popular department of natural history, the museum has now built a reputation for excellent temporary art exhibitions.

121 "Saunterings about Town," *Greenwich Graphic*, August 25, 1906, Hubbard Scrapbook 4, HSTG.

122 Eugene A. Clancy, "The Car and the Country Home," *Harper's Weekly* 55 (May 6, 1911): 30.

123 Alma Morgenthau Wertheim, the mother of historian Barbara Tuchman, was a notable patron of musicians and composers, including Aaron Copland. See Helen Didriksen, "Alma Wertheim of Cos Cob: Portrait of a Patroness," *HSTG Newsletter* (Winter 1994): 6–10.

124 For a perceptive study of this painting and others related to it, see Charles Eldredge, "Skunk Cabbages, Seasons and Series," in Marion M. Goethals, *Georgia O'Keeffe: Natural Issues, 1918–1924* (exh. cat., Williamstown, Mass.: Williams College Museum of Art, 1992).

125 Elmer MacRae (Cos Cob) to Ridgely Torrence (Xenia, Ohio), July 29, 1920, Torrence Papers, Princeton University. (Transcript by Christine Oaklander.)

2 │ The Nautical Landscape

1 The *New York Mail and Express*, quoted in "Of Course," *Greenwich Graphic*, July 14, 1894, p. 1, col. 1.

2 See Leo Marx, *The Machine in the Garden: Technology and the Pastoral Ideal in America* (New York: Oxford University Press, 1964); and Leo Marx, "The Railroad-in-the-Landscape: An Iconological Reading of a Theme in American Art," in *The Railroad in American Art: Representations of Technological Change*, ed. Susan Danly and Leo Marx (Cambridge: MIT Press, 1988).

3 George H. Douglas, *All Aboard! The Railroad in American Life* (New York: Paragon House, 1992), p. 341; Willa Cather, "The Best Years" (1945) in *Willa Cather: Stories, Poems, and Other Writings*, ed. Sharon O'Brien (New York: Library of America, 1992), p. 744.

4 Robert Herbert, *Impressionism: Art, Leisure, and Parisian Society* (New Haven: Yale University Press, 1988), p. 226. For a provocative discussion of the role of the

railroad (and railroad bridges) in French Impressionism, see Herbert, pp. 195–98 and 219–29. Monet's boating pictures are discussed in Herbert, pp. 229–46; and Paul Hayes Tucker, *Monet at Argenteuil* (New Haven: Yale University Press, 1982), chap. 4.

5 Elizabeth W. Clarke, ed., *Before and after 1776: A Comprehensive Chronology of the Town of Greenwich, 1640–1976* (Greenwich: Historical Society of the Town of Greenwich, 1976), p. 68. According to Spencer P. Mead, *Ye Historie of Ye Town of Greenwich* (1911; reprint, Camden, Maine: Picton Press, 1992), p. 333, the vessel was the last packet boat to sail from Cos Cob to New York City, making its last trip in 1890. However, an advertisement in an 1891 Greenwich newspaper announces a "New Packet Line" with the *E. M. J. Betty* still making weekly trips between Cos Cob and New York. Mead lists the vessel as the *E. M. J. Beatty*, but records at Mystic Seaport confirm that it was registered as the *E. M. J. Betty*, the name by which it is identified in contemporary newspapers.

6 Lewis Merritt's age at his death, his full name, and his parentage were verified by the Greenwich Department of Vital Statistics (by telephone, November 14, 1990). Information about the Merritts' boats is based on Mead, *Ye Historie of Ye Town of Greenwich*, pp. 333–34, and the obituary for Lewis Merritt's brother, Captain Caleb W. Merritt, *Greenwich Graphic*, March 4, 1899, p. 1, col. 2.

7 Robinson's diary is in the collection of the Frick Art Reference Library, New York.

8 Lincoln Steffens, *The Autobiography of Lincoln Steffens* (2 vols., 1931; reprint, New York: Harcourt Brace Jovanovich, 1958), vol. 2, p. 438. The Mianus River bridge was one of eight along the Connecticut shore that was renovated or replaced between 1896 and 1918, according to "Movable Railroad Bridges on the Northeast Corridor," National Register of Historic Places Inventory-Nomination Form, 1986 (a copy is in the archives, HSTG). Steffens's account of Twachtman's painting at the construction site in the fall is evidence that the project was under way by the autumn of 1901. (Twachtman died in Gloucester, Mass., in August 1902.) Hassam's *Mill Pond, Cos Cob* is dated 1902. The bridge itself is dated 1904 in the National Register nomination form cited above and in

"Mianus River Railroad Bridge," National Register of Historic Places Evaluation/Return Sheet, 1987 (HSTG). The local press did not report completion of the work until 1906 ("Saunterings About Town," unidentified Greenwich newspaper, June 9, 1906, Hubbard Scrapbook 4, HSTG).

9 *Creek at Low Tide* is not a study for *The Ship Yard, Cos Cob*, although it is identified as such in a recent exhibition catalogue (D. Scott Atkinson [essay] and Brian Paul Clamp [catalogue entries], *Theodore Robinson* [New York: Owen Gallery, 2000], p. 84).

10 Robinson recorded work on shipyard pictures in his diary entries for July 5 and 6 and August 25, 27, 28, and 30, 1894. In his seminal catalogue of Robinson's works, John Baur listed three shipyard paintings with similar titles: *The Ship Yard* (fig. 43); *Ship Yard at Cos Cob* (18 x 22 inches, given by Robinson to Hamlin Garland in 1896, location unknown), and *Ship Yard—Cos Cob* (no dimensions given; probably *Creek at Low Tide*, fig. 44). See John I. H. Baur, *Theodore Robinson, 1852–1896* (exh. cat., Brooklyn: Brooklyn Museum, 1946; reprinted in Baur, *Three Nineteenth Century American Painters* [New York: Arno Press, 1969]), pp. 75 and 93.

11 "The Cos Cob of the Past / Passing of a Shipyard," *Greenwich Graphic*, January 30, 1909, p. 1, cols. 1–3.

12 "Coasters on the Ways," *Greenwich Graphic*, June 17, 1882, p. 3, col. 1; "How the Business Has Changed," *Greenwich Graphic*, April 28, 1888, p. 2, col. 2.

13 The shipyard was shut down in 1907 because of the owners' ages (Denom Palmer was eighty-eight and John Duff was eighty-three), according to Mead, *Ye Historie of Ye Town of Greenwich*, p. 346. The 1909 article on the shipyard ("The Cos Cob of the Past") refers to the recent sale of the property, but it was not revived as a shipyard.

14 "Our Summer Drives," *Greenwich Graphic*, May 19, 1894, p. 1, cols. 4–5. The scriptural verse is Proverbs 3:17, on the joys of Wisdom, personified as a woman: "Her ways are ways of pleasantness, and all her paths are peace." I am grateful to Arlene Nichols for recognizing the allusion and identifying its source.

15 Mead, *Ye Historie of Ye Town of Greenwich*, p. 333.

16 "Talk of the Town," *Greenwich Graphic*, October 16, 1897, p. 5, col. 1. The *Polk* was apparently later brought out of retirement for limited service between Mianus

and New York. A receipt dated 1899 for packet service on the schooner is in the financial papers of Edward P. Holley (Archives, HSTG).

17 The company, Palmer Brothers, was established farther up the Mianus River in 1888 and moved to Cos Cob in 1901. (Mead, *Ye Historie of Ye Town of Greenwich*, p. 346.) The business continued on the land opposite the Holley House, which became known as Palmer Point, until the 1970s. Frank and Ray Palmer, the original owners, were distantly related to Denom Palmer of Palmer & Duff (Mead, *Ye Historie of Ye Town of Greenwich*, pp. 619 and 623). The site is now occupied by condominiums, an indoor tennis court, and a restaurant.

18 I am grateful to Edward Baker, assistant director of interpretation, Mystic Seaport Museum, Mystic, Connecticut, for information about sculling. (Telephone conversation, September 1999.)

19 Mead, *Ye Historie of Ye Town of Greenwich*, pp. 355–56.

20 Annual reports of the Shell-Fish Commissioners of the State of Connecticut, 1884 to 1912, Pequot Library, Southport, Conn. See also "Oyster Business Once Flourished Here," *Greenwich Time*, June 29, 1953, p. 12, col. 1; and Clarence Chard, *Oystering* (Greenwich, Conn.: Friends of the Greenwich Library, Oral History Project, 1976).

21 Hamlin Garland, "Impressionism," *Crumbling Idols* (1894; reprint, Cambridge: Harvard University Press, 1960). The essay on Impressionism was probably based on a panel discussion between Garland, sculptor Lorado Taft, and painter Charles Francis Browne at the Art Institute of Chicago in October 1894. (See William H. Gerdts, *American Impressionism* [New York: Abbeville Press, 1984], p. 144.) When Garland sent Robinson a copy of the discussion, Robinson noted, "It is witty and sensible and suggestive—the sort of thing that ought to do good— I like its freedom from heaviness and dogmatism— and a number of good things are said, *pour et contre*." (Robinson's diary, December 19, 1894.) Although Garland took a narrow view of the appropriate subjects for American paintings and literature, arguing that only one born in a specific place could portray that locality authentically, he encouraged Robinson—and other American artists—to embrace the themes of his homeland.

22 Sarah Orne Jewett, "A Bit of Shore Life," in *Best Stories of Sarah Orne Jewett*, ed. Charles G. Waugh, Martin J. Greenberg, and Josephine Donovan (Augusta, Maine: Lance Tapley, 1988), p. 35.

23 Harriet Beecher Stowe, *The Pearl of Orr's Island* (Boston: Houghton Mifflin, 1884), p. 1. The book was so popular that by 1884 it was in its twenty-fourth edition. Theodore Robinson, a wide-ranging and avid reader, almost certainly knew of it. He enjoyed the depiction of New England village life in Stowe's *Oldtown Folks* (1869), according to his diary entry of October 25, 1895.

24 "With the Oyster Dredgers," *Greenwich Graphic*, August 22, 1903, p. 1, cols. 4–6.

25 "A Small Art Colony," *Commercial Advertiser*, July 22, 1899, p. 1, cols. 3 and 4. The article, clearly the work of an art-colony insider, was probably written either by Steffens, then the paper's city editor, or by Harry Thurston Peck, its literary editor. The tattered clipping was discovered between the pages of a book that belonged to the Holleys.

26 Elizabeth Young, "Midsummer Days at Cos Cob," *Harper's Bazaar* 33 (July 14, 1900): 660.

27 Steffens, *Autobiography*, p. 441.

28 E. Boyd Smith, *The Seashore Book* (1912; reprint, Boston: Houghton Mifflin, 1985), pp. 8, 16, 19, 27, and 23.

29 Ibid., p. 55.

30 "The Cos Cob of the Past." This account does not give the year of the three-hundred-mile race for a purse of one thousand dollars, which the *Stella* won.

31 An advertisement in the *Greenwich Graphic*, June 17, 1882 (p. 3, col. 4) announces boats for rent by the hour, day, or week at Steamboat Dock in central Greenwich. Rowboats could be rented at the Lower Landing, according to Mrs. Mabel Burke Delage, who grew up there (letter to Susan Tritschler, then director of the HSTG, January 20, 1991).

32 Anthony Anable, *The History of the Riverside Yacht Club, 1888–1972* (Riverside, Conn.: Riverside Yacht Club, 1974), pp. 8–9. The clubhouse that Robinson depicted in a series of paintings was demolished in 1928; the existing structure was built partly on the old foundations. (Anable, pp. 43–46.)

33 The 1889 information is taken from "In Their Pretty Club House," *Greenwich Graphic*, June 29, 1889, p. 3, col. 3. The information for 1894 is derived from *River-*

233

side Yacht Club 1894, a booklet published by the club that year listing officers, members, craft, constitution, and regulations. All further information on members is taken from that booklet, which is in the archives of the Riverside Yacht Club. I am grateful to club member Nancy Standard for her generous assistance in researching the archives.

34 Robinson's income is taken from his diary (New York), December 31, 1894.

35 Constant Holley performed in a tableaux at the club, according to "Very Pretty Pictures," unidentified newspaper clipping (before 1900), Riverside Yacht Club archives.

36 Although there is no documentation, it is highly probable that the Japanophile art colonists met the Arais and Murais soon after they settled in Riverside. The houses built by the two Japanese families still stand on Glen Avon Road, a few doors from the house that Steffens bought in 1905. In later years, Rioichiro Arai's daughter-in-law, Mitsu (Mrs. Yoneo Arai), was a close friend of Constant Holley MacRae's. See Haru Matsukata Reischauer, *Samurai and Silk* (Cambridge: Harvard University Press, 1986).

37 A catboat carries one sail on a mast set well forward in the bow. Although Robinson probably did not realize it, they perfectly fit a landscape undergoing change: originally used as fishing boats, their ease of handling made them favorites for recreation.

38 Mead, *Ye Historie of Ye Town of Greenwich*, p. 344. The building was demolished by 1900 according to area maps.

39 "The Riverside Yacht Club," *New York Journal*, September 16, 1891, Hubbard Scrapbook 2, HSTG.

40 For Monet's series paintings, see Paul Hayes Tucker, *Monet in the '90s: The Series Paintings* (exh. cat., Boston and New Haven: Museum of Fine Arts, Boston, in association with Yale University Press, 1989). Both of Robinson's grainstack paintings are titled *Afternoon Shadows*. One version is in the Museum of Art, Rhode Island School of Design; the other was at Kennedy Galleries, New York, as of 2000. Robinson experimented further with relatively small series of two to four canvases devoted to the same subject both in France and the United States.

41 The canvases that Robinson used for the yacht club series were standard sizes, available from artists' suppliers. American artists' suppliers did not designate sizes for subject categories, as did their French counterparts, who offered canvases of different proportions for figure, landscape, and marine paintings. See Alexander W. Katlan, *American Artists Materials Suppliers Directory: Nineteenth Century* (Park Ridge, N.J.: Noyes Press, 1987), p. 399; and Herschel B. Chipp, *Theories of Modern Art* (Berkeley: University of California Press, 1968), p. 40.

42 See William H. Gerdts, "The Square Format and Proto-Modernism in American Painting," *Arts Magazine* 50 (June 1976): 70–75.

43 *Boats at a Landing* probably depicts the long dock that extended into Cos Cob harbor from the boathouse of the Tanawatha Lodge. A photograph of the site, taken from the Mianus River railroad bridge, also includes the Lower Landing and the Palmer & Duff Shipyard (HSTG).

44 Author's interview with Mrs. Mary Filley, who had been a close friend of the Twachtman family, February 29, 1980.

3 | Images of Cos Cob's Architecture

1 Perhaps the first published use of the phrase "Cos Cob Clapboard School" was in Hassam's article "Twenty-Five Years of American Painting," *Art News* 26 (April 14, 1928): 22–28. The phrase is also recorded in Adeline Adams, *Childe Hassam* (New York: American Academy of Arts and Letters, 1938), p. 93.

2 For analyses of Hassam's paintings of churches, see H. Barbara Weinberg, Doreen Bolger, and David Park Curry, *American Impressionism and Realism: The Painting of Modern Life, 1885–1915* (exh. cat., New York: Metropolitan Museum of Art, 1994), pp. 131–33; and William H. Gerdts, "Three Themes," in Warren Adelson, Jay E. Cantor, and William H. Gerdts, *Childe Hassam: Impressionist* (New York: Abbeville Press, 1999), pp. 199–210. The two known paintings of Greenwich churches are both by members of the art colony's second generation. Lawson's *Church at Greenwich* (n.d., location unknown) is reproduced in Frederic Newlin Price, *Ernest Lawson, Canadian-*

American (New York: Feragil, 1930), p. 15. The church, a minor accent in a rural landscape, is impossible to see clearly, much less identify, in the reproduction. Robert Emmett Owen painted *Round Hill Church at Greenwich, Connecticut* (private collection) sometime between 1924 and 1935.

3 The year before, Hassam produced at least three oils depicting buildings in Cos Cob: *The Red Mill, Cos Cob* (private collection), *Fishing* (fig. 36), and *The Smelt Fishers, Cos Cob* (fig. 78).

4 Spencer P. Mead, *Ye Historie of Ye Town of Greenwich* (1911; reprint, Camden, Maine: Picton Press, 1992), pp. 160–68. Putnam's cool defiance was evident in his famous command to his troops at Bunker Hill, "Don't one of you shoot until you see the whites of their eyes."

5 Henry Tyrell, "Mr. Macrae's [*sic*] Art During Past Year Shown at Cos Cob," *New York Evening World*, October 8, 1910, unpaged clipping, HSTG. That version of the Putnam legend is recounted in Mead, *Ye Historie of Ye Town of Greenwich*, p. 175. The information on Putnam's marital status is from Eben Putnam, *The Putnam Lineage* (1907; reprint, Rutland, Vt.: Tuttle Antiquarian Books, n.d.), pp. 89 and 97. For this citation and the age of young Sally Bush, I am indebted to Susan Richardson, archivist, HSTG.

6 "Second Prize Exhibition of Colonial Pictures," *Boston Evening Transcript*, December 2, 1899, p. 8. I am grateful to David B. Findlay, Jr., for bringing this exhibition to my attention.

7 Deed research on this and several other buildings discussed in this chapter was conducted by Nils Kerschus for the Historical Society of the Town of Greenwich.

8 Theodore Robinson, diary (Cos Cob), June 7, 1894, Frick Art Reference Library, New York; "An Art School at Cos Cob," *Art Interchange* 43 (September 1899): 56; "The Oldest House in Town," *Greenwich Graphic*, January 29, 1898, p. 1.

9 Wallace Nutting, *Connecticut Beautiful* (Garden City, N.Y.: Garden City Publishing, 1923), p. 72.

10 Although the painting is titled *Holly Farm*, it actually shows the Holley House in Cos Cob, not Holly Farm in Greenwich.

11 Quotations are from J. H. McFarland, "The Elm and the Tulip: Two Unique American Trees," *Outlook* 75 (October 3, 1903): 278; "How to Kill Elm Beetles,"

Scientific American 74 (May 16, 1896): 310. For a discussion of the theme of the old house with an elm tree, see Michael Kammen, *Meadows of Memory* (Austin: University of Texas Press, 1992), p. 155.

12 Andrew C. Wheeler [J. P. Mowbray], *A Journey to Nature* (New York: Doubleday, Page, 1901), pp. 130–31. The essays in this collection were originally published decades earlier.

13 Alfred Morton Githens, "The Farmhouse Reclaimed I," *House and Garden* 12 (June 1910): 217. For a provocative analysis of the suburban ideal as expressed in American paintings, see Lisa N. Peters, *Visions of Home: American Impressionist Images of Suburban Leisure and Country Comfort* (exh. cat., Carlisle, Penn.: Dickinson College; Hanover, N.H.: University Press of New England, 1997).

14 John Douglass Hale, "The Life and Creative Development of John H. Twachtman" (Ph. D. diss., Ohio State University, 1957), p. 121.

15 Ezekiel Lemondale (Frederick Hubbard), "Our Summer Drives," *Greenwich Graphic*, May 19, 1894, p. 1; "Cos Cob as It Was," *Greenwich Graphic*, December 14, 1907, p. 1.

16 Information about Joseph E. B. Brush is from his obituary (*Greenwich News*, September 4, 1914, p. 8) and from interviews with Mrs. Mabel Burke Delage and Mr. William E. Finch, Jr., conducted by the author in 1994.

17 Twachtman painted at least two other views of the Brush House: *Brush House*, 1895 (Jacob Stern Family Collection, on loan to the Fine Arts Museums of San Francisco) and *View of the Brush House, Cos Cob, Connecticut*, ca. 1901 (Dayton Art Institute).

18 In addition to the three works illustrated here (figs. 20, 71, and 72), Hassam also depicted the Brush House in an etching of 1915 (*The Old House, Connecticut* [C40]) and a watercolor of 1916 (*The Barn, Cos Cob*, location unknown).

19 Rebecca Bennett Talcott, in "Artist's Career Begun at Cos Cob," *Our Town*, December 4, 1915, refers to artist Harry Lachman's roughing it in the Brush house in 1909. In a history of Greenwich published in 1913, Frederick A. Hubbard states that the Brush house had "long since been abandoned as a dwelling." Frederick A.

Hubbard, *Other Days in Greenwich* (New York: J. F. Tapley Company, 1913), p. 314.

20 Harry M. Lounsbury and Katherine L. S. Lowell, *The Strickland Road Area* (Greenwich, Conn.: Friends of the Greenwich Library, Oral History Project, 1978), p. 59.

21 The woodchopper in the pastel may be a surrogate for Hassam. In letters she wrote in the fall of 1902, Constant Holley MacRae expressed her worry that the supply of firewood for the boardinghouse was inadequate for the coming winter. She was relieved when a neighbor offered her a fallen tree, and transformed the task of moving it to the Holley House into an outing for the boarders. "Mr. Hassam is fine on the chop," she wrote to her mother on October 28, 1902, "and we are all going over [to the cedar lot] with apples and saws and bring the tree home. Hot stuff! I pretend it is fun and they all think it is." (The letter is in the Archives, HSTG.)

22 Twachtman, quoted in "An Art School at Cos Cob," p. 56.

23 For paintings by other artists in which hollyhocks suggest tradition, see May Brawley Hill, *Grandmother's Garden: The Old-Fashioned American Garden, 1865–1915* (New York: Harry N. Abrams, 1995).

24 For more on Hassam's paintings of New York City, see Ilene Susan Fort, *Childe Hassam's New York* (San Francisco: Pomegranate Artbooks, 1993); William H. Gerdts, *Impressionist New York* (New York: Abbeville Press, 1994); Weinberg, Bolger, and Curry, *American Impressionism and Realism*, pp. 173–88; and Gerdts, "Three Themes," pp. 135–50 and 159–66.

25 "New York, the Beauty City," T*he Sun*, February 23, 1913, sec. 4, p. 16, reprinted in Ulrich W. Hiesinger, *Childe Hassam: American Impressionist* (Munich: Prestel, 1994), p. 181. For more on this painting, see the catalogue entry in H. Barbara Weinberg and Susan G. Larkin, *American Impressionists Abroad and at Home: Paintings from the Collection of the Metropolitan Museum of Art* (exh. cat., New York: American Federation of Arts, 2001), p. 30.

26 A. E. Ives, "Mr. Childe Hassam on Painting Street Scenes," *Art Amateur* 27 (October 1892): 116; "Broadway by Night," *Harper's Weekly*, January 20, 1894, p. 54.

27 Liberty Hyde Bailey, *The Country-Life Movement in the United States* (New York: Macmillan, 1911), pp. 26–27. Today, in a movement called the New Urbanism, developers are adapting the village model to planned communities throughout the United States.

4 Familiar Faces

1 Although more photographs and related works by Robinson have since come to light, the best discussion of the artist's use of the camera is still John I. H. Baur, "Photographic Studies by an Impressionist," *Gazette des Beaux-Arts* 30 (October–December 1946): 319–30.

2 Robinson mentions *Stepping Stones* in his diary entries for June 11, 15, 20, and 29 and July 4, 6, and 9, 1893, Frick Art Reference Library, New York.

3 Sarah Burns, "Barefoot Boys and Other Country Children," in *Pastoral Inventions: Rural Life in Nineteenth-Century American Art and Culture* (Philadelphia: Temple University Press, 1989), p. 302.

4 Helen Cooper analyzes Homer's watercolors of country girls in terms of market demand and French antecedents. Helen A. Cooper, *Winslow Homer Watercolors* (exh. cat., New Haven: Yale University Press, 1986), pp. 60–62.

5 In a letter to Judith Lefebvre, curator of the Hartford Steam Boiler collection, dealer Susan Powell wrote that the woman in *Barnyard* is Mrs. Twachtman and the child is the couple's youngest daughter, Violet (born May 23, 1895). She does not identify her source for this information. (Susan Powell to Judith Lefebvre, January 29, 1992, courtesy of Judith Lefebvre.)

6 "Greenwich Chicken Fanciers," *Greenwich Graphic*, March 10, 1888, p. 3, col. 6; Mabel Wright, *The Garden of a Commuter's Wife* (New York: Macmillan, 1902), p. 87, quoted in John Stilgoe, *Metropolitan Corridor: Railroads and the American Scene* (New Haven: Yale University Press), p. 283; Fred Haxton, "Why They Left the City," *Suburban Life* 12 (April 1911): 266.

7 A. J. Downing, *The Architecture of Country Houses* (1850; reprint, New York: Da Capo Press, 1968), p. 237; F. H. Valentine, "Pigeons as Pets," *Country Life* 12 (September 1907): 553.

8 For more on Mina Fonda Ochtman, see Susan G. Larkin, *The Ochtmans of Cos Cob* (exh. cat., Greenwich, Conn.: Bruce Museum, 1989). For information on Martha Scudder Twachtman's etchings, see Mary Baskett, *John Henry Twachtman: American Impressionist Painter as Printmaker* (Bronxville, N.Y.: M. Hausberg, 1999). The only published information on Mary Roberts Ebert is a

236

small brochure for the exhibition *Color, Light and Atmosphere: The Art of Charles and Mary Roberts Ebert* (Old Lyme, Conn.: Florence Griswold Museum, 1996).

9 John H. Twachtman to Josephine Holley, postmarked New York City, January 17, 1902, HSTG; for a transcript see Lisa N. Peters, "John Twachtman (1853–1902) and the American Scene in the Late Nineteenth Century: The Frontier within the Terrain of the Familiar" (Ph.D. diss., City University of New York, 1995), p. 550.

10 In titling his canvas, Hassam may have intended an additional allusion. Those who saw *Listening to the Orchard Oriole* in the exhibition of Ten American Painters in spring 1905 would have been reminded of the most popular song of that year, "In the Shade of the Old Apple Tree." Beginning with the line "The oriole with joy was sweetly singing," the lyrics describe a springtime romance, comparing the woman's voice to the song of the orchard oriole. "In the Shade of the Old Apple Tree," by composer Egbert Van Alstyne and lyricist Harry H. Williams, was published by Shapiro, Remick in 1905. It is reprinted in Robert A. Fremont, ed., *Favorite Songs of the Nineties* (New York: Dover Publications, 1973), pp. 161–65. The month of original publication is not known, but the seasonal lyrics strongly suggest an early-spring release. The 1905 exhibition of the Ten ran from March 25 to April 13.

11 Witmer Stone, "The Orchard Oriole," *Bird Lore* 12 (January 1910): 44 and 47. The orchard oriole, once common, is infrequently seen in Connecticut today. See Joseph D. Zeranski and Thomas R. Baptist, *Connecticut Birds* (Hanover: University Press of New England, 1990), pp. 263–64.

12 Liberty Hyde Bailey, *The Holy Earth* (1915; reprint 1943), p. 37, quoted in Peter Schmitt, *Back to Nature: The Arcadian Myth in Urban America* (New York: Oxford University Press, 1969), p. xxi. Bailey was the editor of *Country Life in America*, the journal that best represented the city dweller's ideal of the country.

13 The other works in which the kimono appears are the oils *Bowl of Goldfish* (fig. 93), *The Goldfish Window* (fig. 96), and *Clarissa's Window* (1913, private collection) and the etchings *The White Kimono* (fig. 103) and *The White Mantel* (1915, Metropolitan Museum of Art).

14 Siegfried Wichmann, *Japonisme: The Japanese Influence in Western Art since 1858* (New York: Park Lane, 1985), p. 19.

15 For an analysis of the Western stereotypes of Japanese women, see Nancy A. Corwin, "The Kimono Mind: *Japonisme* in American Culture," in *The Kimono Inspiration: Art and Art-to-Wear in America*, ed. Rebecca A. T. Stevens and Yoshiko Iwamoto Wada (exh. cat., Washington, D.C.: Textile Museum, 1996), pp. 23–73. For a fascinating study of the gender, age, and class distinctions conveyed by different manners of wearing the kimono, see Liza Crihfield Dalby, *Kimono: Fashioning Culture* (New Haven: Yale University Press, 1993).

16 Page from 1905 Sears, Roebuck catalogue, reprinted in Joseph J. Schroeder, Jr., ed., *The Wonderful World of Ladies' Fashion, 1850–1920* (Chicago: Follett, 1971), p. 192; *The Delineator* 60 (November 1902): 738, caption for illustration of kimono patterns.

17 According to the exhibition checklist, *Bowl of Goldfish* (number 136) was hung in Gallery G, *The New York Window* (number 165) in Gallery H. I am grateful to Corcoran archivist Marisa Keller and curatorial intern Paul Manoguerra for this information.

18 The building is the barn where the art students sometimes hung their work. The window before which the model stands, since blocked off, was in a small room behind the north bedroom of the Holley House. Hassam often stayed in the north bedroom and used the adjoining room to store his materials.

19 Benjamin F. Leggett, *Out-Door Poems*, p. 31, quoted in John Stilgoe, *Borderland: Origins of the American Suburb, 1820–1930* (New Haven: Yale University Press, 1988), p. 190.

20 Francis E. Clark, "Why I Chose a Suburban Home," *Suburban Life* 4 (April 1907); quoted in Stilgoe, *Borderland*, p. 192.

21 The symbolism of the goldfish is discussed in Wichmann, *Japonisme*, p. 121, and in C. A. S. Williams, *Outlines of Chinese Symbolism and Art Motives* (New York: Dover Publications, 1976), pp. 185–86. The Japanese adopted both the motif and much of its symbolism from China.

22 I am indebted to historian Katherine C. Grier of the University of Utah for this insight; telephone interview, February 14, 1995. Professor Grier is writing a book on American attitudes toward animals from the late eighteenth to the early twentieth century.

23 Saki (Hector Hugh Munro), "The Innocence of Reginald," originally published in 1904, collected in *The Short Stories of Saki* (New York: Modern Library, 1958), p. 41.

24 Thomas M. Earl, *Pets of the Household* (Columbus, Ohio: A. W. Livingston's Sons, 1896), p. 125.

25 Carl Zigrosser, *Childe Hassam* (exh. cat., New York: Frederick Keppel, 1916), p. 16.

26 Nathaniel Pousette-Dart, *Childe Hassam* (New York: Frederick A. Stokes Company, 1922), n.p. Given that Hassam was known for his unusual involvement in his exhibition catalogues (see Adeline Adams, *Childe Hassam* [New York: American Academy of Arts and Letters, 1938], pp. 87–88), he almost certainly participated in the layout of this book.

27 Luke Vincent Lockwood, *Colonial Furniture in America* (New York: Charles Scribner's Sons, 1921), vol. 2, p. 16.

28 For information about Helen Burke, I am indebted to her younger sister, Mrs. Mabel Burke Delage (telephone interviews in 1994). The other images for which Helen Burke posed are *In the Old House* (fig. 101), an oil titled *Helen Burke* (ca. 1915, location unknown), an etching by the same title (1917, Library of Congress), and the etchings *The Dutch Door* (fig. 95), *The White Kimono* (fig. 103), and *The White Mantel*, all from 1915 (Metropolitan Museum of Art). She may also have been the model for *Clarissa's Window* (1913, private collection).

29 The etching *Painting Fans* (1915, no source known) depicts two unidentified women artists painting fans for a fair; in another etching, *The Breakfast Room* (1915, Library of Congress), painter Caroline Mase stares at a cluster of flowers. These portrayals of women artists are markedly different from Hassam's self-portrait of 1914 (see fig. 106), in which he represented himself in the act of painting.

30 For another discussion of American Impressionist images of women looking in mirrors, see Bram Dijkstra, "The High Cost of Parasols: Images of Women in Impressionist Art," in Patricia Trenton and William H. Gerdts, *California Light, 1900–1930* (exh. cat., Laguna Beach, Calif.: Laguna Art Museum, 1990), pp. 44–46.

31 See Adams, *Hassam*, p. 25.

32 Wallace Nutting, *Wallace Nutting's Biography* (Framingham, Mass.: Old America Company, 1936), pp. 75–76. Nutting's photographs of the Holley House interior were among the first of his popular "Colonial pictures" (p. 284). Two of them are now in the collection of the HSTG, but they were not in the house when the society bought it from Constant Holley MacRae. For a study of the theme of the old-fashioned interior, see Celia Betsky, "Inside the Past: The Interior and the Colonial Revival in American Art and Literature, 1860–1914," in *The Colonial Revival in America*, ed. Alan Axelrod (New York: W. W. Norton, 1985), pp. 241–77.

33 Hassam made this remark in a letter to an unidentified correspondent (Hassam Papers, Archives of American Art, roll NAA1, frames 740 and 749). Immigration in 1914 totaled 1,218,480, the highest in any year since 1820 except for 1907. (U.S. Department of Commerce, Bureau of the Census, *Historical Statistics of the United States Colonial Times to 1970*, pt. 1 [White Plains, N.Y.: Kraus International Publications, 1989], p. 105.)

34 Two writers of the Cos Cob art colony reacted conservatively to the changing status of women. Harry Thurston Peck challenged the feminists' view of women's status in "For Maids and Mothers: The Woman of To-day and of To-morrow," *Cosmopolitan* 27 (June 1899): 149–62. Winfield Scott Moody contrasted the old and new female types in "Daisy Miller and the Gibson Girl," *Ladies Home Journal* 21 (September 1904): 17.

35 Volkmar was a close friend of Elmer and Constant MacRae, who used his glazed pots for her flower arrangements. The vase in Hassam's painting is no longer in the Bush-Holley House, but an important collection of Volkmar pots remains there.

36 Telephone interview with Mrs. Mabel Burke Delage, February 4, 1994.

37 F. Newlin Price, "Childe Hassam— Puritan," *International Studio* 77 (April 1923): 3–7. The quotation is from p. 3.

5 | Familiar Places

1 Ezekiel Lemondale (Frederick A. Hubbard), "Our Summer Drives," *Greenwich Graphic*, July 7, 1894, p. 1.

2 See Spencer P. Mead, *Ye Historie of Ye Town of Greenwich* (1911; reprint, Camden, Maine: Picton Press, 1992), p. 363. Hubbard was probably the model

for Socrates Potter in Irving Bacheller's "Keeping Up with Lizzie" (see chapter 1).

3 These songs are among seventy-eight that include "farm" in the title, in the database *Music for the Nation: American Sheet Music, 1870–1885*, American Memory Collection, Library of Congress, available online at http://memory.loc.gov/ammem/smhtml/smhome.html.

4 Two seventeenth-century Englishmen sympathetic to the American colonists' demand for independence took refuge from royalist forces in a cave on West Rock, where local people kept them supplied with essentials. See Franklin Kelly, *Frederic Edwin Church and the National Landscape* (Washington: Smithsonian Institution Press, 1988), pp. 22–24. An abbreviated analysis is in Kelly, *Frederic Edwin Church* (Washington, D.C.: National Gallery of Art, 1989), p. 42.

5 Twachtman also depicted a haystack in oil (*Hayrick*, High Museum of Art, Atlanta).

6 Jack Larkin, *The Weir Farm: Working Agriculture and the Vision of Rural Life in New England, 1860–1940* (National Park Service Cultural Landscape Report, 1996), p. 106. See also Harold Spencer, "J. Alden Weir and the Image of the American Farm," in *A Connecticut Place: Weir Farm, An American Painter's Rural Retreat*, by Nicolai Cikovsky, Jr., Elizabeth Milroy, Harold Spencer, and Hildegard Cummings (Wilton, Conn.: Weir Farm Trust, 2000).

7 Joseph C. Jones, Jr., *America's Icemen: An Illustrative History of the United States Natural Ice Industry, 1665–1925* (Humble, Tex.: Jobeco Books, 1984). I am grateful to Gail Hogan Lucia and Thom Lucia for referring me to this source.

8 Browne related this to her friend Mrs. Frederick Reed Hoisington, who recounted it in an autobiographical typescript, HSTG.

9 For more on Browne, see Helen Comstock, "A Woman Animal Painter," *International Studio* 78 (November 1923): 129–31; and Jeffrey W. Andersen and Barbara J. MacAdam, *Old Lyme: The American Barbizon* (exh. cat., Old Lyme, Conn.: Florence Griswold Museum, 1982), p. 35.

10 John C. Van Dyke, *Nature for Its Own Sake: First Studies in Natural Appearances* (New York: Charles Scribner's Sons, 1898), p. 170.

11 Charles Eldredge's seminal essay "Connecticut Impressionists: The Spirit of Place" first brought this phenomenon to my attention (*Art in America* 62 [September–October 1974]: 84–90).

12 See Norma Broude, ed., *World Impressionism: The International Movement, 1860–1920* (New York: Harry N. Abrams, 1990); Hamlin Garland, "Impressionism," *Crumbling Idols* (1894; reprint, Cambridge: Harvard University Press, 1960).

13 Robinson's diary (Cos Cob), April 11, 1895, and August 17, 1894, Frick Art Reference Library, New York.

14 Robinson's diary (Greenwich), April 11, 1894.

15 Lisa Peters, "Twachtman's Greenwich Paintings: Context and Chronology," in *John Twachtman: Connecticut Landscapes*, ed. Deborah Chotner, Lisa N. Peters, and Kathleen A. Pyne (exh. cat., Washington, D.C.: National Gallery of Art; distributed by Abrams), p. 29.

16 John Greenleaf Whittier, "Snow-Bound: A Winter Idyl," in *The Oxford Book of American Verse*, ed. F. O. Matthiessen (New York: Oxford University Press, 1950), pp. 166–67.

17 "Statistics of Fences in the United States," *Report of the Commissioner of Agriculture for the Year 1871* (Washington: Government Printing Office, 1872), pp. 506 and 500. See also Susan Allport, *Sermons in Stone: The Stone Walls of New England and New York* (New York: W. W. Norton, 1990).

18 Alfred Henry Goodwin, "An Artist's Unspoiled Country Home," *Country Life in America* 8 (October 1905): 629. John Douglass Hale also mentions Twachtman's enjoyment of building stone walls ("The Life and Creative Development of John H. Twachtman" [Ph. D. diss., Ohio State University, 1957], p. 76).

19 For more on Brinley, see Elizabeth M. Loder, *D. Putnam Brinley, Impressionist and Mural Painter* (published for the New Canaan, Conn., Historical Society and the Silvermine Guild of Artists by University Microfilms International, Ann Arbor, Mich., 1979).

20 Goodwin, "An Artist's Unspoiled Country Home," p. 629.

21 For a detailed discussion of Twachtman's white-bridge series and the two bridge designs that appear in his paintings, see my essay "On Home Ground: John Twachtman and the Familiar Landscape," *American Art Journal* 29, nos. 1–2 (1998): 52–85; the section on the bridge series is on pp. 71–83. See also Lisa Peters, "The Suburban

239

Aesthetic: John Twachtman's *White Bridge*," *Porticus: Journal of the Memorial Art Gallery of the University of Rochester* 17–19 (1994–96): 50–56.

22 John House, *Monet: Nature Into Art* (New Haven: Yale University Press, 1986), pp. 13 and 31.

23 Monet painted three views of the bridge in 1895, a series featuring it in 1899 and 1900, and more in the years after Twachtman's death. For those painted during Twachtman's lifetime, see Daniel Wildenstein, *Claude Monet: Biographie et catalogue raisonné* (Lausanne: La Bibliotheque des Arts, 1979), cat. nos. 1392, 1419, 1419 *bis*, 1509–20, 1628–33.

24 Although Twachtman first exhibited a work titled *The White Bridge* at the National Academy of Design in 1897, he had exhibited a painting (or paintings) titled *The Bridge* in the Carnegie Institute annual of 1896 and the Pennsylvania Academy's annual of December 1896 to January 1897. The Havemeyers purchased two very similar views of Monet's bridge from Durand-Ruel's Paris gallery in spring 1901. After a year, they returned one painting and kept the other, now in the Havemeyer Collection of the Metropolitan Museum of Art (Frances Weitzenhoffer, *The Havemeyers: Impressionism Comes to America* [New York: Harry N. Abrams, 1986], p. 143).

25 Childe Hassam in an interview by DeWitt Lockman, DeWitt McClellan Lockman Papers, Archives of American Art, roll 503, frames 392–93.

26 Kathleen Pyne argues that Twachtman also absorbed elements of Asian religious thinking. See her essay "John Twachtman and the Therapeutic Landscape," in Chotner, Peters, and Pyne, *Twachtman Landscapes*, pp. 49–69. She touches on the same ideas more briefly in her book *Art and the Higher Life: Painting and Evolutionary Thought in Late Nineteenth-Century America* (Austin: University of Texas Press, 1996), pp. 279–82.

27 Edward S. Morse, *Japanese Homes and Their Surroundings* (Boston: Ticknor, 1886), pp. 274–75. The book ran through at least eight printings by 1895, according to Clay Lancaster, *The Japanese Influence in America* (New York: Walton H. Rawls, 1963), p. 67. Another source of information on Japanese gardens was British architect Josiah Conder's *Landscape Gardening in Japan*, published in 1893 with a supplement containing forty photographs of famous gardens in Japan. According to *The Nation*, Conder's work was "the most complete and just account of Japanese gardening which has yet appeared." ("Landscape Gardening in Japan," *The Nation* 58 [June 14, 1894]: 456.)

28 Bridge-pavilions had appeared in Europe since the eighteenth century, when William Chambers published his *Designs of Chinese Buildings, Furniture, Dresses, Machines and Utensils* (London: published for the author, 1757); see plate 7. See also Eleanor von Erdberg, *Chinese Influence on European Garden Structures* (Cambridge: Harvard University Press, 1936), p. 126.

29 Among the evocations of the Eight-Plank Bridge, in addition to the print illustrated here, are the screen painting *Yatsuhashi* (Metropolitan Museum of Art), a small incense box (also at the Metropolitan Museum) and a lacquer writing box (Tokyo National Museum), all by Ogata Korin (1658–1716), and another print by Hokusai, *Noblemen Viewing Iris at Yatsuhashi* (ca. 1820, Honolulu Academy of Arts). A modern variation of the bridge has been constructed in an area planted with Japanese irises at the Pepsico Sculpture Gardens in Purchase, N.Y.

30 Charles W. Moore, William J. Mitchell, and William Turnbull, Jr., *The Poetics of Gardens* (Cambridge: MIT Press, 1988), preface (n.p.).

31 John H. Twachtman (Branchville) to William Langson Lathrop, December 10, 1888. I am grateful to Hildegard Cummings for sharing this letter, which she obtained from Brian H. Peterson, Senior Curator, James A. Michener Art Museum, Doylestown, Pennsylvania. The letters were provided to the museum by Lathrop descendants William Bauhan and Julian Karhumaa.

32 See Milton Brown, *The Story of the Armory Show* (1963; 2d ed., New York: Abbeville Press, 1988), pp. 98 and 116–17. Twachtman was represented by two paintings: *Hemlock Pool* and *The Sea* (location unknown); Robinson by four, none of them painted in Cos Cob (see ibid., pp. 321 and 310). Two other deceased American artists, J. Frank Currier and William Rimmer, were included in the Chicago version of the Armory Show, but their work was not hung in the historical survey (see ibid., pp. 194, 258, and 310).

33 Goodwin, "An Artist's Unspoiled Country Home," p. 630; Simon Schama, *Landscape and Memory* (New York: Alfred A. Knopf, 1995), p. 61.

34 Robert Herbert, *Impressionism: Art, Leisure, and Parisian Society* (New Haven: Yale University Press, 1988), p. 306.

Index